The Color Revolution

Lemelson Center Studies in Invention and Innovation

Arthur P. Molella and Joyce Bedi, general editors

The Color Revolution

Regina Lee Blaszczyk

The MIT Press
Cambridge, Massachusetts
London, England

in association with
The Lemelson Center
Smithsonian Institution
Washington, DC

MIT Press books may be purchased at special quantity discounts for business or sales promotional use. For information, please email special_sales@mitpress.mit.edu or write to Special Sales Department, The MIT Press, 55 Hayward Street, Cambridge, MA 02142.

Set in Minion Pro and Helvetica Neue by The MIT Press. Printed and bound in Canada.

Library of Congress Cataloging-in-Publication Data

Blaszczyk, Regina Lee.
The color revolution / Regina Lee Blaszczyk.
p. cm. — (Lemelson Center studies in invention and innovation)
Includes bibliographical references and index.
ISBN 978-0-262-01777-0 (hbk. : alk. paper) 1. Product design—History. 2. Color in design—History. 3. Color in marketing—History. 4. Consumer behavior—History. I. Title.
TS171.4.B57 2012
658.8'23—dc23

2011052295

10 9 8 7 6 5 4 3 2 1

in memory of William W. Walls Jr. (1932–2011)

Color is in everything! From costly architecture down to 10-cent thimbles!

How did this great color movement start?

How far-reaching will it be?

How, when, and where will it end?

What effect is it having upon us?

How costly is it proving—to the manufacturer and to the consumer?

—*Magazine of Business*, 1928

Contents

Series Foreword

Invention and innovation have long been recognized as significant forces in American history, not only in technological realms but also as models in politics, society, and culture. And they are arguably more important than previously thought in other societies as well. What there is no question about is that they have become the universal watchwords of the twenty-first century, so much so that nations are staking their futures on them.

Since 1995, the Smithsonian's Lemelson Center has been investigating the history of invention and innovation from such broad interdisciplinary perspectives. So, too, does this series. The Lemelson Center Studies in Invention and Innovation explores the work of inventors and the technologies they create in order to advance scholarship in history, engineering, science, and related fields with a direct connection to technological invention, such as urban planning, architecture, and the arts. By opening channels of communication between the various disciplines and sectors of society concerned with technological innovation, it is hoped that this series will enhance public understanding of humanity's inventive impulse.

Arthur Molella and Joyce Bedi
series editors, Lemelson Center Studies in Invention and Innovation

Preface

Lime green is a fabulous color for blondes, and, as a blonde, I was delighted when it came back into style after a period of Armani-inspired black. At different stores in my local mall, I bought a terrific lime-green linen dress and matching accessories. At Target, I even found breath mints in a tempting new lime favor. My outfit drew many compliments from other women. My mother-in-law told me I looked like a refreshing lime sherbet.

It was no accident that my dress, my handbag, my shoes, and my candy matched to a T. My new lime-green ensemble had been color-coordinated by design. It was a product of design practices that had been unfolding for more than a century.

Color is an important but little-understood specialty within the design professions of the global economy. We encounter the work of color experts when we select a lipstick at Sephora, browse through the cereal aisle at Kroger's, or covet a cute Mini Cooper in Chili Red and Pepper White. We find their work at its most ephemeral at Macy's, at Banana Republic, and at LOFT, where the hues of apparel seem to come and go at the drop of a hat. The work of colorists is ubiquitous. Why do we know so little about them?

Several years before my Lime Green Moment, I was a fellow at Harvard University's Charles Warren Center for Studies in American History, hot on the trail of the twentieth-century color revolution that is the subject of this book. I had immersed myself in corporate records, long runs of industry trade journals and women's magazines, and advertising ephemera in libraries up and down the East Coast. I was curious about color merchandising and wanted to understand its purpose, origins, and historical trajectory. It happened that the Color Marketing Group—one of several organizations around the world that analyze and forecast color trends—held one of its semi-annual international conferences in Boston that fall. The CMG's publicist generously arranged for me to participate. I was inspired by what I saw.

I met colorists from Nike and Nissan, from Hilton and Holiday Inn, from Disney and DuPont. I attended seminars in which they debated the latest fads and fashions. I watched them as they discussed major cultural shifts and deliberated the effects of "technology" on taste. They approached American culture with the sophistication of a university anthropologist, and they tackled economic cycles with the analytical rigor of a writer for *The Economist*. Their enthusiasm was contagious.

My field work confirmed the theories that were emerging from my historical research. Professional colorists are important (yet often invisible) players in the creative economy that undergirds the global fashion system. Design historians, business historians, and museum curators who focus on "great entrepreneurs" and "great designers" have overlooked these creative professionals and their influence on products. In my first book, *Imagining Consumers*, I coined the term "fashion intermediaries" to describe the many behind-the-scenes actors who contribute to innovation in product design, colorists among them.

The big question is whether colorists shape trends or follow trends. It was clear from my observations at the CMG conference that colorists try to read cultural trends and to anticipate changes in consumer taste. They want to create palettes that will appeal to consumers, evaluating "where color has been" and "where color is going to go." Their color forecasts, circulated only among members of the CMG, are created to benefit the design process and, in turn, to help each company's bottom line. Collaboration, pop psychology, and historical method are involved. Forecasting is a bit of art and a bit of engineering. But, like many designers and marketers, colorists are largely invisible to the public, except when the occasional journalist decries their work as a "color conspiracy." In this book, I use historical research to look beyond such stereotypes and to examine the colorist's role in innovation.

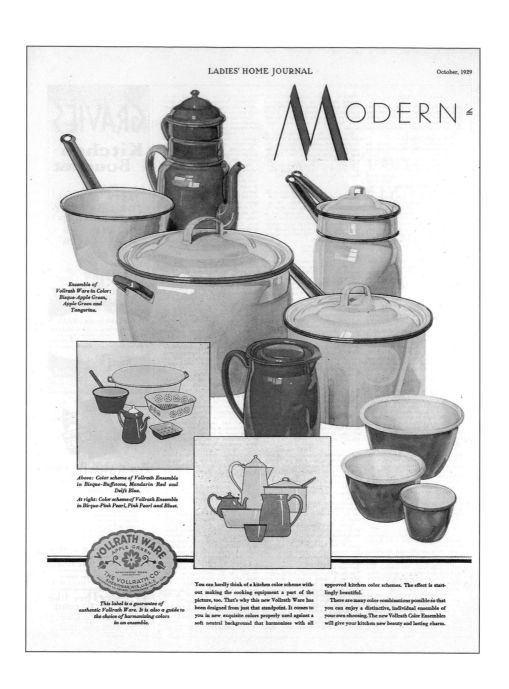

I.1 Advertisement in *Ladies' Home Journal*,
October 1929.

Introduction

Just three months after the stock market crash of 1929, the business magazine *Fortune* published an effusive celebration of American enterprise that included an article titled "Color in Industry." The editors marveled over the "suddenly kaleidoscopic world" in which color served as "a master salesman, a distributor extraordinary." In the 1920s, manufacturers had flooded the market with apricot autos, blue beds, and mauve mops. Color was now seen as a tool for tapping into human emotions and improving daily life. *Fortune* gave this phenomenon a name: "the color revolution."[1]

What was revolutionary about this sudden burst of color? In 1923, when Ford was still making its somber Model T, General Motors introduced the two-tone Oakland. A year later, the Curtis Publishing Company introduced the first four-color advertisements, a visual watershed in the magazine world. The American home was also dipped in the paint pot. In 1926, the New York retailer R. H. Macy & Company launched a "Color in the Kitchen" promotion, offering brilliantly colored housewares. Within a few years, kitchen stoves, bathroom fixtures, and coal furnaces were available in colorized luxury models. The editors of *Fortune* declared that "the Anglo-Saxon" had been released from "his chromatic inhibitions" and was now ready to "outdo the barbarians" in the use of brilliant hues.[2]

Who were the insurgents in this war for the liberation of taste? The command posts were buried deep in American industry, and the officers wore the insignia of the color corps. The nation's first professional colorists—among them H. Ledyard Towle in Detroit and Arthur S. Allen in New York—were master strategists who helped corporations understand the art of illusion and the psychology of color. Their tools were the color wheel and the shade card. Among the important design practices they introduced were visual streamlining, color forecasting, and the enduring merchandising concept of the ensemble. This is their story.

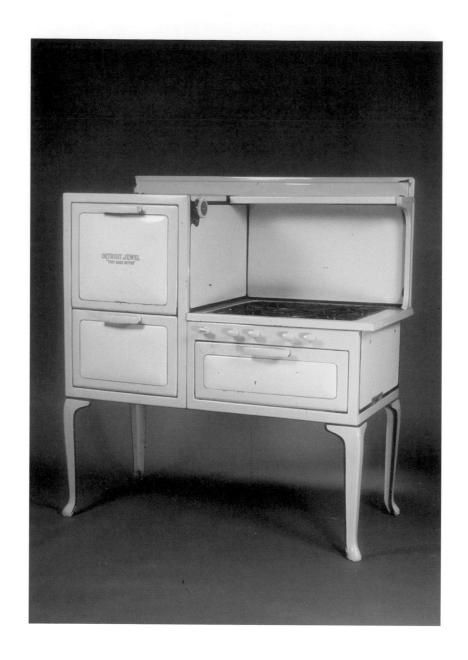

I.2 A gas range with two-tone enameling made by the Michigan Stove Company in the 1930s. Division of Home and Community Life, National Museum of American History, Smithsonian Institution.

Color Is Here to Stay

Color has a long history and has been the subject of countless publications and exhibitions about visual culture, symbolism, science, fashion, and aesthetic meaning. This study takes a different perspective, focusing on a pivotal moment in American economic culture and looking at the work of practitioners of color design rather than at color itself. Building on the extensive literature about the invention of color technologies, it picks up the tale of color's dissemination into the broader consumer market, filling the gap between typical "eureka" stories of invention and design histories of the products. It is organized as a series of biographical vignettes about the people and organizations—the color intermediaries—that interacted with innovations, economic forces, and cultural values to manage chromatic change within American consumer culture.[3]

At the heart of this story are the creative professionals who figured out how to manage the color cornucopia of the Second Industrial Revolution, a socio-cultural-economic transition that reshaped major Western economies from the mid 1800s through the mid 1900s and gave birth to the synthetic organic chemical industry. Chemical companies in Germany and in the United States invested heavily in research and development, and chemists in their laboratories produced a stream of innovations in fields as diverse as pharmaceuticals, plastics, and dyes. The new artificial dyes and pigments enabled other manufacturers to reproduce virtually any color, creating possibilities for great visual variety and for even greater visual chaos.[4] H. Ledyard Towle, Arthur Allen, and other color experts appeared to minister to those afflicted by the chromatic madness.

The setting of the story is the United States during the country's golden era of manufacturing, and, not coincidentally, at the height of the modernist movement in art, architecture, and design.[5] New York, the major commercial center, was home to many of the players, but the color revolution would not have occurred without influence from Paris, the world's fashion capital. A transatlantic business network, which connected the United States to the City of Light, served as a source of both inspiration and irritation. Color allows us to see the complexities of this French-American relationship and the interfaces among business culture, industrial practice, aesthetic values, and the fashion system. It allows us to explore the flow of creative ideas and management practices across national boundaries as the stage was set for today's global economy.

The Industrial Arts: Cradle of the Color Revolution

Color had long been a factor in product design, particularly in industries concerned with taste, style, and fashion. The ancient Egyptians made ointment jars of cobalt-and-white glass. The Greeks, whose vases were in orange-and-black earth tones, painted their Parthenon and other public monuments in bright colors. The Italian Renaissance potters who mastered the art of faience knew how to mix and

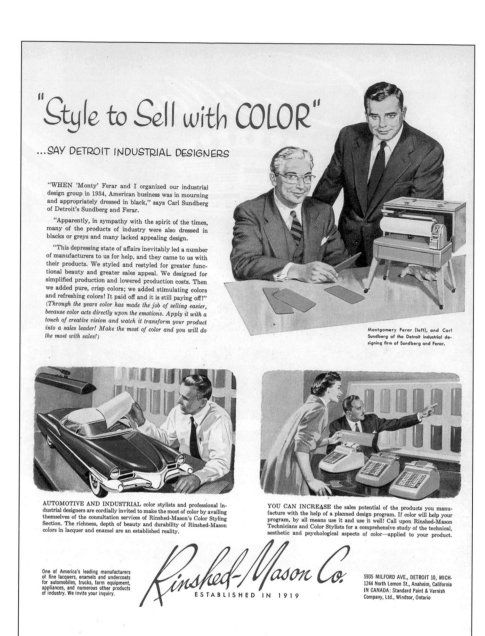

I.3 This advertisement for the Rinshed-Mason
Company shows the paint maker's color stylists
helping a product designer make choices.
Fortune, April 1952. © BASF Coatings, GmbH.

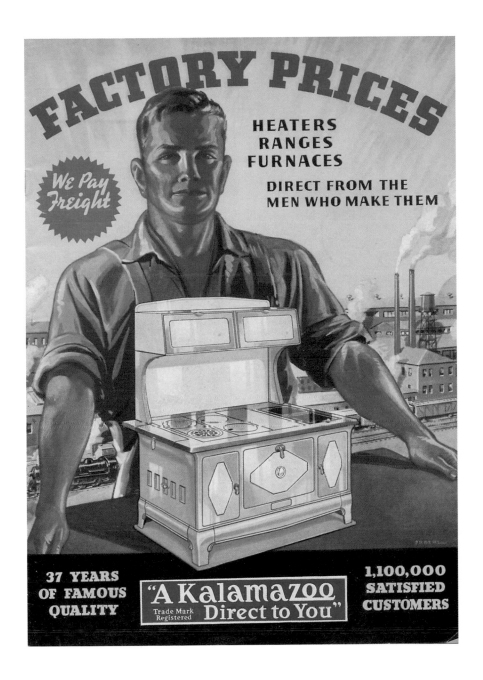

I.4 The color revolution grew out of American industry's drive for efficiency in design, production, and distribution. This is the cover of a 1939 catalog published by the Kalamazoo Stove Company.

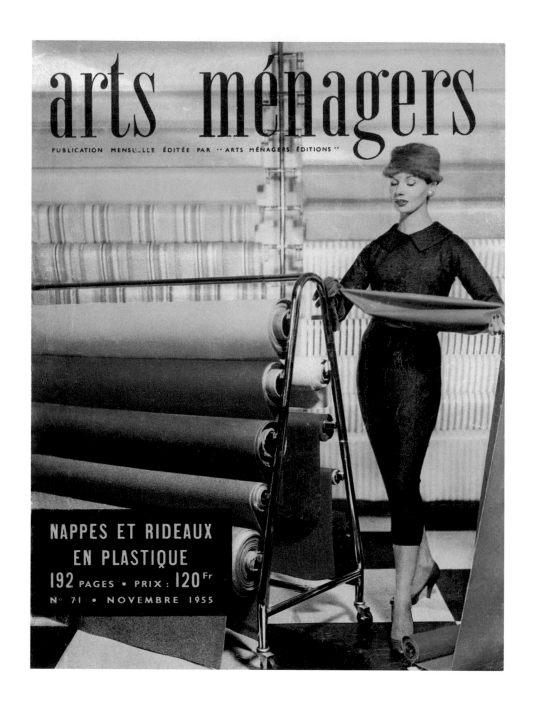

I.5 Paris set the fashion that influenced American color practice. This is the cover of the November 1955 issue of *Arts Ménagers*.

match colors to create a pleasing palette, and produced stunning pottery that delights even the most jaded twenty-first-century eye. The sumptuary laws of early modern Europe dictated who could wear what color, and stimulated regional textile industries that made cloth in Lincoln Green or Prussian Blue. But it was not until the early nineteenth century that the seeds of the color revolution were sown. That happened in Paris, where a curious chemist named Michel-Eugène Chevreul set about to better manage color in the textile mills.

The nineteenth-century economy was greatly different from today's. There were no global companies (such as L'Oréal, Nike, or Toyota) developing brands for worldwide consumption. The nation-state was in its infancy, and the economies of various regions were organized around the specialized production of goods that had been made in those regions for centuries. The Staffordshire potteries, the Manchester cotton mills, the Paris dressmakers, and the Providence jewelers operated in industrial districts or regional clusters that mostly did one thing—and did it very well. The unifying theme was the creation of products that had some sort of eye appeal. The modern strategies of enticement, including mass advertising, had not yet matured, and manufacturers competed on the look, quality, and price of the goods. The goal was to see who could put the most detail on a teapot, print the poster that turned the most heads, or make ribbons of the brightest lilac.[6]

The term "art industries" was often applied to these manufacturers to capture their creative aspect. There was no hierarchy of media. Portrait painting, chromolithography, and fabric design were peers, and the "practical man" who had mastered these "arts" moved between them easily. Most practical men chose to stay within one trade in the "industrial arts," but no one thought it odd to meet a china decorator who was also a wallpaper designer.[7]

Paris was one of the major fashion centers of Europe, a mecca for ladies and gentlemen of taste and refinement who flocked there to absorb the atmosphere and to shop.[8] The French art industries were particularly vexed by the difficulty of managing the great variety of materials and colors. French dye houses and textile mills employed a special group of practical men to worry about this, and soon the first "colorists" were grappling with the technical aspects of dye formation and the aesthetic side of things. Scientists had theorized on the physical nature of light and prismatic color since the days of Isaac Newton, but the art industries needed something more down to earth. Adventurous Parisian researchers such as Chevreul crossed over into art and design and, building on the work of the German natural philosopher Johann Wolfgang von Goethe, deepened their theoretical understanding of color psychology. Questions of taste were at the heart of this inquiry, and music presented opportunities for analogies. "Color harmony" became a major preoccupation of theorists in the industrial arts, along with human perception and optical illusion.[9]

Efficiency and Modern Times

Color harmony continued to perplex the twentieth-century heirs to the industrial-arts tradition. Major chemical breakthroughs such as the development of aniline, azo, and vat dyes introduced the possibility of more and brighter colors. Tastemakers reacted in a backlash that emphasized either the neoclassical look (achieved with white and other light paints) or the earthy arts-and-crafts look of fumed oak. Color came to be a mark of social class: the upper crust set itself apart from the unwashed masses by distancing itself from bright, bold color. This tool of distinction morphed into a pathology that the theorist David Batchelor has called "chromophobia." Jokes abounded about drab Puritans, Quaker gray, and the "taupe age." While color selection came to be seen as the domain of women as consumers, those who defined themselves principally as colorists picked up the mantle for reform. Educators began to ask how schools could train children to appreciate color harmony, and how product designers might engage the principles of color psychology in their work.

World War I proved to be a major turning point when camoufleurs—former abstract artists who developed the "art" of hiding weapons and soldiers—showed how color and illusion could be used to fool the enemy. The end of war brought a new respect for master colorists, and many of them found new uses for their talents in American industry. The older art industries morphed into the "style industries" and, taking cues from Paris, renewed their commitment to color harmony. The emerging chemicals, plastics, automobiles, and aircraft industries looked to older industries for style tips. When chemists discovered that Butanol (a by-product of wartime TNT manufacturing) was an excellent solvent, they used it to create quick-drying paints in many hues. Color came to be seen as a solution to the problem of under-consumption that afflicted the mass-production economy. H. Ledyard Towle and other former camoufleurs applied their knowledge of visual deception to product design and created a new profession: the corporate colorist.

At a Washington meeting on color and the economy held shortly after *Fortune* proclaimed a color revolution, Assistant Secretary of Commerce Julius Klein ventured an opinion on the razzle-dazzle: "Color is a symbol of our new standard of life. It is here to stay." Herbert Hoover won the 1928 presidential election after a distinguished career in public service, having managed food distribution during the war, headed a major engineering association, and served as Secretary of Commerce for eight years. Known as The Great Humanitarian and The Great Engineer, Hoover embodied the progressive reform ethos that had shaped American political and economic culture since the 1890s. Under him the Department of Commerce focused on eradicating inefficiency and waste in industry as a means of improving the American standard of living. This progressive impulse, culturally codified as "scientific management," co-existed with the industrial-arts tradition and was a major influence on the color revolution.[10]

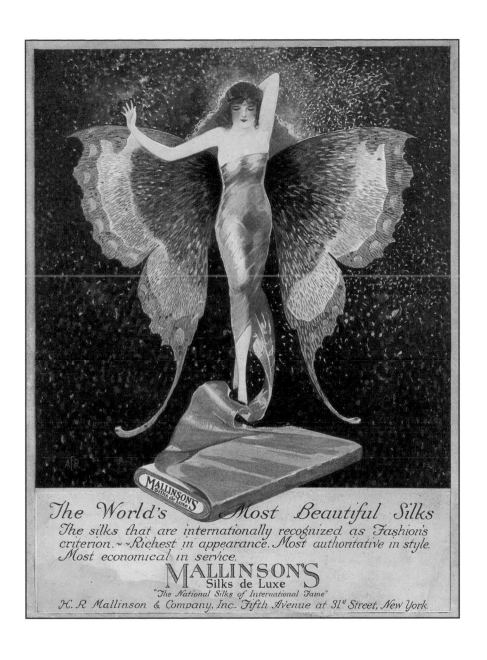

I.6 *The Blue Book of Silks de Luxe, Spring and Summer 1923* (New York: H. R. Mallinson & Company, 1923).

The industrial engineer Frederick Winslow Taylor and the home economist Lillian Gilbreth helped to popularize progressive notions of "efficiency," "simplification," and "standards." The drive to set national standards for everything from paving bricks to traffic signals to colors came from this impulse. Scientific management is most often associated with rules and regulations to increase productivity in the workplace. The most obvious example is the assembly line at the Ford Motor Company's River Rouge plant, satirized in the 1936 film *Modern Times*. The Tramp, played by Charlie Chaplin, is a cog in a wheel; the motions of both man and machine have been pre-set by industrial engineers. The satire focuses on the corruption of the original vision for scientific management, in which experts applied theoretical models to everyday situations with the aim of increasing industrial productivity and improving the general welfare. This reform ethos, which informed the engineering profession, also influenced Hoover's efforts as Secretary of Commerce to extend the idea of the "one best way" into everyday life.[11]

Efficiency experts sought to rationalize all aspects of material life, including the inchoate realm of color. They hoped to bring all industries together to agree on a palette for everyone. This form of voluntary collaboration was widespread in the older art industries, which had long relied on the trade association as a mechanism for self-regulation. In France, La Chambre Syndicale de la couture parisienne and L'Association de protection des industries artistiques saisonniéres operated for the benefit of those who made dresses to measure for private clients. In the United States, the Silk Association and the Textile Color Card Association (which became the Color Association of the United States in 1955) served as exchange forums for member firms. The trade association movement was sympathetic with progressive-era welfare capitalism and its efforts to manage social problems. Color was subjected to rational management routines and to collective revisionism by federal agencies, professional organizations, and trade associations dedicated to the best practices.

Functional Color

The industrial-arts tradition and efficiency-driven scientific management came together in the modern practice of "functional color." Functional colorists combined the concerns of the Victorian practical man and the progressive drive for moral uplift in a new approach that "put color to work." Scientists were concerned with "why" light behaved as it did to create the spectrum, while aesthetic theorists wondered "how" certain colors elicited human response or acquired their cultural meanings. The functional colorist was a pragmatic expert who focused on the "what."

Functional colorists sought to understand "what" colors people liked or disliked and to apply that information in an objective manner. The home was a personal castle, but an office space was in the public domain. Its color scheme should be "engineered" to create ideal seeing conditions, to

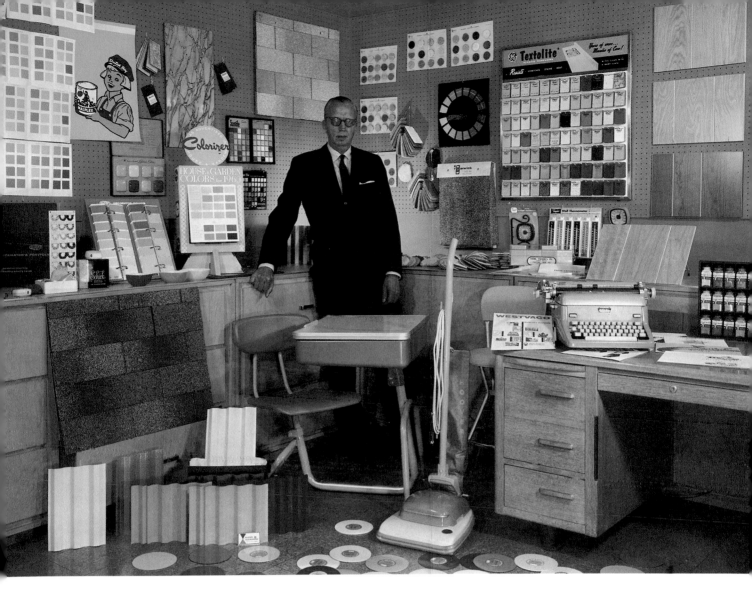

I.7 Faber Birren, the leading proponent of functional color, surrounded by his designs, 1956. Faber Birren Papers, Manuscripts and Archives, Yale University. Reproduced courtesy of Zoe Birren.

promote safety, and to create a better public image. Just as there was air pollution and water pollution, there was also visual pollution ("uglification that scars the city, town and countryside"). It was due largely to indifference. The functional colorists showed architects, interior designers, office managers, school superintendents, and transnational airlines how a basic color plan could tap into human psychology and create a more efficient, more pleasing environment.[12]

Functional use of color began when former camoufleurs applied their wartime skills to the annual model change of the Detroit automakers. It was given a boost by the widespread interest in colorized public spaces. World's fairs were proving grounds for evolving theories about color and electric lighting, color and sound, and color and mood. The constant flow of information between Europe and North America was inspiring and influential. The architects of the great European fairs looked to the United States for tips on the design of colorful evening light shows, and the planners of American expositions learned from exhibitions held in Paris and Barcelona.

World War II, like World War I, helped functional colorists sharpen their focus and find new uses for their skills. H. Ledyard Towle, Faber Birren, Howard Ketcham, and other colorists helped to create safer, brighter, and more efficient environments in wartime industrial plants. Marketing programs such as Color Dynamics and Color Conditioning were meant to sell paint, but they also taught space planners to use color functionally. The pastel interiors of the postwar era—the pale greens, yellows, and pinks associated with offices, hospitals, and schools of the 1950s—were an outgrowth of such promotions. These installations became popular around the time that the European émigrés Ludwig Mies van der Rohe, Walter Gropius, and Marcel Breuer introduced Americans to the avant-garde designs of the International Style of architecture. Functional color—rooted in reverse camouflage techniques and in Taylorist impulses of the industrial heartland—prepared Americans for the International School, Knoll Associates, Design Research, Joseph Albers, and Michael Graves. By the 1960s, the clean Bauhaus aesthetic was in favor for sophisticated office décor, but conservative American clients who had grown up in taupe houses may have been less receptive to that stark look had it not been for the functional colorists of the 1930s, the 1940s, and the 1950s.[13]

Business to Business

The color revolution has been invisible to scholars in part because it was a business-to-business phenomenon. Design historians often focus on the consumer goods that make everyday life more comfortable and convenient, or that reflect the modern aesthetic. The work of professional colorists shaped the built environment, and many consumer products—Cheney silks, Crayola crayons, pastel Buick Specials—were directly attributable to them. But colorists mostly worked behind closed doors

with other professionals. They helped the New Jersey silk mills, the Boston school board, the Fisher Body people, and the Bell Telephone engineers master the vicissitudes of color harmony. In just doing their jobs, colorists helped create Detroit's first visually streamlined cars, figured out how to speculate on future colors, and introduced the coordinated ensemble to mass merchandising.

Les trompe-l'oeil camouflages laid the foundations for the streamlined look that is often associated with modern styling. That look owed much to the cultural fascination with speed and organic form and, as some have claimed, to the eugenics movement.[14] Colorists also informed this new motif. Landscape painters and theatrical set designers returning from the Western Front had learned how a mud pile disguised as a horse carcass could trick the best German sniper. Returning veterans had to make themselves employable back home, and camoufleurs knew how to fool the eye into seeing a thing as it was not. Trickery as to shape, or visual streamlining, was a valuable asset in the construction industry, on Madison Avenue, and in Detroit. As *Fortune* noted, nobody could outdo the ex-camoufleur H. Ledyard Towle at making a stubby car look longer or a stout car slimmer.

Color forecasting was perfected in this context. The emerging management sciences created a place for statistical wizards such as Roger Babson, who ran his own business college and who, using quantitative methods, predicted the crash of 1929.[15] The industrial heartland had its own share of "number guys" who imposed mathematical logic on the sprawling dry-goods trade and the adolescent auto industry. Colorists recognized the value of market surveys and sales reports. They combined their knowledge of human psychology with quantitative data and took the French invention of color forecasting to new heights. A professional colorist combined the "hard facts"— sales figures "crunched" by an army of accountants and the new IBM computers—with educated anticipation to predict fashions in color. Most forecasts were created as business-to-business tools, but some reached consumers in the form of the *House and Garden* Color Program or the Sears Harmony House Colors.

Fashion meant novelty, and cultural currency had many sources. Paris set the pace in dress for wealthy consumers, but vogues could bubble up from below as real-life Gibson Girls and Arrow Men invented unique looks. The consumer with an eye for color and detail had always matched her embroidered collar with the trim on her hat. Textile mills and apparel factories formalized this practice once color standards made it possible to coordinate shades across a range of products. Standard shade cards and seasonal forecasts made it easier for manufacturers of ready-to-wear apparel to specify hues when talking with button suppliers or representatives of department stores. The color ensemble, heralded as the great merchandising innovation of the interwar period, migrated to interior decoration and reached its apex with the Sunshine Yellow appliances that figured in the Nixon-Khrushchev "kitchen debate" of 1959.

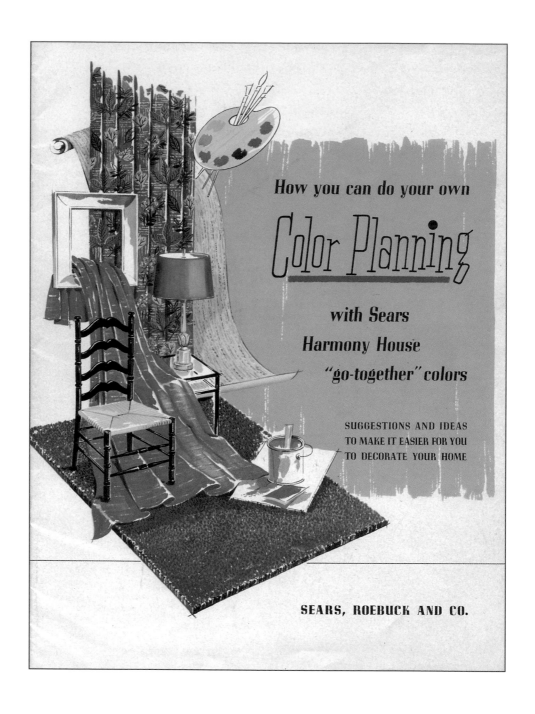

I.8 *How You Can Do Your Own Color Planning
with Sears Harmony House "Go-Together" Colors*
(Chicago, 1955).

The problem of taste and the related problem of color harmony attracted inventors to the color revolution. The most successful colorists were innovators who figured out how to work within the organizational frameworks of the time, notably in business and trade associations. Inventors who sought a place in the new color order often found it difficult to break in. It was tough to invent a new system for teaching the principles of color harmony to schoolchildren and then find somebody to make it and promote it. It was even tougher to imagine connections among sound, light, and color, and to watch the Hollywood moguls adapt the idea to Technicolor animation. The struggles of inventors (successful ones and unsuccessful ones) in the course of the color revolution reveal the dark side of a remarkably creative moment.

A Transnational Story

In a 1946 address to the Design and Industries Association in London, the British industrial designer T. A. Fennemore noted that the color revolution was at once American and transnational. British war industries had dabbled with color, but the great American industrial machine spewed forth a rainbow. Fennemore, who had designed everything from teapots to wallpaper, saw something to be admired among the Yanks. "Much has been done in America," he told his colleagues. The chemical companies, in particular, presided over this new universe, taking the lead in the manufacture of paints and pigments and in the development of functional color. "In this subject of colour application, America has been the pioneer," Fennemore reiterated, "and of all the firms in America I think the greatest credit should go to the DuPont Company, who have studied the question most carefully and who have issued some extremely valuable literature on it. The idea of three dimensional seeing, is to use their words, 'to reverse the business of camouflage.'" It would be prudent for British industry to take heed.[16]

This observation from a Brit-in-the-know points to the uniqueness of the American experience with the color revolution. The French, the British, and the Germans had developed the chemical technology—the new synthetic materials—that allowed textile mills, printers, and plastic molders to create products in virtually any color. French textile mills had invented the shade card as a forecasting tool and established color hegemony in high fashion. The peace that followed the Franco-Prussian War fostered industrial growth throughout Western Europe, but that ended with World War I, reparations and reconstruction, the Great Inflation, the tariff wars, the Great Depression, and World War II. The United States suffered during the wars and the Depression, but American manufacturers developed strategies that targeted the problem of under-consumption. They tried to stimulate sales with color styling and mood conditioning.

American color management was exceptional because of the unique circumstances. The United States, with a population of 106 million in 1920, was the world's largest mass market and had emerged from World War I as the global leader in banking and industry. The American synthetic organic chemical industry, which had been overshadowed by German firms, took off in the 1920s to become a major force in the economy by the eve of World War II. This industry invented the paints, pigments, and plastics that became the designer's new playthings. The American apparel industry, which had grown gradually in the nineteenth century, was given a big boost by the introduction of simple, straight dresses and matching color-coordinated accessories. There was money, and plenty of it, in the 1920s, and businesses were willing to reinvest it in new strategies that promised to help them sell more goods. Market research, industrial design, public relations, big advertising, and color practice all grew out of this moment.

The color revolution was uniquely American, but it was influenced by European culture. Many of the people involved in it were Europeans or had strong European ties. Crude colors and tasteful ones came with them from abroad. "Every barbaric invasion has been followed by a quickened interest in color," the magazine *Nation's Business* asserted in 1928. "The invasion of the Czecho-Slovakians, Italians, and other races from Southern Europe has stimulated interest in the primary colors."[17] In contrast, the more avant-garde perspectives of De Stijl and the Bauhaus, whose practitioners dreamed of closer ties between art, industry, and high modernism, was channeled into the revolution through the immigrant architect Joseph Urban, who startled everyone with his cotton-candy landscape for the 1933 Century of Progress Exposition in Chicago. But the most important links were to Paris. *Godey's Lady's Book*, the *Ladies' Home Journal*, the *New York Times*, and the *Chicago Tribune* all paid resident agents to keep tabs on Parisian color trends, as did American department stores and the American organizations that standardized colors. Immigrant designers whose work was sympathetic to the older art industries were among the most important conduits, bringing the French, British, and Germanic perspectives to the United States and bending them to fit the ethnic-regional-economic diversity.

The great French-American entente put haute couture, Lyon silks, and French luxury cars in front of American designers and awoke them to the possibility of a richer chromatic aesthetic. The cultural hierarchy promulgated by the Museum of Modern Art and other powerful institutions in ensuing decades would forever sunder the fine arts and the applied arts. Yet nothing prevented fine-arts painters such as Henry Fitch Taylor and Georgia O'Keeffe from dipping their brushes in the capitalist pot. Designers working in the American industrial heartland reached out to the modernists in New York and Paris, wanting to see how their color sensibilities might fuel the revolution. The older way of doing things in the art industries—the normality of crossing over from painting to product design—continued, and corporate colorists found allies in the formidable Alfred Stieglitz and the feminine Marie Laurencin.

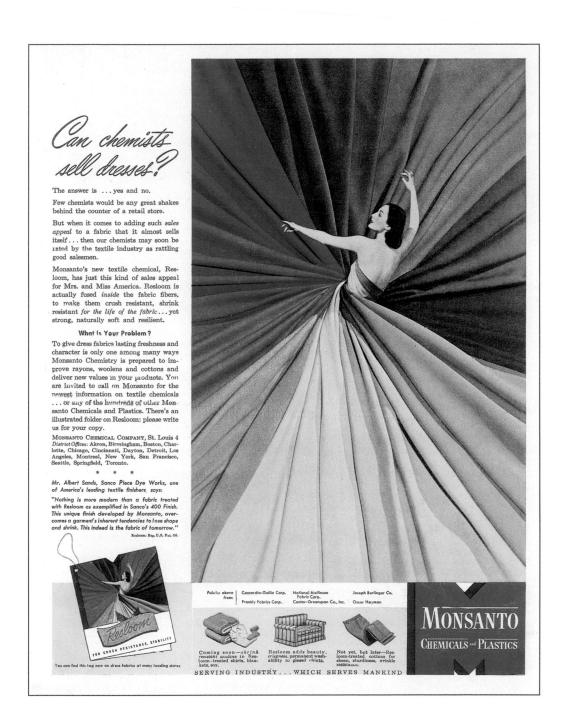

I.9 Advertisement by Monsanto Chemical Company in *Fortune*, September 1946.

The great color theorist Chevreul had taken up the difficult question of color and personal adornment, making recommendations for blondes and brunettes that became standard among fashion editors and interior decorators. The mature color revolution saw the decisions on beauty taken away from the male tastemakers. As color moved front and center, the men who ran textile mills and ribbon factories began to see that their wives, stenographers, and foreladies had something to say. This realization came around the time when physicians discovered that color blindness was unique to men. The style industries in Paris had their share of *madams*, the female entrepreneurs who ran the couture houses, the milliners, and the glove shops. There was something to be said for bringing the "woman's viewpoint" to the color table. Female colorists (among them Margaret Hayden Rorke and Hazel H. Adler) joined the color coterie. Some of them had long-running careers and great influence in fields normally associated with the masculine domain of engineering, including standardization and simplification.

Styling Obsolescence

Twentieth-century colorists used a variety of terms to describe their jobs, among them "color stylist," "color forecaster," and "color engineer." The last of these terms is the most telling, and allows us to place color in its cultural milieu. Color engineers defined themselves as social engineers, and that association marks the color revolution as a product of modern times. The color corps marched to the beat of mass production and mass consumption. The managed palette was seen as a means for improving the human condition. Forecasts and standards were created as business tools that allowed manufacturers and retailers to eliminate wasteful guesswork. The cultural proposal to spread color harmony and to put everyone in a cheerful mindset was altruistic and relatively harmless. Strategies of "mood conditioning" and "color conditioning" were rooted in these well-meaning intentions.

Alternatively, applications such as visual streamlining were part of the annual model change, an idea that carmakers borrowed from the art industries and their eternal attentiveness to fashion. There was little harm in doing up a Model A Ford in polychrome paint if it gave Ford an advantage over Chevrolet. Colorizing pots, pans, brooms, and other inexpensive merchandise was a quick way to stimulate sales. But the tyranny of the annual model change eventually sparked a counter-revolution. Consumers loved the two-tone Oldsmobile Fiesta Super 88, but many balked at the colorized refrigerator. Most people didn't know the difference between mauve and cerise, but they had grown up with a fashion system that offered predictable color cycles. When faced with color appliances, they stuttered and mumbled something about change. Color was a way of providing that change, but the baked-on enameled colors of an Avocado Green stove and a Golden Harvest dishwasher were, unlike the paint on the kitchen walls, not changeable.

Color Management

We cannot truly understand designed objects or technological systems outside of their historical, industrial, technical, social, and cultural contexts.[18] This is especially true of managed color, a modern technology that was developed through a drawn-out process and carried out by countless actors and gatekeepers. Color management, like other technological processes, pivoted on negotiations and transgressions that fueled creativity and sometimes erupted into turf wars. Business institutions often served as incubators, but color practices were shaped by the internal and external environments and were grounded in a variety of factors: individual personalities; inventors' dreams smashed to bits in the innovation process; the realities of production and distribution; transnational networks in fashion, design, and art; the audience's expectations and perceptions.

Color management was a fiercely nationalistic pursuit, a child of the Second Industrial Revolution and the quest for cultural authority among inventors, innovators, and users in France, Britain, Germany, and the United States. Mass production made the U.S. a receptive cauldron. American industry identified color as inexorably suited to mass production, and adapted it as one of its principal design tools. The historian David Edgerton argues that it is the seemingly unglamorous innovations that often have the greatest effects on human experience and comfort. Electric lighting, automobiles, telephones, and indoor plumbing have become so ubiquitous that we forget how transformative they were as new technologies. Likewise, color standards and color forecasts were important visual tools that changed design practice and generated new consumer expectations for uniformity and consistency in everyday life.[19]

This book examines the events, relationships, and concepts that made color management possible and likely in the United States between the 1890s and the 1960s, focusing on the cultural and economic factors that led to its emergence and on the professional links that tied it to the wider world. The story focuses on how American colorists served as intermediaries between the chemical laboratory and the consumer. Social and cultural forces—the imperative to improve popular taste, the rise of mass merchandising, gender stereotypes, growing opportunities for women in the creative professions—shaped color practice. Color was rationalized by interactions in a network of manufacturers, retailers, teachers, and inventors, and those interactions made it at once explicitly American and unabashedly global.

But before visiting the American manufacturing belt to examine the colorists, we will look at nineteenth-century Europe. There, the ranked social order conflicted with rapid industrialization, and innovative chemists courted the fashion system, foreshadowing the color revolution of the twentieth century.

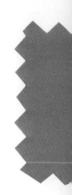

1.1 John Philip, *The Marriage of Victoria, Princess Royal*. Royal Collection, © 2011 Her Majesty Queen Elizabeth II.

1 Mauve Mania

The wedding of Princess Victoria, Queen Victoria's oldest child, was the talk of all Europe in 1858. The royal nuptials fed Britain's craving for pomp and pageantry, and journalists braved the January cold to watch the bridal procession from Buckingham Palace to the Chapel Royal in St. James's Palace. Banners and flags lined Pall Mall, creating a festive path for the royal carriages. By 2 o'clock the chapel was packed with dukes and duchesses. The princess looked angelic in an antique white moiré dress trimmed in orange and myrtle, but the queen stole the day. The *Illustrated London News* gushed: "The train and body of Her Majesty's dress was composed of rich mauve (lilac) velvet, trimmed with three rows of lace; . . . the petticoat, mauve and silver moiré antique."[1]

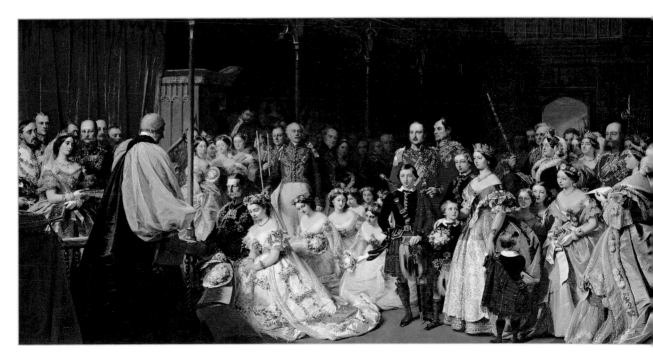

The wedding gave Victoria's royal imprimatur to lilac as a fashion color, stimulating a widespread interest in the various shades of purple among consumers in Europe and in America. In June, *Graham's Magazine*, an American fashion authority, reported on the latest purple confections in London, Paris, New York, and Philadelphia, including an elegant dress "composed of violet color silk" and an opera cloak ("the Princess") made from London Spitalfields silk in "the beautiful hue known as mauve, or, Queen's lilac." By late 1858, mauve was one of the most fashionable colors on both sides of the Atlantic, and consumers were asking local shopkeepers to stock ribbons and fabrics in the new hue.[2]

Why did Queen's Lilac created such a stir? For centuries, royals and aristocrats dressed to express their political power and cultural authority, and Queen Victoria picked her mother-of-the-bride outfit with care. A deep, dark color called royal purple was traditional for princes, but in January of 1858 it was a very particular pale shade that turned heads. Queen's Lilac was a potent emblem of change in Europe's textile mills and dye houses. In the past few decades, the French and British textile industries had introduced new types of dyes. Stunning hues such as Queen's Lilac owed much to these efforts. Royal purple signified tradition, but Queen's Lilac was evidence of international developments in science, technology, and fashion that would transform the color of the material world.

Pourpre français

The story of Queen's Lilac began in the mid 1800s, when interactions between French fashion and French chemistry produced stunning new colors. Since ancient times, artisans had made dyes from natural materials in the animal and vegetable kingdoms. The glandular mucus of mollusks was used to create the lush color known as Tyrian purple. The process was so arduous and expensive that purple had been reserved for the robes of kings since Roman times.[3]

The social flux of the French Second Empire created opportunities for chemistry and fashion, as the bourgeoisie demanded status symbols to show off their newfound wealth and respectability. Ever since the reign of Louis XIV, expensive goods made by France's luxury industries had set an example for the lesser aristocrats and for the bourgeoisie. But now, with the demand for fashion increasing rapidly, color became a tool for adding value. The French fashion industry—the dye houses and textile mills in Lyon, Mulhouse, and Paris, and the dressmakers, accessory makers, and exporters in Paris—led the way. In the mid 1850s, French mills introduced lilac and purple textiles tinted with natural dyes made from an acid extracted from Peruvian guano that had been imported to Europe as a fertilizer. In 1856, purple and lilac ribbons were deemed appropriate accents for black mourning bonnets; soon Dame Fashion would dictate new uses for the new hues.[4]

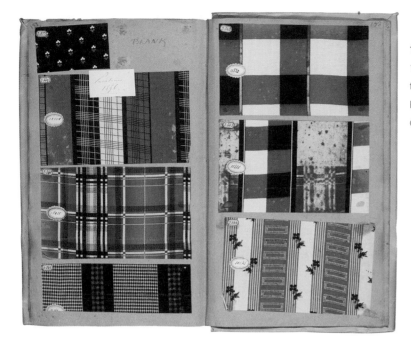

1.2 A French swatch book from the spring of 1856, showing that mauve was already an important color for textiles at the time of William Henry Perkin's experiments. Archives of Art and Design, © Victoria and Albert Museum, London.

Empress Eugénie, the Spanish born wife of Napoleon III, was Europe's leading "fashionista." In the summer of 1857, the new *couleur mauve* caught her attention because she thought it matched her eyes. "The Empress wore a plain lilac silk dress," wrote the *National Era*, and a bonnet trimmed with "a small tuft of lilacs." Fashionable Parisiennes, already attracted to violet, emulated the style. "Light green and lilac," *Graham's Magazine* reported from Paris, "which were so popular in the spring, bid fair to maintain a position through the summer in the ladies' good graces. Young ladies still retain them in promenade as well as ball-dresses—lilac being by far the 'best beloved' of the two. This color is an especial favorite with the Empress Eugénie." In the fall, trend spotters for the *London Lady's Paper* spied "a dress of mauve color silk with a double skirt." These various shades of French purple, from pale lilac to deep mauve, started out as accent colors, but after catching the eye of the Empress, they became de rigueur for the entire costume.[5]

Mauve mania was made possible by the experiments of French "colorists," practical men who learned textile chemistry on the job or at technical schools such as the École de chimie in Mulhouse. Designers and colorists brought market information into textile mills and dye houses. Colorists added to their knowledge of chemistry, aesthetics, and markets by traveling from firm to firm over a

20-year training period, working in France, Bohemia, Russia, and Britain. In Lyon, the colorist J. A. Marnas was a principal in the firm of Guinon, Marnas et Bonnet. As early as the 1840s, this colorist-led firm discovered how to extract picric acid from coal tar and used it to dye silk. In the 1850s, it introduced a Chinese green called Loa-Ka and a colorfast lichen dye for *pourpre français*. But the world's best colorists worked at Mulhouse, which initiated the majority of improvements in dyeing and calico printing between 1840 and 1860.[6]

These French breakthroughs attracted the attention of the international textile industry. Across the English Channel, the world's largest textile industry fixed a hawk's eye on France. Printed cottons, introduced to Europe by the East India trade in the late 1500s, were its mainstay, produced in styles suitable for clothing, for furnishings, and for novelties such as bandanas and stuffed toys. English calico printers catered to the growing mass market at home and abroad, exporting more than 786 million yards of cloth (worth £13 million) in 1858 alone. In the English-speaking Atlantic world, the rise of consumer society had whetted the middle-class taste for fashion. Following the French lead, textile mills in Manchester and on the Continent began to print calicos in the new Roman purple, using murexide dyes extracted from mollusks. However, it soon became clear that these murexide purples faded in England's coal smog. The British calico industry needed a new dye that was both colorful and colorfast, that resisted soap, sunlight, and pollution, and that could be made in large quantities.[7]

Teen Ingenuity

Fashion and commerce dictated a need, and science and serendipity filled it. The story of French mauve is a complex drama with multiple actors, but the Anglo-American chemical industry, seeking validation, simplified it and assigned credit to a single young inventor. The legendary "eureka" moment happened in London, where a precocious college student named William Henry Perkin accidentally synthesized a deep purple dye from coal waste. His discovery, so the story goes, helped to establish the field of synthetic organic chemistry, and ushered in an era of rainbow colors. At the age of 15, Perkin enrolled in the Royal College of Chemistry (now Imperial College), where he studied under August Wilhelm Hofmann. A pioneer in the new field of organic chemistry, Hofmann lectured his students on color, explaining its relevance to dyeing and printing for the textile industry. The young Perkin set up a makeshift laboratory on the top floor of his family's home in the East End and began experimenting.[8]

In the spring of 1856, Perkin stumbled upon the "splendid colours so well known as 'mauve' and 'magenta'" while trying to synthesize quinine, an anti-malarial drug that was needed in Britain's tropical colonies. He was using aniline, an organic compound extracted from coal tar (a noxious

1.3 Jerry Allison, *William Henry Perkin, Pioneer in Synthetic Organic Dyes*, oil on canvas, c. 1980. Gift of American Cyanamid, Chemical Heritage Foundation Collections. Photograph by Gregory Tobias.

black by-product of the manufacture of gas for lighting). Already interested in color, Perkin grew curious when a dark, muddy precipitate spilled and stained a rag a deep purple. He recreated the event by purchasing a skein of white silk in Piccadilly and successfully dyeing it purple. "On experimenting with the colouring matter thus obtained," he later recalled, "I found it to be a very stable compound dyeing silk a beautiful purple which resisted the light for a long time, being very different in this respect to the Archil colour which was sometimes used in silk at that period." In June, Robert Pullar, a friend of the Perkin family who worked at a Scottish dye house, saw gold. "If your discovery does not make the goods too expensive it is decidedly one of the most valuable that has come out for a very long time, this colour is one which has been very much wanted in all classes of goods and could not be had fast on Silks, and only at great expense on cotton yarns."[9]

Perkin dropped out of school and joined his father and brother to establish G. F. Perkin and Sons, a dye works at Greenford Green, northwest of London. The timing was lucky, in view of the growing demand for the French purples. "I am glad to hear that a rage for your color has set in among that all-powerful class of the community—The Ladies," wrote John Pullar (Robert's brother) to Perkin in May of 1857. "If they once take a mania for it and you can supply the demand, your fame and fortune are secure." In December, Perkin's firm made its first shipments of his new dye (called Tyrian Purple after the traditional mollusk colorant) to a London silk dyer. A month later, Queen Victoria wore her lilac gown to the Princess Royal's wedding. No one knows whether her outfit was colored with Perkin's new dye, but everyone in the smart set knew that pale purple was, thanks to the French, in fashion.[10]

Silks accounted for only a small portion of the market; the real money was in printed calicos. To gain a toehold in that lucrative segment, Perkin had to overcome the prejudices of the practical men who worked for the British dyers. These apprentice-trained color mixers and dye-house foremen saw themselves as "the depositories of a secret art" and "exercised a jealous guard over their processes, which has operated to shut out improvement, and perpetuate a succession of absurd and empirical processes." Rolling up his shirtsleeves, Perkin visited practical men in their factories, conducting trials with silk dyers in London and Macclesfield and with calico printers in Scotland, working to overcome technical difficulties and occupational biases. His big break came around 1859, when the Scottish firm James Black and Company adopted his Tyrian Purple for calico printing.[11]

Operators of dry-goods stores and other retail shops were, reportedly, delighted with the new hues. "The colors produced by the use of this new dyeing material" were "very delicate and beautiful," observers noted, and they did not fade quickly. "The same colors when produced, as heretofore, from vegetable dyes, were extremely fugitive; so much so, indeed, that linen drapers rarely exposed fabrics of such colors in their windows." This was the era of the "walking city," and consumers loved to window shop. Homemakers amused themselves with afternoon walks, mothers and married daughters strolling arm-in-arm and looking at the latest fabrics or yard goods. After a long day in a factory or an office, young men and women put on their best outfits and took to the streets. Now retailers could decorate their shop windows with eye-catching silks, calicos, and ribbons that would tempt passersby with their striking colors. In August 1859, the magazine *Punch* poked fun at these promotions by holding shopkeepers responsible for an epidemic of "the mauve measles." The "first symptoms . . . consists [*sic*] in the eruption of a measly rash of ribbons, about the head and neck of the person who has caught it. The eruption, which is of a *mauve* colour, soon spreads until in some cases the sufferer become completely covered with it. Arms, hands, and even feet are rapidly disfigured by the one prevailing hue, and, strange as it may seem, the face even looks tinted with it." Women were most likely to suffer, but men could experience a mild affliction. Consumers hoping to

avoid this "dangerous" malady should steer clear of London's "flower-shows" and its "milliners' and bonnet shops."[12]

The London International Exhibition of 1862 suggested how crowded the synthetic dye industry had become in just a few years. Starting in 1851, world's fairs became a prominent feature of urban-industrial life, a showcase for manufacturers, and a major tourist attraction. Cities competed to outdo one another with their fairgrounds, much as happens today with the Olympic Games. Exhibits focused on the achievements of industrial civilization, on the newest advances to improve everyday life. The textile, steel, and chemical industries, proud of their contributions to Progress, mounted elaborate displays that showed off their latest inventions and innovations. Fashions colorized with new synthetic dyes were a major attraction. In the official catalog of the 1862 exhibition, August Wilhelm Hofmann described "silks, cashmeres, ostrich plumes and the like, dyed in a diversity of novel colours allowed on all hands to be the most superb and brilliant that ever delighted the human eye." G. F. Perkin and Sons put on a "gorgeous display . . . illustrating their manufacture of mauve dye or aniline purple," while the rival South London firm of Simpson, Maule and Nicholson showed a "beautiful magenta dye." Other English and French inventors had ventured into aniline chemistry, rushing to patent new shades of red, yellow, and green. In Lyon, the schoolteacher François Emmanuel Verguin sold his formula for a brilliant "solferino" red to Renard frères et Franc, which patented the dye and renamed the color "fuchsine." Despite continued French successes, the venerable Professor Hofmann predicted that England, his adopted homeland, would become "the greatest colour-producing country in the world."[13]

The manner in which colorists and chemists approached dye research was guided by the market. Innovation was driven, not by a deliberate quest for organic compounds with color as the primary characteristic, but by the need for new effects and for lower prices. Whereas traditional colorists in textile mills looked for new applications for familiar materials, the new laboratory chemists tried to meet consumer needs through "discoveries." These trajectories sparked the innovations that were the foundations of the color revolution. By 1863, Great Britain, France, Germany, and Switzerland all had fledging synthetic dye industries.[14]

William Henry Perkin continued to experiment. He pursued a line of inquiry that led his company to manufacture the next generation of synthetics, the first practical alizarin dyes. Based on a different type of coal-tar chemistry, the new dyes replaced French and Dutch madder root as the source of "turkey red" (the color of the British "redcoats" and the cowboy bandana). Together with azo dyes (a third group of synthetics), they offered the textile industry additional colorfast alternatives to natural dyes. When the editors of the American *Carpet Trade Review* tested upholstery fabrics in the sun, they reported that only the alizarin colors stayed bright after three months. Customers had begun to expect more from their dyes.[15]

1.4 A dress displayed in London's Crystal Palace exhibition of 1862. The fabric was colored mauve by aniline dyes made by G. F. Perkin and Sons. Science Museum/SSPL, London.

Rhineland Reds

The invention of alizarin dyes pitted William Henry Perkin against Heinrich Caro, a German colorist who had mastered aniline chemistry in the calico mills of Manchester. Along with Perkin, Caro was one of pioneers of the aniline blacks, a family of dark colorants that became a staple of the synthetic

dye repertoire. Traditionally made from cheap logwood dyes, black was a popular menswear color that became trendy among the ladies after Queen Victoria, honoring the memory of Prince Albert, made mourning dress her daily uniform. The aniline blacks provided the textile industry with another way to dye and print fabrics in the somber colors that royal watchers wanted to wear.[16]

While in Manchester, Heinrich Caro watched the German dye industry grow by copying British and French innovations. As each of the German states separately pressed ahead with industrialization, great demand was created for factory chemists. In 1866, Caro departed for Heidelberg. Two years later, he was in Ludwigshafen, where he became the technical director for the firm that would eventually become the Badische Anilin- und Soda-Fabrik (BASF). He and Perkin raced neck and neck, filing British patents for alizarin dyes within 24 hours of each other in 1868. Caro's razor-thin lead foreshadowed things to come. The highly empirical French dye industry had fizzled, and anxieties over large-scale industrial research enervated the British business. Perkin and Caro agreed to split the alizarin market, giving the Brits their home territory and the Germans the rest of the world. In 1874, at the age of 35, Perkin sold his factory and retired a wealthy man.

In just over a decade, the Germans had audaciously snatched control of the coal-tar industry from the first movers, the French and English dye makers. After the Franco-Prussian War, German unification under Emperor Wilhelm I and Chancellor Otto von Bismarck made the new nation a major political and economic force. Government policies combined with private initiatives led to the expansion of research universities and polytechnic institutes, favorable patent laws and export-import ratios, and a major investment in science-based research. The Patent Law of 1876, framed with the help of the German dye manufacturers, guaranteed the inventor a monopoly over his process, while state-supported higher education eliminated the barriers between theory and applied science. Scientific cooperation between business and the academy became common. Chemists from both camps shared theories, experiments, student assistants, discoveries, and patents. Most important, the focus of research shifted from industrial engineering and the improvement of processes and products to the discovery of new colors.

Much of the manufacturing capacity of Germany's mighty new dye industry lay in the Rhine Valley, stretching from Basel in the south to the Dutch border in the north. By the 1870s, three of the major companies—BASF, Friedr. Bayer et comp., and Teerfarbenfabrik Meister Lucius & Brüning—had plants along the Rhine. Three other large firms—Leopold Cassella & Co., Die Chemische Fabrik Kalle & Co., and Aktiengesellschaft für Anilinfabrikation (later known as Agfa)—were located elsewhere. Known as the Big Six, these companies invented and commercialized the azo and vat dyes with which Germany gained dominance of the global market. By 1881, Germany produced half of the world's synthetic dyes; by 1900, its share of the market had grown to 90 percent.[17]

The corporate research laboratory was the brain of Germany's color empire. High-tech companies could acquire products by buying patents, signing license agreements, or entering joint ventures, but those strategies were risky. In fast-paced industries such as electrical goods and synthetic chemicals, it was safer to internalize invention, creating a synergistic environment that could generate faster results. Early experiments were done on kitchen stoves, but entrepreneurs soon set up factory laboratories that divided their attention between production quality and the pursuit of new colors. In the 1870s, competition led to the creation of full-fledged research departments staffed by trained chemists who focused on discovery. By 1900, the German chemist who did specialized research in a mammoth lab had displaced the practical colorist and the lone inventor as a symbol of the modern dye industry.

The Germans were also masters of marketing, setting up a global sales network. Whether in Bombay or in New York, resident sales agents learned about customers' specific needs and reported them to the home office, where the products were adjusted to suit local markets. The United States, which industrialized during the nineteenth century, had the world's largest chemical industry. However, American chemical manufacturers had no expertise in synthetic materials such as the high-quality textile dyes being produced by the Germans. As a result, by 1904 the United States was the largest purchaser of German dyes, accounting for 20 percent of Germany's dye exports.

Designing in Color

As colorists and chemists liberated the rainbow, the style industries wrestled with the new abundance of colors. Textile designers had to keep up with fashion trends as they created new weaves, patterns, and shades for target markets. These designers, who had learned their trade as apprentices, needed good reference materials to do their work. Designing fabrics for the mass market depended less on artistic originality than on the ability to synthesize trends and repackage popular colors. In the middle of the nineteenth century, the British calico printer Edmund Potter told Parliament that it was "quite impossible that a pattern could be designed purely from the imagination." "Recourse." he continued, "must be had to some shapes and forms that have been seen elsewhere."[18]

The textile and fashion industries developed sophisticated methods for sending, receiving, and storing reports on trends so that designers could have timely and reliable information at their fingertips. In Europe and in North America, textile mills kept extensive libraries of engravings, illustrated books, and huge scrapbooks filled with swatches. These sample books held swatches of the factory's designs, cuttings of competitors' fabrics, and secret alphanumeric codes that could be deciphered by insiders. "All the minute particulars relative to certain methods of manufacture can be seen at a glance—how an article is started in the loom, the size of the weft and warp used, and the

method of dyeing and finishing." Scrapbooks filled with thousands of swatches systematically collected over the years were invaluable to designers, who used them to study trends and re-interpret them for the mill's customers.[19] (See figure 1.2.)

Early in the nineteenth century, Paris was the major design center for textiles, and practical men from Europe and North America looked there for inspiration. Fabric designers were part of the Parisian fashion-industrial complex of dressmakers, textile mills, dyers, and ancillary businesses (shoemakers, milliners, corset makers, stocking knitters, jewelers, parasol shops, beaders, ribbon makers, feather dyers, and so on). Foreign businessmen visited Paris to study trends in the industry, or hired agents there to survey the scene and collect samples on their behalf.

By the 1830s, Paris-based style services had emerged and were charging fees to gather textile swatches and ship them abroad. Around this time, François and Victor Jean-Claude opened their Paris design studio, J. Claude Frères et Cie; within a few years they were running a swatch service that mailed cuttings of the current styles to foreign manufacturers. By the late 1800s, Claude Frères was the leading subscription bureau in Paris, offering 29 different services classified by fabric and by end use. Subscriptions were costly but were far less expensive than supporting a resident agent in Paris and paying for trips to competitive style centers such as Berlin and Vienna. One American calico print works, the Cocheco Manufacturing Company in Dover, New Hampshire, paid Claude Frères $160 for 42 swatches of "Printed Furnitures for Spring 1882" and $730 for the 1887 annual collection of fabric samples ($3,520 and $17,300 in 2010 dollars). In the factory, the design department typically glued the swatches into the scrapbooks, compiling a record of new fashions to be copied, modified, or combined into new designs. Using this system, a design printed in Europe could be copied in the United States in three weeks.[20]

With the growth of the German dye industry, another visual tool became common: the color handbook or color pattern book. A world apart from swatch books, these cardboard folios were slick marketing presentations created by dye manufacturers for distribution by their sales offices, by resident agents, or by traveling salesmen. The eighteenth-century textile industry had evolved systems for organizing and naming the great variety of colors made from natural dyes, but these systems were forgotten or lost during the upheavals of the synthetic era. In a parallel development, Enlightenment naturalists (among them Jacob Christian Shäffer and Ignaz Schiffermüller) created nomenclature systems for classifying the colors of insects and plants; scholars have not yet determined if their treatises migrated to the textile industry and influenced design practice. Every generation discovers new needs and re-invents practices for current circumstances, and such was the case with color reference materials.[21]

One of the earliest surviving color handbooks showing textile samples dyed with synthetics—shown here in figure 1.5—dates from 1869. These marketing devices could have been modeled after the Shäffer-Schiffermüller color charts or after salesman's sample books (booklets, leaflets, or sheets of paper with miniature products attached that were used to promote everything from leather belting to silver cutlery). "The importance of good pattern-books is manifested in many industries," wrote the British textile chemist Sydney H. Higgins, who visited the Big Six in 1906, but "the Germans seem to have developed this branch of the business to a high state." At a firm such as Badische or Bayer, a large portion of the advertising department was dedicated to researching, designing, and fabricating these large, foldout books. "Many of these are quite artistic, containing scores of patterns, all of which have to be fixed by hand. These patterns are issued for cotton, wool, half-wool, silk, half-silk, leather, soap tints, straw, buttons, wood plaits for hats, wood stains for picture frames, etc., and the intending customer is thus presented with reliable and trustworthy samples of the dyed article, besides elaborate instruction how to perform the dyeing." Produced in many languages, color handbooks seduced

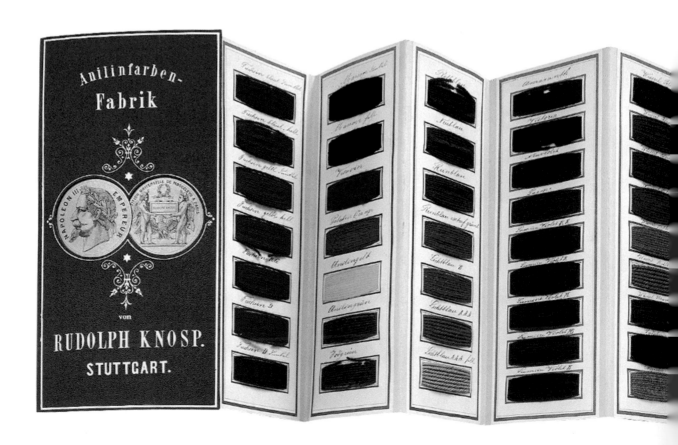

distant customers with the latest technology, presenting a professional image that inspired confidence in the product and expanded the global market for German dyes.[22]

Color Harmony

Even before the triumph of synthetic dyes, a small group of textile colorists saw the need for analyzing the flood of technical information for fellow practitioners. In the 1860s, Charles O'Neill, a practical man who had worked in the Manchester mills, published manuals on calico printing and dyeing, but designers wanted to know more about the relationships among color and aesthetics. Not surprisingly, the most important work in this vein came from the French luxury textile industry. Michel-Eugène Chevreul (1786–1889) was superintendent of l'atelier de teinture at the Manufacture des Gobelins in Paris, a state-supported enterprise that made tapestries for government buildings and official gifts. Between 1829 and 1864, he published four treatises that established him as the major color authority for the industrial arts.[23]

1.5 This 1869 color handbook shows how synthetic dyes were marketed by Badische Anilin- und Soda-Fabrik. BASF Corporate History Division, Ludwigshafen, Germany.

Chevreul—a cheerful, garrulous soul who never drank wine and went to bed early—had an unquenchable curiosity that drew him to organic chemistry. His early scientific research on animal fats, conducted at the Muséum national d'Histoire naturelle, led to better soaps and candles, to the development of margarine as a butter substitute, and to the identification of "that modern bugbear" cholesterol. His later job as head of the Gobelins dyeing rooms, where he worked until his death at the age of 102, was to improve the quality of the tapestries and to keep discerning customers happy. To this end, he researched dye chemistry and, more important, tackled the problem of color management.[24]

Chevreul's theory of color harmony was based on visual perception. Working with natural dyes, he learned to modify formulas to achieve certain color effects. However, like Goethe, he recognized that the eye was important. Rather than endlessly tinker with dye formulas, textile mills might achieve tasteful results by manipulating optical illusion in product design. Chevreul lectured on these ideas to practical men in Paris and Lyon before publishing his masterwork, *De la loi du contraste simultané des couleurs, et de l'assortiment des objets colorés,* in 1839. This influential treatise on the psychology of color, translated into German in 1840 and into English as *The Principles of Harmony and Contrast of Colours, and Their Applications to the Arts* in 1854, went into multiple editions.[25]

Chevreul's major contributions to perceptual color theory were the related laws of *successive contrast* and *simultaneous contrast.* The law of successive contrast described the visual effect (now called a "ghost" or an "afterimage") whereby long exposure to an object of one color leaves the observer seeing a halo or a shadow that fades after some time. A green paint sample viewed for 5–10 seconds leaves the viewer with a visual "memory," causing the next object on which the eye fixates to seem to have a greenish tint. The law of simultaneous contrast explained how two different color samples placed side by side would appear to radiate onto each other. A yellow paint sample placed next to a red paint sample might make the latter seem to be orange. There were no chemical or physical explanations for this, because the change in appearance was an illusion due to the way the eye responded to the light. Chevreul explained how textile designers could purposefully recreate such effects by mixing threads of different colors into one yarn, and discussed how the rules of contrast might be applied to tapestries, calico printing, wallpapers, architecture, interior design, and horticulture.[26]

Over the course of his career at Gobelins, Chevreul developed a nomenclature system that organized color around three principles: *kind, purity,* and *tone.* Using this method, he categorized the 14,000 colors of the wool trade into 72 *kinds* of shades (from red to violet), each having ten degrees of *purity* (the amount of gray or black) and 21 *tones* or degrees of intensity (from pale to vigorous). To help people visualize these abstractions, he improved on Isaac Newton's color wheel, publishing his

first "*cercle chromatique*" (shown here in figure 1.6) in 1855. For visitors to his atelier, he created a life-size version in wool, placing "skeins of worsted upon the floor of the great exhibition hall at Gobelins in a mammoth circle." An "object of great beauty," this "chromatic circle" and printed versions of it inspired the budding colorists Owen Jones and Albert Munsell, who adapted Chevreul's ideas to British design practice and to American art education.[27]

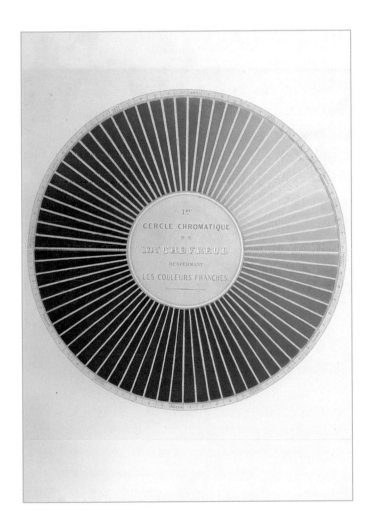

1.6 *Cercles chromatiques de M.E. Chevreul*
(Paris: E. Thunot, 1855). Faber Birren Collection
of Books on Color, Robert B. Haas Family Arts
Library, Yale University.

Chevreul saw the need for a universal system of standards to aid manufacturing and commerce. "The great difficulty experienced by all classes of persons who use colors, whether artists or calico printers," noted the magazine *Scientific American* in 1873, "is to define precisely what they want. . . . Hence, although the dyer may have the proportions for printing scarlet, yet the precise shade cannot be given for want of a suitable nomenclature." Chevreul created the chromatic circle as the first step toward such a standard; he dreamt that textile mills might use pocket versions to order skeins dyed in any shade. His ultimate dream was to have the French government keep and oversee a permanent set of color standards, as it did with weights and measures. Though no such scheme materialized, the idea of a practical set of color standards for the industrial arts lived on.[28]

The industrial arts reveled in Chevreul's theories. In London, Owen Jones drew on the Frenchman's work as he planned the interior paint scheme for the Crystal Palace (the structure built in London's Hyde Park in 1851 to house the first world's fair, The Great Exhibition of the Works of Industry of All Nations). The aim was to use deep, rich colors to create illusions of height, weight, and bulk. The polychrome interior of the Crystal Palace established color as the great illusionist to the fair-going public and popularized Chevreul's theories in Britain. The English translation of *The Principles* was used by designers of porcelain vases, fancy silks, wallpapers, carpets, dresses, coats, hats, and ribbons. In 1857, the eminent British chemist Frederick Crace-Calvert, who had been trained by Chevreul at Gobelins, lectured on his mentor's ideas at the Royal Institution in Manchester. American entrepreneurs had known of Chevreul's theories at least since 1842, when the *American Repertory of Arts, Sciences, and Manufactures* publicized his laws of contrast. In an article that summarized Crace-Calvert's talk, *Scientific American* urged Americans working in design, in production, in sales, or in retailing to consult Chevreul's books. Even shopkeepers, *Scientific American* suggested, could improve their merchandising practices and window displays by learning "the exact color, shade and tint that produces the greatest effect when placed beside another color."[29]

The Future Is Here

In the 1870s, the French dyestuffs industry built on the success of the German handbooks and on Chevreul's theories of chromatic harmony to introduce an early forecasting tool, the color card or shade card (figure 1.8). "Standard color cards have been published in Europe for nearly 50 years," one American milliner recalled in 1926. "Their aim was to furnish a card from which staple colors could be ordered, and so we find in their ranges of 10 or 12 light Blues and Pinks, Reds, Yellows, 2 or 3 families of Greens and Grays, and so forth." These standards eventually evolved into forecasts, strengthening France's position as the style capital of the world.[30]

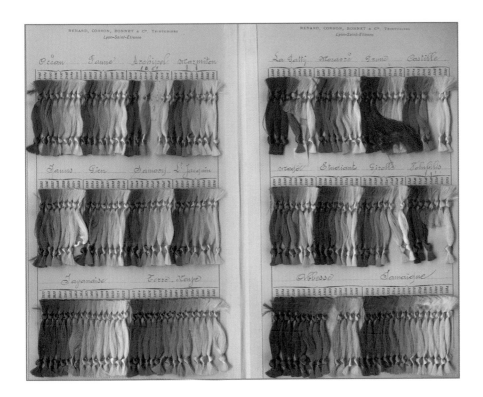

1.7 This fall 1899 forecast by Renard, Corron, Bonnet et Cie, a dye house in Lyon and Saint Étienne, gives a name and a number for each color. The names connected fashion trends; the numbers provided a practical way for textile mills to order dyes. The juxtapositions suggested color harmonies. Accession 2188, Hagley Museum and Library.

Surviving shade cards suggest how French dyers used them to market their technical services and demonstrate their expertise as color futurists. Twice yearly, the sales offices at J. B. Chambeyron fils, "*teinturier*" in Lyon and St. Étienne, published a new shade card, with loops of dyed silk floss pasted into a heavy cardboard book. Issued six months ahead of the season, the cards showed the standard colors and the "*teintes nouvelles*" for spring-summer or fall-winter.[31]

Architectural Color Symphonies

The career of the London-based designer Owen Jones illustrates how the Victorian color explosion affected architecture and the industrial arts. Between 1836 and 1845, Jones published *Plans, Sections, Elevations and Details of the Alhambra*, a series of folios on the fourteenth-century Moorish fortress in Granada. This was the first major book illustrated with color plates made by chromolithography, a new printing process developed in Germany. After colorizing the interior of the 1851 Crystal Palace, Jones went on to a prolific career as a writer, theorist, and designer for the industrial arts. His 1856 motif sourcebook *The Grammar of Ornament* became the standard reference for artists, architects, and designers and established his international reputation as a color authority.[32]

1.8 Silk fabric in the "Peri" line, named after a fairy in Persian folklore. Designed by Owen Jones, and made by Warner, Sillet & Ramm, London, in 1870 or 1871. Catalog no. 1995–80–1, Cooper-Hewitt, National Design Museum, Smithsonian Institution. Museum purchase from Sarah Cooper-Hewitt Fund. Photograph by Dennis Crowley. © Smithsonian Institution.

Architectural polychromy crossed the Atlantic Ocean and found a place in America's creative economy. In Boston, Henry Hobson Richardson's Romanesque Trinity Church, constructed between 1872 and 1877, had an interior painted in rich dark hues and gold leaf à la Jones and accented with stained glass by the noted craft revivalists William Morris, Edward Burne-Jones, and John LaFarge.[33]

The influence of European color theory reached Chicago, where architects were building the first skyscrapers. John Wellborn Root, who collaborated with Daniel H. Burnham on the world's largest office tower, the Monadnock Building in the Loop, drew on the work of Chevreul, Jones, and the British art theorist John Ruskin as he developed a program for architectural expression wherein color would supplant music as an art of pure emotion. Root imagined a new American style—a polychrome city in which dreary red brick and somber gray stone would be replaced by visually exciting buildings of glass, terra cotta, marble, and mosaics. This "symphony of colors," Root explained in 1883, would evoke "the full verdure of woods, the warm blue of summer sky, the eternal joyousness of blooming flowers, crystallized into unfolding color and greeting us in our daily avocations."[34]

After Root's untimely death, his Chicago colleague Louis Sullivan, inspired by Richard Wagner's tone poems to imagine parallels between music and color, began to experiment with symphonic colors in buildings. Just as a composer arranged the notes to evoke emotions, the architect could use polychromy to create a vision that transported the audience to another plane. In 1893, the firm of Adler & Sullivan applied these principles to the interior decoration of the Auditorium Building and to the exterior of the Transportation Building at the World's Columbian Exposition, using color, texture, and lighting to create a spatial tone poem. These pioneering efforts by Chicago architects put polychromy on the map and led to the widespread use of terracotta and colored tile during the Art Deco era.[35]

Each dye color was shown in six shades, ranging from light to dark, and juxtaposed against another color to suggest a stylish pairing. Every shade was labeled with a unique three-digit identification number. With the Chambeyron card in hand, the designer in a textile mill, a garment factory, or a millinery shop could plan the next season's lines, and the manager could order French materials in exact colors by letter or cable. The numerical system was designed to get around the confusion of color names, which often had different meanings for different people.

French trade associations soon recognized the benefits of official shade cards, which could facilitate communication within the organization or between members and their customers. Someone at the trade association's headquarters decided on next season's palette, and members agreed to offer fabrics, ribbons, feathers, buttons, and other sewing necessities in colors that matched the official card. In early 1892, La Chambre Syndicale des fleurs et plumes, the trade association of Parisian trim makers, issued a typical shade card for the winter of 1892–93 that showed bronzes, reds, greens, and blues as the fashionable new colors for artificial flowers and feathers. Designed by and for the fashion industry, these cards capitalized on the cultural cachet of Paris. By 1895, the seasonal shade cards of La Chambre Syndicale de la couture et de la confection pour dames et fillettes, the Paris trade association established by Charles Frederick Worth in 1868 to guard the interests of the custom dressmakers (haute couture) and of the ready-to-wear clothing industry (confection), identified colors by cable numbers and by French names such as "fleur de la passion." French trade associations sold the cards through their administrative offices or through Paris commissionaires such as Claude Frères.[36]

As the world clamored for the latest in Paris fashion, customers put French shade cards to a new use. New York merchants imported the cards for sale to newspapers, magazines, wholesalers, retailers, and manufacturers, who then used the advance color information to fortify their cultural capital. In 1896, editors at *Harper's Bazar* referred to the "color cards sent out from Paris, Lyon, and St.-Etienne" when describing the trendy summer hues. A millinery shop might use a French card to select undecorated shapes, fabrics, and trim from a wholesaler's catalog, or to design a themed window display of Paris-inspired fashion. In September of 1902, a Los Angeles milliner named Gertrude returned from a buying trip to New York with imported hats in Coquellrouge and Burgundy, which were "among the latest shades on the Paris syndicate color card." In October of 1909, as countless Los Angeles stores took their cues from the autumnal yellows of the 1910 color card, it seemed to one observer as if "autumn had dipped her brush in gold."[37]

Punch!

> As for colors, a long time has elapsed since the fashion-writer could point to any
> special one as the favorite color. Time was, when the hues of the rainbow
> followed each other in rotation, but now, one might as well attempt to count the
> sands on the Cape-May beach as enumerate the shades in vogue.
> —Strawbridge and Clothier, 1884

French shade cards permitted retailers such as Strawbridge and Clothier, an up-market Philadelphia department store, to stock merchandise in the newest colors, making it seem as if they were a step ahead of the Paris fashion reports in the press. But everyone knew that American tastes diverged from the French, particularly as one moved from the haute couture client of Fifth Avenue to the shirtwaist-clad shop girl from Brooklyn. Only the very wealthy—the wives of bankers, factory owners, politicians, and surgeons—could travel to Paris for made-to-measure couture. The average woman had a practical wardrobe of some ready-made items, some simple home-sewn garments, and a few good outfits made to fit her figure by a professional dressmaker. The calicos, silks, lace, buttons, brocade, and other trimmings were picked out in dry-goods emporiums, in millinery shops, and on the large fabric floors at department stores such as John Wanamaker, Marshall Field, and William Filene's Sons. Because production and distribution were decentralized, the market offered a wide choice of patterns, designs, and colors.[38]

By the late nineteenth century, cultural critics on both sides of the Atlantic were complaining about the deterioration of consumer taste that resulted from the democratization of color. One famous observer of the British scene, the French philosopher and historian Hippolyte Taine, was appalled by the brash costumes worn by women strolling through London's Hyde Park in 1860–61. "The colours are outrageously crude," Taine wrote in *Notes on England*, "badly matched, striped, fussed, overdone, loud, excessively numerous colours each swearing at the others. . . . One sees purple or poppy-red silks, grass-green dresses decorated with flowers, azure blue scarves." Bright gaudy attire also worried the taste police in Paris. "Everyday, our sidewalks, our streets, our salons, and our theatre lobbies are traversed by women in clashing accessories," reported the *Gazette des beaux-arts* in 1874. One Parisienne's pairing of a scarlet waistcoat and a purplish petticoat was an eyesore, "un scandale optique."[39]

Bright colors and bold contrasts were even more popular in the United States. The flamboyant hues of the dye explosion—first with natural colorants, and then with synthetics—were especially appealing to independent-spirited Americans. French dressmakers recognized "the great demand in America for effects characterized popularly as 'punch' in color," that is, for "contrasting shades, often

1.9 "Punch" on parade. *E. Butterick & Co.'s Quarterly Report of New York Fashions, for Fall, 1870*. Library of Congress.

of strong effect." Culture watchers equated this punch with the first steps of a toddler nation that had "not had time to develop taste," or saw it as the offspring of the "almost abnormally developed tendency for advertising, and its most striking exponent, the advertising poster." Numerous other factors—ethnic diversity, immigrant traditions, and regional climates—whetted the American appetite for punch.[40]

Although ordinary Americans reveled in color, they had no training in color harmony. Shuddering at showy outfits, fashion editors attempted to stamp out chromatic abominations by expounding on Chevreul's principles. *Godey's Lady's Book* introduced readers to Chevreul, the famous French "color-sergeant," in 1855, and four years later that publication responded to the proliferation of "ill-dressed and gaudy-looking women" by describing Chevreul's "becoming colors" for blondes and brunettes.[41]

But American consumers relished the fruits of abundance, and in fashion this translated into brighter, better, and more. "Offenses against good taste in color are rather the rule rather than the exception here," *Godey's* lamented in 1862. When synthetics combined with vanity, things got worse. "The more the merrier seems to be the motto of many as regards to the numbers of colors, and the most showy shades are met with together in the most barbarous combinations," said the *Dry Goods Bulletin and Textile Manufacturer*. "There seems to be an attempt at eclipsing the rainbow, with the difference, however that in the rainbow the passage from one color to another is very gradual, while here it is most abrupt." In the 1870s and the 1880s, it was common to find in "a woman's toilette, as a whole, a clash of colors, as each part was selected separately without relation to the ensemble."[42]

The chromatic discord touched other areas of American material life. On the streets, advertisers tacked up chromolithographed posters and painted giant signs that promoted everything from circuses to hair tonic. Buildings and interiors were tinted willy-nilly. The "architecture of the Victorian period," the magazine *Brickbuilder* noted, "was lavishly colored." Victorian coziness encouraged eclecticism in household decoration. A proliferation of home goods were sold by department stores, home-furnishings depots, china-and-glass shops, open-air markets, mail-order catalogs, and five-and-tens—and none of it matched. As a result, nothing in the average home was color-coordinated. "The bosom friend of my childhood, married to a common-place pudgy little man, and living in a common-place pudgy little house," one *Atlantic Monthly* journalist observed, "was perfectly complacent and happy with her blue plush parlor set, her cerise 'throw' on the mantel, tastefully tied back with blue ribbons, and her gild and onyx table topped with her hand-painted lamp."[43]

Manufacturers, anxious to increase sales, turned to the color card as a marketing tool. Suddenly the average American was a color expert armed with punchy color samples. By the 1870s, American paint manufacturers used "sample color-cards"—cards with paint chips attached—to sell their products to house painters, roofers, and builders. In the magazine *Ohio Farmer*, the paint manufacturer J. B. Tascott & Sons urged readers to "ask your storekeeper for our Sample Card of Colors," or to write to the Chicago factory for a "beautiful Color Card by mail." Color-sample cards were also used to market embroidery thread and packages of do-it-yourself dyes. The Corticelli Silk Company gave away cards with "the actual silk threads in innumerable shades and tints" and instructions for determining how much thread was needed to embroider apple blossoms or buttercups. The Corticelli color card for 1899 featured more than forty "new shades of silks" in "remarkably beautiful tones" of a "fast dye" that could be "used without the least hesitation." Advertisements for Wells, Richardson & Co. urged homemakers to send in for a "Sample Card" of its ready-mixed Diamond Dyes, which they could then purchase at a local drug store.[44]

Tastemakers of the Progressive era organized a frontal attack on punch, hoping to whiten and naturalize everything from houses to haberdashery. The aesthetes ushered in the era of Colonial Revival architecture, Mission-style furnishings, and airy rooms filled with sunlight or electric illumination. The City Beautiful movement led to an American renaissance in public architecture, emphasizing pale gray stone, electric light, and pastel murals, and culminated in the first zoning laws, which outlawed the indiscriminate posting of handbills and posters. Reformers deemed that colors once "in" were now "out." "No one these enlightened days paints his house a blue or a pink—except in Little Italy." "I am offended when a red-haired girl wears a peacock-blue dress," wrote the color critic in the *Atlantic Monthly*. "It is my sincere and deep conviction that magenta is the unpardonable sin." Purple, once a symbol of high fashion, had become a mark of low taste. "People . . . must at a certain time pass through the magenta stage before the reach the plane of a finer vision."[45]

French forecasts encouraged color harmonies à la Chevreul, but they could not ensure compliance. American manufacturers selectively emulated the new Parisian modes just enough to capitalize on their snob appeal. *Ladies' Home Journal* explained: "When Paris announces the new shades of the season, we less favored mortals are supposed to bow to the decree, but if the truth is known our manufacturers pull the French color-card to pieces, and after gleaning ideas from it and many other directions produce a color-card unsurpassable in variety and beauty." After cannibalizing the French palette, "one prominent silk manufacturer of New York" issued its own shade card for 1892, showing "three hundred shades of surah" (a type of twilled dress fabric). While reformers pushed for Colonial Revival white and Mission oak, the giant New England textile mills that produced inexpensive printed calicos did what they did best: make punchy colors that would sell.[46]

The Perkin Jubilee

In 1906, the British chemical industry dragged William Henry Perkin out of retirement and canonized him as its patron saint. In London and in New York, Perkin was feted as "the hero of the greatest industrial victory ever won by applied science" and as a "scientist, wizard, and revolutionizer." In reality, however, the story of synthetic dyes—the long trek from *pourpre français* to the fade-resistant vat dyes—was far more nuanced and international. Since the 1850s, the torch had been passed from France to Britain to Germany. At the time of the Perkin Jubilee, Germany dominated global dye production. Synthetic dyes never did eliminate natural ones; synthetic and natural dyes co-existed to create the great color variety that consumers loved and tastemakers loved to critique.[47]

In 1862, the *New York Times'* London correspondent had sized up the "mauves and magentas" of the second Crystal Palace exposition and had wondered at the "carboniferous" tastes of "our wives and sweethearts." Was Angelina, "as she floats magnificently down Broadway, in all the lustre of youth and fashion," aware "that the exquisite dress she wears . . . is in fact dipped and steeped in the essence

of vile, smoky, stinky, crackly English coal"? Nearly 50 years later, this journalist would have looked farther afield—to Silesia for the coal, the Rhineland for the chemistry, Lyon for the inspiration, New England for the calicos, and New York for the ready-made Gibson Girl outfit. The color fanaticism of Angelina's granddaughter depended on a fashion-industrial system that was increasingly international.[48]

The nostalgic Perkin Jubilee marked the end of an era that, for Britain, began in a boy's East End lab and with a queen's Pall Mall promenade. In the twentieth century, the locus of innovation would move away from Gobelins, Germany, and *Godey's* to American lovers of punch. Trained neither as artisans nor as chemists, the new generation of colorists sought to balance chance, opportunity, scientific systems, and aesthetic reform. Inventors and entrepreneurs such as Albert Munsell, Margaret Hayden Rorke, and H. Ledyard Towle gave new meaning to the color revolution. Fittingly, their first salvo against chromatic anarchy was fired in turn-of-the century Boston, the Puritan city on a hill and a Victorian center of design education.

2 Anarchy

2.1 Albert Munsell showing his Color Sphere to his children. Pictorial Collections, Hagley Museum and Library.

2.2 The Munsell Color Sphere, patented in 1900. Photograph by Andrew Spindler Antiques.

In August of 1898, Albert H. Munsell, a professor of drawing at the Massachusetts Normal Art School in Boston, was sketching at Smuttynose, an island off the coast of New Hampshire, when thunderclouds rolled in. Munsell had been attracted to Smuttynose by its dazzling sunsets, thick mists, and dramatic lightning, and he returned most summers to study the magenta-orange sunsets and purple-gray storm clouds. On this day, as the weather changed, he captured nature's fury in a sketch called "War Cloud"—and then had one of those "eureka" moments famous in the history of invention. Back in his studio, he would plot the sky's color gradations on a "*sphere*," creating a twirling three-dimensional model as an object lesson in the principles of color harmony.[1]

For the next 20 years, Munsell dedicated himself to creating a practical color system for art and commerce. Aesthetic reform—the "improvement" of American taste—was his ultimate goal. Manufacturers could make fabrics, leather, paints, and inks in an endless variety of colors, but taste had yet to catch up with technology. "The gaudiest colors are found in the cheapest stores," Munsell noted, while "in the homes of cultivation and refinement, one finds tempered color." Munsell believed this great divide in taste, and the general visual chaos of the day, stemmed from a lack of color education and a paucity of good design tools. There was no universal language for describing color, no standard curriculum in color theory, and no mechanism for coordinating colors across merchandise categories.[2]

As a student at the École des beaux-arts in Paris, Munsell had read Michel-Eugène Chevreul's books and had visited Chevreul at Gobelins. He planned for his system to popularize the subtle "middle colors," hence improving mass taste and advancing human progress. His invention consisted of a notation system for describing the appearance of a color in three dimensions à la Chevreul: *hue,* *value,* and *chroma.* His nomenclature was meant to be used as a teaching tool in the classroom or as a design tool in the factory or store. He created the Munsell Color System as a one-stop solution to everyone's color needs. It included printed color charts, spinning tops and spheres, colored papers, pencils, and crayons, and a patented photometer. In addition, he wrote three books that explained the underlying principles: *A Color Notation, Atlas of the Color-Solid,* and *Color Balance Illustrated.* There was no stopping the march of chemistry, but the Munsell Color System was one tastemaker's effort to stave off "color anarchy."[3]

The War over Color

Albert Munsell was not the first American to invent a color system. Milton Bradley and Louis Prang, two prominent Massachusetts chromolithographers, had done so in the 1880s. Before then, the idea of teaching color harmony in the public schools was radical. There were no lesson plans, crayons, color chips, or textbooks. Only some editions of Chevreul's *Principles* and some newer books (among them *Modern Chromatics* by Ogden N. Rood) even had engravings and color plates. Visually astute adults such as Munsell could extrapolate from these treatises, but schoolteachers found such books impenetrable.

Bradley and Prang saw an opportunity to improve public taste by convincing the state's Board of Education to include color lessons in the curriculum. And if children were to learn color harmony, their instructors would need a color-order system, good demonstration materials, and simple lesson plans. Prang and Bradley believed that color instruction would refine students' visual skills and prepare them for their adult roles as workers, designers, and consumers. For nearly two decades, these competitors lobbied to get their respective products adopted. As *School Arts Magazine* noted, their commercial feud erupted into the "war over color."[4]

Polychrome Pictures

People these days have gone picture-crazy. . . . They do not care so much for black-and-white as they used to—they want color.

—*Art Amateur*, 1894

In the American industrial arts, printing was a locus of chromatic innovation. The Boston entrepreneur Louis Prang was a prime example. Trained as a calico printer, Prang had emigrated from Prussia to the United States in 1850, settling in Boston and hoping to find a position in a textile mill. Instead, he moved from job to job—publishing architecture books, decorating morocco leather, and engraving for *Gleason's Pictorial*—until 1856, when he set up his first chromolithography workshop. The Civil War gave a boost to his business, as consumers clamored for patriotic sheet music and pictures of their favorite military heroes in color.[5]

Prang and other printers put brilliant color into the hands of the American consumer. Early in the nineteenth century, nearly all printed matter was tinted by hand, and few pictorial advertisements were in color. Fashion magazines such as *Godey's Lady's Book* featured fashion plates printed in black and then colorized by hand using watercolor paints. Chromolithographic printing began to change all of this. Catering to Victorian tastes, printers began making inexpensive color pictures, or "chromos," in a variety of styles. Like Currier & Ives, Prang produced sentimental, religious, and patriotic scenes by the thousands and fostered a marriage between color and marketing in a variety of vibrant new formats: almanacs, bottle labels, bookmarks, cereal boxes, calendars, placards, posters, soap wrappers, and trade cards. Trade cards were small 3-by-5-inch souvenirs, decorated with sentimental or humorous scenes, that stores gave out to their customers. Men used them as business cards, women exchanged them in friendship, and children pasted them into scrapbooks. Advertising posters evolved into a sophisticated medium from the 1870s through the 1890s—particularly in Paris, where Henri de Toulouse-Lautrec supported himself by designing images for a cabaret called the Moulin Rouge. In America, large placards and posters advertised consumer products such as Estey parlor organs and Belle of Nelson whiskey and attractions such as the Barnum and Bailey circus.[6]

The first American world's fair, the Centennial Exposition held in Philadelphia in 1876, spurred a trade-card-collecting fad and heightened color consciousness. Prang observed: "Millions upon millions . . . of the most varied designs were thrown on the market and the mania among children for collections . . . helped to exhaust the supply." As they window shopped, read advertising posters, and played with their trade cards, Victorian consumers learned something about aesthetics—and had their chromatic appetites whetted.[7]

2.3 Advertising calendar, Philadelphia, 1883,
Warshaw Collection of Business Americana,
Archives Center, National Museum of American
History, Smithsonian Institution.

Milton Bradley had achieved success during the Civil War with his Checkered Game of Life. Financially secure, the Springfield board-game magnate could demonstrate his passion for early childhood education. In 1869, he published *Paradise of Childhood*, the first English-language book based on Friedrich Fröbel's kindergarten concept. He then diversified the Milton Bradley Company by producing school supplies. By 1884, his Springfield factory was also making tools for budding young scientists, including a microscope slide box invented by J. H. Pillsbury, a Smith College naturalist who eventually became one of Bradley's chief advisors on color.[8]

In the 1880s, Bradley began to develop the color materials that would lead *School Arts Magazine* to dub him the "god-father of color instruction." Kindergarten teachers needed affordable and reliable sets of colored papers and watercolor paints for art projects. Pillsbury introduced Bradley to spectrum standards and to the practice of visually blending colors with rotating Maxwell disks. Bradley introduced a box of eight crayons—six bright standards (red, orange, yellow, green, blue, and violet) plus black and white—and introduced an art educator's toolkit with Maxwell disks, a color top, color charts, a color sphere, and instructions for explaining the notation system to students. In 1890, he followed up with *Color in the School-Room,* the first textbook to outline a plan of color instruction for kindergarten through the twelfth grade.[9]

2.4. Kathryn Grace Dawson, *Bradley's Graded Color Portfolio for 1st, 2nd and 3rd Grades* (Milton Bradley Company, 1904).

Bradley soon found himself involved in a fiery art-versus-science debate that had raged since Chevreul's day. In the journal *Science,* one reader questioned his use of six primary colors, a choice rooted in printing conventions rather than in David Brewster's widely accepted theory of three primary colors (a theory that was based on the study of light). Bradley retorted that it was not practicable for artists, businesses, and educators to use color systems based *solely* on light. Technical limitations prohibited chromolithographers from printing the exact shades of red, green, and violet as reflected through a prism, an experiment first done by Isaac Newton in 1666. However, they could print approximations of red, orange, yellow, green, blue, and violet on papers, which could be rotated on Maxwell disks to replicate "a very large proportion of all the colors found in nature." Far from perfect, the Bradley system was a *practical* object lesson that allowed artists and art educators to "avail themselves of the scientific theories of color in their work." It bridged "the chasm" between the "the science of color" and "practice of color in the use of pigments."[10]

In 1893, Louis Prang introduced a competing perspective with *Suggestions for a Course of Instruction in Color for Public Schools* and its accompanying craft paper, wall charts, and watercolor sets. Believing that experience and intuition trumped science, Boston's leading chromolithographer built his color system around three pigment standards in bright shades. His wizardry was complemented by the energy of Mary Dana Hicks, a widowed art educator from Syracuse who had joined the Prang Educational Company in 1878 (and who would become Mrs. Prang in 1900). From

tests in the Springfield schools, Hicks began to understand that children perceive colors differently than adults, and that very young children see light, bright colors better than dark, subtle shades. "We have to learn what they see," she explained. Prang's color system blended his experience as a printer with Hicks' know-how as an educator. "The course is not intended to be arbitrary and prescriptive, imposing knowledge on the child," they wrote in *Suggestions*, ". . . it rather aims to lead him to see, to feel, and in some degree to express, the beauty and the power of color."[11]

A Keyboard for Color

By the summer of 1898, it had occurred to Albert Munsell that he might also find a niche in color education. Bradley and Prang had done much for the cause, but Munsell was irritated by their insistence on bright shades. Furthermore, neither of them had used precision instruments to gauge luminosity, which left them open to criticism from physicists concerned with measurement and standards. Munsell saw a need for a color-order system that would teach consumers to appreciate the subtle shades *and* would pass muster with scientists. The subtle colors of his "War Cloud" sketch served to fix his mind on good taste and good research.

After mapping the "War Cloud" on his sphere, Munsell began to keep a diary, meticulously recording his daily activities having to do with color from 1899 to 1918. In June of 1899, he outlined how his "revolving spherical color-chart" might fit into education and commerce. In a classroom, it could be used as an object lesson that showed the "facts and relations of color." In an office or a factory, it could be used to "preserve and reproduce any color group or effect" and to study a color sequence, functioning much like a "key-board" or an "instrument for color arrangements." Munsell, the son of a Boston piano maker, elaborated on the parallels between music and color: "Can we imagine musical tones called lark, canary, cockatoo, crow, cat, dog, or mouse, because they bear some distant resemblance to the cries of those animals? Music is equipped with a system by which it defines each sound in terms of its pitch, intensity, and duration, without dragging in loose allusions to the endlessly varying sounds of nature. So should color be supplied with an appropriate system, based on the *hue, value,* and *chroma* of our sensations."[12]

The Munsell Color System evolved in three overlapping phases: invention, refinement, and commercialization. During the invention stage, Munsell tested prototypes on architects, artists, attorneys, competitors, educators, and scientists. To fine tune his system, he enlisted art educators to run trials in schools. To commercialize it, he looked for a manufacturer capable of making the color charts, atlases, globes, watercolors, and other components. In 1918 he signed the legal papers that created the A. H. Munsell Color Company, which would market the system after his death.

Color Is *in Us* — Not Outside

Munsell invented his color system in two studios in Boston's Back Bay, the first on Trinity Court and the second at 221 Columbus Avenue. Both studios were near the Normal Art School, the Massachusetts Institute of Technology, and Harvard Medical School, where Munsell visited the psychologist Henry Pickering Bowditch to talk about color blindness. William James had established Harvard University as major center for psychological research where vision and perception were studied in well-equipped laboratories. Munsell's reading of color treatises had familiarized him with academic research and prepared him to speak intelligently with distinguished men of science.[13]

When Munsell described his plans for a universal color system, the old guard raised questions about scientific legitimacy. Was it possible to meet the physicists' requirements? The professors were

2.5 Munsell's art studio in Boston. Pictorial Collections, Hagley Museum and Library.

2.6 Students investigating the effects of attention on color perception in Hugo Münsterberg's psychology laboratory at Harvard University in 1893. Harvard University Archives, HUPSF Psychology Labs (BP2).

skeptical and opinionated. Amos Emerson Dolbear, a pioneer in wireless telegraphy and a professor of physics and astronomy at Tufts College, often visited Munsell's studio. In November of 1900, he stayed for three hours, entranced by the color sphere, which he promised to use in his lectures. The professor freely shared his thoughts on the spectrum-pigment debate. "The wave-lengths of the physicist are unserviceable for the artist and the businessman—being impractical and impossible," he told Munsell. "Color is an ancestral and racial experience—not based on the spectrum. . . . The eye

judges by sensations and is the ultimate test." Pigments, he opined, were clearly the best reference point for a color system for art and design.[14]

Ogden Rood, who invited Munsell to visit him at Columbia University, urged caution. In March of 1900, he deemed the inventor's color spheres and Maxwell disks "very successful" at putting "an artistic idea (sequences) into scientific form." This physicist was also an amateur artist who painted landscapes in muted watercolors, and he appreciated Munsell's choice of five subtle colors. Later, however, he was more circumspect: "With all the desire in the world, I have so far been unable to make a scientifically accurate color-system because of the varying and un-measurable amount of white light entering into each pigment." Munsell might do well to rein in his ambitions, and to be satisfied that his system "*practically* represents a scientific arrangement of colors."[15]

Determined to have scientific accuracy, Munsell set himself a new challenge: to invent a daylight photometer "for measuring the luminosity of lights, colors, pigments, and other substances, which is simple in construction, inexpensive to make, easily used, and accurate in results." Though it was not the world's first light-measurement apparatus, his Lumenometer was an improvement over the Tintometer, created by British brewer Joseph W. Lovibond to measure beer colors. Munsell filed papers with the Patent Office on February 6, 1901, and was awarded U.S. Patent No. 686,827 on November 19, 1901.[16]

Building on his success with the Lumenometer, Munsell focused on writing his first book, *A Color Notation,* which established his reputation in scientific circles. Robert Thayer Cross, a professor of physics, liked the book "very much" and ordered a special "15 color (with B&W) sphere for the M.I.T." Amos Dolbear compared the book to earlier treatises by Chevreul and Rood, and commended Munsell for forging "a track across what is now a *desert* between practical and scientific color work." Some years later, the German chemist Wilhelm Ostwald (who had received a Nobel Prize for catalysis research and who in retirement embarked on his own color projects) told colleagues that Munsell was "completely on the right track."[17]

The emerging field of psychology helped Munsell to express an idea that had been germinating since he had discovered Chevreul in Paris: that his color work was about sensory perception. Edward Bradford Titchener of Cornell University, who lectured on color using a double-pyramid object of his own design, pushed Munsell away from physics and toward psychology. "Prof T.," Munsell wrote after one exchange, "says physicist tries to ignore the eye." The artist-inventor became the adopted son of the psychologists who invited him speak at Harvard University, at Johns Hopkins University, and at the University of Groningen in the Netherlands. He reveled in his newfound academic celebrity, and learned to articulate why the senses were important. In 1893, Louis Prang had written "There is no color outside ourselves." Munsell put it more succinctly: "Color is *in us*—not outside."[18]

2.7 A "Titchener pyramid" built in the Harvard Psychology Laboratory in the mid 1920s. Courtesy of Collection of Historical Scientific Instruments, Department of the History of Science, Harvard University.

The Drift Away from Discipline

As modern approaches challenged the old ways, the fin de siècle was a heady moment for art and art education. Albert Munsell, a traditionalist whose commitment to "truth" and "science" stood at odds with the new trends, felt the squeeze. Industrial-arts education took a vocational turn, focusing on

technical skills rather than on product design. Cultural forces split "the arts" into "fine arts" and the "manual arts," and began to divide taste into "high" and "low."

An argument between Munsell and Denman Ross (a Harvard art professor who had been Munsell's sketching buddy at Smuttynose and in Venice) was testimony to this rift. Ross, an advocate of high culture, used his Harvard position to promote a theory of pure design that presaged John Dewey's ideas on art as experience. Hints of discord had surfaced in 1889 when Ross, lecturing before Munsell's class, had promulgated ideas that challenged Munsell's fundamental beliefs: Art was the expression of "feeling." The "artist must express *himself.*" There was no truth; the only thing that mattered was self-expression. Impressionism sought "to define and relate the *shapes of light* and color felt through vision." The friendship between the two men cooled when Ross questioned the usefulness of the Munsell Color System, expressing doubt that it was it fit "to describe masterpieces of painting" but calling it "very valuable for decorative schemes." Here was a preview of the bifurcated art world of the twentieth century, with painters looking down their noses at mere designers.[19]

In exchanges with former classmate and fellow Normal Art School professor Anson Kent Cross, Munsell shared his concerns. "The paying element in manufacture was *skill,*" Munsell reflected in 1892, "and that skill was best developed by an industrial education." "Art education is not to represent nature," Munsell lamented, "but to evolve works of art—even in the school." "Art education has drifted away from *discipline,*" echoed Cross. It had degenerated "into sentimental haziness; and must come back." Perhaps the Munsell Color System, based on scientific truth and visual rigor, would reinvigorate the industrial arts and industrial arts education.[20]

From Invention to Innovation

Munsell waged an uphill battle against the anti-disciplinarians as he turned his invention into an innovation. At first, Boston educators smiled on the Munsell Color System. In December of 1900, Henry Turner Bailey, the supervisor of industrial drawing at the Massachusetts Board of Education, visited Trinity Court to "talk over the scheme." He thought the Munsell system "should be in the schools, since the present methods fail to teach harmony or color relations." Munsell was pleased by the subtle jibe at Bradley and Prang. The Board set statewide trends, and he was glad to have Bailey on his side.[21]

Myron T. Pritchard, headmaster of the Everett Grammar School since 1894, proved a stalwart champion. Seeing color as a "*necessity* in education," Pritchard believed it was "possible to *train* [the] color sense, so that children may have not *only names*—but *color values.*" At the school, Munsell described his models to students in plain words. Pritchard, well-connected in education circles, introduced Munsell to influential people in the Boston school system. Early in 1903, Jennie C.

Peterson, an assistant to drawing director J. Frederick Hopkins, visited Munsell's studio, accompanied by Pritchard, in order to study the color sphere, the top, the charts, and a mock-up of the color atlas. A few months later, she returned to "arrange a course of color study for Boston Schools," and, with her boss, to initiate a decade-long collaboration between Munsell and the city's office of education.[22]

Over the next few years, Pritchard and Peterson continued to visit Munsell's studio, sometimes three or four times a month. There they discussed lesson plans and teaching materials, sometimes heatedly. "Is solar spectrum a standard—is your circle of hues like it? Why not? How do you get that red? Is it measured—by whom, by what? Can it change—will it fade? Can children find any color in your sphere? Do you go from particulars to universals—do you use synthesis or analysis (in teaching color)? Work out a few *harmonious groups* under *rules* and show them."[23]

When Munsell grew discouraged, Pritchard reminded him of the opportunities created by the "school muddles about color." "No teacher understands the subject of color, but everybody is interested in it. It is now *the* subject uppermost." J. Frederick Hopkins intervened with the administrators who decided which books to adopt. "Let me have the [advance] copy by March 16," he told Munsell in January of 1905, "and I will say, 'Gentleman, this is the best thing on color yet—we must have it.'" The networking began to pay off. In October, Miss M. L. Patrick of the Pope School in Somerville told Munsell that she was to do a trial run of his system in grades 1–12. The elated inventor agreed to help by lecturing the teachers on his system. In March of 1906, Munsell wrote in his journal: "The teachers are delighted: say they'll show great advance next year. . . . Wish they had a *color top* to show balance." Munsell rejoiced in the victory and, in the ensuing years, would savor this high point.[24]

Pritchard helped Munsell look for a publisher and develop a marketing plan. Since neither was trained in business, they knocked on doors and asked for advice. In December of 1903, they took the train to New York and lunched at the National Arts Club with Edward Lord, manager of the education division at the publishing house Charles Scribner's Sons. A former schoolmaster and schoolbook distributor, Lord asked tough questions: "How fast will these colors change? Will artists accept a new system—or *this* system? . . . What does it displace? Who will use it?" He got to the heart of the matter: "Will two people agree as to what is harmonious in color?" Pritchard and Munsell went home exhausted, their heads pounding from worry. Ultimately, Munsell's project proved too complicated for the publishing house. Equipped to print conventional books and magazines, Scribner's could not reproduce the color charts to an accurate measure. In the future, the Munsell Color System would give the publishing industry the tools for good color matching required for complex print jobs.[25]

Munsell wondered if he should swallow his pride and join forces with the competition. In Springfield, he visited Milton Bradley. "Send us what you want to do," said Bradley, "and we will see how it can best be published." In turn, Bradley sent his trusted regional manager, E. O. Clark, to see what Munsell was doing. But Charles F. Perkins, the attorney who advised Munsell on patents, thought it best that he steer clear of Bradley, "as he was already a worker in the same line, and had a pet idea." When the Boston sheet-music publisher C. C. Birchard, who compared "color sensation" to "musical sound," offered to help "get out some textbooks," Munsell coyly asked if Louis Prang had "not pre-empted the field." In October of 1904, Prang himself, who had retired from chromolithography in 1899, appeared (with his wife Mary) at Munsell's door. Still passionate about art education, Prang had brought along William E. Cochrane, president of the Prang Educational Company. Munsell's school-board chums warned: "Billy Cochrane can prevent and turn down anything." Face to face with Cochrane in his New York office, Munsell described his need for a partner who could print high-quality color plates and who could produce classroom supplies such as watercolor sets. Cochrane's follow-up letters claiming that *A Color Notation* would hurt the sales of Prang's new books infuriated Munsell.[26]

Eventually, Munsell came to believe that his system could stand on its own. Worthington Chauncey Ford, a noted bibliophile at the Boston Public Library, pushed him toward independence. Over lunch at the Union Club, Ford praised Munsell's "professional view of color," which, he said, would "arouse interest and respect." "The questions opened by this view," he continued, "are of interest to all thoughtful people—to scientists especially." Munsell's art background was a plus. It would be wise, Ford ventured, to "avoid anything that smacks of . . . the mercantile view."[27]

Ford's advice strengthened Munsell's resolve and led him to the George H. Ellis Company, a small Boston publishing house that had produced such educational materials as Henry Manly Goodwin's *Physical Laboratory Experiments* and Charles L. Adams' *Mechanical Drawing: Technique and Working Methods for Students*. It specialized in small print runs, relying on authors to handle their own advertising and marketing. Munsell liked the setup: *A Color Notation* would bear the Ellis imprint and would appear in Ellis' catalog, "but it remains entirely my property—they acting as printers only for me—and granting use of their facilities for distribution." Any lingering fears were allayed when the first copies of *A Color Notation* rolled off the presses in March 1905.[28]

Munsell began searching for a factory that could manufacture the components for his system, including an early version of his *Atlas* (figure 2.8). The challenge would be to reproduce each of the colors accurately and consistently in different materials, such as cardboard, papier-mâché, printers' ink, watercolor, wood, and metal. The job involved considerable handwork. Munsell had difficulty finding a printer that could reproduce the "middle colors" needed for his *Atlas*. He decided to have

the charts painted by hand and cautioned the user to "protect the chart from dust and handling" because the watercolors would fade. The charts and globes had to be painted by hand, and the enamels had to be baked in an oven. Munsell settled on Wadsworth, Howland & Company, a local firm that made Bay State brand paints and sold supplies to artists, architects, and draftsmen. Conveniently, the firm had two downtown stores—one on Washington and one on Clarendon streets, close to Munsell's studio—and a factory in nearby Malden. Early in 1905, Wadsworth, Howland & Company agreed to produce the *Atlas,* the enamels, the crayons, the balls, the spheres, and the watercolor sets.[29]

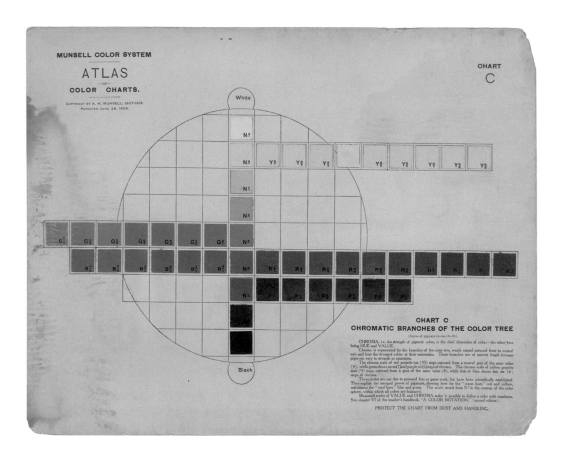

2.8 *Atlas of the Munsell Color System*, ca. 1915.

Accession 2188, Hagley Museum and Library.

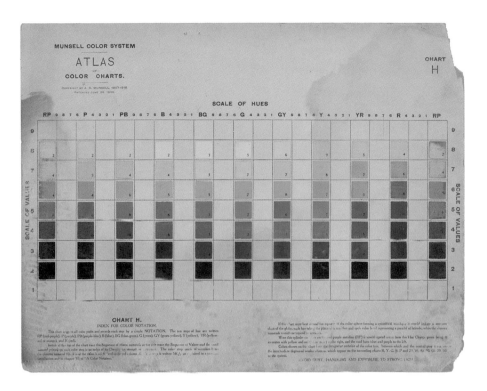

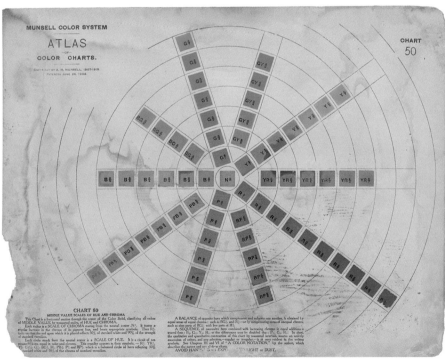

Battle of the Buttercups

The formidable Billy Cochrane kept an eye on schools' experiments with the Munsell Color System. Munsell, in turn, delighted in rumors that Prang's chief lieutenant believed his system to be "the best and most scientific yet." However, his mood soured when an irate colleague telephoned to report that one of Prang's salesmen was "spreading a statement that Miss Patrick has had to give up the Munsell system." Then other friends reported more alarming news. Munsell's system, Prang's agent was said to have carped, "was too complicated and revolutionary" and "was not adopted in any city." Munsell demanded an apology, but Prang's charges haunted him because they had the ring of truth.[30]

By 1908, the Munsell Color System had a devoted following among reform-oriented educators at art colleges, who used it to teach adult students. Munsell did a lecture tour to promote the system, but the public schools (except the Pope School, where Miss Patrick ruled) resisted. Some educators, accustomed to the bright colors of Bradley and Prang, refused to consider alternatives; others were hindered by budget constraints. And a flurry of damaging publicity was generated by Henry Turner Bailey, formerly champion of Munsell but now a friend of Bradley. Now the editor of *The School Arts Book*, Bailey used his magazine as a platform for advocating color in the classroom—and for criticizing Munsell.

Some of Bailey's criticism may have been attributable to a misstep by Munsell. In 1906, a man named Walter Sargent had designed a watercolor set for Bailey's *School Arts Book* and had visited Munsell to ask his opinion of the colors in the set. Horrified by what he saw, Munsell brusquely dismissed Sargent. "His imitation of the spectrum is a failure as far as imitation goes," Munsell wrote in his diary, "and presents totally unrelated degrees of H. V. & C. at every step, so that *all his claims* in the *School Arts* color pamphlets *are destroyed*." When Munsell confided these concerns to his friends at Wadsworth, Howland & Company, they warned: "You must be careful how you play with sharp tools."[31]

Bailey retaliated in *The School Arts Book,* criticizing two aspects of the Munsell Color System: the choice of five standards and the use of neutral shades ("middle colors"). By 1910, art educators agreed that color lessons were here to stay. "The color sphere should be part of the supervisor's mental equipment," Bailey wrote, "a luminous, transparent globe of celestial color, out of which beautiful harmonies of color shall spring as flowers or be mined as gems of the earth." As globes proliferated, educators were hard pressed to choose one. Bradley had introduced the first sphere, using his six bright standards. Denman Ross came out with another version, also based on six colors. Munsell's sphere depicted color in a dramatically new way. "Mr. Munsell," Bailey claimed, had banished "the brilliant colors from the face of his earth. . . . The result is not the world we have loved. All the

glorious golden mountain peaks have disappeared, the emerald hills and the high-lying lakes of purest blue no longer exist, even the plains dotted with flowers have gone. Everything has been reduced to the Dead Sea level."[32]

The Bailey-Munsell feud was rooted in differences of opinion about psychology, taste, and visual perception. The bone of contention was the palette. In 1907, Bailey, echoing other Bradley aficionados, had asked Munsell "Can the youngest child respond to such quiet colors?" The incessant demand for bright colors dampened the inventor's spirit. At a lecture in Cleveland, the audience asked "Why is orange omitted? Can the child react to such quiet color? . . . Must we segregate children from nasturtium and sunset?" In Boston, teachers complained that young children could not "paint buttercup" pictures with the Munsell watercolors. The muted Munsell yellow was difficult for them to see and did not match the bright buttercup yellow found in nature.[33]

To his credit, Bailey agreed to discuss his differences with Munsell at his studio. The artist showered him with evidence from the Pope School, where children did art projects using his middle colors, and from Munich, where the High School of Drawing planned to adopt his system. "So put yourself in touch with progress," Munsell chided. "You certainly need to heed my friendly warning." While Bailey admitted the scientific soundness of the Munsell Color System and agreed that it was the best tool for teaching balanced color relationships, he refused to agree with Munsell's insistence on the middle colors. "You are wrong," he said, "in assuming the child's brain is already developed to a point where it is susceptible to subtle color."[34]

Bradley and Prang had biased the market toward bright colors, but other forces worked against Munsell. "The teacher," the men at Wadsworth, Howland & Company said, "*will not read* a book." Teachers had to be shown that the system was "*simple—simplicity itself—not difficult.*" In response, Munsell wrote *Color Balance Illustrated*, a 32-page teacher's manual outlining "practical color exercises that have succeeded in graded schools." Yet questions about strong colors versus subtle colors continued to plague Munsell, whose hope of shaping tastes in the formative years ran counter to evolving theories about childhood and sensory perception.[35]

Commercial Needs and Scientific Management

The early twentieth century was a pivotal moment for American business. Mergers consolidated the power of large corporations. An impressive transportation and communication network forged a national market. Innovative retailers—mail-order houses, five-and-tens, and department stores— offered competitive prices and extended mass consumption to a broader swath of the population. National advertising boomed as weekly magazines such as *Collier's*, *Ladies' Home Journal*, *Life*, and *Saturday Evening Post* entered their glory years. Though printers still dominated local advertising,

professional agencies began to handle magazine advertising for such national brands as Kellogg's, Kodak, Quaker Oats, and Jell-O. After the first full-color magazine ad appeared in *Youth's Companion* in 1893, ad agencies helped clients create more colorful packages that could be illustrated to advantage in the advertisements. Color was important to the new commercial order, serving to stimulate demand.[36]

Albert Munsell watched as Boston's first skyscrapers appeared in the financial district and as large stores displaced smaller shops on Washington Street and Boylston Street. The Back Bay began to fill up with row houses and apartments, and commuter suburbs sprang up along the trolley lines to

2.9 This Kellogg's Corn Flakes advertisement in *Youth's Companion* (November 5, 1908) used the subtle tones that Munsell favored.

Brookline, Chestnut Hill, Dorchester, and West Roxbury. Enrollment swelled at the art colleges, but the "hot and vulgar" colors proliferated. One man's "punch" was another man's eyesore. Aniline shades had "spread into stores, into women's dress, over all the bill boards and news stands, until they have become a standard of comparison and we are sadly unconscious of their crudity," Munsell noted. "Compare the voice of a coal-heaver and a cultivated person: an auctioneer and a teacher of philosophy." And although many of the new synthetic dyes were reliable, others faded or washed out.[37]

2.10 An example of the "hot and vulgar" colors that Munsell loathed: an advertisement for stockings sold by Young, Smyth, Field & Company of Philadelphia. Archives Center, National Museum of American History, Smithsonian Institution.

Some of Munsell's colleagues, horrified by the visual vulgarity, asked why "colors swear." Munsell determined to learn who was promulgating the color anarchy. The Germans were the global leaders in synthetic chemicals, and he was curious about their methods. By producing colorants for textiles, leather, paint, and ink, German chemical companies were indirectly responsible for shades that "shouted." He encouraged Joseph Smith, the New York agent for Leopold Cassella & Co., one of the Big Six German chemical companies, to test dye samples on his photometer. Smith deemed his system "invaluable for education of the color sense," just the thing for people like him with "absolutely no color education." The inventor's heart sank, however, when he heard about the dog-eat-dog realities. Cassella needed to know "only what would appeal to a business competitor—viz: means to imitate what is fashionable at slightly less cost." In short, German dye makers wanted "measures of the process (mechanical, chemical, etc.) . . . , rather than of the result." It would be futile for Munsell to push his tastemaker's agenda on this industry, which was driven by technology rather than by aesthetics.[38]

Munsell found a more sympathetic audience in the American textile industry. When he addressed the New England Cotton Manufacturers' Association, Charles W. Dennett, general manager of the Hadley Mills in South Hadley Falls, Massachusetts, immediately understood that fabric designers needed tools such as the color globe and the color charts: "Some years ago, when I was designing and used as many as ninety different shades of yarn in two seasons, it was necessary to name the colors in groups for convenient reference in writing out patterns. A great saving of time is made if the arrangement is right." The Munsell Color System could assist "the memory of the designer in combining his colors," making it "very practical and useful in the arrangement and cataloguing of colors in the designing room."[39]

Edward A. Filene, president of William Filene's Sons, also introduced Munsell to fresh possibilities. Along with Marshall Field and John Wanamaker, Filene had made the luxury department store into a mainstay of downtown America, the cornerstone of every big city's shopping district. These palaces of consumption tried to uplift popular taste by stocking Paris fashions, Colonial Revival furniture, Oriental rugs, and other goods of aesthetic merit. Subtlety in design and color was vital to their taste-making mission. Among retailers, Filene was revered for his modern business practices, which included employee benefit programs and efficiency-improving merchandising systems.

After watching Munsell demonstrate his sphere at the Twentieth Century Club, Filene invited him to address business leaders in the Boston Shopkeepers' Association. Not only did the Munsell system offer subtle colors that were in good taste; it had the potential to fill a rising "commercial need." "Retailers want a standard system fixed at all times," Filene explained—a set of "standard

colors" to be used for writing contracts, "telegraphing abroad," and "choosing harmonious combinations." Buyers needed fade-resistant "charts with numbers" to carry on their trips to factories. Without such tools, "buyers fail to get the exact color wished—and are unable to match certainly."[40]

Munsell saw this for himself when Filene hired him as a design consultant for his new department store on Washington Street. Like Field and Wanamaker, Filene had commissioned Daniel H. Burnham, the Chicago architect of the first skyscrapers, to design the flagship store, and he wanted expert advice on the terra-cotta facade. Munsell had done architectural work before, studying the effects of snowfall on the interior office lighting at the Albany Building. After his meeting with Filene, he recorded the following: "At Mr. Filene's office 3–4:30 with Mr. George and Mr. Cory. Discussed external design of new building—cor. Summer St. I suggest points of construction—treatment of set back columns—in windows—framed effect—and color accent for corner."[41]

Through this project Munsell met one Miss Daniels, a Filene's stylist who shared his preference for the middle colors. A new type of merchandising professional, the department-store stylist had general oversight for quality and prestige. Color harmony was second nature to Miss Daniels, whose job it was to ensure that the dry-goods buyer stocked ribbons that matched the newest millinery shades and so on throughout the store. In June of 1911, she asked Munsell when the "*Atlas* will be completed," "if it can guide buyers etc. in selecting colors," and "if it will describe all varieties of colors." She further urged him to "make measured color a business proposition direct to the manufacturer and wholesalers" who wanted to "imitate styles exactly" and sell American goods to retailers who wanted to avoid the tariffs on European imports. These businesses, she suggested, could save the "large expense of experimentation" if Munsell could provide "a more exact method" of color selection.[42]

The department store's concern for color coordination was indicative of the growing American passion for production controls. During the 1880s, the Philadelphia engineer Frederick Winslow Taylor had developed a revolutionary approach to factory management by studying the productivity of workers in a steel mill. Taylor believed that a college-educated engineer could tell an assembly-line worker how best to build a carriage or cast a doorknob. Through time-and-motion studies, a factory's manager would determine the "one best way" to do a task, and would arrange a work station so that a practical man could labor more efficiently, thereby increasing output and reducing costs. Taylor's elaborations on these theories in engineering journals and in his 1903 book *Shop Management*, in combination with his speeches and lectures, helped establish management as a science. They were more broadly disseminated in 1910 when the attorney Louis Brandeis coined the term "scientific management" while arguing against the railroads in the *Eastern Rate* case. Taylor's 1911 book *The Principles of Scientific Management* was attractive to cost-conscious executives and helped to further

the efficiency craze. His followers were known for their religious zeal, which extended the efficiency drive into all corners of American life. Their quest for the "one best way" came to be called Taylorism.

Taylorism coincided with the rising interest in industrial standards. Though Chevreul and other prescient observers had called for national standards long ago, in the United States the need did not coalesce until the birth of scientific management. The creation of color standards fell under the purview of the new Bureau of Standards, chartered by Congress in 1901. Founded as the first physical-science laboratory within the federal government, the Bureau of Standards became the home of scientific measurement and an advocate of quality engineering under the leadership of Samuel Wesley Stratton. It served manufacturers and consumers by setting standards for electricity, light, temperature, and time, and by maintaining hundreds of standard samples that helped to introduce quality control to American factories, augmenting "the one best way." Munsell wrote to Stratton "asking about color." Stratton was slow to respond. In 1911, after Munsell delivered one of his photometers to the Bureau of Standards scientist in charge of colorimetry, Stratton reported that his agency would "be pleased to examine a full set of [Munsell's] elementary color samples, and look over the system of scales."[43]

As magazines and newspapers increased their circulations, some forward-looking printers modernized their plants with the help of efficiency experts from Frederick Taylor's consulting business. Assisting some Boston printers, the Taylorites identified the haphazard approach to color as a source of confusion and waste. In 1910, Munsell noted how one such engineer, William L. Woodward "of the Phila. Firm of Taylor & Co.—'standardizers of business,'" tracked down him down at the Normal Art School. While in Chelsea helping Forbes Lithography with the "standardization of colors," Woodward heard about Munsell's "system of measured color charts" and wanted to learn more. Munsell also met Henry P. Kendall, the manager of the Plimpton Press in Norwood, who was updating his plant under Taylorite guidance. An outspoken advocate of efficiency, Kendall saw a business market for the Munsell Color System and urged the inventor to write "a new book aimed at Science and Scientific Management." Although Munsell never took up that suggestion, printers and standards would be important to his system.[44]

Arthur S. Allen, sales manager for the Philip Ruxton Company, a New York manufacturer of printing ink, first crossed paths with Munsell around 1905. The two men became friends through their mutual interests in sailing, good taste, and the middle colors. Allen abhorred "glaring" advertising ("Most of it screams") and appreciated discretion: "The best that is in us calls for soft, subdued colors, and we enjoy their effect." A tastemaker and an enthusiast for standards, Allen saw how the Munsell Color System could be used to advantage in the graphic arts. At his urging, the Philip Ruxton Company made the system its frame of reference and raised awareness of color

harmony among the best printers in New York and Chicago. In 1911, Emory Cobb Andrews, a manager in Philip Ruxton's Chicago office, published *Color and Its Application to Printing*, a book that drew on Munsell's work and spread the word to the printing industry.[45]

Arthur Allen became a promoter of the Munsell Color System. He convinced one client firm (the J. B. Williams Soap Company of Glastonbury, Vermont) to abandon lemon yellow and strong purple wrappers in favor of wrappers in more harmonious shades. When another customer solicited his opinion about printing on colored stock, Allen responded that it was not possible "to decide what color to use with the pink until you know the value and intensity of the pink paper." Planning a palette without reference to color's three dimensions—hue, value, and chroma—was, he asserted, like trying to select a carpet knowing only that the room was 8 feet wide and 10 feet high.[46]

To sell printers on the Munsell method, Allen often recounted the story of one devoted user, Frederic G. Cooper, a well-known illustrator for *Collier's Weekly*, *Life*, and *Saturday Evening Post* and the creator of the New York Edison Company's famous "Edison Man." In 1915, Cooper had designed an advertising poster for the Maryland Telephone Company and had telegraphed color instructions from his California studio to New York. No color sketches were ever sent to the Philip Ruxton Company, to the engraver, or to the printer. At every stage of production, Munsell Color System notations—for example, "red 55, blue green 55, gray at 50 value"—were used in the telegrams. When the Maryland Telephone Company poster turned out well, Cooper adopted the Munsell Color System for all of his work, including advertisements for New York Edison and for the American Tobacco Company. The printing business, one of the largest industries in America, was on its way to becoming a dedicated user of the Munsell Color System.[47]

No More Windmills

Munsell had spent a dozen years inventing a color system and promoting its use in schools. As a professor of drawing, he naturally saw art teachers and their students as the target audience, but his uphill battle with educators contrasted with the warm reception he received from textile managers, retailers, psychologists, engineers, graphic artists, and printers. Toward the end of his life, Munsell began to wonder if he had been tilting at windmills.

For a number of years, Munsell had been dissatisfied with the lackluster marketing efforts of Wadsworth, Howland & Company and had been seeking another partner who would "create a good demand and properly supply the market." He revisited Edward Lord at Scribner's and approached Milton Bradley, but both turned him down. Josiah B. Millet, head of the Boston publishing house J. B. Millet, urged him to set up his own company, complete with "two expert travelling agents" and "an office with bright tasteful secretary to show the system." After Munsell reconciled with Bailey, they

talked about marketing a color line, but nothing came of it. Munsell remained suspicious, writing a diary entry that unflatteringly compared Bailey to the populist politician William Jennings Bryan.[48]

Meanwhile, Munsell's friendship with Arthur Allen grew stronger as the younger man built his reputation in the thriving New York printing industry. In 1916, Allen was appointed to the board of the American Institute of Graphic Arts, a new club for professionals in advertising, illustration, printing, and publishing. Allen drew Munsell into his circle, introducing him to Ray Greenleaf, an illustrator with a passion for color. During World War I, Greenleaf would design posters for the Division of Pictorial Publicity, a government propaganda bureau, and in the 1920s he would play a prominent role in the New York advertising industry as art director for the Ward & Gow agency and as co-founder of the Art Directors Club. The careers of Allen and Greenleaf pointed to the future of advertising, illustration, printing, and publishing and to the new field of commercial art.[49]

Munsell marveled at the changes that swirled around him as his retirement approached. After he quit full-time teaching, the aging colorist lectured widely in Europe, enjoying friendly receptions in London and Paris. His excursions, however satisfying, extracted a toll, and he was hospitalized with pneumonia in London. Back home, his health continued to decline, and late in 1916 he suffered a "rheumatic attack." The time had come for him to find a way to continue his mission after his death.[50]

In March of 1917, Arthur Allen proposed a company to "push the commercial side of the color system." Printers would be the major customers for a new "color filing cabinet" filled with standard samples that could be used throughout the publishing industry. Time was growing short. In April, Munsell gave up his Back Bay studio and sadly watched his healthier contemporary John Singer Sargent move into the space. In May, he was operated on for appendicitis and was "not expected to survive." Charles F. Perkins, the attorney who had advised Munsell on patent law, was called in to draw up the legal papers for the new firm.[51]

The A. H. Munsell Color Company was incorporated in Boston in February of 1918, a few weeks before the inventor's death. Its chief stockholders were Albert Munsell, Arthur Allen, and Ray Greenleaf. Wadsworth, Howland & Company was given oversight of the educational market. Allen and Greenleaf opened a commercial office in New York, adjacent to the Philip Ruxton Company's showroom. Eventually the company moved back to Boston and was reorganized at the Munsell Color Company, with full control in the hands of Albert Munsell's heirs. Son A. E. O. "Alex" Munsell became president in 1921 and, during the next few years, reoriented the firm around his interests. In the spring of 1923, the manufacture of Munsell crayons was turned over to the Binney and Smith Company, makers of the Crayola brand, and the production and distribution of other school supplies to Favor, Ruhl and Company, one of the original distributors. The son established the Munsell Research Laboratory in Baltimore, close to the Bureau of Standards, to continue research on a simple, practical

system of color notation. But by the mid 1920s, A. E. O. Munsell's interest in science and scientific measurement had all but supplanted the original goal of advancing color education in the industrial arts.[52]

The Omnivore's Dilemma

As the modern era eclipsed Victorian culture, the industrial-arts network that had sustained Munsell for 60 years entered its twilight years. The art industries continued to produce stylish furniture, tableware, fabrics, and clothing, but the drive for bigger, better, and cheaper consumer products steamrolled over some segments of the creative economy. The forces of modernization had begun to create a new economic order wherein the practical man mattered less than the college-educated professional. That shift would affect color practice in the twentieth century.

In the tradition of the practical man, Albert Munsell had invented his color system by drawing on everything within reach. His confidants had included scientists (such as Ogden Rood) and fellow artists (among them Denman Ross). In the end, Munsell had more in common with the Victorian physicist-artist Rood than with the modern art theorist Ross. What began as a warm friendship between two sketching companions was smashed against the cliffs of modernity. Ross' stance on color as "*personal*" and subjective grated against Munsell's theories of "*impersonal*" shades that were "fixed scientifically." In one of their final exchanges, he told Ross that "Science does not accept personal bias" but that it "wishes measures." He then proudly pulled out his trump card: "[T]he five middle colors are at the Bureau of Standards."[53]

The omnivore's approach—Munsell's combination of science and art—became untenable. In 1900, the historian Worthington Ford had praised Munsell's appetite for knowledge and the universality of his invention: "You put a scale into the hands of everybody. The architect and designer can no longer claim exclusive estimates. It is like the interchangeable parts in machinery, a universal scale. What atomic weights have done for chemistry—this will do for color."[54]

The Munsell Color System did indeed have an effect, but not of the sort the inventor had anticipated. After the inventor's death, his son A. E. O. Munsell took the company in a new direction. Very much a man of the twentieth century, he acknowledged the move toward specialization and the necessity of doing scientific research under controlled laboratory conditions. Whereas Albert Munsell had talked to artists, designers, businessmen, physicists, and psychologists, his son almost exclusively allied himself with the new field of color science, a field in which researchers were more familiar with colorimeters than with crayons. At the Munsell Research Laboratory and at the National Bureau of Standards, color became a proxy for the pursuit of pure science. Measurement for the sake of

measurement became the goal. The Munsell Color Foundation, created in 1942 to promote color education, also stressed the scientific nature of the Munsell Color System.[55]

The technical focus of the Munsell Research Laboratory and the scientific mission of the Munsell Color Foundation left commercial color management open to innovators in the older art industries and in the new technology-driven industries that emerged after World War I. Printers continued to use the Munsell Color System, but other industries, driven by internal imperatives, developed their own color tools. Industry-specific rather than universal standards permitted textile mills to communicate their specialized color needs to suppliers and to customers. The eradication of "punchy" styles, the "improvement" of consumer taste, and the dissemination of refined aesthetics mattered less than containing the color chaos that resulted from a lack of planning in design, branding, and merchandising. World War I brought these practical color needs into focus, and as we'll see in the next chapter, led the fashion industry to create a unique trade organization dedicated to the scientific management of color.

3 Nationalism

World War I forever changed the global political and economic landscape, turning the United States from an isolationist nation to a leading world power. Previously, American industrialization had paralleled that of Germany, with both countries trailing behind Great Britain. Although the United States did not join the Allies until April of 1917, the outbreak of hostilities in August of 1914 affected domestic manufacturing and international trade immediately. Shortages of European imports forced American industries to develop new alliances, skills, and technologies.

With respect to color, industry and commerce coped with the crisis in a variety of ways. Albert Munsell had dreamed of universality for his color system, but American industry had different needs. The uneasy symbiotic relationship with Europe, now shattered, was replaced by an intense American color nationalism. Color reformers fused patriotism and efficiency as they wrestled with wartime challenges. Dye houses experimented with the complex chemistry that yielded synthetic colorants. Artists refined their color skills as they designed posters for propaganda agencies or served as apprentices to French camoufleurs on the Western Front. The style industries compensated for the lack of French shade cards by establishing the first American color forecasting group, the Textile Color Card Association of the United States. The TCCA introduced two new color-management tools—the Standard Color Card of America and the seasonal forecast—that were tailored uniquely to the American mass market. This chapter and the next explore how these wartime innovations in art and industry laid the foundation for the color revolution of the 1920s.

Made in U.S.A.

Soon after Germany invaded Belgium, the *New York Times* reported American industry's widespread fear of a "dyestuffs famine." The American love of brilliant colors with

"punch" was jeopardized. Worried manufacturers offered large sums of money for German chemicals already in port, but sagacious observers urged caution "in the face of the possible shortage of colors" for textiles, paint, papers, and leather. Though the famine did not materialize until 1915–16, the early panic testified to America's dependence on foreign synthetic chemicals. The United States had a substantial chemical industry, but this manufacturing sector focused on extractive processes rather than on synthetic reactions. A few dye plants dotted the northeast corridor from Brooklyn to Philadelphia, but large German companies supplied 80 percent of the dyestuffs in America.[1]

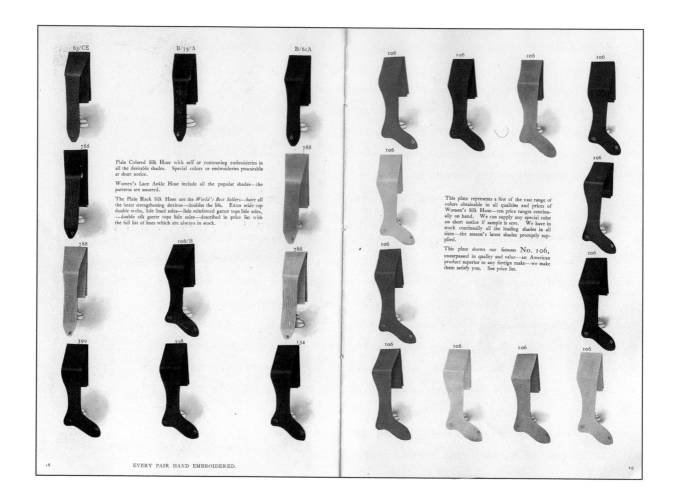

3.1 "Punchy" silk stockings shown in a 1908
Lord & Taylor brochure for Onyx silk hosiery.
Hagley Museum and Library.

The full story of the rise of the American synthetic chemical industry has been told elsewhere, but a few points are worth revisiting. The Trading with the Enemy Act authorized the Alien Property Custodian to confiscate German patents and put them up for auction. This gave American companies access to the intellectual property behind "the Hun's" technological might. E. I. du Pont de Nemours & Company and some other firms sold war materiel and channeled their profits into synthetic organic chemistry during the 1920s. In a scene reminiscent of a spy movie, DuPont smuggled some organic chemists out of Germany, paying handsomely for their expertise. The new laboratories and marketing offices focused on novel products, including dyestuffs, plastics, man-made rubber, rayon, and nylon. By 1926, the domestic dye industry, which before the world war had met 13 percent of the U.S. demand, was meeting 93 percent of it. Driven by necessity during that war, the American chemical industry became a technological leader.[2]

Across the country during World War I, advocates of self-sufficiency rallied under the "Made in U.S.A." banner. By the late summer of 1914, shopkeepers prodded manufacturers to produce substitutes for German, French, and English goods by putting "Made in America" signs in their windows. Concerned business leaders in disparate industries incorporated the Made in America Products Association to manage a national advertising campaign fostering patriotic consumption. "If we get our citizens accustomed to asking for and using American-made goods, this country will soon be virtually independent of the foreign markets," a spokesman told the Wall Street Journal. "This will mean that millions of dollars that formerly went abroad each year will be spent at home. The workshops will kept busy and the entire country will share in the prosperity resultant from this movement."[3]

The fashion business was familiar with the Made in America idea before World War I. In 1909, New York apparel manufacturers had lobbied for greater attention to native ingenuity. The head of the United Ladies' Tailors' Association of America "announced himself a foe of the Empire and sheath gowns" (two avant-garde haute couture styles) and urged New York to assert its independence from Paris. Between 1909 and 1912, the Ladies' Home Journal, the nation's leading women's magazine, ran an "American Fashions for American Women" contest. Challenging the mystique of Paris, the Journal's editor, Edward Bok, invited his middle-class readers to engage their "New World cleverness" and create dress designs for the American context. In 1912, Bok publicized his viewpoint in the New York Times. The Times' own campaign for homegrown styles inspired other newspapers to promote the idea of American fashion. After these efforts fizzled, the Los Angeles Times blamed the snobbery of society ladies: "American women had to have garments with a Paris label."[4]

Early in the war, the Los Angeles Times saw an opening for American clothing manufacturers and implored them to take action. In L.A., the "heads of the great stores" that normally carried European

merchandise set an example by rushing "their buyers to New York to get American made goods, dresses and fabrics." The L.A. newspaper's upbeat beauty columnist, Madame Ise'bell, wrote that "if the seat of fashion must leave Paris" it was destined to move "westward to these shores": "America, with its growing knowledge of esthetics, with its mixed population, is the logical successor of Paris as the world's center of feminine industries."[5]

At the same time, a patriotic flame sparked atop the social pyramid, lit by shakeups at the Paris couture houses and the shuttering of *Gazette du bon ton* and other fashion magazines. In Chicago, the Illinois Federation of Women's Clubs, normally preoccupied with social-welfare issues such as child labor and public health, endorsed a proposal for "simple, becoming, and modest designs" made in America. On the East Coast, *Vogue*'s publisher, Condé Nast, and its editor, Edna Woolman Chase, put their weight behind New York dressmakers by enlisting high society's endorsement of a Fashion Fête at the Ritz-Carlton Hotel that featured local talent and raised relief funds for Europe. However, when the couture houses of Paris reopened in 1915, *Vogue* and the socialites dropped their support for New York designers. Among the producers of American fashion, shortages of materials and other troubles created opportunities and spurred patriotism. The veteran textile marketer M. D. C. Crawford, now design editor of *Women's Wear*, encouraged Americans to seize the moment and "inaugurate, so far as textiles and costumes are concerned, our artistic freedom."[6]

The silk industry, located on the East Coast close to its major markets, was one hotbed of nationalism. Traditionally, silk mills made sewing thread; grosgrains and moirés for trimmings and millinery; linings for shoes, leather goods, and coats; and broad dress silks for frocks, shirtwaists, and petticoats. During World War I, consumers wore more silk apparel than ever before, all sewn from yardage woven in the United States. Even before the war, silk had ceased to be a luxury fabric, and ready-made silk clothing was becoming more readily available. A craze for ballroom dancing that had swept across America in the early 1910s had helped to popularize silk dresses, petticoats, bloomers, and colored stockings like those worn by the dancer Irene Castle. Castle, who toured the country with her husband Vernon, wore loose, flowing skirts that permitted jaunty steps. Her elasticized corset permitted easy movement, while lightweight silk fluttered gracefully over her slim limbs. Castle's celebrity put avant-garde designs by the British dressmaker Lucile in the public eye and created interest in the new soft styles. Up and down the social ladder, women aspired to own at least one silk dress.[7]

World War I brought unprecedented prosperity to silk weaving and knitting mills, whose looms ran at full capacity. As woolen and cotton fabrics were directed into the military, importers continued to acquire Chinese and Japanese fibers duty free. The United States' consumption of raw silk rose from 36 percent of the global output before the war to 65 percent afterward. The silk center of

Silk is at once the most practical and most patriotic fabric for you to wear, so says Mrs. Vernon Castle in this demure frock of Corticelli "Gilt Edge" Poplin.

"It's perfect for an afternoon dress or suit," says she. And the absolute testimony to this is the dress itself—with its long swinging tunic, the straight plaited skirt, the vestee of organdie—and the jaunty Eton Jacket. The corsage and tunic are exquisitely embroidered.

For satin in a soft weave, rich and lustrous, there is Corticelli "Satin Patria." You will like it for dressier styles, as well as for practical frocks.

You will find Corticelli Dress Silks in your own town or city. If your store has not a complete exhibition of the newest Corticelli Dress Silks, please write us. Address Corticelli Silk Mills, Florence, Mass.

3.2 Irene Castle, depicted in *Lessons in Knitting and Crochet, Book no. 8* (Nonotuck Silk Co., 1918). Hagley Museum and Library.

Paterson, New Jersey—established as the "Lyon of America" after the Civil War—saw sales triple between 1914 and 1919. Innovative firms introduced products for the culture of scarcity. Professional dressmakers, home sewers, and the ready-to-wear industry adapted the styles to these new fabrics. Practical sports silks, for example, were substituted for the lightweight woolens normally used in women's tailored suits. Restrictions imposed by the dye famine and military requisitions resulted in subtle colors such as champagne, Egyptian blue, and cranberry.[8]

In October of 1914, the annual Paterson Industrial Exposition and the National Silk Style Show adopted the "Made in America" theme, featuring gowns designed by local designers and made of local fabrics. Apparel retailers lauded the effort and predicted that the war would help Americans "realize that just as good styles and materials could be obtained in this country as in Paris or other foreign places." Individually, the mills touted American silks as the world's best. In 1915, H. R. Mallinson & Company, whose high-end products were exported to the Paris couturiers before the war, participated in a group promotion of "American designed models of American made silks" featuring the newest designs by Lucile—who had relocated to New York—in all-American fabrics.[9]

The nationalist mood also infected other parts of the textile trade. Department stores, the major retailers of dry goods, featured silk departments (sometimes more than one per store) in high-traffic locations. Women shopped for materials to use in interior design projects or as trimmings for hats, and for fabrics for clothes to be sewn at home or by a local professional dressmaker. The National Retail Dry Goods Association urged department stores to stock American textiles and to educate shoppers to "buy American." The president of the American Association of Woolen and Worsted Manufacturers denounced "imported" labels and encouraged companies to use the press to slant public opinion in favor of domestic fabrics.[10]

The color patriotism that took hold in the silk, millinery, and woolen trades was sparked by the disappearance of French shade cards. Silk depended "almost wholly upon color" for added value, and the European colorists' failure to "send over the information as usual" had seriously hampered design in the United States. In August of 1914, one of the major American dye houses announced a plan to "make a color card of its own," but little came of that solo effort. Instead, the Millinery Jobbers' Association, a trade group for hat distributors, toyed with "designing an American color or shade card." As word spread, jobbers around the country, already versed in "American Fashions for American Women," expressed their support for "the syndicating of colors." Paterson's silk makers joined together to plan an interim spring card that would "break the ground for a broader effort in getting up a color card for the Fall in co-operation with the Silk Association of America." Late in November, interested parties met at the Silk Association's Fifth Avenue offices to discuss "the question of an American shade card for next Fall . . . so that the manufacturers in this country may no longer be dependent for such color guides on foreign creators." A few days later, in Paterson, they voted to

solicit opinions "from silk manufacturers, designers, printers, and the garment trade regarding the colors which should be shown in an American color card."[11]

In December of 1914, ships carrying color cards from La Chambre Syndicale des fleurs et plumes, distributed by J. Claude Frères, dodged U-boats and arrived in New York. Brooding and worried, the American fashion industry criticized French color hegemony by complaining about the lack of originality in the 84-shade palette. The absence of "the popular sand and putty colors" was lamented, and some claimed that the tans on the Claude Frères card were "not of the character that the trade believes will prove in demand." There was a "wide divergence" between the French forecast and what the American "millinery and ribbon trades will show during the coming season." The dyestuffs situation already pointed to a spring palette of subtle hues that could be created by stretching out German supplies or by experimenting with primitive American products. New York was abuzz with plans for wartime colors such as Belgian blue, khaki, cherry red, and sand, none of which appeared on the French flower and feather shade card. Claude Frères was expected to import its silk card just after the start of the new year, but further delays and obsequious apologies fueled the rising tide of color nationalism.[12]

American Color for the American People

There exists today thousands of "off-shades" resulting from the lack of guidance by expert color men. It was one of the tasks of the Standard Color Card Association to separate from the multitude of off-colors and shades "the real thing" as near as human can produce it, name it, give it a distinctive number, and publish it.

—*American Silk Journal*, 1915

A divorce from Paris occurred when a new trade association was established to manage the flow of color information among American manufacturers and retailers. The prime mover was Frederick Bode, president of Gage Brothers and Company, a wholesale milliner with a factory in Chicago and offices in New York. Born in Prussia in 1856, Bode had emigrated at the age of 15 and, discovering a talent for sales, had worked his way up the millinery business until 1892, when he purchased a major interest in the venerable Gage Brothers firm. A faint German accent hinted at Bode's origins, but he loved his adopted land. Although Gage Brothers was the largest hat importer in the country, Bode took pride in setting American millinery trends. Under his auspices, the company employed the "best talent in the way of designers and makers" to produce "hundreds of new styles and creations" a day.[13]

Known for his "abundant tact" and "unfailing good humor," Bode inspired and motivated his colleagues by citing the chaos of recent months. "Shades in various lines were matched with much

difficulty, for the reason that the French color card failed to arrive" on schedule, suggesting that it was time for the Americans to take charge and determine "what the shades of color would be from season to season." Bode found allies among New Jersey textile men, including John Love of Forstmann, Huffman Company (a worsted mill in Passaic), Carl Forsch of Pelgram and Meyer (a silk mill in Paterson), and Adolph Müller of the National Ribbon Company (also in Paterson). With these like-minded souls, Bode founded and directed the new Textile Color Color Association of the United States, an umbrella organization for firms and trade groups that wanted to overcome uncertainty and practice self-determination in color. Its patriotic message was "American Color for the American People."[14]

The first project of the TCCA was the creation of a Standard Color Card of America. While the German handbooks advertised a single firm's dyestuffs and the French cards interpreted Parisian trends, "the Standard" (as it was widely called) was a document of the basic colors that were needed to make apparel and accessories that would sell at a popular price in the U.S. market. A fold-out book of silk ribbons, it illustrated, named, and numbered those staple colors and served as a guide to chromatic archetypes for product design, manufacturing, wholesaling, and retailing.

The Standard Color Card of America was a product of a Progressive-era business culture that valued cooperative idealism. Inefficiency and waste were to be eradicated from production and consumption, and color was no exception. The TCCA augmented this ideology with a patriotic desire to supplant Parisian dictates with designs created in the United States. Its goal were to record the colors of everyday fashion and to distribute this information widely, in line with the Taylorist belief that experts had a moral obligation to devise cost-effective practices that would benefit the common good. The noble dream of universality reflected the social objectives of Taylorism's most powerful tool, the standardization movement. In the parlance of the day, "standard" was synonymous with "model" or "archetype," and "to standardize" meant to achieve a high degree of excellence or to make a product to a high level of quality. A factory or a store that adhered to standards could provide value at a competitive price, advancing the progressive goal to raise the standard of living. In the style industries, this had to be done without aesthetic compromise.[15]

In many ways, the Standard was a belated solution to the New England Cotton Manufacturers' concerns, voiced to Albert Munsell, about the paucity of good color tools. "Colors had run riot," a writer explained in the *New York Commercial*, and "the work of the dyer and the manufacturer was anything but easy." Wasteful mismatches occurred when woolen mills and trim makers separately selected colors from one of the numerous European cards. Each imported card showed a different set of reds and a different set of greens, and fancy names added to the confusion. There was no coordination across firms, materials, and industries, and no effort to accommodate American tastes.

"American conditions differ from those in Europe in that our manufacturers seek quantity production," a spokesman for the TCCA told *Women's Wear*. This made it "desirable that we follow a limited line of best shades rather than a large line of good shades." The unique conditions of the mass market, the *Color Trade Journal* seconded, have "doomed the European system for use in this country."[16]

The creative process behind the Standard was as radical as the idea itself. The final palette emerged from within a pyramid, with users at the base, an expert panel in the middle, and Frederick Bode at the top. French shade cards were designed by "one or two individuals or firms," and French luxury colors were chosen by Paul Poiret and other haute couturiers as an exercise in brand building. "No one man can have the final say whether or not a color shall be accepted," explained the *Color Trade Journal*, "but to the contrary many manufacturers are asked for information, and each shade proposed must pass the critical examination of the board of experts." "Never before has this selection been made in quite the same way," one Maine newspaper explained. "Here every interest using color contributes to the information and the final selection."[17]

Color reports from across the country provided the raw material. In February of 1915, the *New York Herald* asked "those having battle ship gray" to share samples with the TCCA, which was "struggling mightily with the matter of shades and tones." The TCCA also asked about two dozen manufacturers to provide samples of basic colors as they appeared in nature—in jewels, minerals, flowers, fruits, and metals. Twenty-three companies sent packages filled with skeins and swatches of popular colors. Sorting through them, the TCCA found 50 examples of navy blue, 23 of white, and countless other mismatches. This discontinuity suggested the extent of the problem.[18]

A seven-expert committee brought "experienced color discrimination and judgment" to this morass. Each of the volunteers appointed by the TCCA's directors had a long career in the style industries and knew his trade thoroughly. There were four representatives of manufacturers: George B. Veit of Veit, Son & Company (a manufacturer and importer of hats and fashion novelties), Arthur N. Decker of L. & E. Stirn and James Gowans of Sidney Blumenthal & Company (both East Coast silk mills with sales offices in New York), and Albert L. Gifford of Worumbo (a Maine woolen mill that had a New York presence). These men understood production economics, distribution costs, and the common color concerns of the textile industry. The other three members of the committee were dry-goods buyers for major New York department stores: James A. Marin of Lord & Taylor, Harry Maurus of B. Altman & Company, and William J. R. Frutchey of John Wanamaker. Working at the intersection of production and consumption, these buyers knew the marketplace and the color combinations that appealed to shoppers. Frutchey, who had been at Wanamaker since 1886, spent much of his day thinking about staple shades and trendy tints.[19]

The directors of the TCCA, by virtue of seniority, had final say over the Standard. In fashion, the details mattered, and there was no substitute for the long view. The expert committee contemplated the basic palette, taking the mountain of skeins as a starting point. They eliminated 2,000 off-shades (including 47 of the 50 examples of navy blue) before recommending the basic palette to Bode and the other directors. When the old guard argued that Old Rose, Ivory, Cream, Flesh, Sage, Pearl Gray, and Turquoise should be included in the Standard, the committee knew it would be prudent to listen. The pyramid design process, which gave voice to users, experts, and directors, minimized the guesswork and reduced the risk.[20]

The Standard Color Card of America, introduced in June of 1915 and priced at one dollar, created a common language and a universal tool for coordinating production, distribution, and merchandising in the textile, millinery, and apparel industries. Everything about it demonstrated the American desire to increase efficiency and "free this country from foreign domination." It showed the 100-plus basic shades that accounted for "75 percent of the color consumption" in the United States. Whereas the French numbered their colors in rotation, the American card was had key that gave the main color, the different blends, and the strength of the shade. Foreign names were, of course, replaced by American ones.[21]

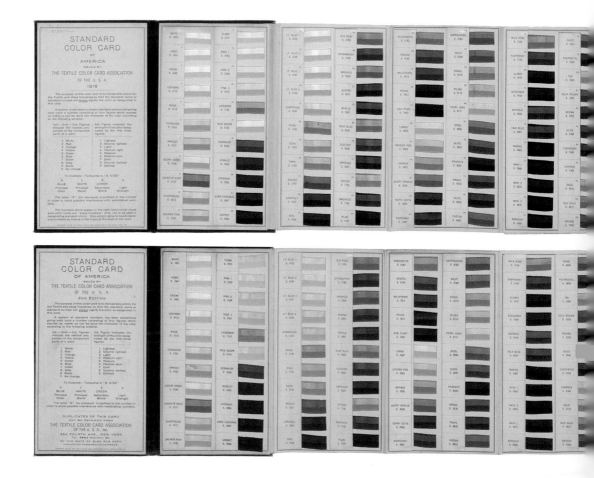

The adoption of the Standard, Frederick Bode asserted, "would mean a great elimination of dead stock, reduction of capital invest[ment], and a more profitable return." If textile mills, garment makers, and retailers fell into step, there would be few miscalculations, less waste, and no need for the French. A department store buyer could take the Standard on factory trips as a guide to use in selecting colors, and an apparel manufacturer could use it to place orders with textile and button wholesalers. One apparel designer told *Women's Wear* how the Standard simplified the "impossible task" of color coordination: "Formerly, after I had designed a dress, I used to hunt around in vain for crepe de Chine, taffeta, buttons, sewing silk and trimmings that would exactly match. Now, however, I simply decide on my color scheme and then order all my supplies in, for example, Ruby S.2604, or whatever the shade may be. That ends my worries and it ends the troubles of the manufacturers, too. They know exactly what I want, and my card assures me that I am getting exactly what I ordered."[22]

Next the TCCA turned to fashion and "the season's whims and fancies." Most ladies' hats were dyed in a basic color, but each year's new hats were trimmed with ribbons, feathers, and bows in new, trendy hues. These variations appealed to consumers who wanted an up-to-date look. Some women purchased their Easter bonnet already decorated, but many loved to browse dry-goods stores for flounce, flowers, and feathers with which to do up their own hats. The TCCA's seasonal color cards,

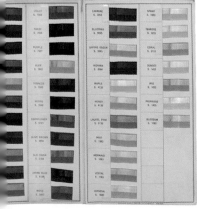

3.3 The Standard Color Card of America, 1915 and 1916 versions. Accession 2188, Hagley Museum and Library.

like their French antecedents, anticipated the new accent colors and stabilized those predictions into a forecast that helped firms keep up with changes. They focused on the small group of colors—a mere 10 percent of those in use—that changed with the seasons while the basic shades endured. Together, these forecasts and the Standard formed a "complete color dictionary for all trades engaged in the making of any part of a woman's costume."[23]

3.4 Advertisement for dyed ostrich feathers, used to add style to ladies' hats. From *New York Styles, Spring and Summer 1914* (Charles Williams Stores, 1914).

Harry Bernard, president of the Retail Millinery Association, described how difficult it was for a consumer to find the right mix of basic and fashion colors in her local dry-goods department. Hat trimming was a creative hobby for thrifty consumers who soaked up fashion trends from store windows, from the *Ladies' Home Journal* and other magazines, and from local newspapers. Poring over trend reports from Paris and New York, women formed definite ideas on how to emulate Mrs. Paul Poiret, Irene Castle, or Annie Russell. "A woman, who is used to building her own individuality into her hats, goes to the trimming department and she selects a shape; she then goes to the material department for taffeta or chiffon, or whatever happens to be in vogue; she then goes to the feather department or the flower department or the ribbon department, and . . . she has all sorts of trouble trying to match these different things. She becomes exacerbated and nauseated. She goes to the artificial light. She looks to see if there is a window, she gathers the daylight, and when she gets through she is in a state of exasperation. She has tried the patience of the salesman and of herself, and when the purchase is completed she is never, never satisfied—and she has good reason not to be satisfied because the shades do not match." This irritated customer would never return to that store; instead she would go to a store that was more in step.[24]

The TCCA's first forecast, the Spring Color Card for 1916, evolved from a "consensus of opinion" among members in the garment, millinery, and dry-goods trades. Created in mid 1915, it focused on fashion tendencies, showing 40 colors for the upcoming season. While the Standard encapsulated popular taste, the forecast had to interpret Parisian chic. By now, the couture houses were up and running, and a new strain of American patriotism heralded French fashion as a symbol of the besieged French nation. This time, besides collecting samples from "as many sources as possible," the planners studied shade cards issued by La Chambre Syndicale des teinturiers; they also studied imported French and Italian fashions and reports from their companies' agents in Paris. Business realities forced the TCCA to swallow its patriotic pride, put aside color independence, and bow to "the other side."[25]

Men in Black

In her 1954 book *It's Still Spinach*, the American fashion designer Elizabeth Hawes commented on gender and dress: "Year in, year out, . . . the adult population of a great country arises and puts on a certain garment without the faintest notion of why they are doing it." Hawes was referring to the Western convention of trousers for men and skirts for women. Clothing plays an important role in the social construction of gender identities. From an early age, people learn what types of garments are "masculine" or "feminine." These gender norms also extend to color.[26]

The advertisement for the Arlington Skirt Manufacturing Company reproduced here as figure 3.5 shows how color and gender worked together in the early twentieth century. A well-dressed man flirts with two young women who try to avoid getting their skirts wet in the rain. He wears the classic attire of an executive. His top hat, pinstriped trousers, overcoats, cravat, and shoes with spats are all black and/or gray; the only color variation in his outfit appears in his brown vest, his greenish gloves, and his red carnation. In contrast, one woman wears an olive-green dress, the other a blue one, and the women's outfits are trimmed in white lace, black ribbons, and colored feathers. The lifted-up skirts reveal pointy boots, embroidered black stockings, and lacy silk petticoats, one pink and one blue.

What were the origins of these conventions of black for men and color for women? In early modern Europe, sumptuary laws dictated type and color of attire, classifying people by rank and social position. Louis XIV upset that system by encouraging the luxury industries to produce lavish clothing for his court. The bourgeoisie and other middling sorts emulated the aristocrats, the men wearing bright frock coats, embroidered silk vests, lacy shirts, powdered wigs, silk stockings, and shoes with big buckles. But in the Protestant countries there was a backlash against French frivolity. English and Dutch businessmen, for example, wore black suits that were seen to befit the seriousness of their convictions.

Late in the eighteenth century and early in the nineteenth, French frilliness was replaced for men by a simpler, darker, more conservative form of dress. Dubbed "The Great Masculine Renunciation" by the psychologist J. C. Flugel in 1930, this radical shift in men's attire was inspired by the sociopolitical upheavals of the French Revolution, but it also had roots in the English struggle for political and cultural power between aristocrats and the rising middle class, dating to the seventeenth century. Later in Regency England, Beau Brummel introduced beautifully cut black waistcoats, white shirts, and silk cravats to his fellow dandies in London's West End, making black a fashionable color for men's evening wear. The dark suit with matching trousers evolved over the next few decades and eventually became office attire. Standing collars gave men a crisp, clean appearance, and elaborately knotted neckties added an air of elegant formality.[27]

In the second half of the nineteenth century, the suit evolved into the form that came to dominate men's clothing, and fashion came to dictate appropriate variations for different occasions such as a weekend stroll or an evening at the opera. In everyday life, middle-class and upper-middle-class men wore suits in subdued tones and textures. In the early 1900s, middle-class men saw the suit as conveying a businesslike seriousness of purpose. Dark suits hid the dust created by coal heating, the manure in the streets, and the dirty urban rain.

For most of the twentieth century, a well-equipped businessman's wardrobe consisted entirely of suits. Many designers and artists who were active in the color revolution adhered to these conventions even as they transformed the look of the material world. The dark suit was the favorite work attire of the camoufleur H. Ledyard Towle, the polychromists Léon Victor Solon and Joseph Urban, and the stylists who worked under Harley Earl at General Motors. Not until well after the social and cultural upheavals that followed World War II would the penguin be transformed into a peacock.

3.5 Advertisement for Arlington Skirt
Manufacturing Company, New York, 1910–1915.
Archives Center, National Museum of American
History, Smithsonian Institution.

France was an innocent babe in comparison with "the Hun." The feared dyestuffs famine became a reality after March 1915, when the British Royal Navy blocked German ships from the North Atlantic. American dyers increased their production of pastels, and the TCCA adjusted. In July, Frederick Bode argued that pale hues were the best fashion choice. His evidence included reports from the Gage Brothers' agent in Paris ("she writes this morning that there is a tendency to lighter colors") and a shipment of 1,000 pastel Gage Hats intended for Atlantic City, Newport, and other seaside resorts. The Gage designers took their inspiration from some basic "Italian shades" and from the yellow hats and yellow sweaters in the windows at Bonwit Teller, an exclusive Fifth Avenue retailer that catered to the carriage trade. The rules of contrast, set in Paris decades ago, were not to be violated, even in the midst of a world war. If pale colors dominated dress fabrics, William Frutchey observed, "just the reverse" should hold for hats. Dark hats would be trimmed in pastels to match the main outfit, and the forecast should reflect this. Bode concurred, but his empathy for the French was short-lived. In a burst of patriotism, he insisted on using the English language in the forecast, borrowing names of flowers from *Color Standards and Color Nomenclature*, a 1912 book by the Smithsonian Institution scientist Robert Ridgway. The French-American flip-flop lasted into August, when the men of the TCCA finalized their forecast and planned for its release before mid October.[28]

In a few months, the TCCA had established the team model of color planning that would be used for the rest of the twentieth century. This model was based on "cooperative associationism," the progressive idea that businesses could set aside their differences and use trade associations to advance the common good. Whereas an avant-garde couturier might make a statement with color, the TCCA's standards and forecasts were designed to reflect existing and emerging trends. Bode, Frutchey, and other fashion intermediaries watched style trends and heeded them. Much of their work was intuitive, but it was based on decades of experience. The TCCA recognized that a revision every few years would be prudent, but this flexibility did not detract from the Standard's usefulness. (The dye crisis made it necessary to update the Standard several times during the world war, as in 1916, when the TCCA decided to include "the pastel shades" in the new edition.) The collaborative process of creation, with its built-in feedback loops, assured users of the Standard's utility in the near future. Meanwhile, the forecasts served immediate purposes.[29]

Chromo-Utopia

After a frenzied start, the Textile Color Card Association settled into a routine, monitoring use of the Standard Color Card of America, issuing seasonal forecasts, and contemplating the future. In view of haute couture's lower wartime profile and the need for more efficient production, the style industries

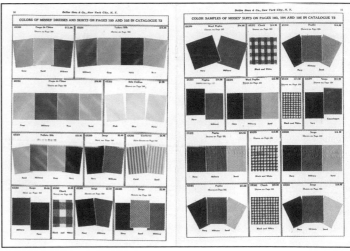

3.6 This 1916 catalog supplement contained swatches in the pale wartime hues as an aid to color selection.

3.7 A selection of wartime colors.

were receptive to standardization; however, the TCCA directors expected that peace would revive old habits. For the Standard to become "standard," the TCCA had to make converts soon. "I should think to establish this card firmly and forever, it has to be done now before the war ends," William Hand of the Paterson silk firm John Hand & Sons noted. "If it is established now, it will stay established." To achieve this goal, the reformers had to cast a wider net. "It is perhaps a Utopian idea that all the trades might be brought in line," Frederick Bode said, nudging his business associates to imagine the possibilities.[30]

This idea of a broader "chromo-utopia" was energized by the growing Made in America movement. In the autumn of 1915, the Unique Suit and Cloak House in Los Angeles, which usually imported Paris couture through resident buyers, was packed with American goods. The window displays had native-made garments alongside "patriotic decorations, such as American flags, muskets, canon [sic] and pictures of patriots." The somber mood and the dire dyestuffs situation were evident in the palette: Field Mouse, Artists' Tan, Moss Green, African Brown. "This is the best season in the history of our business," the Unique Suit and Cloak House's proprietor, Max Isaacs, told the *Los Angeles Times*. "We have sold more and better garments than ever before. . . . We have discovered the possibilities of American genius and must give it due credit." In Washington, political wives showed their support for homegrown designs by creating the Woman's National Made in the U.S.A. League, whose members pledged to "buy American." "Let us . . . make the demand for goods 'Made in the U.S.A.' a permanent demand. Let us never be lured away by the glitter of false gods again. Nations, like people, are like sheep and we will find Europeans clamoring for our goods, too. And then, wouldn't it be great sport to be able to say to Paris, 'I told you so.'"[31]

World War I was a time of high employment, high profits, and rising output, but the market could not always deliver goods at the right prices or in the needed quantities. The federal government looked favorably on economic stability and encouraged cooperation among businesses, trade associations, unions, and government agencies. A modified socialist economy was adopted as a mechanism for allocating scarce resources. The U.S. Food Administration, headed by the energetic engineer Herbert Hoover, asked consumers to reduce their consumption of meat and to grow their own vegetables. Beginning in the spring of 1918, its industrial counterpart, the War Industries Board, had authority to set priorities and fix prices in manufacturing. Two of its principle tools were standardization and the elimination of waste. The War Industries Board set designs for military textiles, limited the number of plow models, and reduced the variety of typewriter ribbons. The war made it fashionable to be economical. Sacrifice, self-denial, discipline, mutual cooperation, and forbearance became watchwords. Fashionable American women who before the war had tried to outdo their neighbors now made do with last year's bonnet. This environment was ideal for the

TCCA. "[T]he time is ripe," Frederick Bode said in 1918, "for us to standardize, stabilize and economize."[32]

Color theories reached the TCCA from elsewhere in the culture. Impressed by one of Alfred Munsell's lectures, Bode saw points of connection between the Munsell Color System and "the theory of a standard card": "He has a plan he has worked out which is quite extensive, and which, I think, will in time prove in the color use the same, as for instance, he claims he can write colors, colors being the sensation of the eye; he can write colors the same as you write music today, which is the sensation of the ear; and his system, by the use of his chart, which, as in music if you strike the note C, there are certain sounds follow which make a chord harmonious. He demonstrates that if you make a color, other colors have to follow." Munsell's concerns with color harmony, Bode saw, had potential ramifications for the textile industry, commission agents, and especially the apparel business: "I think that, too, the Textile Color Card Association may profit by Professor Munsell's ideas as that is in line with standardizing colors." The TCCA's directors attended a lecture by Munsell at a convention of dress fabric buyers and added his books to their library, but Munsell's work remained just one of many influences on their association.[33]

The need to expand the TCCA's membership forced the color reformers out of their comfort zone. The association's modest Fifth Avenue office was in New York's fashion-industry district, with hundreds of potential subscribers nearby. Because the Standard Color Card of America, like most color concepts, was visual, the directors knocked on doors, promotional materials in tow. Bode, who relished the spotlight, addressed the National Retail Dry Goods Association and wrote a pamphlet titled *The Story of the Standard Color Card*. The networking paid off, attracting new subscribers. Manufacturers of cotton thread reduced their inventory of 950 colors to the 100 or so shades of the Standard, and the new National Aniline and Chemical Company labeled its dyes with those names and numbers. The giant American footwear industry, forced to use cloth uppers when leather was requisitioned as war materiel, asked about special forecasts for shoes and hosiery, and the Glove Association too lobbied for special forecasts. Such alliances enhanced the TCCA's visibility and paved the way for other changes.

The TCCA's efforts to recruit the H. B. Claflin Corporation, a large dry-goods wholesaler, was an attempt to reach out to distributors. Claflin sold fabrics made in New England to retailers across the country and to the 35 department stores it controlled, including Lord & Taylor and Hugh O'Neill in New York. This wholesale powerhouse, whose buyers routinely placed orders worth $2 million, was a marketing pioneer that collected national statistics, compared crop yields with sales, and forecast the future demand for dry goods. Knowing that consistency and quality translated into money, Claflin adopted the Standard. "The head of the firm had brought together all of the chiefs of departments,"

said a delighted Bode, "and requested them to order all their goods from the Standard Color Card so they could have harmony in colors all throughout the establishment." H. S. Heitkamp, the man in charge of cotton linings, told Bode: "[W]e are hoping it will spread to the retail dry goods merchant, and then we feel, having these colors, that they will help us in ordering, in the transaction of business." "This will increase the sale of their goods," Bode noted, "which might be unsalable unless the color harmony existed in the general stock."[34]

Some progress was made with influential department stores, whose mail-order divisions competed with old-time jobbers such as Claflin. With enormous buying power, department stores pressured suppliers for good prices, fast delivery, and the best styles. If a buyer from Marshall Field specified a Standard color, the factory manager would insist that the factory's designer follow the buyer's instructions. "The real merit," Bode explained, "is if the demand comes from the purchaser who says, 'I want the color from the Standard Color Card.'" Back home in Chicago, he cajoled the buyers, but adoption would happen only if the front office issued a mandate. Important store executives often came to New York on business, and it was there that Bode met the top man at the retailer Carson, Pirie, Scott. Mr. Pirie promised "to take additional measures to bring the buyers together in Chicago and say to them: 'Now, look here, we want you to order from this card. Adopt it and use it.'" Powerful merchants could generate "propaganda" about the Standard, teaching new audiences to see its value as a restocking tool.[35]

Frederick Bode saw retailers as crucial to success, but, despite the inroads made with Pirie, the going was tough. Department stores had favored ready-made clothing over dressmakers' fabrics for some time, and the war economy helped this trend along. Between 1914 and 1918, the American manufacturing labor force rose from 8.2 million to 10.2 million, and many of the new workers were female. Despite inflation, well-paying war jobs gave women access to a higher standard of living and piqued their interest in stylish merchandise. Consumer pressures encouraged bargain emporiums to offer higher-quality designs. This process created tensions between upscale stores such as B. Altman and newer mass-market retailers such as McCreery's and Gimbels. The TCCA was torn between distinctive Fifth Avenue and discount Herald Square. "I have an appointment with Mr. Straus of Macy's to talk to him about the card, to have their firm adopt it," Bode told his fellow directors. "Of course, if they adopt the card the probabilities are then that the Fifth Avenue houses would not adopt it." As modernization democratized consumer culture, the elite stores closed ranks in their quest for distinction, isolating color reform from a major source of prestige.[36]

By early 1918, the TCCA's 230 subscribers, each paying a $25 annual fee, demanded more up-to-the-minute news. When the Claude Frères cards reached New York, the silk men frowned on the light, washed-out shades. A French dye famine was responsible for the dearth of bright tones, which

Americans had learned to associate with spring and summer Paris fashions under Paul Poiret's influence. A three-man color patrol was assigned to monitor New York fashion trends and to compile a monthly style bulletin. This color service, like the Paris style bureaus, provided advanced fashion news that subscribers could share with their customers. "We will be able to notify the out-of-town retailers," Albert Gifford of Worumbo noted, "of the color that is running well," long before the press. "As the ideas develop," Adolph Müller of the National Ribbon Company ventured, "we will say, 'This color is strong.'" The bulletins provided a spontaneity not captured by the Standard or the seasonal forecasts, keeping members abreast of radical departures such as fads ignited by a Broadway play or rations imposed by the War Industries Board. Step by step, the TCCA learned that fashion and immediacy one-upped the Standard, lent esteem to its expertise, and attracted more subscribers.[37]

The guest list for the TCCA's annual Waldorf-Astoria luncheon in the autumn of 1918 showed that its scope was widening. New members from the textile industry included Henry Creange of the Cheney Brothers Silk Manufacturing Company and H. Schniewind Jr. of the Susquehanna Knitting Mills. (Schniewind was also president of the Silk Association.) There were attendees from DuPont, from National Aniline, and from other dye makers. From the New York garment industry there were Ralph Applebaum of King & Applebaum, Samuel Lerner of the Lerner Waist Company, and Alfred Son, president of the Dress & Waist Manufacturers' Association. There were journalists and editors from the major women's magazines, including *Good Housekeeping*, *Harper's Bazar*, *Delineator*, *McCall's*, *Woman's Home Companion*, and *Ladies' Home Journal*, and from several New York newspapers: the *Globe*, the *World*, and the *Herald*. E. W. Fairchild, publisher of *Women's Wear*, attended, as did Edna Woolman Chase of *Vogue*. Board member Albert Gifford and John Cutter were proxies for the War Industries Board. The interior design and color consultant Hazel H. Adler, J. Meyer of R. H. Macy & Company, and an assortment of milliners rounded out the guest list.[38]

Fashion seemed like a wild animal, and to tame it the TCCA needed to understand the "woman's viewpoint." By this time, advertising agencies, department stores, and electrical utilities had Women's Departments whose female staffers interpreted the desires of "Mrs. Consumer." It was believed that color blindness was unique to men, and that women were better at perceiving differences in color. Frederick Bode knew firsthand that a woman with business acumen and color smarts could produce results. In 1909, he had married Esther Ellen Simpson, considered "one of the first business women" in Chicago; the romance had blossomed in the Gage building, where Simpson worked as the *madam* (which in common parlance referred to "the manager of the French section of a wholesale millinery house"). And by early 1918, Margaret Hayden Rorke, an actress from Brooklyn and a suffragette, was working in the TCCA's office. Soon the poised Mrs. Rorke had made inroads at the Retail Research Association, had met the head of Emery & Beers Company (maker of Onyx hosiery),

and had ingratiated herself with New York retailers as different as Stern Brothers, Saks & Company (predecessor to Saks Fifth Avenue), and McCreery's. Impressed by this articulate, accomplished "New Woman," the directors of the TCCA appointed her managing director in October of 1919. Over the next four decades, Rorke would take the TCCA through boom, bust, war, and recovery, finding new color opportunities at home and abroad.[39]

An American Idea

Women's Wear got straight to the point: "'Standard Colors' is an American idea." "American ingenuity has captured color, the vague and elusive," echoed the *New York Evening Sun*, "and reduced it to a scientific code." Based on French prototypes, the Standard Color Card of America owed much to American businesses' emphasis on efficiency and scientific management. Its creators had focused on the distinctive color requirements of the United States. They had borrowed selectively from European practices, fusing Old World ways with new American needs. The birth of the Textile Color Card Association in the Progressive era, and its commitment to disseminating information for the betterment of society, distinguished it from European producers of shade cards. Only in America did a trade association determine the basic colors and circulate data among competitors for the sake of better business practice. Only in America did collaboration among experts generate fashion forecasts that could be applied across a broad range of style industries.[40]

Wartime nationalism made color management a tool for use in the industrial arts and a shield against European domination of synthetic chemicals, modern design, and fashion. The TCCA steered away from haphazard measures and introduced more reliable alternatives: standardization and forecasting. The success of "American Color for the American People" was rooted in universality and diversity, a combination that would nourish color practice in the years ahead. "We must not allow our imagination or artistic temperament to stagnate, but must offer sufficient latitude in which to indulge its fancy," said Frederick Bode. "We must encourage our Artists and take advantage of their inspiration to assist in creating a color atmosphere typical of the United States." Bode's interest in the ideas of Albert Munsell foreshadowed the type of thinking that would expand design reform into a broader color revolution. That revolution, in a fitting tribute to the TCCA's founders, saw few restraints or boundaries. In the 1920s, color management became a focal point for advertising men, product designers, modernist painters, and classical musicians who strove to create, in Bode's words, "an American color atmosphere."[41]

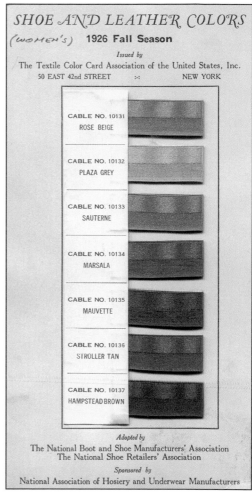

3.8 Margaret Hayden Rorke. *Woman's Journal*,
October 1929.

3.9 Rorke's forecast of *Shoe and Leather Colors*
for fall 1926. Accession 2188, Hagley Museum
and Library.

4.1 A portrait of the fighter pilot Edward Vernon "Eddie" Rickenbacker painted by the young Impressionist H. Ledyard Towle in 1919. National Portrait Gallery, Smithsonian Institution.

4 Hide and Seek

"American artists, join the camouflage!" exclaimed H. Ledyard Towle in the *New York Times* in June of 1917. Towle was a prime mover in the Camouflage Society of New York, a civilian group formed to mobilize visual artists for national defense. "Camouflage" (a French word meaning "puffing smoke") referred to techniques developed on the Western Front to conceal men and materiel from the enemy. Trained as a portrait and landscape painter, Towle helped the U.S. Army to recruit and train artists in "the great game of hocus-pocus" and eventually went to France as a machine gunner and front-line camoufleur. Such experiences turned fine artists like Towle into masters of illusion and prepared them for future jobs as commercial colorists.[1]

Towle's remarkable "aptitude for color" and his "even more satisfying sense of measure" were qualities that suited him well for camouflage and for his subsequent career as America's leading industrial colorist. Born in Brooklyn, he had studied painting at the Pratt Institute and the Art Students League under Frank Vincent DuMond and William Merritt Chase, mastering the Impressionist style. It was from DuMond's extraordinary color sense that he had learned how distance and atmosphere affected visual perception. Towle kept a studio on Forty-Fifth Street and exhibited paintings at the Salmagundi Club and at other New York galleries. His one-man show at the Arlington Art Galleries on Madison Avenue attracted the attention of a critic writing for the *New York Tribune*. This rising star of American Impressionism, the critic noted, "appeals to one chiefly through the glow of his color."[2]

Many other artists also contributed to the American war effort. Graphic designers flocked to Washington to create patriotic posters for Army recruitment, bond drives, and food conservation. Many painters worked for the Merchant Marine, colorizing ocean-going vessels as a safeguard against U-boat attacks; others helped the Army develop camouflage techniques for hiding land targets from German spy balloons, cannons, and

bombers. A camoufleur combined a painter's command of optical illusion with a naturalist's understanding of deceptive coloration. The Impressionists used primary colors and small brush strokes to create a picture that would be perceived as a whole from a distance, evoking a mood, a place, or a phenomenon. Similarly, a camoufleur was a colorist-trickster. "Bear in mind that the sole purpose of camouflage is to deceive the human eye," wrote Everett L. Warner, an artist who colorized Navy ships. "We are, therefore, not interested in things as they *are* but as they *appear*." The trompe-l'oeil concept appealed to the Impressionist in Towle and helped him develop as a visual artist, a teacher, and a color illusionist.[3]

4.2 A poster by the American Impressionist Frank Vincent DuMond. Library of Congress.

Protective Coloration

H. Ledyard Towle's artistic grandfather in camouflage was Abbott Henderson Thayer, a painter who was the first American theorist to explore visual trickery in nature. (See figure 4.3.) Much like Albert Munsell, Thayer was trained in the academic style, having studied at the Brooklyn Art School, at the National Academy of Design in New York, and with Jean-Léon Gérôme at the École des beaux-arts in Paris. Realism piqued his curiosity about animals in their natural environment and led him to theorize on their "protective coloration."[4]

4.3 A stencil used by Abbott Henderson Thayer to show how wild birds blended into their native habitat. From a study folder for book *Concealing-Coloration in the Animal Kingdom* (1909), Smithsonian American Art Museum. Gift of the heirs of Abbott Henderson Thayer.

Signals, Science, and Safety

On September 6, 1898, two trains from the Old Colony Railroad collided at Whittenton Junction, near Taunton, Massachusetts. These evening trains from Boston were due at the crossroads five minutes apart, but the one from Park Square was late. The engineer slowed on approach, but as soon as he reached the switch the headlights of the Kneeland Street train flashed around the curve. The oncoming train rammed into the third car and pushed it off the tracks. One passenger died, two suffered crushed limbs, and ten others were badly cut and bruised. The engineer of the Park Street train had mistaken the glow of a roadside lantern for the white signal that meant "all clear, safe to proceed." In the wake of the crash, the Old Colony Railroad replaced its white caution signals with yellow ones, then found that the new color was mistaken for red or green at a distance.[5]

As rail traffic increased, signal failure was a source of persistent worry. The Railway Signal Association recommended better practices to the American Railway Association, the body that set national codes for the industry. Semaphores were particularly vexing. Their globes and lenses were made from cased glass that could fade in the sunlight and could break when exposed to extreme temperatures. Some engineers had trouble seeing them from a distance, at night, and in bad weather. There was no universal decision on which colors meant "stop," which meant "caution," and which meant "proceed," and mix-ups occurred when the railroads shared tracks.

This "color muddle" was resolved by a partnership of vision researchers, specialty glassmakers, and railroad signalmen. The inspiration was an 1899 speech by Edward Wheeler Scripture to the New York Railroad Club. Scripture, a professor of psychology at Yale University, was an expert in perception whose color-sense tester was used by railroad physicians to check for color blindness. After the much-admired professor lamented the lack of consistency in signals, he was invited to help find a solution.

The invitation came from the Corning Glass Works in upstate New York. No stranger to technical challenges, Corning had made the glass for Thomas Edison's first light bulbs and was now a supplier to the Edison General Electric Company. It was also one of the few glass factories that made signalware, but it was falling behind Kopp Glass, a new firm in Pennsylvania. "We are in a bad mess," a Corning manager wrote. "Instead of getting better, our lenses are getting worse." Kopp improved the formulas for red glass, adding selenium to the batches to make a lens that filtered out most of the spectrum and transmitted a true red that was easier to see. Hoping to get a leg up, Corning supported signal-color research at Yale's Psychological Laboratory. One of Edward Scripture's doctoral students, William Churchill, went to Germany to collect samples of optical glass. Upon his return to New Haven, Churchill ran comparative photometric studies on different lenses and colors. In 1904 he was hired to set up an optical lab at the Corning Glass Works, where he continued to search for glass formulas and colorants that would produce better roundels and lanterns.

William Churchill sought practical guidance from railway signalmen. Debates over the need for color standards had reached a crescendo, and the desperation worked in Corning's favor. The New York firm's optical laboratory became the "mecca" of railroad engineers, who welcomed the chance to participate in color standardization. A committee of the Railway Signal Association worked closely with Churchill, attending field tests and helping to decide on the ideal shades of red, yellow, green, blue, purple, and white. In 1908, the RSA published the photometric specifications of the Corning colors, and within a few years, the Corning-RSA colors became the informal industry standard. Green became the commonly recognized signal for "go," yellow for "caution," and red for "stop." Frazzled engineers would no longer mistake a stray white light as meaning "all clear, safe to proceed."[6]

4.4 Railroad lanterns and roundels, MacBeth-
Evans Glass Company, Charleroi, Pennsylvania,
ca. 1915. Division of Home and Community Life,
National Museum of American History, Smithson-
ian Institution. Photograph by Eric Long.

Close observation of forest animals led Thayer to develop his principle of "counter shading," now called "Thayer's Law." As an artist, he knew how to use shading to create an illusion of three dimensions on canvas. (For example, highlights placed atop a figure fooled the viewer into seeing a rounded surface.) Thayer identified a similar phenomenon in nature, as exemplified by the field mouse. Predators had trouble spotting the rodent because the light washed out the brown on its back and the shadow darkened the white on its belly. Thayer published his findings in the American ornithological journal *The Auk* in 1896, and in the Smithsonian *Yearbook* two years later. His ideas sparked the interest of the British entomologist Edward B. Poulton, and in 1902 the two men co-authored "The Meaning of the White Under Sides of Animals" for *Nature*.[7]

Thayer argued that nature colorized for protection, countering the Darwinian view that privileged procreation or intimidation. He was one of the first observers to identify the two types of protective coloration: *blending* and *disruption*. With blending, the animal resembles the habitat so closely that the two are indistinguishable, as a ruffled grouse in the forest. With disruption, the animal's markings break up the outline-silhouette and render it nearly invisible to predators. Conspicuous in a circus, a zebra is difficult to spot at an African watering hole because its bold stripes obliterate its shape and allow it to blend with the reeds. Thayer's magnum opus, *Concealing-Coloration in the Animal Kingdom*, co-produced with his son in 1909, illustrated these principles with paintings of New England animals in their habitat.[8]

This work on protective concealment coincided with rising concerns about the colors used by the U.S. Navy. The problem came into focus after the sinking of the battleship *Maine*. Popular images of the shattered white ship going down in Havana Harbor symbolized American indignity at the hands of Spain and embarrassed the Navy Department. In 1899, the Navy began painting ships Battleship Gray "on the theory that in such dress they were indistinct against the horizon or even, in misty weather, invisible."[9]

Thayer loathed that color decision. He and a fellow artist, George de Forest Brush, unsuccessfully lobbied the Navy to use counter-shading. In 1902, Thayer and Brush's son Gerome patented a "Process of Treating the Outsides of Ships, &c., for Making Them Less Visible." If the right shades were selected, they argued, an ocean vessel could be made to "appear transparent and to cause the observer to seem to look through it, as if it were not there." Surfaces normally in the sun should be painted in darker shades of white; depressed or shadowed surfaces should be lighter. With this type of "quarter shading" or "compensative shading," a vessel would be nearly impossible to spot, much like a deer in the forest. Thayer and Brush painted numerous ships by this process, but it never achieved widespread acceptance.[10]

Razzle Dazzle

The ships of Theodore Roosevelt's showy Great White Fleet, which sailed from Hampton Roads, Virginia, in 1907, were the Navy's last white ships. Naval engineers looking to update marine paint

technology sought help from Maximilian Toch, research director for Toch Brothers, a New York paint manufacturer. "In 1910," as Toch later recalled, "the Bureau of Construction and Repair of the United States Navy had come to the conclusion that the Battleship Gray . . . did not give good results." Salt water corroded the paint, causing it to absorb moisture and change color. By the time World War I broke out in Europe in 1914, the Navy was using Toch's improved Battleship Gray formula.[11]

The German U-boat threat called for a new approach to colorizing ships. Abbott Thayer continued to argue that Battleship Gray aided the enemy by making the ship an easy target. In August of 1916, Thayer lashed out against the naval authorities for neglecting the "science of appearances" and the tonal qualities of color. "How does it happen," the *New York Tribune* quoted him as asking, "that men who know that their mathematics, gunnery, navigation, etc., have put them beyond the competition of outsiders *in their field* can't take in that the like is also true of the specialists in all *adjacent fields*?" White quarter shading, Thayer insisted, was the best solution. Weren't the superior concealment properties of white confirmed by the fact that lookouts on the *Titanic* had failed to spot the iceberg? "There is only one color that when set up vertical is light enough not to be a dark figure against the sky beyond," Thayer asserted, "and that color is white."[12]

Not everyone agreed. The British maritime painter Norman Wilkinson, a consultant to the Royal Navy, believed that white paint and compensative shading were poor options. What coal-burning ship, he asked, would "retain white paint for more than a few hours?" The smokestacks of a ship on the move constantly belched black soot, and the vessel's silhouette could always be spotted on the horizon. Since it was impossible to prevent a vessel from being seen, the only recourse was to paint the ship in a way that would confuse the enemy.[13]

In October of 1917, Wilkinson proposed the Royal Navy adopt a colorful alternative: "dazzle painting." He founded the admiralty's Dazzle Section, and in 1918 he advised the U.S. Navy Department on the new approach. Once the U.S. Treasury Department's risk experts mandated protective coloration for merchant ships, the North Atlantic was dotted with vessels painted in bold, abstract patterns and bright colors. (See figure 4.5.) Washington authorities stipulated several official color schemes that Navy researchers and artists had devised. The aim was to confuse a U-boat's captain, who had only a few seconds at the periscope to calculate a target's size, speed, distance, and direction. "When he came up again he found that the vessel was taking a course quite different from the one he had figured on, with the result that it was safely out of his reach," explained the ship colorist Alon Bement. "Or it might be so close to him that he came up practically under its bow, and before he could escape he was rammed and sunk."[14]

William Andrew Mackay, an Impressionist artist who had studied under the muralist Frank D. Millet and who oversaw paint schemes for the U.S. Shipping Board, based his dazzle designs on color theory. Around 1912, Mackay was working on the interior of Alva Vanderbilt Belmont's Chinese Tea

4.5 Frederick K. Detwiller, *Fitting Out and Camouflage, Wooden Ship Yard*. Smithsonian American Art Museum, Transfer from the National Museum of American History, Division of Graphic Arts, Smithsonian Institution.

House in Newport, Rhode Island, when he had a "eureka" moment. He began sketching a destroyer in the harbor and returned to find the ship had pulled away. In frustration, he blotted the cardboard with paint until the silhouette disappeared. "What if a real destroyer were daubed over with like colors?" he wondered. "Would it merge in with its background at sea and be lost to the eye?"[15]

Mackay dusted off his copy of Ogden Rood's *Modern Chromatics* and borrowed ideas on the primary colors to devise a new painterly approach to marine camouflage. "Daylight is not of uniform clarity," he told a journalist, but "according to hour and clearness of the air one or another of three dominating colors prevail. The dominating colors are not red, blue, and yellow so long accepted, but red, green and violet. Instead of starting out with gray coats, I use colors bright when viewed near by, colors upon which atmosphere would work metamorphosis as distance increases." By 1913, Mackay was helping the Navy Department create paint schemes for submarines, and by 1917 he was running a school of marine camouflage.[16]

Like Albert Munsell, William Mackay took inspiration from Ogden Rood's diagrams of a spinning color wheel and created one of his own. In the spring of 1917, he impressed the Naval Consulting Board in Washington with a "little machine for spinning various colored discs." He "placed on this machine a disc, the sectors of which were colored successively red, violet, and green in fixed proportions. He spun the disc, and it thereupon blurred into a gray as nearly identical with that of a sea horizon as human vision could register. Then, placing on the machine a disc of alternately green and violet sectors, properly proportioned, he spun it, and the result was the blue of sea water."[17]

Building on this object lesson, Mackay explained how the correct colors could protect transatlantic shipping. "He opposed paint designs which brought in white or gray, on the ground that these colors do not actually appear in nature in the traveled latitudes of the Atlantic; they appear only *in effect*. He ruled out battleship gray on the ground that it gives off a reflected color, and is not an original source of color waves. . . . He analyzed the horizon light into its primary colors and proposed to mingle those colors in a painted pattern that would merge in the distance and become a kinetic source of radiation of the desired shade. He declared that a ship so painted—painted with pigment light, as it were—would tend to merge completely into the marine background."[18]

Mackay's Impressionist color schemes were reported to render ships "as nearly invisible at sea as the art-science of camouflage can make them." The hull and the upper works were painted in an eccentric pattern of bright reds, greens, and violets. From a distance, the ship appeared to have a hazy outline or looked as if it was vibrating. Another dazzler, Everett L. Warner, explained how the eye was fooled by dazzle designs: "The pattern contains dark spots that will blend with a dark shore line, and light spots that match a delicate sky; so that, no matter what the background for the moment may be, the ship's contour will never be seen with perfect definition."[19]

Other dazzle painters one-upped Mackay with bolder, less symmetric designs that looked like Cubist art. Warner preferred a two-color scheme of pale violet and green, placing the deepest tones and largest spaces near the water and putting small, light-colored spots on the upper hull and the rigging. Artistic differences fueled rivalries, but all agreed that optical illusion, created by juxtaposing the right patterns and the right colors, was the best insurance against U-boat torpedoes.[20]

Section de Camouflage

Military chicanery was as old as war itself, as shown by Homer's Trojan Horse and Shakespeare's Birnam Wood, but modern warfare brought new challenges. In the Second Boer War (1899–1902), General Jan Christiaan Smuts painted the equipment of the South African Republic's guerilla forces in "colors that harmonized well with their surroundings." That conflict also introduced khaki, the favorite color of the British imperial forces in India, into general use in soldiers' uniforms.[21]

During World War I, new technologies—zeppelins, airplanes, espionage balloons, aerial photography, long-distance artillery, rangefinders—created a need for more sophisticated terrestrial camouflage. On the Western Front, French soldiers who in civilian life worked as artists, designers, and stagehands applied their visual skills to hiding troops, guns, and supplies. Their imaginative constructions—papier-mâché horse carcasses that hid snipers, dummy targets, counter-shaded guns, spotted trucks—relied on color.

Military air power was still in its infancy, but German aerial reconnaissance over France made defensive camouflage necessary. Early in the war, French artist-soldiers such as Lucien-Victor Guirand de Scévola, Louis Abel-Truchet, and Jean-Louis Forain took it upon themselves to develop methods for hiding big guns and lookouts from German spy planes. Seeing the value in that, the French military authorities created the first Section de Camouflage, which by mid 1917 had more than 1,000 members, some of whom were skilled craftsmen who knew how to build scenery for theaters, hippodromes, circuses, and movie studios. Other members were painters, sculptors, and haute couturiers (among them Paul Poiret). Some women worked in camouflage factories away from the front, sewing nets and painting tarps.[22]

The military audience found Abbott Thayer's theories on protective concealment, "counter shading," and disruptive patterning attractive. French and British camoufleurs admired Thayer's work, and rumors circulated that members of the German high command had read his book. With the guidelines that Thayer provided, it was relatively easy for artists versed in color theory and atmospheric perspective to concoct visual tricks. Artillery pieces, trains, trucks, and wagons were painted in disruptive patterns and shrouded with nets, splotched fabrics, and branches. Canvas, paint,

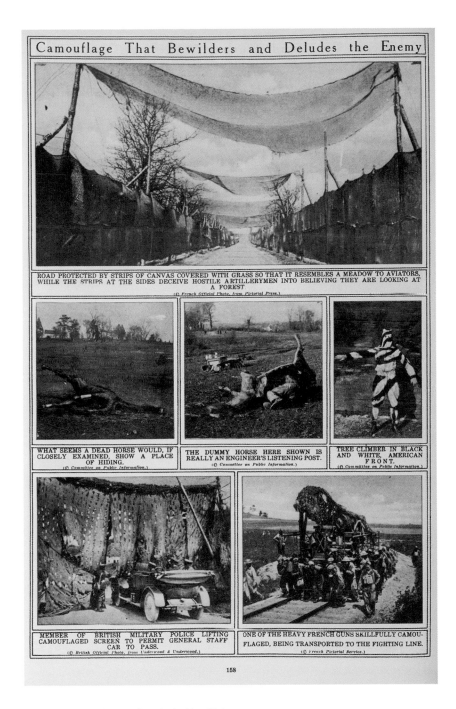

Camouflage That Bewilders and Deludes the Enemy

ROAD PROTECTED BY STRIPS OF CANVAS COVERED WITH GRASS SO THAT IT RESEMBLES A MEADOW TO AVIATORS, WHILE THE STRIPS AT THE SIDES DECEIVE HOSTILE ARTILLERYMEN INTO BELIEVING THEY ARE LOOKING AT A FOREST.
(© French Official Photo, from Pictorial Press.)

WHAT SEEMS A DEAD HORSE WOULD, IF CLOSELY EXAMINED, SHOW A PLACE OF HIDING.
(© Committee on Public Information.)

THE DUMMY HORSE HERE SHOWN IS REALLY AN ENGINEER'S LISTENING POST.
(© Committee on Public Information.)

TREE CLIMBER IN BLACK AND WHITE, AMERICAN FRONT.
(© Committee on Public Information.)

MEMBER OF BRITISH MILITARY POLICE LIFTING CAMOUFLAGED SCREEN TO PERMIT GENERAL STAFF CAR TO PASS.
(© British Official Photo, from Underwood & Underwood.)

ONE OF THE HEAVY FRENCH GUNS SKILLFULLY CAMOUFLAGED, BEING TRANSPORTED TO THE FIGHTING LINE.
(© French Pictorial Service.)

158

4.6 Illustrations of camouflage in the New York newspaper *The War of the Nations*, December 31, 1919. Library of Congress.

paper, plaster, and wood were used to create a facade of death and decay. Behind all the fakery—horse carcasses, deserted cannons, and burned-out trees—were lookouts and snipers.[23]

The illusions baffled German airmen. One Frenchman, "the head of one of the great designing houses of Paris," received the Croix de Guerre avec palmes for his camouflage work at the Battle of the Somme. German planes circled the skies looking for targets. One especially important military road, which stretched across an open field to the front, was closely watched. French camoufleurs painted a cloth canopy to look like a tree-lined road. It worked. For five days, men and materiel passed under the canopy while the German aviators reported "nothing moving on the road from Amiens."[24]

Because early reconnaissance photography was quite primitive, color choices were important in camouflage design. Camoufleurs had to understand how black-and-white cameras interpreted color. A painted cannon that passed visual inspection on land might stand out in an aerial photo. Because photography lightened the cool colors, camoufleurs learned to prefer warm colors, such as brown-green peppered with black and white. The task became more difficult as the Germans adopted color filters. "The time of day changes natural colors at a distance," the *New York Times* explained. "A wood may be green in the early morning, blue at noon, and violet at night. . . . There is a radiation peculiar to each material, and the artist disguising military constructions must be conversant with many laws of optics."[25]

Systemized Disguise

"If the French were ingenious enough to invent it and the Germans to copy it," *Architectural Record* ventured, "it is safe to say that we Americans shall first of all *systematize* it." In the United States, land camouflage moved from a peripheral curiosity to a new military discipline during the mobilization drive. Over the course of the war, universities, volunteer organizations, government agencies, and military bases developed separate approaches. Ideological skirmishes emerged, pitting the hard-nosed scientists of the National Research Council against visual artists working for the Army, the Navy, and the Shipping Board. Despite these tensions, the drive for efficiency distinguished American camouflage from its European counterparts and imposed unity. *Architectural Record* predicted: "We shall make a business of it—not a cut and dried business, but one directed with level reasoning and touch by American humor and inventiveness."[26]

A heady idealism bordering on naiveté inspired some New York artists to organize themselves as *les camoufleurs américains*. After Congress declared war, the sculptor Sherry Fry and the muralist Barry Faulkner planned to assemble colleagues from the American Academy of Design, the Architectural League, the Society of Illustrators, and the Society of Scenic Painters into the Camouflage Society of New York (later the American Association for Camouflage). From his cousin

Abbott Thayer, Faulkner heard that 79 volunteers were eager to help the War Department. Columbia University's president, Nicholas Murray Butler, provided materials, instructors, and a site for a training camp. The volunteer artist corps that initially gathered at Camp Columbia (headed by William Boring, a professor of architecture) grew to 200 members in three cities.[27]

Major General John J. Pershing's appraisal of the Western Front and Professor William Boring's pleas for a systematic study of camouflage got the Army to take the art of concealment seriously. In August of 1917, the Army Corps of Engineers issued a recruitment call for "ingenious young men who are looking for special entertainment in the way of fooling Germans." Major Evarts Tracy, an architect in the reserves, was put in charge of the new Camouflage Corps, formally known as Company A of the 25th Regiment, U.S. Engineers. Like its French counterpart, the U.S. Army needed enlisted men who would follow military discipline for the duration. Fry, Faulkner, and friends flocked to the new Camouflage Corps; tradesmen and artists in other sections transferred into it. Under the veil of secrecy, recruits were sent to Washington for orientation at the Engineer Corps facility at Fort Myer and for specialized training on the grounds of American University.[28]

American camouflage had a steep learning curve, but it built on the successes and failures of the Allies. After perfecting painted colors, the French moved on to master the arts of screening, mimicry, and distraction. The British lagged behind, as the novelist H. G. Wells noted in this stinging comment: "With a telescope the chief points of interest in the present British front in France would be visible from Mars. . . . But the effect of going from behind the French front to behind the English is like going from a brooding wood of green and blue into an open blaze of white canvas and khaki." American camoufleurs had to sort through incoming reports and determine the best options. Some American artillery officers reportedly were "aghast at the idea that yellow and blue and green paint would be slopped on their shining guns." French techniques had to be streamlined, and the new army hierarchy had to be educated. Protective battle coloration was "not merely a matter of daubing paint," wrote the American architect-camoufleur J. André Smith; it called for "the right sort of daubing and the right sort of color."[29]

American efficiency stepped in to rationalize camouflage colors. Camp American University joined with the Signal Corps to conduct a study of film, filters, and lenses. This applied research, much like the Shipping Board's laboratory work on dazzled models, collected practical data that could be useful in the field. "An artificial green which would deceive a naturalist at a few hundred yards might show black under the merciless gaze of the camera," one popular magazine reported. "One of the arts of camouflage is to make certain that the object to be concealed contains all the color values of its background, and the artists know that if one color is omitted the object at once becomes very noticeable."[30]

The Army codified the rational color approach in officers' pamphlets. *Notes on Camouflage* warned: "It is not sufficient to paint a canvas merely grass green—such a canvas will show up light in a photograph and look like a plane surface. There must be shading to give idea of depth and form; without this, color is absolutely useless." *Camouflage for Troops of the Line* offered insights from Thayer and information on dazzle painting, color theory, and the Western Front experience. "All objects of military importance, therefore, which can not be otherwise concealed should be protectively colored so as to render them less visible. . . . The most effective means of protective coloration is to render them similar in tone and color to natural objects, and to destroy their shadows. . . . It is also desirable to destroy the expected outlines by blotches of color."[31]

There were several training options for camoufleurs. In New York, a plum teaching assignment went to H. Ledyard Towle, now a lieutenant in the 71st Regiment of the New York Guard. On a 60-acre training site in Yonkers, he taught recruits to pick out "color values, lights, and shades" in the landscape and to notice how they changed from dawn to noon to dusk. He also gave a short course for the Women's Reserve Camouflage Corps, part of the National League for Women's Service. This group consisted of 35 to 50 women who were educated in color, painting, sculpture, photography, and woodcarving. The three-month course included military drills, target practice, map making, first aid, French, and photography at the Billings Estate in upper Manhattan (now The Cloisters). The goal was to train women in the art of realistic cover-ups, principally for homeland defense. In addition to his knowledge of color theory and Impressionist painting, Towle made use of secret photographs from the French military.[32]

Color, light, and visual perception were central to Towle's lessons. At local Army facilities, his class studied camouflaged ambulances and took notes as he explained the "whys and wherefores of the curious waves of color with which these vehicles were covered." Thayer's theories were discussed at the Museum of Natural History in Towle's lecture on how nature made birds "almost invisible by the peculiar markings of their feathers." Students found that "a knowledge of fabrics is necessary" because "different materials have different ways of taking color."[33]

Towle's class for female camoufleurs ("camoufleuses") was a novelty, and officials recognized its publicity value. Government agencies asked the ladies to colorize some of the tanks, ambulances, and trucks that advertised the war effort to potential recruits. "Wherever the camoufleurs went in their uniforms, spreading their bright paints," the National League reported, "a crowd was sure to gather." Fans congregated at Union Square in July of 1918 when the women unveiled a new paint scheme for the mock battleship *Recruit* (figure 4.7). At the request of Navy Commander W. T. Conn, they scaled a William Mackay design to fit the ship and, working after dark, painted the model in black, white,

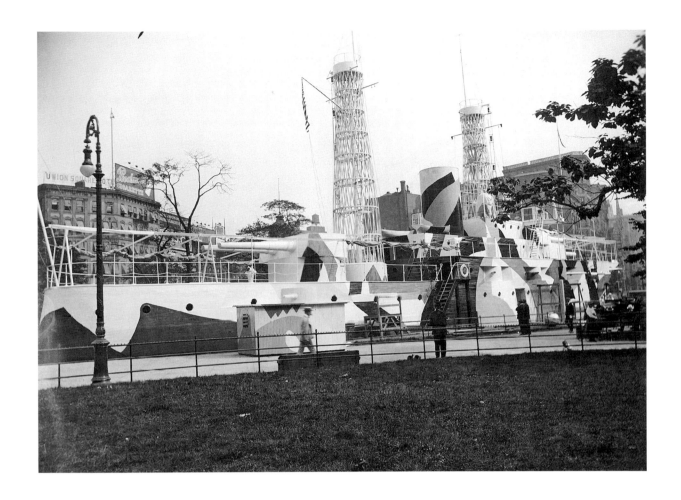

4.7 A photograph of the American battleship *Recruit*, captioned as follows: "If any German submarine is looking around Union Square, N.Y., it must be dazzled and confused by the variety and brilliance of the new war paint on the battleship *Recruit*. The ship has been camouflaged, the painting being done by 24 girl artists from the reserve corps of the National League for Women's Service." U.S. Naval Historical Center Photograph NH 41722, Naval Historical Foundation.

pink, green, and blue. "One day at sundown New Yorkers saw the ship a tame, neutral grey. The next morning it wore a wild, fantastic design of many colours."[34]

Columbia University's Teachers College hired Towle to lead a twelve-week course on "military concealment," with Richard Bach, an industrial-arts specialist at the Metropolitan Museum of Art, as co-instructor. Intended for mature adults with experience in the arts, the course consisted of lectures, laboratory, and field exercises. To prepare men for the Camouflage Corps, it focused on accurate documentation, close observation, and thorough photographic analysis. Like engineers and other technicians, Towle and Bach explained, camoufleurs needed to develop their visual and color skills.[35]

Towle's artistic approach was criticized by Matthew Luckiesh, a physicist who had pioneered the field of illuminating engineering at the Nela Research Laboratory in Cleveland (since 1913 a subsidiary of the National Lamp Works of the General Electric Company). Before the war, Luckiesh had studied the effects of color filters on photography, and his expertise had landed him the wartime chairmanship of the National Research Council's Committee on Camouflage. From that highly visible position, he campaigned to make camouflage more scientific, often criticizing the artistic approach. To Luckiesh, science deserved all the credit for camouflage's success on land and sea. "The artist has aided in the development of camouflage, but the definite and working basis of all branches of camouflage are the laws and facts of light, color, and vision as the scientist knows them."[36]

Luckiesh saw artists like Towle as dabblers who failed to establish "an art based upon sound scientific principles." Painters relied on vision, but physicists wanted verifiable facts. Early dazzle designs, Luckiesh argued, were "merely wild fancies with no established reasoning behind them." Vast improvements came when concerned engineers formed the Submarine Defense Association to "systematize and standardize" the artists' work. George Eastman put the Kodak Research Laboratories at their disposal, and a Kodak scientist named Lloyd Jones invented a visibility meter that "made it possible to tell from the examination of a painted model ship just what combination of colors gave the most protection at a distance." Luckiesh considered this a victory: "Science came to the rescue, and through research and consultation, finally straightened out matters." Turning to terrestrial camouflage, Luckiesh conceded the artist-camoufleurs had applied Thayer's theories correctly but put his money on the new precision instruments for measuring light and color. "An artist who views color subjectively and is rarely familiar with the spectral basis may match a green leaf perfectly with a mixture of pigments. A photographic plate, a visual filter, or a spectroscope will reveal a difference which the unaided eye does not."[37]

Luckiesh's biting comments raised familiar questions about subjectivity, objectivity, and the art-science dichotomy. Should color be studied as it was, or as it was seen? Artists were accustomed to defending their intuitive approach, as Thayer did in a protracted public feud with Theodore Roosevelt

over African colors. Everett Warner and other respected artists defended the visual study of camouflage colors. "The appearance of an object is governed just as certainly by definite laws as are its weight or actual dimensions, but the appearance is capable of an infinite number of instantaneous changes, simply by an alteration of position or by an alteration of the source of light falling upon it. Measuring these changes by any other agency than the human eye itself became, therefore, a matter of the most extraordinary difficulty." Scientific men were prone to "misconceptions . . . because their whole life is spent in studying things as they are." The Luckiesh-Warner debate was just one more skirmish in the color wars, also fought by Albert Munsell in education and by the Textile Color Card Association in retailing.[38]

American factories ignored the art-science debate and set their minds to systematizing the production of camouflaged materiel. The War Industries Board pressed munitions manufacturers to speed up, and companies developed techniques for applying colored patterns with rapid-fire efficiency. At the American Car and Foundry Company, khaki-clad women workers colorized gun carriages as they rolled off the assembly line. "The paints of different colors, in huge tanks, were deposited by means of a gigantic reproduction of the air-brush, used by artists everywhere. A stencil pattern covered all of the caisson except that which was to be painted yellow, for example; the camoufleuse wielded a hose as big as that of a vacuum cleaner, and in a few seconds all the exposed parts of the apparatus were covered with yellow. Then the blue, brown, and black were sprayed on by the same means." Meanwhile, the Army Corps of Engineers standardized the colors of military paints and varnishes, reducing the number of shades from 315 to 99 without adverse effect on camouflage projects. The *Architectural Record*'s prediction—"We shall made a business of it"—had come to pass. All over America, efficiency experts rationalized and streamlined camouflage production.[39]

Early in 1918, Company A of the Camouflage Corps sailed for France to join the American Expeditionary Forces. The outfit consisted of 22 or 23 architects; 40 carpenters; 30 iron workers; 48 house, sign, and scene painters; 24 fine artists; 30 stage carpenters and movie men; 20 tinsmiths; and 10 plumbers. The architects were said to know how to "visualize results" and create "large surfaces, which in texture and color resemble or mimic natural objects." It was discovered that big guns sometimes had to be painted twice a day, "the colors used depending on the light effects." The Army deemed camouflage an essential skill needed by every company, and eventually the high command integrated camouflage into basic training and disbanded the special Camouflage Corps.[40]

H. Ledyard Towle transferred to the infantry, shipping to France as commander of a machine-gun company and as head camoufleur for his division. The lessons of the Natural History Museum and the drills in Yonkers were put to the test. He saw one group of soldiers ignore camouflage

discipline. After concealing some buildings in foliage, the men hung their laundry to dry on the facade. The disruptive markings attracted the sharp-eyed Germans, who then had the buildings strafed. Everywhere they looked, Towle and other camoufleurs saw how color and shading worked to deceive the viewer. American cannons, with cream, yellow, and green blotches outlined in black, looked "like futurist nightmares." From afar, "the eye sees the prominent outlines of the colors and not the outlines of the gun." Towle and his men returned to America with an indelible memory of camouflage. "There is no magic about it—it is simply distraction."[41]

Reverse Camouflage

Camouflage put colorization in the public eye and prepared artist-camoufleurs for postwar careers as color designers for industry. Color theory, electric lighting, psychological research, and wartime experience combined to generate the popular belief that "the average person is more alert to visual stimulation than to auditory sensation." In 1919, *American Architect* cautioned designers to select room colors with care: "Some colors soothe, others irritate." Military metaphors invaded living rooms, where colors influenced the inhabitants' moods. "Protective coloring, apart from its recently acquired usage in the sense of camouflage, may also mean the function of color to protect him against his own melancholy or exhilaration." The deceptive practices of war found new applications in design strategies for the growing consumer culture.[42]

The former dazzle painter Alon Bement, who taught figure drawing and later directed the National Alliance of Art and Industry in New York, pushed fellow veterans to adapt their concealment skills to commerce. During the recession of 1919–1920, businesses looked for ways to induce consumers to spend money. Careful adjustments to shape, weight, and color could transform mundane products into an attractive, saleable line. "Camouflage has been a great help in winning the war. It has saved many ships. But, with the great struggle a thing of the past, we can take these principles, which we have evolved through such bitter necessity, and put them into practical everyday use." Camouflage contributed to the rising interest in color psychology, a new commercial practice designed to tap and manipulate human emotions for the benefit of economic growth.[43]

Bement explained how camouflage techniques could improve the appearance of the typical factory worker's cottage (a flimsy, two-story wooden box with a steep, pitched roof) with a few cans of paint. "The main trouble with such a house is that it looks narrow and cramped and seems to have no real base," Bement told readers of *American Magazine*. "What it needs is breadth and basis and a sense of giving real shelter. Without changing the main lines of such a house, you can nevertheless alter its appearance by camouflage." The narrowness could be disguised by "making the eaves longer and thicker," creating the illusion of a lower, broader structure. Wide moldings would strengthen the

front door, paned windows would break up the facade's monotony, and shrubbery would add weight to the base. "If you do not want the eye to stray to the peak of your narrow, high house, you must keep it occupied with something nearer the ground; for instance, put a window box with gay flowers on the first story. That is simply shrewd camouflage."[44]

Shrewd camouflage could also transform the interior space of a home and the unfavorable aspects of a person's appearance. A low room could be made to seem taller with floor-to-ceiling moldings and an "atmospheric" paint scheme in blue-gray sky colors. A large room could be made to seem smaller by putting brilliant bouquets on the tables, thereby directing the eye downward. The same trickery worked in apparel—the right patterns, lines, and colors could hide severe figure flaws. In shoes, a short vamp (the section that covered the front of the foot) could make a long foot seem shorter, and vice versa. A stout matron could conceal her midriff bulge by wearing outfits with long lines, as exemplified by the Irene Castle flapper look.[45]

An entrepreneurial camoufleur could earn a decent living by repackaging his skills for the consumer culture. The art of visual manipulation held enormous potential for a veteran camoufleur who wanted a career in advertising, architecture, merchandising, and product design. H. Ledyard Towle was the first to recognize these opportunities. He came home with captain's stripes and with confidence in his color skills. In accord with Alon Bement's ideas, he adapted to the postwar context and inverted the wartime rules of camouflage. Years later, he reminisced about those early years of readjustment: "It was realized that if Camouflage DISTORTED and change the appearance of a thing—REVERSE CAMOUFLAGE could by the proper use of light and dark colors—warm and cold colors—advancing and receding colors—bring out the best design of an object—a building, a room, or anything else." As we'll see in the next chapter, Towle perfected the art of reverse camouflage to become America's top automotive and paint colorist. As he developed visual streamlining and color therapy for big business, he always remembered the lessons of World War I, always citing camouflage as one of the cornerstones of the color revolution. Towle's contributions to that revolution would give new meaning to the slogan "American artists, join the camouflage!"[46]

5.1 This Buick ad from May 1928 shows a car

with a polychrome paint job.

5 True Blue

H. Ledyard Towle, camoufleur extraordinaire, was the founding director of the Duco Color Advisory Service in New York, a styling division of E. I. du Pont de Nemours & Company. During the early 1920s, DuPont and the General Motors Corporation collaborated to develop Duco Finish, a quick-drying, durable, and inexpensive nitrocellulose lacquer that modernized automotive coatings. For the first time, mass-produced cars rolled off the assembly line in brilliant colors. As the creative leader behind Duco, Towle showed DuPont and General Motors how to design with color.[1]

As big business ventured into consumer goods, a need arose for fashion intermediaries who could advise managers, engineers, and marketers on design and visual culture. Towle pioneered the role of the corporate colorist, first at DuPont and later at General Motors. Towle and Howard Ketcham, his successor at DuPont, connected the practical man of the nineteenth century with the color consultants of the Depression years. They helped the chemical industry, the auto industry, and other high-tech industries to understand fashion, forging connections to Paris while introducing cost-effective techniques to manage the palette. Their innovations included the new practices of visual streamlining (a "reverse camouflage" technique for painting a car so that it looked slimmer) and statistical color forecasting. It was these efforts that, along with the rainbow palette, drew the attention of *Fortune*'s editors to the color revolution.

Duco and Innovation

One of the first things a woman thinks of when the purchase of a new car is considered, is whether the color of the upholstering will harmonize with her personality, coloring and clothes. In other words, "Will she look well in it?"
—*Autobody*, 1925

In the years before World War I, color was widely used as a design element in fashion (millinery, shoes, textiles, hosiery, ready-made clothing) and as an eye-catcher in printing

(trade cards, magazines, billboards). Luxury cars—finished by hand with carriage varnishes—were also very colorful, as *Motor World* noted in 1924: "In the early days of the automobile it was quite common to see fire engine reds, blaring yellows and grass greens and occasionally a violet or purple that you could almost smell." Still, the palette for mass-market durable goods was limited. In 1937, one colorist, looking back at the year 1917, recalled that 95 percent of fountain pens had been black and 88 percent of blankets white. Tableware had been white or cream with small floral decals, and houses had been painted in pale, washed-out hues. But after World War I, the American chemical industry introduced new dyes, paints, and pigments that made it possible to design more colorful products.[2]

Nearly everyone concerned with moving consumer goods was interested in color. Advertising agencies, publishers, and printers encouraged manufacturers to invest in more colorful packaging and advertising. Mass-circulation magazines increased the number of colored advertising pages. In 1907, only 5 percent of the advertisements in the *Saturday Evening Post* were in color; by 1922, it was 28 percent. As shown in chapter 3, the American fashion industry invested in color management through the Textile Color Card Association. Before long, large national corporations acknowledged that color had market value. Matthew Luckiesh established the science of illumination and educated the public on the effects of electric lighting on visual perception while working at General Electric's Nela Research Laboratory in Cleveland. Between 1918 and 1923 he published more than half a dozen new books, including one titled *Light and Color in Advertising and Merchandising*, making the case that color could help companies sell more goods.[3]

Duco Finish helped to launch this color revolution. By early 1922, DuPont and General Motors had begun to transform Viscolac (a DuPont nitrocellulose lacquer used on pencils) into a new lacquer for use on automobiles. At that time, the only durable and cost-effective automotive finish was the famous black enamel that the Ford Motor Company had adopted for the Model T in late 1914 or early 1915. In 1923, when Ford dominated the low end of the market, 80 percent of American cars were finished in black or in a dark tint. High-end cars that came finished with the brighter old-fashioned carriage varnishes often had to be repainted. "I purchased thru a local Cadillac dealer, a Cadillac Phaeton, and within a period of 90 days, practically all the paint came off the hood and cowl of the machine," complained R. J. Hole of Greensboro, North Carolina. "From my observation of Cadillac cars sold locally, this condition exists with nearly all of them, and this, of course, is disastrous to the peace of mind of the owners of the cars."[4]

The finishes used on cars had not caught up with the rest of automobile production, or with consumers' growing interest in colorful designs. In 1922, body engineers noted that "the continued practice of using black" had "killed many an owner's pride in his car" and pressed the auto industry "for more color; more color in the interior and more color in the exterior." When French observers

derided American automobiles as "funeral cars because so many of them are black," the editors of the magazine *Automotive Industries* urged car manufacturers to "develop other colors which can compete with black in cheapness and durability."[5]

Luxury car dealers and shops that repainted cars became advocates of color. Edward Patton of the Franklin Motor Car Company in Cleveland documented a wide variety of regional color preferences. Country folk loved the fancy paint jobs that some city slickers shunned. Occupation, ethnicity, and social standing also influenced color preferences. In upstate New York, lumbermen liked green, small-town conservatives liked blue, and one Italian bootlegger went for "a vivid green car with brilliant red wheels." Wheeler Earl, who ran a Hupmobile showroom on Broadway, asserted that women were "the biggest factors in deciding sales," and that "they must be perfectly satisfied about the appearance and comfort of the car." Refinishing shops also noticed the growing influence of women, who often selected the paints and the upholstery for reconditioning jobs. "Milady," *Motor Vehicle Monthly* noted, "is gaily marching into the field of color selection and her selective faculty must be catered to. She knows colors, and, for the most part, quite intimately enough to give her views."[6]

As consumer society expanded, Americans assumed a higher standard of living, and things that had once been considered luxuries—running water, electricity, ready-to-wear clothing, phonographs, automobiles—came to been seen as necessities. As automobiles became necessities, Detroit developed its own internal hierarchy, with luxury cars like the Packard Twin-Six limousine designed for wealthy consumers and the Ford Model T as the car for the common man. Trade-ins allowed more consumers to own vehicles and thus expanded the market. First-time buyers could make do with an inexpensive second-hand car that had been refurbished by a local refinishing shop. Automakers had to create a reason for consumers to sell their car and upgrade to a flashier, more expensive model.[7]

As early as 1921, executives at General Motors acknowledged "the very great importance of styling in selling." Beginning in 1923, they gradually introduced the annual model change—an important weapon in GM's arsenal as it battled Ford for dominance of the auto market. Alfred P. Sloan Jr., who had become GM's president in May of 1923, believed that consumers up and down the social ladder would appreciate fashionable cars in a range of durable colors. Besides being a brilliant financial man, Sloan was a "clothes horse" and was interested in art and design. In his 1924 annual report to GM's stockholders, Sloan explained his famous decision to introduce "a car for every purse and purpose." He divided the American car market into several price brackets and focused each brand on a particular segment, with Chevrolet at the bottom and Cadillac at the top. Ford, in contrast, continued to focus on making a no-frills Everyman's Car in black—the Model T (figure 5.2).[8]

5.2 A 1926 Ford Model T in basic black. Division of Work and Industry, National Museum of American History, Smithsonian Institution.

Duco provided General Motors with an inexpensive way to differentiate its brands while adding value to the entire line. In 1923, GM experimented on the Oakland, a budget model that competed with the Model T. At GM's Oakland Motor Car Company, seven 1924-model touring cars were painted with early batches of Duco. To capitalize on the popularity of "the adorable blues" on recent show cars, each vehicle got two shades of blue, with accent stripes of red or orange. In September of 1923, six test vehicles, dubbed the True Blue Travelers, left Michigan for a countrywide tour of Oakland dealers. Muddy roads and extreme weather did little damage to the paint. When the True Blue Oaklands debuted at the New York Automobile Show in December, dealers and consumers responded to Duco's aesthetic dimension and its promise of greater durability. In March of 1924, Duco was announced in the *Saturday Evening Post*, and orders for Oaklands poured into GM showrooms. Recognizing that Duco would be a sensation, Sloan recommended that GM apply it to all models. By mid 1925, all of GM's divisions, from Chevrolet to Cadillac, had put aside traditional varnishes and enamels in favor of Duco.[9]

5.3 A 1924 True Blue Oakland Six. © 2004
M. Zack/Oakland County, Michigan.

5.4 Mrs. Consumer contemplates a new paint
job for the family car. *Motor* (August 1926).
Courtesy of the Smithsonian Institution Libraries,
Washington, DC.

Besides visual variety, Duco had several technical advantages over traditional coatings. Old-style buggy varnishes were brushed on by hand in more than a dozen steps and required lengthy drying periods between coats. Duco—which could be sprayed, and which dried quickly—reduced the number of stages, the drying time, the labor costs, and the need for storage space. It took ten days to finish a body by the old method, but only eight hours with Duco. Traditional varnishes chipped, cracked, crazed, and faded. Duco lacquer was a vast improvement. It stood up to air, sun, rain, mud, dampness, heat, cold, salt water, bacteria, perspiration, dirt, soaps, and detergents.[10]

Determined to keep up with DuPont, other makers of automotive paint, including the Egyptian Lacquer Manufacturing Company and Valentine & Company, introduced their own quick-drying varnishes and lacquers. The chemistry behind nitrocellulose lacquers was complicated, and DuPont benefited by licensing its technology to competitors. In addition to coachbuilders and automakers, local custom-painters adopted the new coatings. The Murphy Varnish Company and the Ditzler Color Company created color harmony charts for refinishing shops (figure 5 5). These tools gave refinishers the confidence to advise customers on color choices. Together, auto-industry executives and paint-shop proprietors were learning about color.[11]

The Duco Color Advisory Service

The selected color combination must not only bring the body lines out to best
advantage but it must be a combination that the public will buy. Color harmony
is part of this picture.
—*Motor*, 1926

At first, DuPont prospered by selling Duco to more and more coachbuilders, car manufacturers and refinishing garages. By early 1925, its customers included five divisions of General Motors and fourteen other automakers. That year, DuPont sold more than a million gallons of Duco at $5 each. Duco surpassed the competition technically, and the future looked bright. Yet marketers thought DuPont had not yet caught up with the growing sophistication of consumers and their desires for stylish products.[12]

In January of 1925, two DuPont managers discussed the firm's need for "practical advice" on "the psychology of colors." F. B. Davis, general manager for plastics, confided his ideas to Fin Sparre, head of the development department. The plastics division, which made the Pyralin brand of hairbrushes, had kept up with changing color preferences by tracking sales statistics. Davis was convinced that a color specialist versed in fashion trends and in scientific management could do better. An experienced colorist could anticipate a major color trend, helping DuPont to capitalize on "its popularity for at least one season before other manufacturers come into competition on the same color." Whether the product was plastics or paint, color management was all about anticipating styles to raise profits.[13]

5.5 Advertisement for Murphy Varnish Company, *Autobody*, January 1924. Courtesy of the Smithsonian Institution Libraries, Washington, DC.

In October of 1925, Duco hired H. Ledyard Towle to establish the Duco Color Advisory Service and to design the "latest and most desirable color combinations" for the auto industry. After leaving the Camouflage Corps with his captain's stripes, Towle had worked for the Victory Liberty Loan Committee, and while in Washington, kept in touch with other commercial artists who were re-entering civilian life. He then found positions in the burgeoning field of advertising, working as art director for the H. K. McCann agency and for the Frank Seaman agency in New York and for the

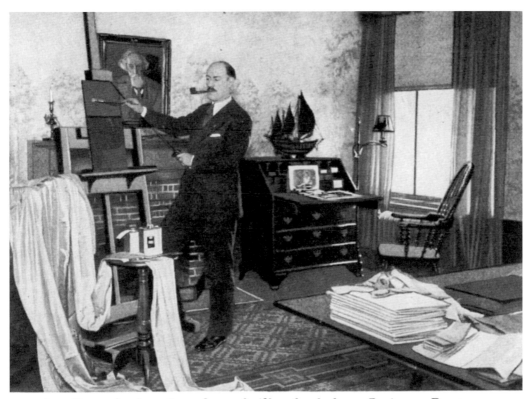

Reproducing the colors of silks, fresh from Paris, in Duco

5.6 H. Ledyard Towle at the Duco Color Advisory Service in New York. From *DuPont Magazine*, May 1926. Hagley Museum and Library.

Campbell-Ewald agency in Detroit. At Seaman, Towle was assigned to the DuPont account. During his stint at Campbell-Ewald, GM's ad agency, his office was in the new General Motors Building.[14]

In the 1920s, the larger advertising agencies billed themselves as full-service companies prepared to help clients conceptualize campaigns, write copy, create artwork, design products, stimulate publicity, and do consumer research. Their art departments showed clients how to capitalize on color's eye appeal in magazines, newspapers, and billboards, and it was not unusual to extend this advisement to product design. In his job as an adman, Towle "first worked on color with the automotive industry back in 1924," when he was "the only color engineer calling on the automobile trade." At Campbell-Ewald, he may have played a role in creating the smart, dual-color Duco paint job on the gussied-up 1925 Chevy that outshined the Model T.[15]

The former camoufleur was the ideal person to help DuPont rationalize the chaotic world of color. Duco offered unfamiliar options, and automakers needed guidance. "Choosing a color scheme for a car was not difficult when there were only a few colors," Towle explained. "But now with the automobile color card rivaling the rainbow, the problem of making a discriminating choice is much more difficult." Duco came in more than 1,000 shades, with no end in sight. This raised a question: "How can we face this mass of color, of tone, of hue, and intelligently take from it certain elements, place them upon our cars so as to enhance their lines, give them lustrous beauty and most of all, sales appeal?" Many of DuPont's auto customers manufactured models at different price points in the middle ground. Towle steered them toward color combinations "known to please the average," which his "staff of color experts" knew "how to choose with certainty." This meant tying DuPont finishes to European fashion trends, keeping abreast of regional tastes, and designing paint schemes that enhanced automotive shapes.[16]

To advance the first mission, Towle sailed to Europe every autumn, visiting the Olympia Show in London and the Automobile Salon in Paris. There he studied the new cars of the smart set and cabled reports to the Duco Color Advisory Service, which then prepared press releases for newspapers around the county. "All Paris is color mad!" the *Providence Tribune* quoted Towle as declaring in late 1926. The Grand Palais, which hosted the auto salon, seemed aflame in warm maroons and burnt oranges. On Parisian boulevards, the cars of the "haute monde and the demi-monde" whirled by in "squadrons of satisfying color . . . like a flashing mountain torrent at the end of a rainbow." At the opera in the evening, the balconies at the Palais Garnier looked like flower boxes, blossoming "with beautiful women, their gowns of orchid, peach, Rose de Versailles, Saint Germaine green, glacier or cloth of gold." Towle saw color everywhere, understood its place in the fashion system, and sought to explain its significance to Americans.[17]

Towle's grand tours gave him the chance to meet with top fashion designers in London and Paris. He shopped the major couture houses, taking notes on luxury fabrics—and commenting favorably on the new vogue of couture colors for motorcars. In the autumn of 1926, he reported on automotive color schemes by Jeanne Lanvin, Philippe et Gaston, Lucien Lelong, Premet, Drecoll, Jenny, Callot Soeurs, Madeleine Vionnet, Paul Poiret, and Jean Patou. Lelong had daringly combined green and peach tones on a roadster and royal purple and silver on a town car, and Vionnet had created a scheme for a sports car in "tones of Dekkan Brown and London Smoke." The "Paris creators of style" were working their magic to glamorize the road.[18]

In New York, Towle attended the Automobile Salon and the National Automobile Show, where American carmakers exhibited the latest engineering features, accessories, upholstery, and color schemes. By the mid 1920s, "punchy" hues were in fashion. At the January 1926 National Automobile Show, black appeared on only 7 percent of the cars, gray on 31 percent, blue on 26 percent, green on 14 percent, cream or yellow on 9 percent, olive or tan on 6 percent, brown on 3 percent, and red on 1 percent. Among the show stoppers were twelve Lincolns in spectacular hues "adapted from the plumage of rare American and tropical birds." A year later, the colors were even more striking. The "mass production man," Towle wrote, had caught on to the fact that "the whole country is becoming more fond of the use of color." Automakers exhibited cars with two-tone schemes in "warm, appealing beautiful harmonies." Fenders, window brackets, rear tire covers, and upholstery now matched the rest of the car. With satisfaction, Towle described the 1927 National Automobile Show as "the high water mark in color harmony."[19]

The color riot did lead to some design errors. Some automakers went wild with the new nitrocellulose colors. "From the appearance of some of the cars" at the New York show, a Packard body engineer sniped, "one would judge that a painter of barber poles had been employed as chief decorator." After one company painted the entire body of a roadster with a brilliant paint intended for stripes only, Towle pointed out that a coupe was not a taxicab or a fire engine, and the paint should not scream. The best paint jobs, Towle wrote, accentuated the machine's form and hid its figure flaws.[20]

The careful application of color—the techniques of visual chicanery that Towle had used in camouflage—could create the illusion of a beautiful, streamlined shape. In the showroom a smaller car might look like a runt next to a larger model, but a smaller car could be "lengthened visually" with the right colors. The lower portion of the body should be a light color; the upper portion should be a darker tone; the fenders and splash aprons should be black. A pale belt running from the radiator to the trunk would direct the eye downward. "Long vigorous stripes along the lower band molding" made a model "look longer." And why not, Towle asked, wrap this band around the car's front?

Conversely, a dark lower body and a light upper body would make a tall brougham look lower and less old-fashioned. A truly tasteful paint job copied the rich tones of a Persian rug, rather than the brashness of a decorated layer cake. The camoufleur had become an aesthetic doctor, with the visually naive auto industry as his patient and with judiciously applied color as his medicine.[21]

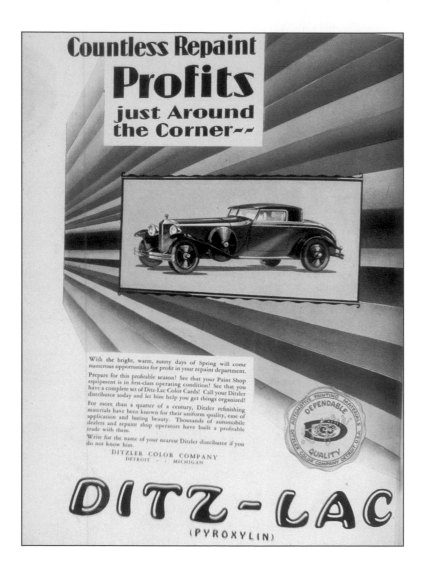

5.7 Advertisement in *Motor*, March 1929.

Courtesy of the Smithsonian Institution Libraries, Washington, DC.

Streamlining Color at GM

> The automobile color artist has arrived.
>
> —*Automotive Industries*, 1926

In August of 1926, DuPont's vice-chairman, Irénée du Pont, and the Buick division's general manager, Harry Bassett, deliberated the future of color styling. Bassett wanted Towle to move to Michigan, where GM's Fisher Body division would have better access to his skills. Du Pont objected on the ground that Towle was needed in New York to oversee his company's color programs. Towle remained with DuPont in 1926, despite GM's overtures. By July of 1928, however, he had moved to Detroit to work as GM's "first color engineer" in the new Art and Colour Section alongside the flamboyant Harley J. Earl.[22]

5.8 Towle (left) in GM's Art and Colour Section, 1928. Collections of the Henry Ford Museum.

Towle had impressed GM's executives with his camouflage skills. While still on the DuPont payroll, he was a frequent presence at the Duco sales office in the General Motors Building in Detroit. In June of 1927, he went to the General Motors Proving Ground to meet with GM's president (Alfred P. Sloan Jr.) and research chief (Charles F. Kettering) and with the managers of the Oakland and Chevrolet divisions for the purpose of discussing "the influence of color on beauty and sales." Towle gave an object lesson in "reverse camouflage," showing three pairs of Chevys in two-tone paint schemes that made some of them look long, others high, and still others squat. When the GM managers said they saw cars in different sizes, the master of illusion savored the victory. He had demonstrated how deceptive coloration could influence visual perception and create a streamlined look. Delighted, Sloan announced a plan to establish an "Art and Colour Section for the purpose of developing outlines and colors for the various cars in the Corporation." Under the direction of Harley Earl, the new office would cooperate with all of GM's car divisions and would provide "attractive color combinations for our product."[23]

In 1927 the Cadillac division created a sensation with Harley Earl's design for the LaSalle. Earl had learned to design cars in the Los Angeles body shop of his father, J. W. Earl, where luxury models were customized for movie celebrities. Impressed by Harley Earl's talent for color harmonies and sculptural designs, the Cadillac division's president, Richard Collins, commissioned him to build six sports sedans. In 1925, Cadillac's new chief, Lawrence P. Fisher, met Earl at a Hollywood party. With characteristic confidence, Earl boasted that he could "make a car . . . like your Chevrolet . . . look like a Cadillac." Judging the proposal audacious but promising, Fisher invited Earl to Detroit as a "consulting engineer." His LaSalle design, introduced in March of 1927, brought the look of an expensive car to the mass market. The LaSalle, long and low with rounded corners, emulated the look of luxury vehicles favored by the rich and famous. It suggested a star-studded world far removed from the monotony of an office or a factory. Earl's belief that consumers saw automobiles as entertainment and escapism seemed to indicate that he had spunk of a sort that Sloan wanted for General Motors.[24]

The establishment of GM's Art and Colour Section coincided with the escalating rivalry between GM and Ford. GM expanded its market share by offering competitive prices and quality engineering plus installment financing, trade-ins, stylish interiors, side windows, hard roofs, annual model changes, and fashion colors. In May of 1927, Ford discontinued the Model T as it re-tooled to introduce the snazzier Model A.

Up to this point, GM's Fisher Body division and its car divisions had divided the design process, each working out body sections and then combining them into one vehicle. Harley Earl, in contrast, designed a car's silhouette as a whole, sculpting the model in clay. Earl introduced this approach to the new GM design department. A year later, H. Ledyard Towle set up his color studio next door in

the General Motors Building. Earl later recalled that the "artist . . . did a remarkable job of organizing it and getting the colors and the trims and all that."[25]

Sloan, the quintessential organizational man, delighted in the prospect of managing color "on a scientific basis." Forecasts were already a part of GM's operations, and now the same statistical methods would be applied to color trends. Every ten days, the franchised dealers mailed in their sales reports; GM's "number crunchers" then analyzed them to delineate sales patterns and anticipate future demand. Those forecasts enabled the division managers and the procurement staff to purchase the right quantities of steel, glass, fabric, tires, and paint. Likewise, the Art and Colour Section could study the feedback from dealers to determine consumers' preferences for body types, color schemes, upholstery fabrics, hood ornaments, and other style elements.[26]

Already the wizard of visual streamlining, Towle now became GM's master of color futures. Color forecasters, he explained, were like meteorologists who studied evidence from around the country and used their knowledge of historical patterns to predict change. "The only way to make cars in colors that will sell well to the public," he explained, "is to have the manufacturer's dealers gather definite information as to colors that the public prefers." If one dealer "says that blue is popular, you are not sure," he cautioned. "If another dealer somewhere else also says that blue is popular, you begin to think it may be so; and if the same news come from all over, you are very sure that blue should be the color of your coaches and sedans." Ever watchful, Towle compared dealers' reports with evidence of public taste "in the periodicals, in newspapers and over the radio as regards clothing, house furnishings and other articles." He drew on the hard facts, but also on experience, intuition, and common sense.[27]

Towle issued a monthly *Forecast with Colour News and Notes* consisting of a lively discussion of general style trends and a statistical appendix listing car sales by color. In the June 1929 edition, he published a report on the color blue that described the many factors that influence consumer choice. Dealer feedback for May had revealed that the most popular colors for cars were various shades of blue, including Jefferson Blue, Briton Blue, Calumet Blue, Cadillac Blue, and Bonneville Blue. At first glance this information seemed like a simple testament to the enduring influence of True Blue, but Towle's detailed tabulations showed that that consumers' choices varied from region to region and from model to model. Among Pontiac buyers in the Pacific Northwest, 87 percent preferred shades of blue, 5 percent brown, 5 percent green, and 3 percent cream. In the Northeast, only 17 percent of Buick buyers preferred blue; 30 percent preferred green, 22 percent beige, 14 percent black, 3 percent gray, and 2 percent brown. Although Towle could summarize national trends, it would have been dangerous for him to make broad generalizations. The consumer's need for individualization always added an element of complexity.[28]

Though there was no way to get inside consumers' heads, Towle tracked down the best consumer-research practices and adapted them to Detroit. He picked "the brains and experience of men who have made a lifelong study of color" and urged automakers to heed "the leading fashions in the silk, hosiery and shoe trades." His monthly forecasts paralleled the work of Margaret Hayden Rorke at the Textile Color Card Association, but his own ingenuity was impressive. He was the first Detroit colorist to tap the prestige of French couture, the founder of statistical color forecasting, and a fearless critic of fads. When Arthur S. Allen lectured the Society of Automotive Engineers on "color finishing" and invoked the Munsell Color System, Towle spoke out against that system's constraints on creativity. Whereas devotees of the Munsell Color System followed strict rules, Towle preferred to mix and match until the right ensemble caught his eye. Chance had a place, and the best color combinations often emerged from "accidents" in the studio. "Style setting" was a "risky business," an inexact science that depended on serendipity.[29]

Shortly after the former camoufleur Towle settled in Detroit, the gradual move toward lower, longer car bodies diminished the need for color streamlining. Consumers' tastes also began to shift away from "exploding orange with ketchup scarlet on the side." "We certainly want beauty in the color of our cars but we do not like to have to buy these awful 'coats of many colors,'" carped a critic in *Autobody* who wasn't fooled by the "camouflage." Around 1930, the emerging trend was to paint a car's roof, belt, moldings, window frames, wheels, and body in a single color. Although streamlined steel bodies didn't enter mass production until the mid 1930s, Towle probably saw concept designs and manufacturers' prototypes of curvy cars with plainer paint jobs. His skill in camouflage was becoming obsolete. The master of style cycles was falling victim to changing fashions.[30]

In 1930, Towle returned to the Campbell-Ewald advertising agency, where he handled the GM account and helped to publicize the Chesapeake & Ohio Railway's kitten mascot, Chessie. Perhaps he was unable to adapt to change, or perhaps he was at odds with Harley Earl's forceful vision. In a memo to Charles Kettering, Towle hinted at discord, calling GM's color studio a "vale of tears." In 1934, he became the founding director of the Division of Creative Design and Color at the Pittsburgh Plate Glass Company, which created color schemes for appliances, layouts for showrooms and storefronts, new hues for paints and varnishes, and artwork for corporate advertising. At PPG, Towle remained an important figure in the color revolution and extended its influence to commerce and architecture.[31]

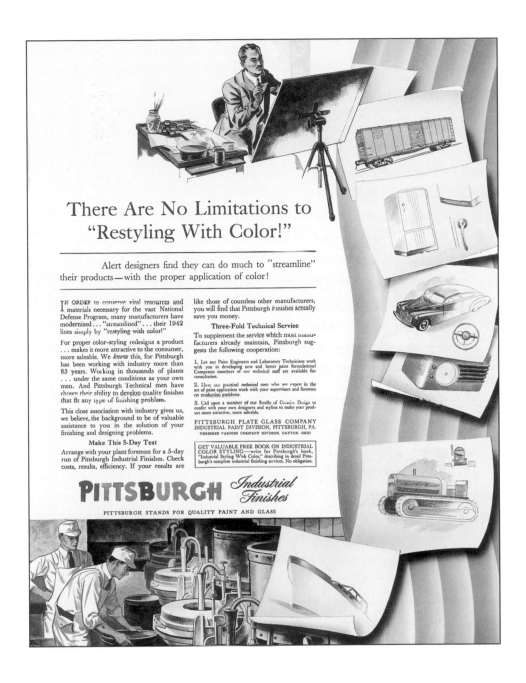

5.9 An advertisement by the Pittsburgh Plate Glass Company featuring Towle as creative director. *Fortune*, 1942. Reproduced courtesy of PPG Industries, Inc.

Simplifying the Duco Palette

"Watch your color." This three-word warning comes from the "color-psychologist" who has entered the automotive field. . . . He is not alone interested in finding harmonious color combinations . . . , but he goes a step beyond and endeavors to chart the reactions of people to colors.

—*New York Motor News*, May 1928

Towle's successor at the Duco Color Advisory Service was another adman turned colorist, Howard Ketcham. A member of New York high society, Ketcham was the maternal grandson of George E. Brightson, a wealthy executive at a phonograph company. After his parents divorced, young Howard often traveled with his fashionable mother to Paris, Deauville, Nice, Cannes, and Como. He learned French before English, crossing the Atlantic 26 times before the age of 12. When not in Europe, the young sophisticate lived in his grandfather's Oyster Bay mansion, learned to sail, and eventually went to Amherst College for journalism, fraternity life, and football. A talent for art led the 1925 college grad to the advertising business. He followed in Towle's footsteps, working in H. K. McCann's art department while taking classes at the New York School of Design. Three weeks into a new job with a manufacturer called the Magazine Repeating Razor Company (later known as Schick), his old boss told him about an opening at the Duco Color Advisory Service. In 1927 he took a job at DuPont, where he worked until 1935. He then established Howard Ketcham Inc., a color consultancy in New York.[32]

By 1928, the Duco Color Advisory Service was part of an expanded DuPont effort in sales engineering aimed at providing customers with fashion advice from offices in New York and Paris. The Pyralin plastics division was going strong, the dye business was growing, and the finishes division had introduced Brush Duco, a household paint for do-it-yourselfers. Beside Ketcham, the styling staff included an artistic salesman named Matt Denning and several design and merchandising consultants. In his eight years as DuPont's head colorist, Ketcham continued Towle's legacy by forging new connections in the style industries but left his own mark. His innovations included initiatives to rationalize color forecasting, standardize the Duco palette, and enhance DuPont's reputation for high-quality automotive finishes. His alignment of the Duco Color Advisory Service with Taylorist practices established Ketcham as the "father of color engineering."[33]

In his early days at DuPont, Howard Ketcham continued H. Ledyard Towle's mission of augmenting the company's cultural capital through associations with luxury brands. One such project included a fashion palette created in conjunction with a venerable textile mill, the Cheney Brothers Silk Manufacturing Company. The nation's largest manufacturer of silk fabrics, Cheney Brothers grappled with a declining demand as new cellulose fibers such as rayon and cellulose acetate crowded the textile market. As we'll see in the next chapter, Cheney Brothers fought back with an aggressive marketing program that put French design, modern art, and American color in the spotlight. Over the years, the sales manager of Cheney Brothers, Paul Thomas, had been friendly to the DuPont Company, supplying DuPont with his firm's proprietary forecasts for silk colors. He now hoped that a tie-in with DuPont, a technology leader, would strengthen Cheney Brothers' position in the troubled market for luxury silk fabrics.[34]

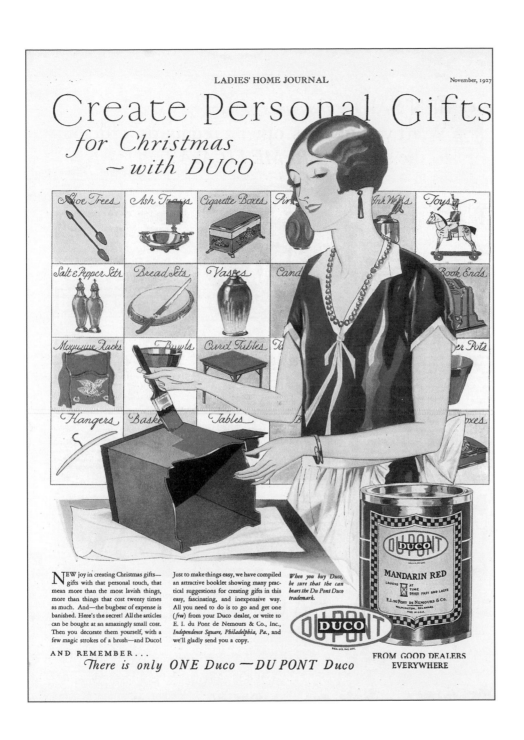

5.10 Advertisement for brush Duco, *Ladies' Home Journal*, November 1927.

Art Deco Radios

In 1932, the Bakelite Corporation sponsored a symposium to help the creative industries expand their knowledge of plastics. The invitation list read like a "who's who" of freelance designers: Helen Dryden, Gustav Jensen, Norman Bel Geddes, Lurelle Guild, John Vassos, Donald Deskey, Henry Dreyfuss, George Sakier, Walter Dorwin Teague. Here were the leading lights of the profession of design consulting, which had emerged after the Exposition internationale des arts décoratifs et industriels modernes in Paris in 1925. These entrepreneurs, taking their cue from advertising men, stylists, and colorists, offered design expertise to companies seeking advantage over their competitors for consumers' dollars. Many were devotees of Art Deco, a version of European modernism toned down for the American mass market. Over the course of the decade, plastic would become one of their favorite materials.[35]

Plastics, first formulated in the Victorian era, were a response to the need for low-cost man-made substitutes for natural materials such as gutta-percha, hoof, horn, India rubber, ivory, and shellac. In 1868, the chemist John Wesley Hyatt made a semi-plastic material from wood pulp. He then formed the Celluloid Manufacturing Company. Celluloid was used to make a variety of products, including costume jewelry, piano keys, and dentures. The development of celluloid also led to the photographic film sold by Eastman Kodak and to DuPont's Duco nitrocellulose lacquer.

Next came synthetic plastics, exemplified by the phenolic resin that Leo H. Baekeland invented. This test-tube material, known as thermosetting plastic, could be molded into various shapes by applying heat. The General Bakelite Company was established to make molding powder for the electrical, telecommunications, and automotive industries. The firm merged with others to become the Bakelite Corporation in 1922. Five years later, when the Bakelite patents expired, other resin makers rushed into the field.

How to color plastics was one of the major challenges to their manufacturers. The older celluloid plastics came in earth tones, and products made of them were designed to look like ivory and other natural materials. Likewise, the early phenolic resins were limited to dark colors and faded after prolonged exposure to light. Urea resins, patented in the 1920s, made a wider range of colors possible. Melamine, introduced by American Cyanamid in 1937, could be colorized in pastels.

The growth of the plastics industry coincided with the golden age of broadcast radio. In the 1920s, electronics companies used Bakelite to make various components of radios. In 1931, the International Radio Company introduced a plastic console that was colorized to look like agate. The stay-at-home culture of the Great Depression furthered the radio boom. The Bakelite Corporation's 1932 plastics symposium was meant to encourage synergies, and it succeeded. Electronics companies, molding shops, chemical manufacturers, and industrial designers put their heads together and joined the color revolution.

The Patriot, a tabletop radio designed by Norman Bel Geddes, combined innovative molding and color styling. The Emerson Radio and Phonograph Corporation made Bakelite consoles but wanted to expand beyond the black-and-tan palette. To offset the gloomy mood of 1940, the firm hired Geddes to create a celebratory design for its 25th anniversary. The chassis determined the cabinet's dimensions, but Geddes was free to choose the emblems, motifs, and colors. He came up with a "cabinet inspired by the Flag." The clean, simple design used "the white stars and the blue field of the 'union' as calibration points and background on the tuning dial; and, by converting the stripes into baffle strips across the speaker orifice, provided a novel and pleasing mask for this usually obvious opening." The colorful plastics were made by Monsanto.

Patriot radios were a big hit with consumers. Retailers reported that they flew off the shelves; one store sold more than 700 of them in one day. Geddes repeated this success with "other, non-patriotic color schemes" in greens, blues, and marbleized grays, using colorful plastics to establish a new trend in radio design.[36]

5.11 Sketch for "The Patriot" radio, 1939.
Norman Bel Geddes Theater and Industrial
Design Papers, Harry Ransom Center, University
of Texas, Austin.

Late in 1928, Ketcham turned the Cheney Brothers forecast for the autumn of 1929 into a new set of Duco automotive colors. The palette included Red Shadow Red, "a yellow red suitable for use with brown or beige, as a wire-wheel color or for striping," and Sea Bubble, "a natural beige first developed by the silk industry which has received wide acceptance in the textile trade as well as in the automotive industry." There were also Pewter Pot, Blu-Gray, Gray Gull, Bay Tree, Verdancia, Water Glo, and Lei Orange—mellifluous names that suggested exotic times and places. The DuPont-Cheney palette showed how companies worked together to advance the color revolution. It also showed the complexities of that revolution, as the DuPont Rayon Company produced the man-made cellulose fibers that were fast becoming the flapper's favorite fabrics and eroding sales of Cheney's luxury silks.[37]

By 1929, nearly every auto company had its own color engineer, and a new role other than automotive color advisor evolved for the DuPont stylists. Keeping one foot in the industrial arts with projects like the Cheney Duco colors, Ketcham embraced the practices of the engineering profession. Alarmed by the size of DuPont's color portfolio (thousands of shades), he made simplification the watchword of the Duco Color Advisory Service. By determining which colors appealed to the "average American," Ketcham simplified aesthetics for the paint shops that used Duco.

Ketcham's first step toward simplification was the Automobile Color Index, a monthly quantitative analysis of paint sales published for coachbuilders, refinishing shops, and used-car lots. Dealers faced the problem of reselling trade-ins, and a lively reconditioning business developed around used cars. Reconditioners were always on the lookout for ideas on how to make over a five-year-old car to suit current trends. The Automobile Color Index provided color tips on interior upholstery and exterior paint. This color tool owed its analytical rigor to General Motors and its respect for fashion to the style industries.

Borrowing ideas from Cheney Brothers, Ketcham divided Duco colors into three groups: standard colors, style colors, and staple colors. Standards were always available, regardless of fads. Style colors were trendy, reflecting clothing fashions. Staple colors fell in between. Beginning in the summer of 1929, Ketcham tracked these three groups and measured the rise and fall of color families, such as reds, browns, and yellows. His research revealed how the economic downturn affected consumers' buying habits. By 1933, black was back in business, a major challenger to blue. The Index summarized these trends in elaborate charts and graphs that were published in *Autobody* and other trade journals, accompanied by DuPont's fashion reports from London and Paris. Duco customers could use these trend reports to help gussy up used cars for the showroom or to help consumers select up-to-date colors for a refinishing job.[38]

In 1932, Ketcham introduced Duco Calibrated Colors, a palette of 290 mix-and-match shades suitable for mass-market vehicles. At the time, American paint companies had 11,500 different

automotive colors in their inventories. There was no logic behind the proliferation; the palette had grown willy-nilly. Some paint producers, finding it difficult to control chemical reactions in their plants, generated "as many as 80 variations of one original color." Harried automakers exacerbated the problem by accepting the variant colors. Things got worse when car companies switched paint sources only to find the new supplier wasn't able to match the old colors. By dramatically reducing the number of Duco shades, Ketcham made it easier for coachbuilders, refinishers, and used car dealers to manage color. Now they didn't have to worry about color harmonies; Duco had done the research and presented the results in a neat, understandable package.[39]

In line with DuPont's orientation toward science, Ketcham based the Duco Calibrated Colors on the Munsell Color System. The language of color measurement—the occasional references to hue, value, and chroma—gave a hard edge to descriptions of color harmonies. Writing for the refinishing trade, Ketcham described one two-tone paint scheme this way: "Allover color a light maroon. The character of such a maroon can be improved through the use of light, bright blue green as a striping accent. Maroon is in reality a low value of red. Blue green is the complement of red. The use of a color with its complement tends to intensify both colors." Ketcham's decision to use the Munsell Color System was testimony to DuPont's commitment to engineering; color could indeed be tamed, controlled, and packaged. Ultimately, the Society of Automotive Engineers endorsed Duco Calibrated Colors, and they became the industry standard for lacquer manufacturers.[40]

In the ten years between Towle's arrival and Ketcham's departure, DuPont experienced a remarkable transformation in color practice. Although their temperaments and techniques differed, Towle and Ketcham shared common assumptions about the role of the professional colorist in the buyers' market. "It is just as costly to be too far ahead of the color trend as it is unprofitable to lag behind it," wrote Ketcham. "So, the manufacturer or dealer who wishes to meet markets when they arrive does well to determine in advance the public choice in colors." How was this feat accomplished? Seasoned colorists took their lessons from the marketplace, whether watching ladies examine Paris gowns or analyzing the sales of blue Buicks. They were, in short, "obliged to keep abreast of the consciousness of the color consumer."[41]

From Reverse Camouflage to Body Streamlining

Mr. and Mrs. Average Car Owner center more attention to the choice of a smart
color design than upon the sum total of all the other items comprising the finish.
—*Motor Body, Paint and Trim,* 1931

The story of DuPont and GM shows how large national corporations with enormous market power contributed to the color revolution. Historians have written about their investment in industrial

research, but less is known about the creative professionals that took their new science-based products to market. H. Ledyard Towle and Howard Ketcham showed big business that fashionable colors could sell automotive finishes, and, in doing so, laid the foundation for the profession of colorist to industry.[42]

In 1939, the U.S. Department of Commerce reported that the vast majority of passenger vehicles—60 percent—were painted in colors. The nitrocellulose lacquers had created a wealth of visual possibilities; they had also created color chaos. At first, there were no procedures for managing the large variety of colors that laboratory chemistry made possible. Towle and Ketcham helped DuPont and GM get control of the situation. They created order with an approach to color management that combined statistical forecasting, efficiency theories, the status appeal of Paris fashion, and common sense.[43]

Even in the glory days of scientific management, there was no "one best way" to manage the palette. DuPont evolved methods suited to coatings, while GM focused on color futures for Alfred P. Sloan's hierarchy of automotive consumption. High fashion was influential, but couture colors had to be modified to have mass appeal. A woman might look good in a hot pink flapper ensemble, but a hot pink car would soon be out of date. Exact copies of Paris couture colors often looked strange on vehicles, but there were always exceptions. After the House of Worth introduced a particular brown at the 1931 Couturier's Ball, low-priced cars painted in Duco's Worth Brown sold well for the next two years. Towle and Ketcham explained how color trends evolved, the patterns of taste, and why variations were inevitable.[44]

In the auto industry, color was integral to the annual model change and the concept of styling obsolescence. It also led to the most important design innovation of the era, body streamlining. Towle inched toward this concept with reverse camouflage, and Ketcham helped it along with Duco Calibrated Colors. Color acclimated consumers to cosmetic changes and enhanced Detroit's reputation as a style leader. The artist Alon Bement, a former dazzle painter, noted: "The automobile industry, by endowing its products with beauty of design and color, has become America's foremost influence in cultivating public taste." The high-water moment of polychrome styling—the years 1924–1928, when punchy color was the ultimate design solution—opened Detroit's eyes to aesthetics as a money-making proposition. Harley Earl of General Motors built on this foundation when he put body streamlining at the center of design practice and expanded the ranks of his in-house color staff. By the mid 1930s, color authority had moved from periphery to the center as a marketing value. When industrial colorists spoke, corporations listened.[45]

6 Entente

Auto manufacturers pioneered a new use of color to meet and stimulate consumer demand, but they were not the only ones playing in that field. Practitioners in the emerging field of marketing pointed to the heightened color sensibilities of women, and new opportunities emerged for colorists to study and explain these consumers. Artists, interior decorators, textile designers, and publicists all claimed knowledge of color psychology and promoted themselves as experts on visual perception and consumer behavior. Visionary thinkers imagined the possibilities of a great French-American entente and of connecting American industry to modern art.

The Proper Study of Markets Is *Woman*

In the 1920s, businesses wrestled with the unpredictability of consumer desire shown in the peaks and troughs of demand. As anxious manufacturers sought new ways to increase sales, the new field of market research linked women and color in ways that seemed irrefutable and irreversible. The marketing pioneer Paul T. Cherington was instrumental in this process. His 1913 book *Advertising as a Business Force* had popularized "Mr. Advertiser" and "Mrs. Consumer" as commercial parlance. According to a 1929 article in the magazine *Printers' Ink*, "the proper study of mankind is *man*, but the proper study of markets is *woman*."[1]

These gender categories were based on the cultural assumption that women were by nature more emotional than men, and more sensitive to form, design, and color. Mainstream culture perpetuated these stereotypes by relegating women to handicrafts such as needlework, sewing, and interior decorating. Medical science gave credence to them by suggesting that only men could be color blind and (building on the theories of Sigmund Freud) describing how the subconscious shaped behavior. Women, the story went, were particularly susceptible to color's suggestive power. In the marketplace, color

worked swiftly, persuasively, and efficiently to mobilize their emotions. It touched some mysterious corner of the consumer's inner self in some uncanny way. Red excited, blue calmed, and various other colors also had particular effects. As a tool of design and marketing, color would catch the eye, engage the imagination, and encourage feminine interests in shopping, interior design, and fashion.

As the style industries emulated the auto industry, there was a need for experts who knew something about color psychology and consumer demand. Like H. Ledyard Towle, the veteran dazzle painter William Andrew Mackay put his deceptive skill with colors to work at a Madison Avenue advertising agency, where he answered clients' color questions. Interior designers published advice books on color and mood. For example, *The Book of Happiness: Predicated upon the Scientific Selection of Colors for Interior and Exterior Decoration* told a housewife how to improve her family's well-being by means of a color scheme based on principles of scientific management. The *Ladies' Home Journal* tutored women on household camouflage, and the International Correspondence School showed window dressers how to use light and color persuasively. The gist of these publications was that color could be managed so as to manipulate.[2]

6.1 Marie Josephine Carr, *The Charm of Color: Expressing Your Personality in Home and Wardrobe* (Monroe Chemical Company, c. 1931). Hagley Museum and Library.

Women proved to be some of the most adept colorists *cum* psychologists. Margaret Hayden Rorke noted that color (rather than weave or pattern) had become the best "silk salesman." Whether a homemaker or a shop girl, the average female consumer now owned at least one silk dress. She may have bought it off the rack, paid a dressmaker to sew it, or made it herself. Color, novelty, and luxury came together in the work of several female designers. Irene Castle continued to promote elegant simplicity, serving as a spokesperson for a silk mill and designing her own apparel line for a mail-order house. Virginia Chandler Hall, an American socialite who had grown up in France, ran a style service in Paris that interpreted French fashion for American businesses and later worked as a silk stylist for the Belding-Heminway Company. Lillian Callahan spent ten years as a fashion director for H. R. Mallinson & Company, creating hundreds of "original shades by combining from two to seventy-five variations of color tones." Margery Nevins worked for the pattern maker Butterick and for the magazine *Pictorial Review* before joining Schwarzenbach, Huber & Company, a silk importer and manufacturer with showrooms in the new Garment Center along Seventh Avenue in New York, where she applied her "knowledge of color, coupled with that rarity known as color judgment."[3]

The color vogue and the economic boom focused the attention of American business on women as consumers—and as adept colorists with something special to offer business. Celebrities and suffragettes became color and style experts. Female colorists upset cultural assumptions about women and showed business how the "woman's viewpoint" could be useful in product design. As a business tool in feminine hands, the color craze seemed to offset complaints about the facelessness of urban life and to embody the very essence of modernity.

The Taylor System of Color Harmony

If you were asked to supply a number of color combinations which would harmonize with the reigning color, Fuchsia, could you do it intelligently and comprehensively?

—Hazel H. Adler, 1921

Hazel H. Adler typified the entrepreneur who capitalized on modern colors and feminine psychology. In 1916 she published *The New Interior*, an advice book that established her as a design authority on a par with the leading lights of the field, Elsie de Wolfe and Frank Alvah Parsons. In 1923 she designed a color harmony chart for *Good Housekeeping* and wrote a trade catalog for the George W. Blabon Company, a linoleum manufacturer. Tapping into pop psychology, Adler urged Mrs. Consumer to redo her "colorless home" lest people think she had a "colorless personality." But Adler made her real mark with her consulting business, the Taylor System of Color Harmony.[4]

Color in the Kitchen

Why, bless you, in your kitchen you can unlock all the repressed desires for gay and giddy colors that you have so carefully toned down in the more public rooms of your house.

—*Better Homes and Gardens*, June 1925

By the mid 1920s, the glaring white kitchens of the germ-conscious Progressive era looked outdated. *Better Homes and Gardens* encouraged women to update their kitchens with color. Suburban developers courted potential homeowners with kitchens painted gray and white, but Genevieve Callahan, writing in *Better Homes and Gardens*, criticized such "ready-made color schemes." Why, she asked, not redecorate the kitchen with some new Chinese Red linoleum, or some Czechoslovakian peasant pottery, or sheer lavender-pink curtains? "You can make your most used workroom a perfect frame for yourself, studying your own coloring and your own personality."[5]

Department stores promoted colorful kitchens and pantries after the Exposition international des arts décoratifs et industriels modernes, the 1925 Paris fair that launched the Art Deco style. Inspired by a display of "gay enameled pots and pans" at the Paris Exposition, the New York department store R. H. Macy & Company held a promotional campaign called Color in the Kitchen. In 1926, Macy's Herald Square housewares basement and two show windows on Broadway featured sponges, brooms, eggbeaters, and vacuum cleaners in the primary colors (red, blue, and yellow) and in green. Buyers for stores elsewhere in the country took up the idea. Department stores such as Kaufmann's in Pittsburgh dressed their dishware displays in a "wondrous garb of color." But after nine months, "the goose that laid the golden egg became nearly moribund." Macy's shoppers grew tired of the bright Milton Bradley colors, and a quest for more enduring shades followed.[6]

Manufacturers responded with pastels. In 1926, the Fostoria Glass Company of Moundsville, West Virginia, introduced a line of transparent pink and green tableware to compete with fine china, but the product sensation of that year debuted at the American Gas Association convention in Atlantic City. One exhibitor showed gas ranges painted in pale-colored porcelain enamels, much to the delight of the delegates' wives. Salesmen from the regional gas companies raved about "the new idea in ranges," and "the fight began to work out plans for their manufacture and sale." Enameled ivory stoves outlined in apple green became fashionable, as did linoleum in multi-colored patterns. (See figure I.2.) Sherwin-Williams, Martin Senour, Benjamin Moore, and other paint companies encouraged Mrs. Consumer to make over her entire kitchen in color.[7]

6.2 Advertisement for paint, *Literary Digest*, February 11, 1928.

The Taylor System of Color Harmony was the invention of Henry Fitch Taylor, an American painter who worked in the Impressionist and Cubist styles. He had spent his youth in Paris and Barbizon. In New York, he managed the Madison Gallery, co-founded the Association of American Painters and Sculptors, and helped to organize the Armory Show of 1913, which introduced European modernism to the American public. In Paris around the time of the Armory Show, the young Americans Stanton MacDonald-Wright and Morgan Russell applied color theory to abstract painting to launch a style known as Synchromism, meaning simply "with color." Taylor's work, like that other American modernists, was influenced by their expressionist philosophy, which linked abstraction and color to the emotions.[8]

Around 1915, Taylor used his painterly and entrepreneurial skills to design a visual tool for making fresh color combinations. The creative industries still saw Michel-Eugène Chevreul as a major authority on color, but his theory of harmony was outmoded. "It provides only one harmonizing color for each color in the circle," the *Color Trade Journal* explained, and "furnishes only the most elementary means of checking up the subtle use of color of the master designers." Taylor wanted a more "elastic and comprehensive" method that would be sympathetic to the interpretive approaches of Impressionism and Synchromism. Assisted by the painter Arthur B. Davies, Taylor developed a cardboard color harmony keyboard that used moveable black masks to show 20,000 harmonious combinations, each combination using at least two shades and some as many as eight. The original system, priced at $200, was bought mostly by large manufacturers that could afford it. Eventually, Taylor collaborated with Hazel Adler to simplify the system so that it could be sold more widely. By 1921, Adler was selling the Taylor System to art directors, designers, merchandise managers, and stylists for only $15.[9]

Hazel Adler was a deft promoter and publicist, as is evident from her use of the Taylor System to resolve a problem for the motor vehicle authorities of New York State in 1924. The state's pearl-gray-and-white number plates for cars were "artistic and delicate," but, like gray battleships, they blended into the background. During Prohibition, the "alarming popularity of motor cars for bootlegging, escaping bank robbers, and other law-breakers" created a need for number plates that could be read from afar. Adler designed a more visible paint scheme with black letters on a yellow background. Traffic cops, *Motor* magazine, and the *New York Times* praised the plates.[10]

The name Taylor was familiar to engineers and other devotees of scientific management from the work of Frederick Winslow Taylor, and Adler took advantage of the coincidence. Her use of the name Taylor was a carefully crafted suggestion that this particular color system was inspired by the father of scientific management. She was dedicated to efficiency and harmony, which implied links to both industry and art. "A hit-or-miss method in any of the branches of manufacture is now

recognized as costly, wasteful, and inefficient," one popular magazine explained. In "the selection of colors, . . . a manufacturer makes up fifty or sixty designs, trusting to luck that ten or fifteen of them will succeed. The remainder are ticketed as 'lemons' and jobbed to the highest bidder." Adler hoped reduce production costs by eliminating "lemons," but, like Albert Munsell, she had a broader aesthetic agenda. "The general purpose of the keyboard," she explained in *American Dyestuff Reporter*, "is not that of a color standard for matching shades, although it is used in this capacity by many textile manufacturers. The direct aim is to afford the layman, artist or student a means of accurately and quickly building up harmonious and distinctive combinations on a wide range of foundation colors. The harmonies on the keyboard are insured—by the eye and by corroboration with all known color laws." As in jazz music and in modern art, the colorist was given an instrument and expected to compose his own harmonies.[11]

This measured approach to creativity appealed to large engineering-driven corporations, many of which adopted the Taylor System. Adler's impressive list of clients included B. F. Goodrich & Company, the National Lead Company, and Sears, Roebuck & Company. Her work for the Murphy Varnish Company was publicized in *Motor* and caught the attention of the Ford Motor Company. Hired by Ford to colorize the new Model A, she designed paint schemes in Arabian Sand, Dawn Gray, Gunmetal Blue, and Niagara Blue. For the Kohler Company, a major manufacturer of plumbing fixtures, she did some remedial work. Inspired by Macy's Color in the Kitchen campaign, a Kohler manager had "thrust a handful of samples of pink chiffon, green voile and possibly a bit of heliotrope jersey into the hands of the chief engineer." On the notion that "these are the popular colors in New York this season," he wanted them to be used in Kohler's sinks. After the sinks sold poorly (as a result of poor quality control and inappropriate colors), other Kohler managers called on Hazel Adler for help. Adler and two female assistants revamped the palette for Kohler's Color Ware on the basis of home-furnishing trends and consumers' responses to color samples. They chose Silver Green, Bisque, and Thrush Gray for kitchen and laundry fixtures, and replaced Old Ivory with Tuscan for bathroom fixtures. Kohler showrooms around the country reported favorably on Adler's color selection and made Tuscan a best seller.[12]

Hazel Adler's color consultancy won national acclaim. Her Taylor System jazzed up color practice in the industrial arts with references to efficiency, psychology, and modern art.

The Colors of Modern Art

Henry Fitch Taylor was one of many modern painters who used color to both artistic and commercial advantage. A younger generation of avant-garde artists who gathered around Alfred Stieglitz in the 1910s and the 1920s focused on rendering what they believed would be, in the words of Wanda Corn, "the first, the only, and the most authentic American art." Known as the second Stieglitz circle, the

Kohler Tuscan Imperator Bath

Eleven Important Points About Plumbing

1 *Kohler designs* are decorative, purposeful, correct.

2 *Kohler enamel* is made by an exclusive formula, fused with an everlasting bond and keeps its smooth, glistening surface.

3 *Vitreous china* pieces are sculptured for beauty and service . . . thoroughly vitrified at high temperatures and armored with a smooth, lustrous, lasting glaze.

4 *Kohler colors* are soft, livable pastels . . . the white is a perfect white.

5 *Kohler metal fittings* are engineered for efficiency . . . heavily plated with chromium, nickel, or gold. They match the fixtures in style, character and quality.

6 *Materials* are the finest—*manufacture* is most particular. All Kohler products show craftsmanship and care.

7 This company *pioneered* many of the big advances in plumbing. This year's Kohler products are next year's new ideas.

8 Kohler quality extends to the *kitchen and laundry* —for every plumbing need.

9 Kohler quality *costs no more* . . and saves money later.

10 Kohler fixtures and fittings are handled and installed by qualified plumbers.

11 Back of the Kohler trade-marks are the traditions and spirit of *an entire community* . . . beautiful Kohler Village.

6.3 A page in *New Beauty and Utility in Plumbing Fixtures* (Kohler Company, 1930). The illustration shows Tuscan, a new shade of gold designed by Hazel Adler for Kohler Color Ware bathroom fixtures. Archives Center, National Museum of American History, Smithsonian Institution.

6.4 The cover of Hazel Adler's *Home Furnishing Color Chart* promoting the Taylor System of Color Harmony, 1926.

painters Georgia O'Keeffe (1887–1986), Arthur Dove, Marsden Hartley, John Marin, and Charles Demuth and the photographer Paul Strand saw this new American art as drawing sustenance from everyday life. This art, much of it characterized by a new kind of realism, with striking compositions, vernacular themes, and bright, bold colors, sought to capture the spirit of America in ways that a broad public could understand.[13]

During the 1920s, these American artists, through Stieglitz's advocacy as gallery owner, publisher, promoter, and all-around entrepreneur, achieved acclaim in New York. Before the Armory Show, Stieglitz—a leading pictorial photographer and the proprietor of the 291 Gallery—had introduced Picasso, Cézanne, and other French modernists to the United States. By the time of World War I, however, his attention had shifted to American artists whose paintings sought to express an American sense of place. He vigorously promoted their work in New York, aiming for their widespread acceptance. In 1925, he mounted an exhibition, Seven Americans, that celebrated artists who Stieglitz believed captured the spiritual essence of American-ness. Georgia O'Keeffe, his wife, was the focus of special promotions.[14]

Stieglitz developed strategies for establishing O'Keeffe's reputation as an artist and a colorist and for stimulating sales of her works. Influenced by Freudian theories about sex and desire, he contended that O'Keeffe's gender made her stand out among painters, enhancing her powers of perception. He put O'Keeffe forth as the American modernists' ideal of true womanhood. His nude photographs of her, which had astonished New York in 1921, displayed a sensual being comfortable in her own skin, an up-to-date woman unafraid of her sexual appetite. Thus portrayed, O'Keeffe appealed to daring patrons seeking social status by acquiring and displaying art that challenged the status quo. Although O'Keeffe herself rejected the sexual inferences, Stieglitz's sexual allusions continued to shock and titillate the public.

Stieglitz expounded on the relationship between O'Keeffe's gender and her art in both public and private venues into the 1920s. In a 1919 essay, "Women in Art," he put it simply: "Woman feels the World differently than Man feels it. . . . The Woman receives the World through her Womb. That is the seat of her deepest feeling. Mind comes second." He repeatedly identified O'Keeffe as the feminine other in his close-knit circle. The sensuous flowers and fruit she exhibited in her solo show at the Anderson Galleries in 1923 seemed to confirm Stieglitz's assertions. Her daring and vivid use of color shocked observers, who often attributed her palette to gender. Critics read her words as verifying her feminine and passionate nature, particularly when she made remarks like "I paint because color is a significant language to me." Here was O'Keeffe as the surrogate for everywoman, attuned to the nuances of color more than her male counterparts. Stieglitz, aware that sexuality had market value, did nothing to curb the media frenzy over women, passion, and color.[15]

The controversy escalated in 1925 and 1926, when O'Keeffe's large-format flower paintings, arresting for their sexually suggestive botanical details and dramatic color, were exhibited for the first time. New York critics marveled at her colors. One early admirer remarked that nothing rivaled her "red apples, . . . purple-green alligator pears, flaming red cannas, dead white calla lilies and yellow and red autumn leaves." In 1926, *Art News* noted that the expressiveness of O'Keeffe's paintings stemmed partly from her exceptional "color sense"; it was "pure and resonant" and "strangely selective." Whereas the "multitude of colors and the diversity of tones" on any given day might bewilder a less-talented painter, O'Keeffe had an uncanny ability to overcome sensory overload and to home in on the essential yellowness of a tree, the redness of a barn, or the blueness of a petunia.[16]

Cultured readers of the gallery columns in New York newspapers understood that O'Keeffe was on to something exciting, even if the editors prohibited the journalists from discussing the obvious sexual references. Male writers who were confused, embarrassed, or censored focused on how gallery-goers responded to the O'Keeffe's palette. In the magazine *Dial*, Henry McBride admitted to a fascination with female visitors to the Intimate Gallery, where their "shrieks and screams" signaled a distinctive feminine sensitivity to O'Keeffe's motifs and colors. Writers like McBride could only hint at the sexuality of O'Keeffe's silky vaginal flowers, using coded discussions about basic womanly instincts and color sensitivity. One had to read between the lines.[17]

Color as Corporate Strategy

A little while back some enterprising manufacturer thought he might as well
throw a monkey-wrench into the works and start something. He did. That
monkey-wrench was Color, of course.
—*Nation's Business*, 1929

Avant-garde art and commercial color practice continued to cross paths as the enthusiasm for modernism permeated American culture, reaching city sophisticates through magazines, museum exhibitions, and retail displays. In the textile industry, H. R. Mallinson & Company, the Stehli Silk Corporation, and the Cheney Brothers Silk Manufacturing Company connected avant-garde art and design practice. In 1925, Stehli introduced the Americana Prints, a line of dress fabrics by prominent American graphic designers. As competitors invested in stylish motifs, Cheney focused on bold, modernistic color.[18]

Cheney Brothers was among the most innovative of the textile companies. In 1920, it was the largest American producer of broad silks for upholstery, draperies, and clothing, with factories in Manchester, Connecticut, and with design, advertising, and marketing efforts managed from offices

in Manhattan. While other silk houses imported cheap fabrics from Europe and Asia, Cheney manufactured high-quality textiles for interior decoration and a range of fabrics for women's clothing. The company owed its longevity largely to the popularity of silk as a material for better daytime outfits and for "Sunday best." In the early 1920s, two developments disrupted this model.[19]

First, new textiles woven from man-made fibers threatened silk's position as the world's most-coveted fabric. "Miracle materials" such as DuPont's rayon, a cellulose-based fiber marketed as artificial silk, began to compete with real silk. "Rayon has given us a new life and new inspiration, for there is a light catching quality in rayon which gives it priceless artistic value," one fabric stylist explained in 1926. "The immense possibilities for various beautiful effects are in their infancy." Budget-wise shoppers enthusiastically embraced the durable new imitation silks. The retail buyers responsible for stocking mail-order houses, specialty shops, and department stores filled their dry-goods sections with these less expensive fabrics.[20]

Second, the boom in ready-made apparel created another crisis. Around 1920, textile sales were equally divided between retailers that sold yard goods and the ready-to-wear industry. The revolutionary flapper dress was easy to sew in a factory, and its loose styling meant that an off-the-rack outfit was more likely to fit the average figure. Around this time, the New York apparel industry, seeking to modernize its factories, moved from the Lower East Side to the new Garment Center skyscrapers along Seventh Avenue above Thirty-Fourth Street. Rayon, along with inexpensive silk imports, appealed to garment manufacturers (called "cutters" within their industry) that were eager to reduce costs. By 1931, these garment cutters accounted for 80 percent of apparel fabric sales; only 20 percent went to retailers. Department stores, which traced their origins to the dry-goods emporiums of the nineteenth century, reduced the amount of floor space allotted to fabrics and made room for ready-to-wear.[21]

Such developments meant trouble for American silk makers unless they took decisive action. The major silk companies that had supported the Textile Color Card Association during World War I pulled back from that organization as they looked for up-market business. Competitive collaboration took new forms. The Silk Association of America sponsored trade exhibits to promote the industry among dry-good wholesalers, retail buyers, and garment manufacturers. As the cooperative ideal yielded to fierce competition, the Silk Association tried to battle design piracy by establishing a fashion bureau that registered printed patterns. But these countermeasures could not stop the rise of rayon and of ready-made apparel. The silk industry entered a period of rapid decline.[22]

Cheney Brothers' managers devised tactics to reposition their high-quality fabrics in the dry-goods trade. If cheaper rayon and imported silk fabrics were to dominate the mass market, their firm's only hope for survival, they reasoned, rested on luxury brands for wealthier women who still relied

on dressmakers. These shoppers could afford to follow Parisian trends, having their dressmakers sew new styles from season to season as hemlines, silhouettes, textures, patterns, and colors changed. Cheney silks would be their fabric of choice only if the designs were sufficiently distinctive. The better Seventh Avenue cutters would fall into line, catering to the preferences of well-off shoppers. The challenge for the firm's managers in the New York office was to give Cheney silks these elusive and evanescent qualities.

Cheney Brothers turned to color merchandising. Silk mills had always paid attention to color, but now they expressly articulated their interest in color in their branding and merchandising efforts. Cheney Brothers subscribed to the Textile Color Card Association's standards and forecasts, but as a niche marketer it needed proprietary colors and unique promotions that would give it a competitive edge. Expensive designs were created behind closed doors rather than in collaboration with other firms. These efforts, which drew inspiration from the color vogue, had a decidedly French twist.

First Stop, Paris

Cheney Brothers looked to Paris, developing relationships with French designers, dressmakers, and painters to augment the firm's aesthetic capital, its expertise in design, and its knowledge of color. Modern art could endow silk with much-needed distinctiveness. French modern art could give it cachet, updating its exotic image by association with the center of European fashion and modernism, where designers and artists, inspired by the Far East and Africa, pioneered a new look in material and visual culture. These efforts were masterminded by the French designer Henry Creange and the American public-relations consultant Edward L. Bernays.

Cheney Brothers hired Creange as its first art director in 1918. Born in Alsace-Lorraine, Creange studied art under Auguste Rodin and, like Albert Munsell and Abbott Thayer, studied painting and color harmony under Jean-Léon Gérôme at the École des beaux-arts before building an international reputation as a product designer. He was also an authority on transatlantic commerce and culture. Creange first came to the United States at the age of 15, working for importers until 1907 when he launched his own New York wholesale business. In 1916, he toured the United States on behalf of the French prime minister to research the American market for French goods. As Cheney Brothers' art director, he maintained his European ties, living in Paris and steaming across the Atlantic several times each year. At home in Paris, he visited the couture houses, the department stores, and the various shops, studying the latest dresses, fabrics, and accessories. He adapted these styles to create Cheney Silks, a brand of luxury fabrics intended for the high-end market.[23]

After 1923, Edward Bernays was hired to publicize Cheney Silks as inspired by modern art and the color revolution. Having worked for the Committee on Public Information during the war, this

former propagandist ran a New York consulting firm that specialized in corporate image making. A nephew of Sigmund Freud, he was a master of psychology who claimed to tap into the consumer's subconscious desires as he helped corporations to "manufacture consent." Whether the product was Lucky Strike cigarettes or Cheney Silks, he worked the media to get his client's message to the public, which he called the "group or mass mind."[24]

Creange and Bernays developed a strategy for promoting Cheney Brothers as the silk maker that had mastered French modernist styles and knew what color-conscious American shoppers wanted. The Cheney Style Service was created in 1923 to publicize Cheney Silks out of Bernays' office in New York. The first project was to promote Creange's fashion sketches in a series of circulars titled *Croquis de la Mode Nouvelle en Cheney Silks*. These pamphlets, issued six times a year, were filled with French terminology and colorful watercolor drawings, alerting style-conscious journalists and retailers to Cheney's serious approach to Paris fashion.[25]

In 1924, Creange helped to develop an innovative advertising campaign for Cheney Silks that featured full-color reproductions of paintings by French avant-garde artists. In Paris he routinely rubbed elbows with painters, sculptors, and designers on the cutting edge, and in Manhattan he probably saw their work at the Wildenstein Gallery, which specialized in contemporary French art. Calkins and Holden, the New York advertising agency handling the Cheney account, reproduced colorful paintings by such French modernists as Eugène Cyprien Boulet, Jean-Gabriel Domergue, Jean Dupas, Marie Laurencin, and Kees van Dongen, and by Gerda Wegener, a Dutch illustrator who lived in Paris, in direct-mail circulars and magazine advertisements for Cheney Silks. This advertising art featured stylish women, thus linking femininity, French fashion, and Cheney color.[26]

Cheney's connections to French modern art were fully established by the summer of 1925, when the Exposition internationale des arts décoratifs et industriels modernes opened in Paris. In February, Creange launched the spring Cheney Silks advertising campaign with a reproduction of Jean Dupas' *Scheherazade Modernized*, which had served as the official poster of the Salon des arts décoratifs the previous year. He chose this picture and others by French modernists to appeal to the readers of elite women's magazines such as *Vogue* and *Harper's Bazar*. To consumers versed in high culture, the painting by Dupas would have signified Cheney's affinity with the Paris fine arts community. The Salon des arts décoratifs had already begun to foster the innovative designs for high-end furnishings that would be spotlighted at the Paris Exposition. Later called Art Deco, this Parisian style combined contemporary and "primitive" materials, shapes, colors, and forms in exciting ways. Cheney's advertisement, juxtaposing Dupas' poster with descriptions of the firm's silks as modern industrial art, would have suggested to readers that the firm was *très au courant*.[27]

Creange and Bernays visited the Paris Exposition as part of a small U.S. delegation appointed by Secretary of Commerce Herbert Hoover. The Department of Commerce had declined to show American products at an exposition that focused on high-end decorative arts and other luxury goods, but it sent mass-production emissaries to learn. Between the elegant fetes and the factory tours provided by French dignitaries and industrialists, Creange and Bernays studied the latest European furnishings and household accessories. The Department of Commerce had asked Bernays to bring home information about European designs that could be publicized in the press. The two men contributed to the official U.S. government report on the Paris Exposition.[28]

Invigorated by what he had seen at the Paris Exposition, Creange envisioned "a great French American entente in art and industry." The goal was to fuse American and European approaches to management and aesthetics. Creange wanted to adapt Taylorist principles to factories to increase throughput and augment profits without compromising the quality of the designs. "American large-scale industry, just as it has in late years installed in its mills efficiency experts, attached to . . . accounting and production, and just as commerce has in the past decade acquired merchandising experts, should now maintain experts in Art Direction as part and parcel of its executive staffs." Those art directors would study French fashion, but French "fashion news must indicate—not regulate—creation" for the U.S. market. Together, Creange and Bernays acknowledged that convergence—whether the meshing of fine and applied art, European and American, culture and commerce—fueled creativity. If borders existed, these two modern men looked beyond them, stressing adaptability, transgression, and flexibility.[29]

Mass Production of Style Goods

> Just as we can foretell that so many loaves of bread will be needed each day . . . ,
> we can also approximate how many yards of cotton or silk will be needed to
> clothe the women, how many pairs of shoes, etc. . . . But what kind of shoes,
> what color silks?
> —Henry Creange, 1926

Cheney Brothers' experiments with French modern art went hand in hand with the firm's venture into color merchandising. Creange's task was to systematize the design process, eliminating the guesswork that led to product failures, which in the dry-goods and ready-to-wear businesses materialized as inventory buildups and end of season returns. If a line of silk fabrics or apparel failed to sell, the producers—silk mills, garment makers, and retailers—lost profits.[30]

Creange organized the design process at Cheney Brothers around the building blocks of the transatlantic entente: the "mass production of style goods." He combined American scientific management with European traditions of craftsmanship, quality, and style. The factory's output was limited to three types of products: staple, semi-staple, and novelty. If widely adopted by the American style industries, Creange told the *New York Times,* this "three-phase system" would improve efficiency, reduce waste, and increase profits. The staples would "keep the mills busy" and generate income to "finance the creative effort." The factory art director, in turn, could focus on "new ideas."[31]

Ward Cheney, lecturing an executive conference at Babson College, explained how Cheney Brothers used the three-phase system to help its customers. "Color is one of the most influential factors in the saleability of products," he said, "and we must pay attention to it whether it is represented in the color of motor cars or the color of the package of cigarettes." Like DuPont and General Motors, Cheney Brothers had accountants that analyzed weekly sales statistics. They produced a color index that showed the "relative popularity of the various color families, the relative movement of novelties and staples, and the individual importance of the leading novelty colors." Factory salesmen, in turn, used these internal forecasts to guide retailers as to what proportion of staples, semi-staples, and novelties they should stock, and to predict the "public response . . . to these three groups."[32]

Creange's creative work on the novelty line Cheney Silks focused on the judicious choice of colors that reflected cultural trends. In using color in silk design and merchandising, he took inspiration from fine art and popular culture and speculated about the changing expectations of Cheney's target markets. Among his responsibilities as art director was using the statistical reports to anticipate how the latest trends—high and low, Parisian and American—might affect Cheney Silks. He also created forecasts for the luxury trade that complemented the mass-market reports of the Textile Color Card Association. Although forecasting was consistent with Creange's vision for the free flow of information in the great French-American entente, sharing data went against the instincts of some silk men who were battling the encroachment of rayon. Creange countered these critics by remarking that "if to anticipate the demand seems dangerous, to await it, and then try to serve an impatient public, is fatal."[33]

In 1925, with his grand scheme for cross-industry fertilization in mind, Creange experimented with signature colors for Cheney's novelty fabrics. He believed that each major style season—fall–winter, spring–summer—should be assigned "prevailing colors." These dominant hues should refer to the larger cultural events of the moment, such as the opening of Tutankhamen's tomb, Rudolph Valentino's tango dancing, or the decorative arts of the Paris Exposition. As fashion-conscious consumers wearied of the latest fad and its palette, styles would become obsolete more quickly. Such

shifts could have enormous appeal to the targeted audience of elite shoppers, a ready market for fabrics and clothing that varied from year to year. To test his ideas, Creange declared 1925 a "copper-red year"—probably in honor of the fiftieth anniversary of Georges Bizet's *Carmen*, an event that was celebrated with lavish productions at the Opéra Comique in Paris and the Metropolitan Opera in New York. For spring, Cheney introduced a dramatic Spanish palette that highlighted a range of harmonious reds, from copper to amber to bronze, and under Bernays' supervision, the Cheney Style Service touted red as the color of the season. But color-coordinated red silks—even when associated with Bizet's opera—failed to appeal to consumers. Accustomed to chromatic variety, shoppers and the retailers who catered to them scoffed at the monotony of a single dominant color.[34]

In 1926, Creange responded to this debacle by refining his color strategies and inaugurating the Cheney Color Service under the auspices of Bernays' office. That year, Richard Abercrombie, Cheney Brothers' manager for dress fabrics, announced the firm's decision to forecast a broader range of colors for the new season. Creange planned a palette of nineteen hues, spanning the "novelty" and "staple" ranges. The men turned to their female colleagues—Helen Cheney at Cheney Brothers, Miss Barnes at Calkins and Holdin, Kathleen Goldsmith in Bernays' office—for color names. These women coined names—Ambroon, Bluridge, Flambic—that expressed the "psychological effect of the color." These fanciful names were "original and modern" and could be used "in connection with any vogue that develops." It was expected that consumers would understand and remember them. In May of 1926, the Cheney Color Service released its official forecast of colors for fall and winter (figures 6.5, 6.6). Many conveyed upbeat modernity, evoking something intangible but exotic. Others were conservative, echoing popular older styles. Most important, the palette included shades of blue, brown, gray, green, and red to accommodate a wide variety of taste preferences. Creange had his satisfaction in August, when the Paris couture openings reinforced his predictions. In a truly international move, the Cheney Color Service had scooped the French style makers.[35]

Like Cheney Brothers' efforts with French modern art in national advertising, this program of color styling demonstrated an affinity with innovative ideas. The Paris Exposition stimulated a wide interest among New York tastemakers in the new French style that would be nicknamed Art Deco. Where the Paris Exposition and the French modernist campaign had linked the company to the European avant-garde, the Cheney Color Service tied the old New England silk maker to innovative thinking in American business circles, where color styling was heralded as the design solution of the decade. Eye appeal mattered in the silk business, and Creange, a designer with two decades of experience, had to keep up.

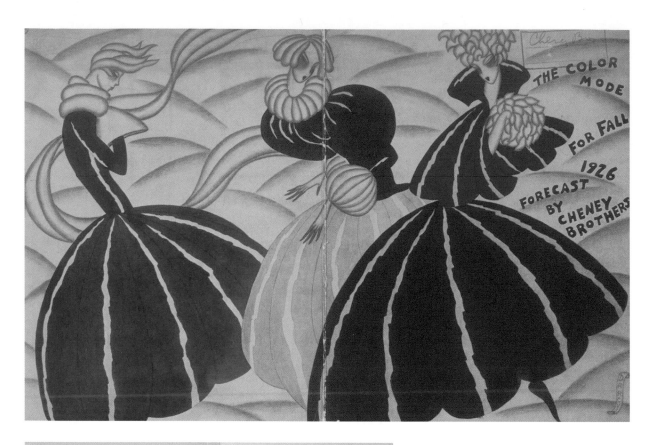

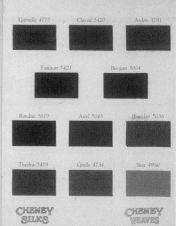

THE PARISIAN OPENINGS
VERIFY THE CHENEY
FORECAST OF COLOR STYLES

It is significant that the favored colors of the *haute
couture* are the same as those emphasized by Cheney
Brothers for this Fall and Winter.

The nineteen colors shown in Cheney Brothers'
previous announcement—(a copy was sent to you) are
already living up to predictions.

As the season advances certain shades of
deeper tone will win a place among the original nine-
teen. They have the same character—belong to the
same family, as shown on the opposite page.

The three original blues, Bluridge, Astel and
Rondac, are given added emphasis by including them
on this supplementary color card.

6.4 Cover of the large-format fall 1926 color fore-
cast for Cheney Silks. Edward L. Bernays Papers,
Library of Congress.

6.5 Color chart in pocket edition of the
fall 1926 forecast for Cheney Silks. Edward L.
Bernays Papers, Library of Congress.

The Cheney-O'Keeffe Colors

> To obtain the best color judgment, taste and art possible in defining fashion's
> new acceptable colors, Cheney Brothers has gone to Miss O'Keeffe, who in turn
> has symbolized with her brush . . . the new shades.
> —Paul Thomas, Cheney Brothers, 1926

The success of the Cheney Color Service depended on national advertising, cross-industry coordination, and avant-garde tie-ins. With Edward Bernays' advice, the Calkins and Holdin advertising agency continued to run the French modernist campaign in top fashion magazines. In August of 1926, a *Vogue* advertisement featuring *La Rose Blanche,* a 1924 painting by Marie Laurencin shown at the Wildenstein Gallery in New York, announced the stunning new fall line and its unusual keynote color. The advertisement, which attributed the "vogue of Marie Laurencin's art" to the painter's willingness "to break sharply with tradition and go forth freshly to a newer and untried world," went on to assert that Cheney's "interpretation and unique presentation of the fall colors" departed "from anything done before." Laurencin, a designer of costumes for the French stage, was known in Paris and New York for her distinctive portraits of stylish women in pastel colors.[36]

While advertisements in *Vogue, Harper's Bazar,* and other fashion magazines told consumers what to think, the staff of the Cheney Color Service kept in touch with retailers by distributing press releases, color cards, and direct-mail folders. Inquiries from firms in style-conscious industries, from shoes to automobiles, including the "Duco people," inundated the Cheney sales staff. These firms' adoption of the silk maker's new hues for their fall lines fortified Cheney's eminence as a fashion innovator.[37]

"A thing which is stylish is an artistic creation which conforms to the popular taste of the moment," wrote Ward Cheney, "and which is sponsored by persons of authority." In line with the latter requirement, Edward Bernays pressed Cheney Brothers to secure an endorsement from a celebrity. Owing to the novelty of color forecasting with its ties to scientific management, the firm needed public affirmation from a native-born artistic luminary whose reputation was just as edgy as the color Ambroon. The task of getting this endorsement fell to the bold Bernays, who secured the cooperation of New York's leading avant-garde figures: Alfred Stieglitz and Georgia O'Keeffe.[38]

In April of 1926, Bernays visited the Intimate Gallery—a little room rented by Stieglitz in the Anderson Galleries on Park Avenue—and made an unusual proposal to Stieglitz and O'Keeffe. He was fully aware of the excitement over O'Keeffe's color paintings and the debate about the so-called feminine qualities of her work. O'Keeffe's solo exhibition Fifty Recent Paintings, on view at the Intimate Gallery since early February, spotlighted her talents as a feminine artist and an avant-garde colorist. Bernays knew from the critical acclaim of this and other recent shows that the moment was

right for a Cheney-O'Keeffe liaison. O'Keeffe's celebrity as a colorist and a woman artist was perfect. What better way to impress a colorful product on potential customers for Cheney Silks than with color itself, that great persuader of the emotions? Bernays had seen some of O'Keeffe's "symbolic erotic color work" and thought "wouldn't it be a great idea" if she "could do these color symbols" for Cheney?[39]

When Bernays introduced the subject, Stieglitz and O'Keeffe reportedly balked at his audacity. Craftily, Stieglitz kept two metaphorical hats in his closet: an elegant black top hat that he wore when expounding on the virtues of high art and a weathered brown fedora that he used when talking about business deals. Initially, he put on the silk top hat of the self-appointed pied piper of American modernism, playing the role of the critic who decried the crudity and crassness of commercial culture. Lashing out, Stieglitz asked why O'Keeffe should risk her hallowed reputation by accepting an advertising commission? As the artiste, he segued into a diatribe about the mistreatment of artists by society. In a brilliant move, Bernays defused Stieglitz's ire with a proposal of patronage, offering him a rent-free studio in a Manhattan building owned by this family. Outmaneuvered, Stieglitz grew silent. Bernays, smelling victory, promised to telephone the next day on the Cheney matter.[40]

Ultimately, Stieglitz decided, as O'Keeffe's agent, to accept Cheney's commission. The artist agreed to provide five flower canvases to Cheney, selecting colors that matched the Creange-designed silk palette for the 1926 fall season. The art department at Calkins and Holdin framed O'Keeffe's plaques (each 16 by 12 inches) for window displays and reproduced her images on large posters for stores, on small placards for countertops in fabric departments, and on leaflets for direct mailings to retailers and consumers (figure 6.7). The public responded favorably to O'Keeffe's abstractions. Department-store window dressers placed the original O'Keeffe paintings beside colorful Cheney Silks in eye-catching displays at Marshall Field in Chicago and at B. Altman in New York (figure 6.8). A *New York Times* art critic commended the vision, foresight, and boldness of Cheney in securing "O'Keeffe's glowing color symphonies."[41]

O'Keeffe's paintings were never used in Cheney's national magazine advertisements, but their use in display windows and publicity materials complemented the fall 1926 French modernist print campaign. For retailers, Bernays' office created sales aids that explained the Cheney-O'Keeffe colors and produced sample newspaper ads that showed stores how to advertise the latest colored silks. Direct-mail circulars and store booklets described O'Keeffe's renderings, which depicted each group of new colors as a highly magnified floral abstraction. O'Keeffe's color symphonies, as Bernays had anticipated, made heads turn. According to the copy, the shades of green—Kern, Spreen, Tamac— expressed "the surging upward movement of all green things in curves, in angles and in ever changing shades." These colors represented "spring or an enveloping river, the burgeoning grass or ocean water,

CHENEY BROTHERS

INVITE YOU TO BE

PRESENT AT THEIR

FALL OPENING, ON

WEDNESDAY, MAY 5,

1926, AT 2.30 P.M. ∾

181 MADISON AVENUE

AT 34TH ST., NEW YORK

6.7 Invitation to Cheney Brothers' preview for fall 1926, featuring artwork by Georgia O'Keeffe. Edward L. Bernays Papers, Library of Congress.

6.8 This show window, featuring a sketch by the French modernist Kees van Dongen, suggests how the Georgia O'Keeffe artwork might have been displayed. B. Altman Window Display photographs, 1930–1987, Fashion Institute of Technology, FIT Library Department of Special Collections and FIT Archives, New York.

or emeralds." The browns—Ambroon, Krubble, Sarn, Tawn—recalled "the bark of living trees or the rich or fruitful earth." The blues looked like "the unfolding of many, many petals moving in undulating curves upwards and into themselves" to convey "a feeling of cool and restful serenity." Several of those blues—Astel, Bluridge, Rondac—reminded Bernays of "sailing on the Mediterranean or looking deep into a sapphire." The story was much the same for the grays and the reds. Some people, Bernays recounted, said that the O'Keeffe painting in red had "the restless fickle movement of

flames." Others "shuddered and thought they looked like the color of internal organs of some mysterious kind." Still others saw in the picture "some reddish manifestation of nature" or "red germs moving under a microscope." The red startled even Bernays, for "it showed the essence of life itself." Perhaps shocked by the sultry eroticism or the raw sexuality, "one salesman," he reported, "almost fainted."[42]

Fainthearted salesmen notwithstanding, this colorful partnership between American art and industry succeeded—at least for the moment. The O'Keeffe paintings helped Cheney Brothers maintain its status in the textile industry as American silk fought its losing battle against rayon. Bernays reported that Cheney's new color palette "forged ahead" in part because of the "dynamic interest lent to the line" by the "O'Keeffe symbols." It didn't matter that she hadn't designed the colors. In the visual culture of the 1920s, fabrics and flowers were coded as feminine, and the O'Keeffe images simply went one step further, equating silky petals with silky sexuality with silky fabrics. American abstraction, like French modernism, had proved its market value. Cheney Brothers gained cultural capital through its association with the American avant-garde and the color revolution.[43]

The Importance of Being Colorful—and Modern

Everything that people wear, everything they use, everything they surround themselves with, must have color. Here is a decided merchandising trend.
—Walter G. Baumhogger, vice-president, Montgomery, Ward & Co., 1929

The stories of the Taylor System and the Cheney Brothers show how the color revolution made transnational partners of modern art and business culture. It created a space for consultants such as Hazel Adler, who built on Henry Fitch Taylor's work as a modern artist and on Frederick Winslow Taylor's theories of scientific management to sell her services in color psychology. It dovetailed with the expansion of ready-to-wear and provided the textile industry with a new marketing tool at the moment when rayon threatened silk. Long known for quality fabrics, Cheney responded by developing new ways to apply aesthetics to design and commerce. Color was the linchpin that connected this firm to New York, Paris, and the modern art of Marie Laurencin and Georgia O'Keeffe.[44]

Henry Creange was a citizen of the world who felt equally at home in Paris and in New York. His vision of a French-American entente showed his deep personal connection to both countries and his commitment to cross-cultural exchange. Like other trend watchers, he acknowledged the need for two-way flows across the Atlantic Ocean. In the United States, one trade journalist noted, fashion "follows the trend of the Paris fashion, . . . with an American accent," but "Paris does not originate all

of the styles. Some of them come from America." This was certainly true for color and for the mass production of style goods. Creange knew that it would be futile for New York to ignore Paris, or for couture houses to look down their Gallic noses at Seventh Avenue cutters. Unknowingly, he pointed to the global future—to the twenty-first century, in which the fashion industry operates across national boundaries and creates different palettes for different markets—but his transnational hopes were circumscribed by the economic and institutional realities of his time. Cheney Brothers was a style leader, but its resources were diminishing as a result of the declining demand for silk. Working within those constraints, Creange combined color's emotional power, modernistic textile motifs, and fine art in advertising to strengthen the Cheney brand during a major crisis.[45]

By showing how companies could use color to evoke an emotional response, to seduce, and to manipulate, Edward Bernays introduced a new variable. Psychological machination was the forte of this pioneer of public relations, who showed Creange how to use color as a tool of persuasion. A few years later, Bernays again used color's suggestive power in a secret promotion for the American Tobacco Company. Women wouldn't buy Lucky Strike cigarettes because they thought the dark green package clashed with their wardrobes. The chief executive refused to redesign the package, having spent millions of dollars advertising it. Enlisting the support of New York high society ladies, Bernays launched the Green Ball, a spectacular charity event at the Waldorf-Astoria, which made dark green the fashion sensation of 1934. His staff worked behind the scenes getting stores to promote green, mills to make green, and prominent women to wear green. The Green Ball evoked color as a status symbol, a fashion trend, and a money generator. Bernays was a hidden persuader who would use any available means to advance his clients' interests. His work represented the dark underside of the color revolution.[46]

In the end, neither psychological appeals, gendered imagery, the avant-garde connection, nor dreams of entente could protect the silk companies from the onslaught of rayon. The organic chemists responsible for the color explosion had miraculously created fibers from wood pulp and were quietly working to synthesize the world's first test-tube fiber, nylon. During the Great Depression, sales of silk plummeted as consumers economized and the ready-to-wear industry reduced production. Many turned to man-made fibers as cheap alternatives to cotton, wool, linen, and silk. Marshall Field, which had a wholesale yard-goods division, embraced the trend by purchasing a rayon mill, expecting that half of its 1934 sales would be of products made of man-made fibers.[47]

Color technology and the mass media continued to challenge Cheney Silks. Initially, rayon and other cellulose-based fabrics owed much of their eye appeal to novel textures rather than to color. Once the chemical industry developed methods for dyeing the viscose mass before it was spun into

yarn, textile mills could weave cloth from colored rayon thread, rather than dyeing gray goods. This improved the quality of the color, further reduced production costs, and contributed to rayon's continued appeal. Cheney did not abandon silk, but it surrendered to the new order by diversifying into rayon in 1933. The future lay in synthetics. As Hollywood filmmakers experimented with

6.9 Invitation to 1934 Green Ball. Edward L. Bernays Papers, Library of Congress.

Technicolor film, they discovered that rayon cloth—supplied by DuPont, American Viscose, American Enka, and other large chemical companies—looked better in movies than other fabrics. American women longed to emulate the movie stars who graced the screen in beautifully tailored rayon suits and sportswear. There was no stopping the forward march of progress, chemistry, and color.[48]

Color took on greater significance with the explosion of consumer culture in the 1920s, leading commercial, industrial, and aesthetic subcultures to intersect and enrich one another. Cheney Brothers and other manufacturers looked to both popular culture and fine art as they incorporated color into product designs, marketing efforts, and advertising campaigns. Modern artists, understanding that there was no "one best way," also explored color's various dimensions, commercial and otherwise. Elsewhere in the style industries, the Textile Color Card Association continued to provide direction and sought to cope with the endless demand for novelty by connecting to Paris and by promoting a major merchandising innovation: the ensemble.

7 *L'Ensemble américain*

Born of spirited patriotism, the Textile Color Card Association faced new challenges as the American ready-to-wear industry expanded in the 1920s. New York apparel makers introduced easygoing "sporty apparel"—suits, blouses, and dresses in jerseys, rayon, and other modern fabrics—meant to be accessorized. Paris had inspired the trend; New York popularized it. As fashion became more affordable, American women took pride in assembling outfits that showed off their personal style, and learned to appreciate color accents in the process. The vogue for "ensemble dressing" created a need for color coordination across the fashion industries so that a woman's ready-made dress would harmonize with her shoes, her gloves, her belt, her stockings, and her hat.[1]

Ensemble dressing forced the Textile Color Card Association to reassess its mission—color standardization for the sake of efficiency—and adjust its color policies. Should the TCCA's emphasis be on Taylorism, or on trendy fashion? Margaret Hayden Rorke, an astute and style-savvy manager, arrived at a compromise position based on the TCCA's founding principle of "intelligent cooperation, the kind that marks [*sic*] for real progress." She promoted the cause of efficiency and scientific management *and* acknowledged the renewed influence of Paris. She recognized the importance of the national market to the future of American fashion and helped to foster its growth with a new merchandising concept: "color harmony in the ensemble." In doing so, she balanced American taste with French style, gaining widespread acceptance for the TCCA and establishing its position as the leading American color authority.[2]

Spreading the Gospel of Color Standardization

The great difficulty of matching the emerald of the shoe with the emerald of the stocking tends to discourage even the most experienced shoppers. And brilliant shoes that *nearly* match the equally brilliant stockings are taboo in the wardrobes of the well dressed.

—F. Blumenthal of Amalgamated Leather Companies, 1921

The widespread interest in color in merchandising was a new reality for the Textile Color Card Association. "Punchy" colors such as True Blue for cars and Alice Blue for silk dresses

(figure 7.1) dominated the mass market and masked the challenges of managing the unruly palette. Margaret Hayden Rorke acknowledged the American appetite for shocking shades and even accommodated it as she made herself the leading American authority on color in apparel and accessories. She spent the early years of the 1920s "making war on old fashioned methods, on the indolence, which is satisfied with things as they are" and spreading the "gospel of color standardization."[3]

Figure 7.1 An Alice Blue gown. The 1919 Broadway musical *Irene* popularized the color azure, naming it Alice Blue after Alice Roosevelt Longworth, the daughter of Theodore Roosevelt, who loved the new shade. Undated chromolithograph marked "K. Co. Inc. N.Y."

The expansion of the TCCA brought Rorke's diplomatic skills to bear on membership issues as she weighed the advantages of generating new dues against the organization's gate-keeping function. Between 1921 and 1926, the number of subscribers doubled to 1,450, but there were nagging questions as to who should belong. Rorke extended a warm welcome to leather tanners, auto manufacturers, Paris commissionaires, and European factories that exported to America; however, she found that retailers either shied away from the TCCA or wanted to publicize the confidential advance reports in store promotions. Consultants were persistent and irritating. Hazel Adler was reprimanded by Rorke when it was discovered that Adler had invoked the TCCA in sales pitches for the Taylor System of Color Harmony. Rorke had to handle these situations with discretion as she advanced the TCCA's mission and guarded its reputation.

The New York garment industry presented distinctive opportunities and challenges to Rorke as managing director of the TCCA. Even before the 1911 Triangle Shirtwaist fire, forward-looking apparel manufacturers had embraced progressive business practices in health, safety, design, and production. The Protocol of Peace—the historic 1910 compromise between the garment manufacturers and the International Ladies' Garment Workers' Union—improved the sweatshop image, as did the bright new factories of the Garment Center that was built along Seventh Avenue in the 1920s. Enlightened entrepreneurs versed in scientific management—among them Ralph Applebaum of King & Applebaum, Max Meyer of A. Beller & Company, and Jacob Goldman of the Associated Dress Industries of America—shared their knowledge of this labyrinthine industry, dominated by the descendants of Jewish immigrant tailors, family firms, and specialized business associations.

There was no way to predict the Garment Center's reaction to a standardization movement initiated by outsiders. Inexpensive blouses and undergarments lent themselves to quantity production, and those manufacturers saw the value of standardization early on. The United Waist League of America, led by the visionary M. Mosessohn, emphasized the elimination of waste, created its own shade card, and inspired other trade groups to standardize the sizes and colors of undergarments. Ultimately, the Waist League joined forces with the United Skirt League of America to issue a joint color card based on the Standard Color Card of America and agreed to manufacture skirts and blouses "in harmony with each other, instead of in the old hit or miss way." Conservatives hesitated: "Oh, well, we have our own colors. . . . We don't want to have the common colors that everybody else uses. We want colors that the others haven't got, and we think that our selection is just a little better." Margaret Hayden Rorke was patient, keeping her eyes on the apparel industry's leaders. Small victories boded well for future cooperation with the garment cutters. The manufacturer Adolphe Ortenberg of the Associated Dress Industries of America joined one of the TCCA's

committees, and Richard Beller of the Industrial Council of Cloak, Suit and Skirt Manufacturers gathered fellow cutters into an advisory group that helped the TCCA to promote seasonal colors for apparel.[4]

The TCCA's members from the leather industry were especially interested in color harmony. The Standard Color Card of America had proved its worth as a reference guide to staple colors, and the seasonal forecasts were a helpful tool for predicting fashion trends. But the leather tanners and jobbers wanted a program that would coordinate color trends across the various footwear industries. In the early 1920s, no one used the term "ensemble" to describe the evolving taste for matching accessories, but leather-industry executives knew that the discriminating shopper wanted emerald shoes that matched her emerald stockings. They saw the TCCA as the best means of coordinating color futures across all industries. This need was most pressing among the tanneries, which decided on their palettes far in advance in order "to get the leather dyed in time for the manufacturer."[5]

Margaret Hayden Rorke organized a style committee of tanners, shoemakers, and footwear retailers to select the staple leather colors for the fall forecast. That was a wise move. The inclusion of leather colors in this seasonal forecast was seen as a "great benefit to the hosiery industry and other allied trades, such as thread and shoe accessories." This positive outcome led to a series of special color cards for leather and to greater cross-industry coordination. (See figure 3.8.) The chairman of the Styles Committee of the National Boot and Shoe Manufacturers Association suggested that Rorke create "some kind of concise card" that would connect the colors of footwear to the colors of garments and the colors of millinery. He also wanted "style information" that would complement these color forecasts. Late in 1925, Rorke responded by publishing the inaugural edition of her Chart of Color Harmonies, a first step in the TCCA's formal commitment to fashion.[6]

The War on Waste

The Textile Color Card Association extended its reach to Washington, where Margaret Hayden Rorke found a strong supporter in Secretary of Commerce Herbert Hoover, a progressive advocate of a new type of government that would work closely with industry. From 1921 to 1928, Hoover turned the Department of Commerce from a backwater bureau with a "do-nothing" reputation into an agency actively working to improve industrial efficiency and advance the American standard of living.[7]

Hoover had arrived in Washington as one of America's most prominent citizens, celebrated as The Great Humanitarian and The Great Engineer. A devout Quaker and an organizational wizard, he had managed the wartime U.S. Food Administration, orchestrated Belgian relief, and directed the Federated American Engineering Societies, an association of trade associations that addressed pressing economic problems such as inflation. Under his auspices, the FAES surveyed ten American

industries to ascertain how manufacturing might become more efficient. The final report, *Waste in Industry,* faulted profligate practices that led to excessive variety, inordinate costs, and high prices, and offered a blueprint for optimizing industrial performance.[8]

Hoover then took the war on waste to Washington, where it shaped his policies as Secretary of Commerce. Hoover saw bureaucracy as a means to an end, as a technology for crafting a new "American system" of "progressive democracy." The Department of Commerce advanced this agenda by bringing together different interest groups—business, government, professional societies, farmers' alliances, trade associations, labor unions—with a common goal of industrial efficiency. Collaboration, it was thought, would lead to greater productivity and economic security. Greed and avarice would be canceled by uplift and reform.

Implementation of this technocratic vision fell to the Bureau of Standards, where the new Division of Simplified Practice battled profligate manufacturing practices. Its first step in the war on waste was *standardization,* the process of creating an ideal model, or a standard, against which precision could be gauged. As Rorke knew, standards were now widely applied to producers' goods such as electric wiring, raw cotton, and petroleum and to such phenomena as electricity, radio frequency, temperature, and color. Much like the TCCA, the Department of Commerce saw itself as an orchestrator, a clearinghouse, and an archive. Scientists and engineers at the agency identified areas in need of standards, then did the research. "By standardization," Hoover explained, "we secure a positive approach through the establishment of definite notation in dimensions, quality, and performance of materials and machines, which must be accompanied by the development of tests to be applied in the determination of the fulfillment of those standards." That was jargon, but the objective was plain and simple: a better model that would result in better products.[9]

Another weapon against waste was *simplification,* the process of discontinuing designs that were impractical, unpopular, or unnecessary. Companies and trade associations were encouraged to identify excess capacity and to seek the agency's help with retooling. This strategy of "self-control" applied to wool blankets, tissue paper, steel bars, grinding wheels, sidewalk lights, and other goods. Rapidly increasing construction costs made new houses prohibitively expensive until a simplification project established national standards for lumber, bricks, and roofing tiles. The now-ubiquitous two-by-four emerged from these deliberations. Nine systems for hosiery were replaced by one, and ready-to-wear sizes were agreed upon. "By simplification," Hoover wrote, "we secure a negative approach through elimination of the least necessary varieties, dimensions, or grades of materials and products."[10]

Standardization aimed to measure quality and ensure its persistence, and simplification sought to streamline production and reduce costs. The dream was to achieve an ideal level of comfort—

"an increase of twenty to thirty percent in our standards of living," Hoover said. Some skeptics worried about the adverse effects on individuality and idiosyncrasy, fearing that stores would be forced to sell "one type of biscuit, one shape of shoe, one type of hat, one cut of coat." But that was never the goal. "We do not by this process propose to abolish Easter bonnets," the Division of Simplified Practice explained. "We propose more bonnets for the same money and effort."[11]

More Easter Bonnets

The prospect of making "more bonnets" for "the same money and effort" resonated with Margaret Hayden Rorke, and by the time Hoover was Secretary of Commerce she was well on the way to becoming America's chief chromatic officer—the top authority on how color coordination could reduce waste and increase efficiency. And whereas corporate colorists such as Matthew Luckiesh, H. Ledyard Towle, and Henry Creange were sworn to confidentiality, her goal was, as befit the "trade association movement," to forge connections and disseminate information.[12]

Owing to the Department of Commerce's contacts with the Munsell Research Laboratory in Baltimore (see chapter 2), Hoover understood color's importance. One of his early budget proposals as Secretary of Commerce to Congress requested funds "to develop color standards and methods of manufacture and of color measurement, with special reference to their industrial use in standardization and specification of colorants such as dyestuffs, inks, and pigments, and other products, paint, paper, and textiles, in which color is a pertinent property." His Bureau of Standards helped industry to determine color standards for a variety of materials, from cheese, oils, and sugar to porcelain, celluloid, and wood. "If manufactured teeth do not match nature's, they are worth little in dentistry," explained one government colorimetry expert. "Hardware and furniture often assume appreciably greater valuations because of their colors. . . . The finest mahogany does not interest the person unless the color scheme meets his requirements." While colors "may be fixt through trade customs," the Bureau of Standards preferred the Munsell Color System and spectrophotometric readings to introduce precision.[13]

The spirit of cooperation led Rorke to contact textile experts at the Bureau of Standards and plant the seeds for standard government colors. The American flag was the first order of business. "As you know, our association is the promoter of the movement for color standardization for the benefit of American Industry," she reminded the Division of Simplified Practice's flag committee. Flag specifications were relatively new, dating from an executive order by President William Howard Taft that dictated the proportions of the design elements. The patriotism of the 1920s, fueled by xenophobia, needed nationalist symbols, and the next logical step was to fix the colors of Old Glory. The textile mills that made the flag fabrics had a vested interest, and Rorke took their concerns to Washington.[14]

Military expansion and the availability of American dyestuffs opened other government doors. The wartime dye famine had forced the American armed services to abandon the traditional blue uniform, worn since the Revolutionary era, for olive green. When American dyes became available, the War Department re-instated the dark blue uniform. Large orders were at stake, and color mismatches would create substantial waste. Margaret Hayden Rorke used the opportunity to make herself an authority on color in uniforms. At the Quartermaster Depot in Philadelphia, she charmed the procurement officers and explained how "a set of standard colors for all the various branches of the Marine, Navy and Army" could save time and money. Why not assemble a small committee, with people from each military department, to choose a palette based on the Standard Color Card of America? If the extant shades were not quite right, Rorke would design "whatever colors were desired" for a special military card. "The quartermaster department could use these in furnishing information to manufacturers from whom they purchased material." Already versed in the Standard, procurers welcomed the proposal and encouraged Rorke to seek the advice of the Quartermaster General, which had the final say on uniforms, and the Bureau of Standards, which could test the fastness of the colors. In Washington, Rorke's interventions may have convinced Hoover to appoint a color committee within the Department of Commerce's new Federal Specifications Board, staffed by experts from the Bureau of Standards, the Army, the Navy, the Marine Corps, and the Department of Home Economics. By early 1926, Rorke was on well on the road to setting standards for military colors.[15]

Three years later, the Textile Color Card Association unveiled the United States Army Card for Arms and Services, dyed to match textile standards kept in Washington. The card specified the accepted colors for fabric and trim, such as stripes, chevrons, cording, and shoulder insignia. There were 18 official colors that were applicable to all 24 military branches, including old divisions such as the Cavalry and the Chaplains and new units such as the Air Corps and Military Intelligence. The Quartermaster Depot sent a copy to every single post, camp, and station, where purchasing officers would refer to it as a color standard while ordering textiles. Before long, the Marine Corps, the Bureau of Navigation, the Naval Supply Depot, and the Naval Academy at Annapolis had adopted the Army Card.

The Old Glory project moved much more slowly than the standardization of uniform colors. The flag committee of the Federal Specifications Board, where Rorke sat as an "unofficial observer," lacked motivation and expediency. There was no real reason for change, as the number of states in the union had stayed at 48 since 1912, when the last set of design rules went into effect. Not until 1935 were the final tests conducted and the standards approved. "Through our efforts," Rorke told the TCCA in triumph, Taylorism was extended to "the Red and Blue of the American flag."[16]

Washing Machine Gray

The history of Maytag washers shows how the color revolution affected manufacturers that hadn't yet dabbled in color. The Maytag Company, an Iowa producer of farm machinery, began making wringer washing machines for farm households in 1909. After World War I, F. L. Maytag looked to tap the urban market, where houses were being wired for electricity. A national advertising campaign and door-to-door demonstrations raised public awareness of electric washers and increased sales from $2 million to $53 million between 1921 and 1926. When sales dropped to $50 million in 1927, F. L Maytag predicted a continued tapering off due to competition, trade-ins, and fewer wiring projects.[17]

Maytag experimented with color styling as a marketing strategy. In the mid 1920s, when most wringer washers had a varnished wooden tub and bronze hardware, Maytag introduced steel-bodied washers in two colors: light gray and green. The slow-selling green washers were discontinued after the stock market crash of 1929, but Maytag returned to color within a few years, offering one model in two tones of gray and a polychrome model in tans and browns. By then, the majority of Maytag washers were gray and the production of other colors was limited.[18]

Maytag, like other newcomers to product styling, learned that colors could not be monopolized. Various companies tried to stake claims to particular colors, but the Patent Office and the Supreme Court ruled against it. The authorities judged corporate logos that combined color, symbols, and letters in a distinctive way—yellow taxicabs, Wrigley gum packages, and Gotham Silk Hosiery boxes—as protected under law, but wouldn't extend the ruling to a color by itself. "Mere color is not capable of exclusive use," explained the patent commissioner. Color by itself, "*apart from some design or symbol*, cannot alone constitute a valid trade-mark." As soon as a shade entered the marketplace, it was in the public domain and was available for anyone to copy. When Maytag sued a competitor for painting its washers "the same color, i.e., a light gray," the appellate court ruled in favor of the defendant. The jurists learned that it was impossible to apply brilliant colors to steel appliances, because the "heavy pigments" did not "adhere to the Udylite" (a type of electroplating applied to the metal body to keep it from rusting). Technical limitations thus made gray the color to use on washing machines. "Other manufacturers also use gray paint to the extent that it has become standardized and known as 'washing machine gray.'"[19]

New Deal regulations affected the colors of washing machines. Under the National Recovery Administration (a body that was set up to facilitate business-labor cooperation), industrial committees made up of representatives from industry, labor, and government wrote codes to regulate output and set minimum prices. These interventions irked appliance manufacturers, who danced around the rules with a bit of creative coloring. The Maytag Company repainted brown-and-tan models in green and blue, and marketed those models as new designs to "avoid the code agreement in price cutting as retail price was changed from $69.50 to $64.50."[20]

During the Depression, color differentiation became a strategy for entering new segments of the market. Improvements in coating technology allowed for a wider variety of color options. In 1936, Maytag introduced olive green models with the goal of creating "a better appearing washing machine in order to increase sales in low price bracket." Experiments continued until Maytag settled on three basic color schemes: brown, gray-and-white, and plain white. When consumers responded positively to the white washers, the other colors were discontinued. By 1942, when washer production was halted because of the war, Maytag was making only white machines.[21]

7.2 Washing machines on a Maytag assembly line of the 1920s. Theodor Horydczak Collection, Library of Congress.

Paris, *Tout Ensemble*

> The ensemble idea as a device for increasing the sale of style merchandise to the
> consumer is presenting itself in a new way—women are wearing shoes, a
> handbag and hat trimming all made of the same leather, or at least leather of the
> same color.
>
> —*Printers' Ink,* 1926

On the fashion front, Margaret Hayden Rorke's major achievement was connecting the Textile Color Card Association to Paris and to the vogue for ensembles. The matching outfit was an old idea—the American press had reported on the European *ensemble* for at least 100 years—but it was rediscovered and reinvented for modern times. "The old ensemble idea consisted of a costume with a matching dress," Cheney Brothers explained in fall of 1925, "but this season the term ensemble may mean any costume which is based on a studied harmony of color." As this trend spread, American shoppers would "become more adventurous" and "welcome suggestions as to more daring harmonies." The leather industry had pointed in this direction by responding to consumers who wanted shoes and stockings that went together. But it was Paris that articulated a vision of ensemble dressing based on color harmony, and it was New York that turned this couture idea into a mass-market merchandising concept. The TCCA was instrumental in this development.[22]

In the mid 1920s, the Paris couture houses advocated greater coordination between costumes and accessories. This was a reaction to the style upheavals of recent years—the outrageous Orientalism of Paul Poiret, for example—and the endless style changes that had led to aesthetic discord. Couture houses turned away from turbans, pantaloons, Russian colors, and Arabian motifs in favor of simpler, sporty outfits or "ensembles." "On one point all the Parisian artists seem to be in accord, at least for the time being—ensemble. It has become a sort of slogan," wrote the *New York Times* in 1924. "A harmony in style, color and *raison d'être* in one's dress is required on all occasions." In no small way, the female dressmakers—innovative drapers such as Madeleine Vionnet and athletic newcomers such as Gabrielle "Coco" Chanel—advanced this concept by designing youthful, easygoing clothes with matching accessories. "Ensemble is the ideal of the couturiere, and sports suits assume that hat, shoes and stockings, gloves, even belt and tie, must match or work into an artistic scheme."[23]

Paris went "ensemble mad" as New York grappled with consolidation of the national market and the drive for "creating style in America." Local tastes and idiosyncrasies came to matter less and less, "being limited more and more each year on the strength of women's magazines, radio, etc." Chain stores attracted bargain-hunters who liked bright lights and low prices. The ensemble was the ideal

7.3 This knitted woolen ensemble, made in Paris around 1927, included a sweater, a cardigan, a skirt, a beret, and a scarf in color-coordinated gray, pale blue, and navy blue. © The Museum at FIT.

merchandising concept for national growth, providing a framework for manufacturers that wanted to sell their goods from coast to coast. By 1924, members of the TCCA were lobbying for greater consistency among the various parts of the outfit, including the hosiery and shoes carried by the chain retailers. "The great vogue of the ensemble," one silk stylist said, "has drawn us all together more closely and we are trying to match up everything, hats, coats, and all these things."[24]

The Exposition internationale des arts décoratifs et industriels modernes in Paris in 1925 extended the influence of the couture ensemble to the decorative arts and to interior design. The Paris Exposition's signature style, *L'Art moderne*, affected the industrial arts profoundly, pushing some American manufacturers at the upper end of the market to create designs that could rival those of French manufacturers in originality. Luxury department stores now offered apparel, furniture, records, and electrical appliances. New York stores, using large staffs of buyers, stylists, and merchandise managers to create distinctive public images, set trends that were copied all over the country. Whereas an old-time buyer knew that standardization could enhance profits, a younger generation saw standardization as the antithesis of style. Many reveled in the avant-garde aesthetics of the 1925 Paris Exposition and pushed modernistic designs. This led to Macy's Color in the Kitchen promotion—and to strange-looking grandfather clocks painted in the primitive colors of modern French art.[25]

As Paris set the pace, American manufacturers wrestled with the old problem of imperfect information. The Parisian fashion-industrial complex generated an endless stream of fabrics, dress models, hats, and shoes; nobody knew which would cross the Atlantic and become popular in the United States. Paul Hyde Bonner, a vice-president at the Stehli Silk Corporation, explained: "There are probably more than fifty thousand different models shown at each seasonal opening in Paris, of which only about two hundred are ever brought to this country or adapted for use here. Of this two hundred, probably only twenty ever become generally accepted by the country at large. To wait and see which twenty of the fifty thousand will 'take' would mean missing a season, as the time elapsing between a Paris opening and a general American acceptance is about three months, or about the time it would take the silk manufacturer to make the material demanded by these twenty dresses." Even in the American mass market, some believed that the "day of staples" had passed, and the only thing that mattered was high fashion. Some mills hired their own designers to connect with Paris (the prime example was Henry Creange at Cheney Brothers), but keeping up to date was difficult.[26]

The TCCA grappled with its own version of this problem: how to secure fast and accurate color information from Paris for its members. At first Margaret Hayden Rorke relied on the TCCA's officers, who sailed abroad every year for "the races and openings," but the logistics proved frustrating. In January of 1923, two executives just off the boat from Europe—Arthur Decker of L. &

Copyright, 1928, by The Dean-Hicks Co.
PLATE XCIV. A STRIKING COLOR SCHEME FEATURES THIS MODERNISTIC BALLROOM OR NIGHT CLUB

7.4 An example of Art Deco featured in a 1928
issue of *Good Furniture*. Courtesy of the
Smithsonian Institution Libraries, Washington, DC.

E. Stirn, a novelty silk manufacturer, and Edward S. Johnson of James G. Johnson & Company, a braid
and trim distributor—handed over fabric samples and sketches collected for group color planning.
This material was used in the fall forecast, which Rorke rushed to put "in the hands of the
manufacturers earlier than the French Cards could be issued." Nevertheless, members carped when it
arrived after the French forecasts.[27]

Rorke looked for a better, faster connection. Subscription services such as J. Claude Frères et Cie
provided some help, but discretion and personal attention were required. She needed very detailed

L'Ensemble américain

175

descriptions of color, and the best option was a resident agent at her beck and call. That person would have to know American tastes and would have to scout around for colors that would fit. In mid 1924, Rorke petitioned the board for a "representative in Paris from whom definite color information could be gathered." Funds were approved for "the advising of Mrs. Rorke weekly via a Paris letter of general tendency in style and color; the sending of swatches; the cabling of information whenever needed, etc."[28]

By the time of the Paris Exposition, the style service of A. Cardinet & Cie was engaged as Rorke's color advisor. Adeline Cardinet was one of many Americans who flocked to Paris after the war, soaking up the creative energy and earning a living in art, design, fashion, or commerce. Born in California to French parents, she had worked in the millinery trade in Sacramento and in 1919 had applied for a passport to go abroad as a buyer. A stylish, bilingual woman, she probably had worked for the Paris office of an American retailer or for a French commissionaire before going into business for herself. Rorke found her in the 10th *arrondissement*, an area thick with commissionaires. Research for the TCCA, billed at $150–$200 per month ($1,900–$2,000 in 2010 dollars), was handled by

bilingual staff members. Cables, sketches, and letters began to flow, describing shoes, millinery, and hosiery and showing French ensembles.[29]

Alarm bells went off when Rorke received the August 1926 report on the Chanel openings—which showed the "little black dress" that American *Vogue* would famously call "a Ford signed 'Chanel.'" The significance of this new chic look, which epitomized the practical modernity of the New Woman, was lost on the Cardinet staff. "The person who would have wanted to have at Chanel a striking impression of novelty would have certainly been disappointed. Chanel having a very conservative and private clientele seems not to have made such a strong effort to get away with last season's idea. . . . The silhouette . . . is still straight and long. Large loose panels complete the effect." The color black—trendy since *le vogue nègre* of the Paris Exposition—was never mentioned.[30]

Rorke expressed her frustration to a few trusted officers and committee members and lobbied for greater nuance. The TCCA's new president, Edward S. Johnson, appreciated the vivid prose of Edna Hughes Roberts, a journalist for *Dry Goods Economist* who prepared trend reports for private clients. Her letter to Johnson from St. Moritz, a Swiss ski resort, cataloged the colors of sports apparel and evening dress in vivid detail: "We cannot overemphasize the growing vogue of grey alone or combined with violet shades. . . . Next in importance was navy with one of the Directoire blue, other popular color combinations being chamois with brown, black with orange, navy with orange, white with scarlet and black with white." The blunt Adolphe Ortenberg, speaking for the garment cutters, wanted better coverage of couture, which set the ensemble trends that New York wanted to follow: "France is the fashion dictator of the world. . . . No matter how competent an American designer is in creating styles for the American woman, she or he must take the basic principals [*sic*] from the French couturiers. . . . This applies to color as well, which your organization fails to do."[31]

When Rorke tightened the screws for "more efficient results," Adeline Cardinet reassigned the account to her niece Estelle Tennis, a French-speaking California art school graduate. On her next trip to Paris, Rorke took the young woman under her wing, showing her how to recognize color tendencies embedded in clothes and how to coax advance information out of designers, manufacturers, and retailers. The trick was to be ladylike but intrepid, to knock on doors and ask questions, and to analyze without interjecting one's own tastes. Above all, the focus should be on color directions and the ensemble, rather than on fabrics or silhouettes. Schooled in this new way of

7.5 Telegrams and a sketch sent to Margaret Rorke by cable from A. Cardinet & Cie in October of 1926. Accession 2188, Hagley Museum and Library.

seeing, Tennis told Rorke: "I now have a much more concise idea of the kind of information you require."[32]

Estelle Tennis focused on couture, watching history unfold as some houses introduced signature hues. Among the unique colors were Jenny's pale pink (called Jenny Rose) and Jean Patou's versions of green and salmon pink (which Patou called Chartreuse and Ibis). Other savvy marketers followed the trend. Lucien Lelong had joined his father's dressmaking business in 1918 and had first sold designs under his own name in 1923. In a flourish, he lured the best designer away from Maison Worth and created Lelong Blue and Lava Green, advertising it all in a florid brochure: "Enclosed is a dissertation by Monsieur Lelong on various phases of the mode, particularly color, which I am sure you will be interested to read. I had a personal interview with him." Tennis begged swatches for Adolphe Ortenberg and for others on Seventh Avenue who loved Paris fashions. "Our *vendeuse* at Lelong's has promised to send me samples of some of their outstanding colors, including the Lelong blue."[33]

Color spectacle dominated the salon of Jean Patou, a modernist couturier known for his love of all things American. Two years earlier, Patou had introduced his fall-winter show with 25 American "mannequins" (models) in otherwise identical dresses of two different colors, suggesting that France and the United States walked side by side in style. As this trope evolved, color became a regular feature of openings. This imaginative play on cross-cultural exchange was a living, breathing modernist work of art that blended French aesthetics and American standards. "Patou's collection lays special emphasis upon the importance of color in the new mode," Estelle Tennis wrote, "but his colors are for the most part away from the more vivid pure tones and more in the realm of the yellowed and 'antique' shades." No single hue dominated, but a color story unfolded as the models glided onto the stage. "Sometimes three mannequins appear at the same time wearing similar frocks except for the change in the touch of color—for example, there are three dresses in a grege jersey, one with navy stripes, another with red, and the third with brown." In a backlash against Chanel's little black dress, here was the Parisian counterpart to Ford's new Model A, rolling off the assembly line in the colors of the moment.[34]

Margaret Hayden Rorke shared the reports from Paris with members of the TCCA in several ways. Her research bureau was always open for consultation, helping members design textile prints on the basis of "the combinations of colors that the couturieres are using." *Broadcast*, an occasional circular introduced in 1926, delivered style advice directly to the mills. When telegraphs and letters from Paris arrived, Rorke pulled information from them for use in *Broadcast*, which had to reach members before the next French shade card or the new issue of *Vogue*. The *New York Times* and

A. Cardinet & Cie
Société Anonyme

Adresse Télégraphique:
CARDINETAC-PARIS
Téléphone : PROVENCE 27-11
27-12

R.C.SEINE 520.523 B.

13, RUE D'HAUTEVILLE

HS.

Paris, le October 11th. 1927.

RECU OCT 18 1927

Mrs.Margaret Hayden RORKE,
c/o The Textile Color Card Ass.,
200,Madison Avenue,
NEW YORK.

LONGCHAMP-RACES.

Dear Mrs.Rorke,

The Occasion of the Prix de l'Arc de Triomphe
brought a very smart crowd to the Longchamp races last
Sunday.

The gathering which was more distinctly
Parisian than during the Grand Prix Races this Summer,
included many chic women wearing costumes and hats from
the more important Model-houses.

The predominating color was black in both
hats and coats, the latter however being frequently trim-
med with lynx fur in the natural tone - with the younger
set at least, this seems to be the favored trimming for
cloth and even darker fur coats.

Madame Agnès, the milliner, wore Louise-
boulanger's chic cape costume of black velour de laine
trimmed with natural lynx on the collar and with a hori-
zontal band of this fur half way down the cape. Her hat
was a tight fitting little shape of very supple black
"agneau rasé", the same medium as the hat in the enclo-
sed photo No I. There was no trimming on the hat save
a rhinestone brooch.

A very smart Girl whom I afterwards saw
at the tea at the Ritz had on this same Boulanger Model
and Reboux's close fitting "mis en plis" hat of black
velour, which I mentioned in my letter of Oct.7th. This
little hat is by the way a great success. I saw it on
some of the very smartest women - a mother and daughter
both wore this hat, the former having a bunch of black
aigrettes at one side. Another hat much favored by chic
women is Reboux's black "agneau rasé" hat shown in picture

- - - -

7.6 This letter from Estelle Tennis to Margaret
Rorke, dated October 11, 1927, includes pictures
of wealthy women in the latest turbans. Princess
de Faucigny-Lucinge (lower photograph) wears a
top-of-the-line model entirely covered in feathers.
Accession 2188, Hagley Museum and Library.

Women's Wear kept tabs on Paris, but they emphasized fabrics and silhouettes. *Broadcast* delivered precise, immediate color information tailored to the members' needs in design, production, and merchandising. French color names were replaced with American ones from the TCCA's forecasts and its Standard Color Card of America, making it easy for the members to identify the shades. The American perspective was given precedent, buttressing the TCCA's position as a color authority attuned to Paris without compromising its commitment to the American mass market.[35]

The Paris Agents

The fashion of coloured accessories has become staple.

—Tobé Coller Davis, 1938

The color nationalism born of World War I yielded to a transnational perspective as the Textile Color Card Association connected to the wider world. Trend reporting developed into a niche business as New York solidified its role as the center of the American fashion-industrial complex. The rapport between Margaret Hayden Rorke and Estelle Tennis grew into a warm friendship that brought the younger woman to the New York office in 1928. Her move coincided with the TCCA's enlarged scope as its membership grew to 1,500 international subscribers in a "heterogeneous collection of industries," from shoes to paints.[36]

As manufacturers and retailers demanded information, new forecasting bureaus appeared, each promising a better connection to Paris. Tobé Coller Davis founded Tobé and Associates, a company that tracked New York and Paris fashion trends for retailers across the country, shortly after Rorke launched *Broadcast*. The public-relations impresario Edward Bernays, seeing opportunities in the Paris rush, helped his clients to capitalize on the ensemble concept with a fashion coordination report (figure 7.7). The competition was fierce, but the TCCA, having first-mover advantages, held on to its place as the leader in color.[37]

During the 1930s, the TCCA kept tabs on Paris through two resident advisors with complementary expertise. Bettina Bedwell, an American journalist and fashion designer who had been in the City of Light since 1921, wrote a syndicated column for the *Chicago Daily Tribune*. Besides her own fashion networks, she had ties to the French avant-garde through her American husband, Abraham Rattner, a Cubist-Expressionist painter who traveled in the same circles as Pablo Picasso, Man Ray, Henri Matisse, and Marc Chagall. Lucien Schloss worked for his father in the family firm of Adolphe Schloss Fils et Cie, an old commissionaire at 4, rue Martel in the 4th *arrondissement*. Bedwell saw color through the eyes of an expatriate, acting as a surrogate for the American consumer. Schloss, who had spent his youth in the United States, came from an established firm with "entrée to

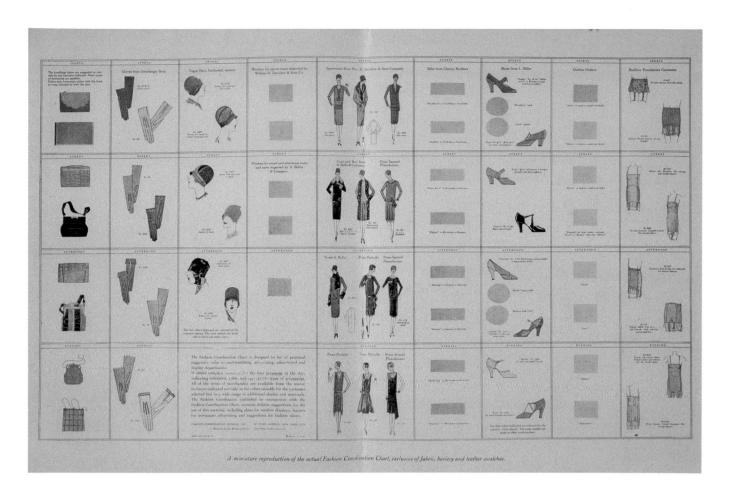

A miniature reproduction of the actual Fashion Coordination Chart, exclusive of fabric, hosiery and leather swatches.

7.7 The fall 1927 edition of *The Fashion Coordinator* included this Fashion Coordination Chart, which showed how to pull together an ensemble. Edward L. Bernays Papers, Library of Congress.

all the leading fashion houses and his sources of information were unsurpassed." The lack of any evidence that Bedwell and Schloss knew of each other suggests that Rorke deliberately sought independent views. Experience had taught her the need for objectivity, and two advisors provided a system of checks and balances.[38]

Bettina Bedwell worked much like Estelle Tennis, bringing a designer's eye to color scouting. From her home in Montmartre, she hopped around the Ile de France, sized up the fashions, and returned to her office at 36, rue de Montpensier to pound away at her typewriter. She chronicled color trends at the leading couture houses—Chanel, Vionnet, Lelong, Edward H. Molyneux, Jean Patou, Elsa Schiaparelli—and documented what hues chic women wore. At Les Ambassadeurs, a restaurant in the posh Hôtel de Crillon, she scrutinized the stylish clientele, which included India's young Princess Karam, the muse of *Vogue*'s photographer Cecil Beaton. On Easter Sunday, she went to the horse races "in the hope that there might be something of particular interest" and was disappointed to see that in the cold rain "fur coats were more abundant than new spring costumes."[39]

The American passion for ensemble dressing and the TCCA's role in promoting it focused Bedwell's attention on the relationship between couture and accessories. In May of 1929, she summarized the fall forecast issued by the Industries françaises de la mode, which described a new green called Vert Amande, first used by Jenny and then copied by "almost all of the fall collections." Maison Worth used it in "alpaca models"; Philippe et Gaston showed variants in fall suits. The color found its way to accessories through the Italian shoemaker André Perugia, whose Paris shop on the rue du Faubourg Saint-Honoré catered to stars from Hollywood and the Folies Bergère. Perugia used it in brocades and leathers for "sandals and dancing clogs." The path was much the same for other autumn hues, which moved from the couture houses into the custom boutiques.[40]

Bedwell documented this tug-of-war between French aesthetics and American buying power in her survey of glove trends. With "practically no exception," she wrote before the February 1936 openings, "navy blue and white are considered as the two colors that will be outstanding for spring." However, two major glove makers, Chanut and Dumont, believed that a major shift was imminent, pointing to the American "interest in costume colored gloves" featured by a few bold couturiers. The innovator was the English-born Edward Molyneux, who had worked for Lucile in London and in America before opening his own Paris house. This renowned master of understatement put restraint aside when he showed day and evening gloves in seven bright hues. The American fondness for bright colors inspired "one of the outstanding New York department stores" to snap up Molyneux gloves for a spring promotion. Parisiennes hesitated, but Chanut and Dumont speculated that by fall "costume colored gloves will have increased considerably in selling volume."[41]

7.8 The smartly dressed Bettina Bedwell at the Jardin des Tuileries, ca. 1937. Unidentified photographer. Abraham Rattner and Esther Gentle Papers, Archives of American Art, Smithsonian Institution.

Bedwell snooped around Paris to verify such hunches. She was startled when Alexandrine of Paris—known as "the most fashionable glove shop in Europe"—vehemently expressed a dislike of costume colors. The head of that exclusive retailer "emphatically stated that she would not show them in her line, nor did she think that smart women in Paris would wear them." In March, it became clear that Alexandrine had misjudged, and that Paris designers and manufacturers were looking at styles from New York. "Bright colored accessories are becoming increasingly important," Bedwell noted after seeing reds and greens in the handbag boutiques. By April, Schiaparelli had reported strong sales of "bright colored tulle gloves for evening," and Bedwell saw costume hues in all "the department stores and most of the specialty shops, with the exception of Alexandrine." The usual direction in the fashion flow was interrupted as American influences breathed life into a marginal couture trend.[42]

Transatlantic color forecasting was complicated by inaccurate reporting in the *New York Times* and in *Women's Wear*. As hemlines rose, Americans took a liking to tinted hosiery that matched the ensemble. French women, in contrast, preferred brown shoes and stockings in neutral beiges. In 1936, when Schiaparelli showed yellow, green, and purple stockings for evening, American reporters pronounced a new vogue. Excitedly waving their newspapers, members of the TCCA queried Margaret Hayden Rorke, who cabled Paris. Colored stockings, Bettina Bedwell responded, were not widely accepted: "I wish to point out to you again that none of the leading manufacturers here or the high class specialty shops believe that unusual colors will be popular or smart in Paris, and stockings in such colors which they have in their line have been added very reluctantly by them, and mostly for foreign consumption."[43]

The benefit of having two Paris agents was shown when Lucien Schloss confirmed Bedwell's report: although some Paris shops carried burgundy, green, blue, and navy hose, no stylish Europeans wore them. In London, Schloss had seen colored stockings at Harvey Nichols, but the manager had brought them back from United States as novelties. A few Amsterdam shops had imported American examples from London and had them in windows as advertising gimmicks. "It seems," Schloss commented, "that there are more high colored stockings worn in the States than anywhere in the world."[44]

Color names, many of them coined by journalists, also created confusion. For the sake of accuracy, Margaret Hayden Rorke required her agents to provide "the names given by Couturiers to the new shades"—exactly, with no deviation. Lucien Schloss complied by sending descriptions and swatches of Schiaparelli's Danger Red, Patou's Adroise and Bleu de Gumée, and Erik's Paris Blue. His temper flared over trade gossip about American promotions for two new Marcel Rochas colors, "Poison green" and "Byrrh red." Checking with the house, Schloss found that Byrrh was the name of a dress model that came in red and learned that "Rochas never gives any names to his shades." Tracking

7.9 Advertisement for Blue Moon hosiery, made by Largman, Gray Company, a Philadelphia knitting mill with a New York sales office, late 1920s.

down rumors and verifying newspaper reports absorbed a good deal of energy. When New York buzzed over a new green used by Schiaparelli, Schloss wrote: "Peacock green is certainly a name that *Women's Wear* chose." After a notice of Molyneux's "Dante Gabriel Rossetti blue" appeared in Virginia Pope's *New York Times* column, Schloss phoned "the Director of Molyneux with whom I am in the best of terms, . . . and he absolutely does not know to what this refers." Apparently the *Times* had fabricated this color name to coincide with the first day of a lecture tour of the United States by Rossetti's niece Olivia Rossetti Agresti, a League of Nations dignitary and social reformer from Italy. "This shows once more," Schloss commented, "that it is nearly impossible to foresee what newspaper ladies might imagine."[45]

Fancy names, both genuine and bogus, proliferated around the time of the Exposition internationale des arts et techniques dans la vie moderne of 1937, the first major fair to be held in central Paris since the Art Deco exposition of 1925. Schiaparelli created "Exposition colors" for her fall collection, shown a few weeks before the gates opened. "The most important one," one observer noted, "is certainly her pink named SHOCKING." The name Shocking also was used for a new perfume (sold in voluptuous pink bottles suggestive of Mae West's curvaceous figure), and the color was "repeated in certain collection numbers." Schloss secured authentic Schiaparelli color samples for New York. The information flowed uninterrupted until Sara Pennoyer, a publicist for the Bonwit Teller store, announced the "advanced authentic colors" in the *New York Times*. After that, Margaret Hayden Rorke pressed her Paris agents for precise information on colors at the fair. Lucien Schloss discovered that, although the fair had no official palette, the enterprising Pennoyer had secured permission for Bonwit Teller to duplicate the blue and orange used on a certain promotional leaflet. In New York, only Bonwit Teller showcased the "authentic" Paris 1937 colors, beating everyone else to the punch and embarrassing the TCCA.[46]

Journalists and retailers, with their drive to be the first to forecast trends in color, played havoc with the Paris connection and undermined the collaborative dream. Pressured by tight deadlines, American reporters attended the couture openings, sized up the dress samples, and wired their reports "by memory." There was no time for verification, and reporting colors accurately was not the goal. Bettina Bedwell, by virtue of having a good eye and having TCCA materials at her fingertips, avoided the pitfalls to some extent. Lucien Schloss, however, was a Paris insider who loathed guesswork and spared nothing to ensure precision. Weeks before the openings, his staff descended on the local offices of the major silk mills seeking information on fabrics purchased by the couturiers. "You will have received the color combinations made on paper of the best new shades for silks, which have been water colored on paper after inspection of some 20 collections of the silk houses, jobbers or manufacturers, who placed their novelties with the dressmakers." He then attended the openings,

because only then would he "know if such or such Couture house has adopted and launched any new colors." After private meetings with the managers, he wired descriptions of the colors to Margaret Hayden Rorke in New York, following up his wires with meticulous letters and swatches. Color reconnaissance had built-in delays and while little could be done to trounce the press or outmaneuver the stores, the two Paris agents provided Rorke and the TCCA with the most accurate color information available.[47]

Flags and Fashion

The year 1940, the Textile Color Card Association's silver anniversary, created an occasion for Margaret Hayden Rorke to look back on the past 25 years. Formed "not in the Mauve Decade, but on the fringe of the Alice Blue epoch," the TCCA had been created "to promote the movement of color standardization; the interpretation and adoption of a universal nomenclature for colors used for industrial purposes; and the creation of the American Color Cards (Standard and Season) to help industry in promoting commercially beautiful colors as well as practicable ones." Having "[thrown] a pebble into the pool of American industry," the TCCA had "watched the ripples of color reach out to the shores of today."[48]

In 25 years, the TCCA had standardized 4,751 colors and issued 120 thematic collections. Its membership, which had declined during the Depression, was on the upswing. There were now 1,200 subscribers, nearly one-fourth of them outside the United States. Resident sales agents around the world solicited new members in Argentina, Japan, Mexico, New Zealand, and South Africa. The research bureau was always busy. In 1939 alone, Rorke and her staff distributed 8,700 press releases, 6,700 advance swatches, 11,700 *Broadcast*s, and 19,500 color cards. They also answered 1,100 queries and gave 170 customized color clinics in new areas, among them cosmetics and menswear.[49]

The TCCA described itself as the trailblazer of "the modern approach to the merchandising of color in our every day business life." It created the first American forecasts to be used in design and production, and it united disparate interests around the banner of "economy and sound planning." It was the first American organization to coordinate color for the American fashion industries and to promote color harmony in the ensemble. New designs and practices emerged from these initiatives. The emphasis on standards led to better Army uniforms, brighter American flags, and a new College Color Service that made sure Harvard's crimson was always crimson. The fashion focus resulted in improved connections between the United States and Paris, bringing influences of haute couture to the American wardrobe.[50]

The spirit of industrial cooperation inspired colorists around the world. The British and Australian textile industries saw the TCCA as a model. "If imitation is the highest form of flattery,"

Margaret Hayden Rorke reported, "then we should be proud of the fact that our system of standardization and coordination of color between industries, is now being emulated by different industries in several foreign countries." Soon after the British textile trade journal *Drapers' Organizer* wrote about the need for a British version of the TCCA, Rorke was in Manchester advising the leading industrialists on setting up a British Colour Council. In New York, the Museum of Science and Industry mounted an Exhibition on the Science and Art of Color that paid tribute to the interdisciplinary work of professional colorists, and Rorke lent her expertise. American colorists formed the Inter-Society Color Council as a professional organization for promoting exchanges of information across industries, disciplines, and institutions. As a founding member of the ISCC, Rorke shared her enthusiasm for the progressive model of cooperative associationism with designers, professors, and scientists who wanted to foster the free flow of color theories and methods.[51]

As it matured, the TCCA abandoned the heady idealism of the "one best way" and inched closer to fashion, with all of its uncertainty. Standardization was the backbone of the organization, but style was the flesh and blood. By the late 1930s, Margaret Hayden Rorke had developed a lightning-fast countermeasure to careless news reports and publicity stunts that threatened stability. Around the time of the Paris openings, her staff translated overnight cables from Paris into practical Colorgrams that went out to members within a few hours. Color consultants introduced services that were faster (and more expensive). When Howard Ketcham invented the Colorcode—a system for "cabling exact colours direct from the Paris Openings and reproducing them at lightning speed"—he enlisted Tobé Coller Davis as a fashion advisor and Bonwit Teller as the exclusive retailer for what may have been the first "fast fashion." On February 4, 1938, with Colorcode cables in hand, Ketcham and his advisors decided which Paris colors to copy, the American Silk Mills dyed the fabrics within 24 hours, and a manufacturer called Capri delivered dresses to Fifth Avenue on February 10. But Rorke had confidence in her own accomplishments. "Often times we have 'scooped' all other sources of color news," she explained, "and this has been used by many of our Retail Members for fashion promotion and retail display."[52]

Success was a double-edged sword, particularly when it came the old guard. Tobé Coller Davis offered the "woman's viewpoint" in her trend reports to retailers across the country. To Margaret Hayden Rorke, that approach worked magic with difficult prospects on Seventh Avenue, but had little sway with journalists. M. D. C. Crawford of *Women's Wear*, who had his own ideas on how to advance American design, privately dismissed the TCCA in a letter to a colleague: "Mrs. Rorke as you know is a delightful lady of the usual secretarial type. Personally my interest in the [Textile] Color Card Association is tepid. They don't do anything and they are rated in my judgment among institutions that only function with institutional limits."[53]

Crawford's criticism of the TCCA highlighted the uneasy marriage of standardization, free enterprise, and fashion. Trade associations sought to control their markets through industry-wide cooperation, and the standardization movement aimed to benefit the common good. Silk mills, luxury department stores, and fashion editors saw this as a threat to creativity and individuality. Like the couture houses, the major department stores wielded enormous cultural power and monopolized "taste." To attract a status-conscious clientele, the Fifth Avenue stores needed to "be a little bit different" from each other and a lot different from Gimbels and from Macy's. They sought to express their difference by means of store layouts, window displays, and house merchandise. The pursuit of distinction resulted in sideswipes such as the 1937 Paris promotion at Bonwit Teller and in continued resistance by other upper-crust stores.[54]

Consultant designers such as Raymond Loewy and William Snaith, who redecorated the Lord & Taylor store in 1938, understood that unique colors flattered complexions, improved salesgirls' moods, and piqued the interest of shoppers. Loewy and Snaith turned Lord & Taylor's tired-looking ready-to-wear floor into the "last word in modern fashion merchandising" through color planning. "Colour opens your eyes the minute you step off the elevator," noted the *Tobé Fashion Report*. "Startling, vibrant colours—cerises, purples, peacock blues and revolutionary greens—are blended harmoniously," the total effect amplified by a "promenade of mirrored columns" and mannequins coiffed by Elizabeth Arden. "The better hat department, decorated in three shades of feminine pink," would give the shopper "real inspiration in ensembling her costume." "Fifth Avenue's No. 1 department store" applied the ensemble concept to interior design, creating a colorized envelope for the colorized merchandise. The luxury department stores saw color as a tool of distinction and exclusivity—and snob appeal was their purview.[55]

The ongoing battle between the TCCA and the upscale department stores on Fifth Avenue raise questions about the roles of trend setting and trend spotting in style innovation. The Fifth Avenue stores distanced themselves from the TCCA's mass-market objectives and would *never* deign to promote pre-packaged colors. Without their cooperation, it wasn't possible for Margaret Hayden Rorke to "create a demand" for colors; she had no access to the publicity machine or the social networks that stimulated desire among the smart set. Instead, she chased down colors that had already entered the fashion system and made them more available in the popular culture. As soon as Rorke's forecasts were issued, they entered the public domain to be copied. Just as there was no way to "stop individualism," there was no way to halt the egalitarian impulse that made mass production and consumption inexorable in the United States. Thus was the anticipation mode exemplified by color forecasting embedded in the American fashion-industrial complex.[56]

8.1 Advertisement for Majestic radios, *Saturday Evening Post*, June 14, 1930.

8 Rainbow Cities

The color revolution turned the drab Victorian city into a brilliant modern showcase of terra cotta, electric light, sound, and paint. Expositions and world's fairs, the great tourist attractions of the era, popularized electric lighting. Colorful architecture and bright colored lights came to be expected features of the urban landscape. A person might work in a terra-cotta skyscraper, watch a projected light show in the theater prior to the movie at a Saturday matinee, and listen to "colorful" symphonic sounds on a parlor radio. New public buildings, whether classical or Art Deco in style, were colorized and modernized with electric lights, ceramic tiles, murals, and bright paints. In combination, these technologies marked the dawn of a new architectural era—the Age of Color.

The "rainbow city" owed much to industrial research and development done in the electrical sector. The Westinghouse Electric and Manufacturing Company, the General Electric Company, and other firms were heavily invested in R&D projects related to lighting. Thomas Edison and George Westinghouse had been the inventor-entrepreneurs of electrical lighting, and Charles Steinmetz had been the R&D pioneer, but now innovations in color and light were coming from a younger generation of illuminating engineers. The physicist Matthew Luckiesh, director of General Electric's Lighting Research Laboratory in Cleveland, wrote books and articles that helped the public to understand the relationships among color and electric lighting. Other prominent illuminating engineers joined forces with architects, muralists, and musicians to publicize the capabilities of electrical technology. The marriage of light and color transformed the look of American cities.

Electrical Jewelry

The twentieth-century vogue for white public buildings was influenced by the Beaux-arts tradition and by the breathtaking purity of early electrification. In 1893, Chicago mounted

the World's Columbian Exposition for the 400th anniversary of the European discovery of America. Although Louis Sullivan colorized the interior of the Auditorium Building and the exterior of the Transportation Building, there was little other polychromy at the exposition. Daniel H. Burnham and Frederick Law Olmstead designed white neoclassical buildings that were fitting backdrops for the era's great technological wonder: electrical lighting. Westinghouse won the illumination contract in a bidding war against General Electric. Some 26 million spectators marveled at the Westinghouse display of "5,000 arc lamps of 2,000-candle power" and 93,000 incandescent lamps of 16 candlepower, "the first ever seen by many of those visitors." The blinding bulbs so bedazzled visitors that the exposition's main buildings came to be known as the White City.[1]

Colored electric lighting was introduced at the Pan-American Exposition in Buffalo, New York, in 1901. That fair celebrated the region's leadership in electrification, attributed to the new long-distance power grid built by Westinghouse and the Niagara Falls Power Company. The main buildings were ornamented with a "heavy, deep coloring of red, blue, green and gold"; in the evening, the central Electric Tower, painted in various tints, was the focal point of a beautiful light show. "It seemed like another world, so weirdly glorious and magnificent."[2]

The Pan-American Exposition—nicknamed the Rainbow City—had an unexpected effect on the skyscraper boom, first in Buffalo and then in other northeastern cities: it fueled the interest in colorful terra cotta (a type of building block or tile made from fired clay) as a backdrop for nighttime illumination. Buffalo architects began using terra cotta facades that were spotlighted after dark. Even more remarkable, the General Electric engineer H. H. Magdsick lit up the terra cotta facade of the Woolworth Building in New York City. "The tower," Matthew Luckiesh wrote, "is visible for many miles as a beautiful decorative shaft. . . . The intensity of the illumination increases toward the top and . . . the sparkling effect superposed upon the cream terra cotta surface intermingled with the touches of blue, green, red, and buff makes the whole a beautiful spectacle."[3]

As more and more expositions featured color-light displays, professional colorists and lighting engineers emerged. In 1914, the Panama-Pacific Exposition in San Francisco was the first fair to have a color director and a lighting director. Jules Guerin, a muralist and illustrator from New York, took charge of the palette, painting the buildings in "the grayish cream of the Travertine marble used in Rome" and adding accents of "oriental blues, orange and dull reds, all in pastel shades." Walter D'Arcy Ryan of Westinghouse, an illuminating engineer who in 1907 had designed spectacular lighting effects for the American Falls at Niagara, again achieved dazzling effects with searchlights and colored gelatin filters. At night, a scintillator run by 60 men produced "evolutions of color, auroras, and displays like great lilies that can be seen from all sides of the bay." The Tower of Jewels, a 400-foot structure hung with 200,000 crystal baubles, was lit to look like a "flaming mass of quivering colors."

The Panama-Pacific Exposition marked the beginning of a new relationship between color and light. Architectural colorists and illuminating engineers now were working together in pursuit of color harmony.[4]

Mobile Color

The theater and the movie palace have whetted the public's appetite for color by using new lighting effects that made color an actual force.

—*Business*, 1928

Ever since Isaac Newton, people had been fascinated by the apparent analogy of the seven steps in the musical scale and the seven spectral colors of the rainbow. During the Enlightenment, a mathematician named Louis-Bertrand Castel had dazzled Paris society with the first color-music instrument, an ocular harpsichord that diffused pigment light through windowpanes at the strike of a key. In 1893, a British inventor named Alexander Wallace Rimington had patented a Colour Organ that used gas jets and arc lamps to generate colored light as an accompaniment to musical instruments; the idea was to translate musical tones into visual hues. Rimington's taste-making objectives presaged those of Albert Munsell: he hoped to sharpen the senses of the British working classes and to teach them to prefer the palette of the Chartres rose windows over the crass aniline shades of Manchester calicos.[5]

Some artists, influenced by psychological research about the anomaly of dual sensory experience, or synesthesia, tried to unite color and tone as a means of inducing transcendental experience. Their efforts sometimes bordered on the mystical; the musical paintings of Wassily Kandinsky and the tone poems of Alexander Scriabin are examples. The Carnegie Hall debut of Scriabin's color symphony *Prometheus—the Poem of Fire* featured the Chromola, a piano-like instrument that projected twelve colors synchronized to the orchestral music. "The entire house was darkened," wrote one observer, and the "audience centered its attention on the colors and listened to the music, thus receiving two sensory interpretations of the piece—by sound and by light." Critics were puzzled, unable to fathom the color-sound connection: "It worked; it distracted; and it added nothing—except the gratification of curiosity."[6]

In the 1920s, two independent inventors, Thomas Wilfred and Mary Hallock Greenewalt, popularized "mobile color." The Danish-born Wilfred introduced his Clavilux Color Organ in New York in 1922. He rejected theories of an analogy between color and sound, but he believed that the Clavilux could provide audiences with aesthetic pleasure—"music for the eye." One newspaper reported "an Arabian night of color, gorgeous, raging, rioting color" in which "jewels were poured out

of invisible cornucopias [and] lances of light darted across the screen to penetrate shields of scarlet or green or purple." The Clavilux projected colorful shapes in silence, but in 1926 Wilfred collaborated with the Philadelphia Orchestra (conducted by Leopold Stokowski) in a performance of Rimsky-Korsakov's *Scheherazade*.[7]

Mary Hallock Greenewalt, a concert pianist and a recording artist, introduced another type of "mobile color" in 1906. Like others, she wanted to enhance the experience of an audience by creating pictures in colored light that matched the music: "Sunlight makes the world sing; why shouldn't light help the song sing?" This idea came from her musical interest in the correlation of rhythm and emotion and her assumption of an equivalent relationship between color and feelings. Ever practical, she rejected the synesthetic notion that music could be made from colors: "C is C and red is red." She proposed a sixth fine art (after painting, poetry, music, architecture, and sculpture): a new art form she called Nourathar (a word formed by cobbling together the Arabic words for "the essence of light"). Nourathar would consist of an atmospheric light show generated by a keyboard instrument, the Sarabet, operated alongside a piano. The invention required mastery of music, electrical engineering, physics, and color theory. Greenewalt received eleven patents for technologies such as the rheostat, which provided dimming capabilities, and for the practice of associating light and music in performance. She even developed a portable "Light and Music" phonograph for the home.[8]

Greenewalt was one of the few women who ventured into electric illumination during the color revolution. Art and invention shaped this colorist's identity; she called herself a musician and a "distinguished original research scientist." The electrical engineers saluted her. "I have heard of your work in trying to develop the use of light as a structural element in the art of music," wrote Charles Steinmetz of General Electric, "and have been very much interested in the idea, as it appears to me to have great possibilities in the advance of the art of music."[9]

Public demonstrations attracted patrons and prizes. A color-organ was installed in a greenhouse at Longwood, the country estate of Pierre S. du Pont. In 1926, Greenewalt received a gold medal from the Sesquicentennial International Exposition, held in Philadelphia in commemoration of the Declaration of Independence.[10]

Recent theatrical developments inspired Greenewalt to search for broader applications for Nourathar. The New Stagecraft had introduced an approach to set design that focused on simple props and spectacular lighting effects. It seemed that movie theaters might be suitable for colorful electric light shows. In the transition from vaudeville to Technicolor double features, theaters were one-stop entertainment centers, offering newsreels, comedy acts, and live concerts in addition to films. At a typical matinee, a live orchestra played short symphonic pieces suitable for mood lighting. To tap this market, Greenewalt rented her projector to local theaters. Soon large theater chains in

Philadelphia, New York, and Washington introduced their own color-light shows. During a run of the Al Jolson movie *The Jazz Singer*, Greenewalt noted how the orchestra and lighting crew created a color-mood for Tchaikovsky's *March Slav*. "The auditorium ceiling lighting . . . was made into a low dull blue. . . . As the first theme began, . . . a low blue was gradually brought up from the base of the curtain which shaded into an ashen above as a lugubrious match to the sombreness of the music." She thought this use violated her patent on a musical notation system for colored lighting effects.[11]

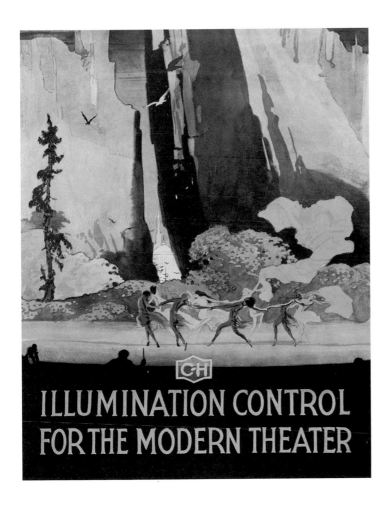

8.2 Cover of *Illumination Control for the Modern Theater* (trade catalog, Cutler-Hammer Manufacturing Company, Milwaukee, 1926). Mary Hallock Greenewalt Collection, Historical Society of Pennsylvania.

Mary Hallock Greenewalt fought several legal battles against moneyed interests. One lawsuit challenged owners of theaters to "show that the colored rays of light were at an early date used as matching . . . the emotional values of music." A reporter interpreted "the emotional values of music" as "something like the choice a woman exercises in choosing a dress of this color for a certain occasion, of another color for an occasion different in kind, or the choice of a man exercises in wearing a necktie of this or that color at this or that time." The choice was highly personal and subject to interpretation. The court dismissed the case because, true to her generous temperament, Greenewalt had shared her ideas before obtaining patents.[12]

She received some satisfaction when, on appeal, a federal court granted her priority in color light-play. The judge deemed her "a scientist as well as an artist," noting that her sophisticated approach distinguished her from a would-be synesthesist or a matinee lighting crew. Her deep knowledge of how musicians created aural harmonies from a "succession of distinct sounds" enabled her to elevate "mobile color" to the plane of fine art. Nourathar was cerebral, not silly, and was worlds apart from garish theatrics based on the "rapid succession of distinct flashes." The invention combined beautiful music and light projections, carefully colorized by the artist to reflect her innermost emotions. There were no recordings, templates, or prepackaged directions. Like all fine art, color light-play was rooted in the premise that "mechanical standardization" and creative expression were incongruous. But no compensation was awarded.[13]

Although the noble dream of a sixth fine art fell short, "mobile color" entered popular culture through mechanical reproduction in theaters, nightclubs, and cocktail lounges. Manufacturers of electrical equipment and suppliers to theaters developed technologies that made light shows into yet another entertainment medium. The use of "mobile color" in commercial interior design played a part in this transition. The interior designer Winold Reiss borrowed from mobile color to make the entertainment rooms of the new St. George Hotel in Brooklyn a colorful "inviting ensemble" in the Art Deco style. The main ballroom had a color organ that splashed the white walls with hues synchronized to music. In San Francisco, the interior decorators for Fairmount Hotel created a jazzy atmosphere by combining geometric mirrors and colored lights. Mobile color stimulated an interest in lighting effects for movie theaters, but as abstract expressionist art it was limited by its complexity. Sadly, Mary Hallock Greenewalt watched in dismay as her sixth art form was reduced to a pop-culture curiosity that presaged the psychedelic light shows of the 1960s.[14]

Prince Polychromy

Colored city buildings are certain to increase.

—Carl Paul Jannewein, *New York Times*, 1927

The skyscraper boom was a boost to manufacturers of terra cotta, particularly in Chicago, Los Angeles, New York, and Philadelphia. The industry employed sculptors to create stock designs or to

customize designs in the Beaux-arts and Art Deco styles, and boasted its own theorist: Léon Victor Solon. Solon, an Englishman of French ancestry, was art director at the American Encaustic Tiling Company, the world's largest tile manufacturer, which had plants in Ohio and a sales office in New York. Based in Manhattan, Solon was active in the local and national industrial-arts scene, a peer among influential architects and designers. In the decade that followed World War I, Prince Polychromy (as Solon was called by his family) was the terra cotta industry's favorite expert on color.[15]

8.3 Léon V. Solon's work was included in *The Architect and the Industrial Arts* show at the Metropolitan Museum of Art in 1929. This photograph shows the exhibitors: (seated) Eugene Schoen, Raymond Hood, Ely Jacques Kahn, Eliel Saarinen, and (standing) Ralph Walker, Armistead Fitzhugh, Léon Solon, and Joseph Urban. Joseph Urban Collection, Rare Book and Manuscript Library, Columbia University.

Color and classicism were in Léon Solon's blood. His French father, Louis Marc Emmanuel Solon, had won international acclaim for his neoclassical porcelain designs at the Manufacture nationale de Sèvres. When Sèvres shut down during the Franco-Prussian War, Solon père found asylum at one of England's leading potteries, the Minton Works in Staffordshire. Léon, born in Stoke on Trent, studied books about Greek vases. Formal training at the National Art Training School in London (now the Royal College of Art) advanced his chromatic individualism. Returning home to design for Minton's, Léon introduced Secessionist Ware, a line of jardinières, vases, and candlesticks decorated with sinuous motifs in deep, rich colors.[16]

Léon Solon came to the United States in 1909 and went to work at American Encaustic a few years later, just as the illuminated terra cotta of the Woolworth Building was drawing attention. Few skyscraper architects considered ornamental details to be within their purview; they relied on the ceramics manufacturers for decorative trim and for suggestions about color and ornament. Solon exploited this reliance to build a career as America's leading architectural colorist and architectural color theorist. In his mind, color was a necessary complement to form, as befit the Greek tradition. His detailed studies of artifacts in the English countryside, at the British Museum, at the Vatican, and at Greek and Roman archeological sites led him to see how ancient and medieval builders had approached color. He came to believe that classical Greek monuments had been painted, and that their colors had been planned from the start. His rational approach was well suited to America's efficiency-oriented business culture: "Designing for color requires a special form of ornamental planning."[17]

Color theory informed Léon Solon's work, but he was never enslaved by it. He saw parallels with sound and tried to create a notation system similar to written music, but threw up his hands after discovering "the inadequacy of signs to convey grades of color intensity." He borrowed from the Munsell Color System for design projects, but found the formulas awkward and inflexible. The industrial arts had taught him to analyze problems in the old-fashioned way: by studying, drawing, and mulling over the historical examples.[18]

Solon's first American challenge was interior decoration. Observers of the time had characterized American interiors as plain and anemic and mainstream culture as "strangely unresponsive to the appeal of color." The popular Beaux-arts and Colonial Revival styles embodied that chromophobia. "Whether it be due to the rigorous mental cast of our pioneer settlers, to drab Puritan and gray Quaker, the fact remains that the average American looks askance upon any degree of chromatic license. Sober of temper and habit, we have for over a century been closing our eyes to color in many of its most appropriate manifestations." The influx of Southern and Eastern European immigrants,

8.4 Léon V. Solon, "Polychrome Study: The Gothic Principles Applied to Detail from the Porch of Bridlington Church," *Architectural Record*, January 1924. Courtesy of Smithsonian Institution Libraries, Washington, DC.

with their bright peasant costumes, fueled nativist sentiments, which in turn fed the mainstream reaction against colors with "punch" and "pizzazz."[19]

The mainstream American preference for colorless interiors also had roots in reform aesthetics and in a dread of dirt. For decades, white had been promoted as signifying antiseptic purity in kitchens and bathrooms. The cleanliness craze accelerated with widespread electrification, because lighting made grease and grime more visible. The pale look extended to other rooms of the house as middle-class consumers abandoned Victorian clutter and smoky gaslights for clean, simple modernity. In public places, walls were covered with pale oil-based paints, whitewash, or murals; foyers, hallways, and bathrooms were tiled. Fear of immigrants and their germs also shaped these choices.

Léon Solon criticized the antiseptic, xenophobic approach, advocating color schemes that emphasized America's multiethnic character. Surveying American culture through European eyes, he detected a unique spirit in the strange, dynamic rhythms of jazz music and ventured that color would be the next vehicle for American self-expression. The increasing popularity of colored terra cotta facades and public murals suggested that color might be a good option for interior decoration. Solon invited architects and designers to imagine the possibilities as they visited American Encaustic's showroom on East Forty-First Street just off Fifth Avenue.[20]

In 1921, Léon Solon was chosen as the polychromist for the exterior ornamentation and the interior decoration of the Philadelphia Museum of Art. He helped the architects to select the golden-orange stone, designed many of the decorative accents, and colorized the colossal tympanum figures sculpted by Carl Paul Jannewein and John Gregory. Once Jannewein and Gregory had sculpted the models at one-third scale, Solon created the palette—scarlet vermilion, gold, black, buff, blue, and green—and set the figures in a model pediment for proper study. In the next step, full-scale models in colored plaster were hoisted into position on the building, and the effect was judged. Once the team agreed, Solon helped the Atlantic Terra Cotta Company with the difficult job of crafting the colossi, using his knowledge of clay and glazes to replicate the colors. This approach, which emulated ancient Greek practice, ensured that the colors would fit in with the overall design from the start. "Many will probably be surprised to find the relatively small amount of color that is permissible in a polychrome exterior of the classic type," Solon wrote in *Architectural Record*. "Color under no circumstances can be regarded as having structural significance," he told *Art and Archeology*. "Its obvious purpose in application is decorative." The Philadelphia Museum of Art was a monument to color planning that balanced ornament and mass, adapting the glories of ancient polychromy to urban industrial America.[21]

By this time, New York architects agreed that color was here to stay, but they debated its role. Modernist sensibilities bumped up against the Beaux-arts perspective. "The entire building will eventually have a distinct color," Raymond Hood ventured. As skyscrapers got taller, terra cotta ornamentation would yield to an overall color scheme. "To color only the architectural embellishments and a few outstanding cornices and lattices will appear like the rose decorations on a woman's white dress. They are hardly noticeable." Hood used large masses of color—coal black, brick red, and gold—to achieve Art Deco splendor in his American Radiator Building at 40 West Fortieth Street. But Solon, ever the historicist, remained committed to the polychrome tradition. "The tendency will be to color the embellishments. It is not likely that one color will predominate in the entire building."[22]

Architects also considered the role of color in modern interiors. Should interior spaces have plain walls, dark paneling, painted murals, or colorful tiles? For public spaces and for the private residences of the wealthy, murals came into favor. The painter Ernest Peixotto saw the introduction of mural painting into the homes of the elite as "a reaction against the plain putty-colored walls which followed the indiscriminate use of color and pictures." Another approach, suggested by Raymond Hood, was a kin to the Purist interiors of Le Corbusier: a series of rooms would be painted in colors that changed in increments from space to space, creating a unified whole and a total mood.[23]

At the ground level, local building contractors who dealt with consumers daily were desperate for color advice. When homeowners or landlords remodeled, they demanded color installations, but local builders threw up their hands. In panic, Tile & Mantel Contractors' Association approached Margaret Hayden Rorke at the Textile Color Card Association. "Up until recently the bulk of the tile work done in this country has been installed in white floor and wall tile," the tile association's executive secretary explained. "Today the public is demanding color," but tile contractors knew nothing about color psychology and color harmony. He had crude impressions of gendered color preferences but wondered if those differences had been studied and codified. "For instance, we know that men prefer plain shades; women prefer tints. Men prefer blue as a first choice, while women prefer red, vice versa, as second choice." Perhaps the Mrs. Rorke and the TCCA could hold a class to help tile contractors choose "clientele colors that will blend and harmonize."[24]

Solon, now with the Mosaic Tile Company, helped contractors to imagine the possibilities. "We live in a 'Machine Age' and all standards of living—including artistic standards—are under rapid modification." It was time to get with scientific management and the new rational approach to color. At a convention of tile contractors, Solon explained that color had "assumed a position of national economic importance" and urged the contractors to see it "as a controlling factor in their sales." After all, General Motors had discovered color, and what was good for GM was good for the country.

Detroit spent "millions of dollars" on "color research each year," and the chemical giants were a close second. That "a firm like the DuPont Company" included color in its economic plan indicated that "it is a very important subject." The color revolution, which began in chemistry and migrated to architecture, had come full circle. The foremost color theorist for the industrial arts saw the links and spent his career connecting the practical man with the new world order of the professional colorist.[25]

Urban Vision

Urban did not like all the walls of a room to be the same color. They never can
be, for the color changes subtly with variations in the light.
—Alvin Saunders Johnson, 1952

Léon Solon's historicist approach contrasted with the modernist sensibilities of another New York colorist, Joseph Urban, whose color masterpiece was the 1933 Century of Progress Exposition. Trained in the applied arts at the Akademie der Bildenden Künste Wien, the Austrian-born Urban had participated in the Vienna Secession, an avant-garde design movement that anticipated many of the post-World War I departures that would be associated with modernism. Emigrating to the United States at age 40, he eventually landed in New York, where he worked as a theatrical set designer. For 15 years he dominated Broadway, bringing the stark simplicity known as the New Stagecraft to the Metropolitan Opera and the Ziegfeld Follies. At the end of his life, Urban turned to interior decoration, store window displays, and, ultimately, the 1933 world's fair.[26]

A love of bright, pure color—inspired by visits to the Middle East—ran through Urban's career. Vienna was one of the most colorful cities in Central Europe; one of its main attractions was Schönbrunn, a stunning Hapsburg palace with a golden façade painted in "Schönbrunn Yellow." But Urban didn't articulate his interest in color until he saw Egypt. "My arrival in the Harbor of Alexandria was really my first impression of color. The strange deep blue of the Mediterranean, the white city, the flaming sails of the boats, the rioting of color in the costumes, and over all a purple sky—this enormous impression followed me my whole life and dominated for years my color scheme." This passion played out in his set designs, which cast aside nineteenth-century clutter for impressionistic simplicity. Urban used primary colors and pointillistic techniques to make backdrops that reflected the projected light; the filtered spotlights picked up the paint spatterings to create a distinct mood suggestive of a Maxfield Parrish print. This technique, common today, was new to the United States when Urban used it the 1910s. Enormous success in the theater led to interior-design commissions, which in turn encouraged Urban to become a licensed architect. He achieved that goal in 1926. The next year, he collaborated with Thomas Lamb on the Ziegfeld Theater, a terra-cotta-clad Art Deco extravaganza whose interior was a complex tapestry of color.[27]

In 1930, Urban colorized the building of the New School for Social Research in ways that foreshadowed the Century of Progress Exposition. Founded in 1919, the New School was the first American university to be based on the premise that consumer society had created a new kind of student: the lifetime learner. Success led the school to build an "ultra-modern" adult education center that embodied its forward-looking pedagogy. The school's co-founder and first president, Alvin Saunders Johnson, a self-described "addict of functional architecture," confessed that he "could hardly refrain from laughing" when he "passed a savings bank with the façade of a Greek temple, or a college library of colossal masonry with deep-set narrow windows for the light to look in, furtively." He was a great admirer of Frank Lloyd Wright and also of Joseph Urban, whom he characterized as "an artist of universal talent" whose "conception of functionalism was essentially the same as mine."[28]

For the seven-story New School building, Urban employed color as a design element that maximized the volume of the interior space. His design combined Broadway stagecraft and the budding International Style of architecture—a functionalist approach being pioneered by Walter Gropius in Germany and Charles-Édouard Jeanneret (later known as Le Corbusier) in France—in an exemplary expression of American modernism. In the heart of Greenwich Village, at 66 West Twelfth Street, the New School featured an auditorium with high-tech acoustics, murals by Thomas Hart Benton and José Clemente Orozco, and a distinctively American architectural polychromy. A showcase of light and color, it had a ceramic facade in black-and-white stripes, like a sideways zebra, and a polychrome interior that could be glimpsed through the fenestration. Inside, Urban painted the walls in strong colors—reds, blues, greens, yellows, oranges, whites, purples, browns, and dark blues—to create the illusion of space (figure 8.5). Visitors walked from one colorized room to another, experiencing different moods in different spaces. Cool colors were always in the shadows, warm colors in the sun. Whereas Léon Solon focused on color for color's sake, Urban used it as a tool to unify space. Here was the modernist backlash against ornament. Color was moved to the background, where its "proper function" was to augment light and space.[29]

A Polychrome Festival

This will be a polychrome festival and people will carry away with them a
multitude of impressions.
—Joseph Urban, 1932

The Century of Progress Exposition, created for Chicago's hundredth birthday in 1933, was a paean to the color revolution. Whereas the Columbian Exposition had focused on moral and social achievements, this one showcased consumer products and technologies that promised to make life

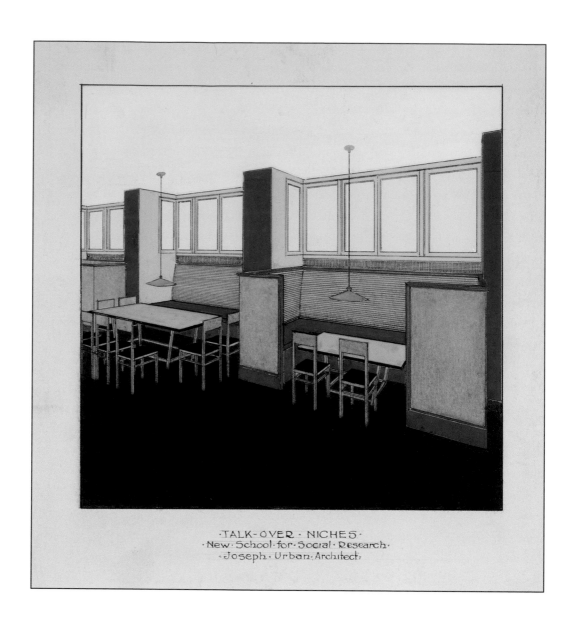

·TALK-OVER · NICHES·
·New· School· for· Social· Research·
·Joseph· Urban· Architect·

8.5 "Talk-over niches" designed by Joseph
Urban for the New School for Social Research,
ca. 1930. Joseph Urban Collection, Rare Book
and Manuscript Library, Columbia University.

more comfortable, convenient, and efficient. Committed to scientific determinism and technological authority, the builders converted a long narrow park along Lake Michigan into a visitor experience organized around the theme "Science finds, industry applies, man conforms." "Color had been used in the expositions at Buffalo and San Francisco," one art magazine noted, "but in a restricted way and in mild tones, as an accent to the architectural forms but not as a motive of composition." The Chicago fair so effectively used "color composition, both by day and night" that it usurped the nickname of the Buffalo fair: Rainbow City.[30]

In the spirit of progressive idealism, the planners of the Century of Progress Exposition appointed an architectural commission to make aesthetic decisions about the buildings, the exhibits, the landscaping, and the lighting. The commission voted for a streamlined look as the official style and selected the Philadelphia architect Paul Philippe Cret, a master of Classical Modernism, to lay out the fairgrounds and to design the exposition's centerpiece, the Hall of Science. They later decided to use inexpensive high-technology materials, such as wallboard and casein (milk-based) paints, to achieve a futuristic look on a Depression budget. Colorization was thought to be the perfect complement for Cret's streamlined Hall of Science and the ideal unifying element for the numerous pavilions by other architects.

The planning commission included the architect Daniel H. Burnham Jr., a world traveler who looked for color tips at other exhibitions. In 1929, he visited the Exposición Iberoamericana de Sevilla and the Exposición Internacional de Barcelona. In Seville, the Spanish electrical engineer Carlos Buígas had imagined the fairground in mobile colors—"wave after wave of blues and purples and reds and yellows . . . over the vast panorama"—and had asked Westinghouse to execute his vision. A similar color-light show in Barcelona, designed by Buigas with a Westinghouse engineer named Charles Stahl, took Burnham's breath away. He marveled as the buildings and fountains simultaneously changed colors. This display, Burnham wrote in his diary, "far surpasses all previous expositions," and "was what we have dreamed of for Chicago in 1933."[31]

In 1931, Burnham visited L'Exposition coloniale internationale de Paris, an eclectic celebration of empire that featured modernist architecture, Asian and African temples, and a cage-free zoo. "The Electric fountains," he noted, "are of course a most important part of the night illuminations but the general lighting of the grounds and buildings has been done on a scale of exquisiteness never before reached in any previous exposition. San Francisco and Barcelona were more intensely and brilliantly lighted but Paris is half shadows and moonlight and had a quality of fairyland not seen before in previous shows. This is my idea of the way Chicago should be lighted."[32]

The European architects who were pioneering the International Style also had definite ideas about colorized public buildings. In 1925–26, Walter Gropius had the concrete exterior of the Bauhaus

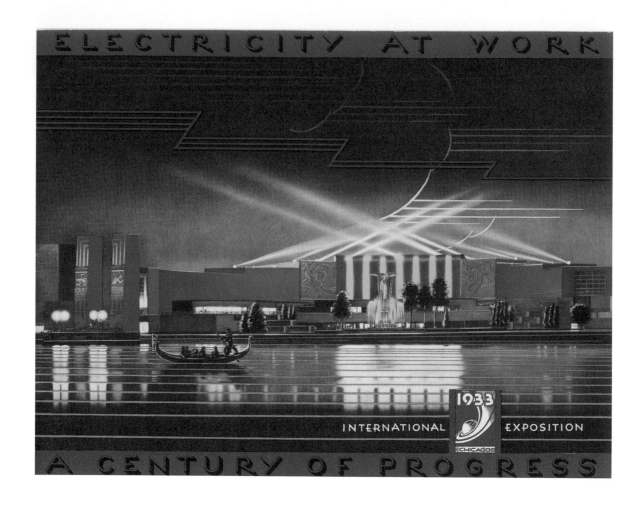

8.6 An illustration showing Joseph Urban's colorization of the Century of Progress Exposition, which was accentuated by innovative lighting. From *Electricity at Work* (Chicago: Twentieth Century Press, 1933). Joseph Urban Collection, Rare Book and Manuscript Library, Columbia University.

facility in Dessau painted in soft gray-green tones consistent with his notion of how architecture should embody the spirit of the Machine Age. Le Corbusier adamantly opposed the use of color on exteriors: "Polychromy on the outside has the effect of camouflage; it destroys, disrupts, divides and thus works against unity." However, Le Corbusier thought the Dutch design reform movement known as De Stijl (The Style) was on to something with its colorized rooms. "The Dutch apply a formula that is not entirely new, but [that] does deserve the greatest attention," he said in 1923. "A red wall, a blue wall, a yellow wall, a black floor, or a blue or red or yellow one, I see a total transformation of the decoration of the interior." Joseph Urban, for his part, believed that bold blocks of solid color could be appropriate both inside and out.[33]

Late in 1930, Joseph Urban visited Chicago to discuss the exposition's need for a colorist. On his recommendation, the commissioners hired Urban's young assistant, Shepard Vogelgesang, as a full-time "consultant on color and various matters pertaining to the decoration." By late 1931, the planners, yearning for a mature man's opinion, had invited Urban to submit a preliminary color scheme. Matters were complicated by turf wars between the architectural and illumination committees, and complicated further by an obstructionist lighting engineer and by bureaucratic meddling by the works department. Early in 1932, a new design department, which included Shepard Vogelgesang, was created to oversee the exhibits. By April, the managers had resolved to unify the exposition's architecture, landscaping, and lighting by appointing Urban as the Director of Color.[34]

Joseph Urban was no stranger to expositions. In 1904, he visited the United States as the interior decorator for the Austrian Pavilion at the Louisiana Purchase Exposition. A decade later, he designed an exhibit on the history of footwear for the Panama-Pacific Exposition. He tackled the Chicago assignment with enthusiasm, personally tracking down Maximilian Toch, the chemist who had improved Battleship Gray in order to ask him some questions about paints. But Urban was getting on in years (he would die in mid 1933), and the young men around him saw their chance. William Muschenheim took credit for the choice of colors ("He left it to me entirely, . . . the decisions were all mine"), although other sources point to Urban and two other assistants, Shepard Vogelgesang and Otto Teegen. Most likely, the project drew on the men's collective talents in draftsmanship, presentation, model making, and color harmony.[35]

The design challenge was to orchestrate a chromatic symphony from the hodgepodge along Lake Michigan by unifying the three-mile park and the disparate buildings, each designed by an architect with his own concept of streamlined modernism. To create cohesion, Urban's team broke away from the conventional practice of imposing color on form in a decorative manner. In contrast to the approaches of the muralist Jules Guerin and the polychromist Léon Solon, they demonstrated how a palette in the "strongest, clearest, purest, most direct, pigments available" was the perfect complement to modern architecture. Instead of a traditional world's fair's pale stucco buildings decorated with

bunting and banners, they opted for a "pageant of pure color in broad surfaces." They studied the placement of the major buildings in relation to each other, saw how the layout created discrete zones, and artfully manipulated color to express the moods of those spaces. In architecture, as in fashion, color was the linchpin of the ensemble.[36]

Urban's team seized the moment to popularize color as a visual tool in architectural and landscape design. Versed in European modernism, they believed color had intrinsic value as a medium, governed by its own laws of harmony, balance, and power. "Urban visualized the Exposition buildings as a background for moving crowds," Vogelgesang explained. "He selected his palette for the effect that would be produced by people moving before the masses of color. He tried to get life into this most colossal of all his settings—blood, warmth, texture, and motion." According to Teegen, Urban "saw the entire Exposition primarily as a huge stage setting, on a far more extensive scale than any Ziegfeld production" and "had a definite intention to 'knock people in the eye.'" And because the exposition was held during the Great Depression, there was also a desire to create a festive mood, expressing a confidence in capitalism and a hope for the future. "One goes to an Exposition to be happy, to be gay. It should provide an atmosphere lacking in our daily life. Our cities and towns are, on the whole, very drab. . . . The color on A Century of Progress buildings is a challenge to the world to use color and to use it boldly."[37]

Paint chemists and manufacturers provided the technology that allowed Urban to implement his color plan. The Urban studio sketched out the palette in egg tempera, a medium that yielded brilliant opaque colors. Saturated colors had never been used on exterior walls of American buildings, and there were no performance data on new pigments such as cadmium yellow and ultramarine blue. The illumination plan required a matte surface that would absorb rather than reflect the light and would not fade over time. The consensus among paint manufacturers was that Urban's palette could not be reproduced in traditional oil-based paints, and a quest ensued for a weather-resistant alternative. Extensive exposure tests at the fairgrounds led to the adoption of quick-drying casein paints. (Casein, a milk-based emulsion, readily accepted pigments and yielded brilliant hues.) Urban had used such paints for the New School, and union rules permitted the Chicago painters to apply them with atomizers. Technical constraints thus led to the development of innovative paints that permitted Urban to express his colorful vision.[38]

Urban and his crew reviewed exhibitors' color choices to ensure the continuity of the ensemble. Teegen was in charge of the exteriors; Vogelgesang oversaw the interiors. One stunning corporate pavilion was that of the Firestone Tire and Rubber Company, which used colored paint, electric lighting, and pumped water to celebrate the wonders of industrial production. Stupendous illuminated fountains surrounded the structure; inside, the exhibits included a miniature tire factory, with the machinery and the workers on colorized platforms and the details of the equipment picked

8.7 A souvenir postcard of a colorized work station in the Firestone Building at the Century of Progress Exposition, 1933.

out in contrasting hues (figure 8.7). Visitors were enveloped in colorful surroundings designed to put them at ease. Elsewhere at the exposition, the Florida Tropical Home had a pale stucco exterior and pastel furnishings that evoked a casual lifestyle, and the Italian Pavilion used bright Mediterranean colors to showcase that aspect of America's multicultural heritage.[39]

Musical analogies helped the contract architects to understand the logic of the ensemble and to create a memorable orchestration that conveyed the futuristic theme in a playful, upbeat way. "We are taking color and applying it to planes and volumes," one assistant explained, "making it plastic, playing with it in space." Every color, like every musical note, had a specific value; in combination, they modified each other. Whether a composer or a colorist, the artist arranged the notes to produce "a certain atmosphere, establishing tension or repose." Variations of hue, value, and chroma occurred throughout, as in the passages of a musical composition. Colors were meant to "be played with, contrasted, composed with, until a whole is achieved which, like a symphony, can be translated into no other form of expression."[40]

And like a symphony, the color ensemble was difficult to describe in words. A list of paint colors (25 exterior hues and 36 interior hues) did little justice to the effect, but a description of a walk through the exposition better conveyed the total effect. From the main entrance (off Twelfth Street), visitors were immediately immersed in the first color mood. The Avenue of Flags, lined with red banners on hot days and blue ones on cool days, led northward past the South Lagoon to the curved North Court of the Hall of Science, where the second mood or key was encountered. The Hall of Science had a tower in deep orange, wings in lighter orange, and striped terraces in blue and white. The sides of the tower were painted to match the adjacent field, with blue on the wall next to the Avenue of the Flags. Just to the north, a white bridge took visitors to the third color mood at the General Exhibits Building. That structure was mainly black, with gray-blue-green wings. As fairgoers headed to the North Lagoon, they saw a blaze of cobalt blue, white, and yellow in the distance; this fourth mood, though distinctive, harked back to the terrace of the Hall of Science. Thus the ensemble unfolded, changing keys or moods from space to space, but creating a visually unified whole.[41]

This painted landscape was a festive stage for spectacular lighting. In mid 1932, the chief illuminating engineer, Edwin D. Tillson, told *Popular Mechanics* that the fair had been "built from the ground up with the illumination idea always paramount." Later that year, the planners replaced Tillson with Walter D'Arcy Ryan on the recommendations of General Electric and Westinghouse. After his triumph at the Panama-Pacific Exposition, Ryan had spearheaded the development of high-intensity street lamps and ornamental flood lighting as head of General Electric's Illuminating Engineering Laboratory. His sartorial style reflected his professional enthusiasm for light-and-color play. "It's easy to see," the trade journal *Electrical Merchandising* wrote, "why they call W. D'Arcy Ryan the wizard of spectacular lighting." With "a light suit, and brand new straw capital," he stood out among engineers "like a 'horse in Detroit!'" An ecstatic Otto Teegen wrote to Urban: "Mr. Ryan will have entire control of the situation. I am sure he will look for your help and judgment, and will cooperate in every way."[42]

Ryan assembled a design team of General Electric and Westinghouse engineers to illuminate the asymmetrical landscape after dark. The eccentric buildings were mostly horizontal, with large windowless walls, an absence of relief embellishment, and planes of bold color. The lighting effects were keyed to these jazzy silhouettes and, in Ryan's words, created "a blending of the modernistic with the futuristic." The major attraction was a spectacular aurora generated by a scintillator on the shores of Lake Michigan. Beams of colored light fanned across the sky, changing character as they landed on man-made steam clouds in the shape of delicate feathers, fantastic plumes, and fiery pinwheels. Fireworks and smoke bombs exploded above, adding to the drama. Elsewhere, white searchlights and lamps picked out the zigzags and curves of the painted buildings, and the South Lagoon's fountains sparkled red, amber, green, and blue. New types of tube lamps, neon and otherwise, gave luminosity to Joseph Urban's color vision.[43]

The Century of Progress Exposition drew mixed reactions. Working-class visitors reveled in the chromatic splendor, relishing the carnival atmosphere as an escape from harsh economic realities. Some people equivocated on the colors. "I saw conservative people gasp at the violent pigments covering a whole façade," wrote the architect Paul Philippe Cret, and "when they left the Fair grounds, wonder why the streets of the city were so dreadfully grey and drab." Highbrows at *The Nation* turned up their noses: "The fair was a poor eye rack. It was jazz. . . . The forms were chaos, and the color was camouflage." Although worried about the demise of polychromy, the *Magazine of Art* admitted the fair might set a positive example for the new plastic age: "A successful use of color will . . . do much for the future of American architecture, for we are passing from the sole use of natural materials to an increasing use of composite and synthetic materials, which lend themselves readily to color."[44]

Those familiar with color merchandising were upbeat. *Business Week* thought the "strikingly beautiful light effects" would stimulate the demand for electricity. *Inland Printer* hoped the ensemble would inspire advertisers to invest in colorful artwork. The paint industry saw a promising future for matte paints in saturated colors: "Thousands of people going home from the fair will try to reproduce these interior and exterior color effects in homes, institutions, schools, offices, etc." Saturated paints would be "required for the brilliant harmonies of these modern decorative schemes."[45]

The original intent of the exposition had been to commemorate the Chicago centennial, but the economic downturn transformed civic boosterism into a national celebration of science, technology, and capitalism. Joseph Urban added an international dimension, bringing Viennese color sensibilities to the gritty city of Chicago. Modernist color entered the American architectural lexicon and was given free rein by a panoply of new materials. Urban unified the disparate elements, using the color wheel as his tool. Walter D'Arcy Ryan abetted this effort by putting on the light show of a lifetime. Here at last was Albert Munsell's marriage of art and science.[46]

The Taupe Age

Mary Hallock Greenewalt was not happy with the Century of Progress Exposition. Initially enthusiastic about the fair's emphasis on color and light, she arranged to show Nourathar in a Hollywood concession. Determined to "make the whole Century of Progress Exposition a tribute to my color originations," she saw those hopes scuttled at Chicago. Exhibit installers misplaced components, suppliers failed to deliver, and the chief electrician proved to be a buffoon. She saw little merit in the Urban-Ryan scheme. "For it be known the wholesale color display at the Fair was but walls painted red, blue and green, lighted up. Sometimes there would be blue colored filters on lamps lighting blue walls and red filters on lamps lighting red walls." The bitterness lingered, even a dozen years later. "The result was not even a true murmur, ripple or rattling of color ray." This was "nothing but *lighting up paint*" rather than "painting with light."[47]

Mural Shades

The 1939 New York World's Fair soothed the nerves of a nation on the brink of war with pastel colors. This $156 million extravaganza—located in Flushing Meadows, 9 miles from Midtown Manhattan—was the largest fair to date, triple the size of Chicago's Century of Progress Exposition. Early on, Grover Aloysius Whalen, head of the Fair Corporation, decided on a feel-good interpretation of technology and social progress. Henry Dreyfuss and Raymond Loewy, rising stars among the new consultant designers, developed the main theme, Building a World of Tomorrow. Innovations such as Plexiglas acrylic plastic and colorful neon lights were added to conventional design elements—painted stucco, Art Deco sculptures and murals, and illuminated fountains—to create "a series of color cocktails at every turn in the road."[48]

The color revolution had flummoxed fair designers ever since A Century of Progress. Most architects and critics agreed that Joseph Urban's ensemble was provocative, but some thought the colors were too controversial. A backlash occurred. The 1936 Texas Centennial Central Exposition, which relegated bright hues to "accents and mural paintings," was characterized as the "Tawny Fair, its lion's mane color dictated by a desire to minimize the glare of Southern sunlight." The 1937 Exposition internationale des arts et techniques dans la vie moderne in Paris also took a refined approach. The newly painted Eiffel Tower, Grover Whalen reported, had its latticework base illuminated by the General Electric Company's new pastel neon tubes. "These lights," Whalen commented, "are done in the most delicate hues," rather than in "the red Neon light, which is terrible." In San Francisco, designers contemplated the palette for another 1939 fair, the Golden Gate International Exposition, a celebration of the marvelous new bridge.[49]

Howard Ketcham thought the New York exposition could benefit from color planning. In October of 1936, he submitted his proposal for "A World's Fair of Color" that suggested how color psychology could be used to delight attendees and to facilitate crowd control. Ketcham re-imagined Flushing Meadows as a polychrome "mosaic," with colors assigned to spaces on the basis of psychological associations. "An experienced Color Engineer, by the skillful application of such color schemes, would play upon the emotions of the crowds to the extent of tending to keep them in a cheerful frame of mind, making them almost oblivious to fatigue, adding to their appreciation of the displays, and making them more tolerant of the enforcement of Rules and Regulations."[50]

In January of 1937, the Fair Corporation did make a color commitment—but not in the way that Ketcham had hoped. The Board of Design hired Julian Garnsey as the color director. This young Harvard-trained artist had definite opinions about color that were based on his work as a Hollywood art director and as a muralist for the Texas Centennial Central Exposition. "There are many possible color schemes and as many ideas about color as there are individuals," he told Grover Whalen. "If there is no centralized control, there will be no unity and no dramatic effect." Impressed by the logic, the fair's design chief, Stephen Voorhees, hired Garnsey and pulled together a small color committee. The chief muralist, Ernest Peixotto, masterminded the color scheme; the lighting expert, Bassett Jones, designed the illumination; and Garnsey oversaw the execution.[51]

In contrast to Chicago, the New York palette was created in step with the architecture and landscaping. Peixotto's rainbow theme followed the geometric layout. At the center were the futuristic symbols of the fair—the white Trylon and Perisphere—surrounded by roads and buildings in graduations of pure prismatic color. Three main avenues radiated from this hub in primary colors: yellow to the north, red to the northeast, and blue to the east. The brightness and intensity increased with the distance. The spokes were connected by the curved Rainbow Avenue, which introduced shades of violet and orange. A warm gray-white and harmonious color accents were applied throughout to relieve monotony. The choice of the official flag colors, orange and blue, was influenced by the flag of the City of New York.[52]

Technological factors influenced the color scheme. "[W]e should start the Fair as a bright, brand new, colorful show, because the writers who describe it and induce others to come will see it at the opening," Julian Garnsey explained. "We know that all colors will fade, but I think we should begin with the brilliant and unusual color effects that we have planned." But when pigments such as cadmium and ultramarine lost their punch in the new synthetic-resin paints, the color committee moved away from saturated colors to paler, grayer tones, which in vintage newsreels and home movies look almost white.[53]

The Fair Corporation intended the New York fair to pull the United States out of the Great Depression. Social engineering—increased consumer spending through aesthetic appreciation—was the ultimate goal. "We believe that our visitors will carry home to all parts of the country new ideas of the possibilities of the use of color and that this influence will be reflected in demand for more color in manufactured products," Julian Garnsey wrote. "Already many manufacturers are preparing to supply such a demand by restudying the color of their wares." New shade combinations at every turn would etch color into Everyman's memory.[54]

Howard Ketcham, after contemplating these developments at his office in Rockefeller Center, sued the Fair Corporation for copyright infringement. Nothing came of his proposal for "A World's Fair of Color," and he found the press coverage of Peixotto and Garnsey irritating. His lawsuit got lost in the general chaos that followed the beginning of World War II.[55]

Howard Ketcham vs. The New York World's Fair was a showdown between two paradigms: color as engineering and color as artistic expression. In court, the muralists closed ranks and Peixotto pulled out

the fine-art trump card. Ketcham's color mosaic was rooted in systematic consumer research and scientific principles, but *his* rainbow plan had sprung from the imagination. Based "upon esthetic grounds," it "had no scientific reason, or so-called reason for existence, . . . but was intended to bind together the buildings of different shapes into a certain unity and yet a variety of ensemble." In the gloomy days of 1940, the judge seemed to think this dispute over color hegemony was trivial. In the end, he commended Ketcham's design but determined that the fair's color scheme was unique.[56]

The color engineer seethed, knowing full well that all creative consultants took risks and were susceptible to incursions on their intellectual property. Design proposals sent out on speculation often found their way into someone else's designs. Color copycats were everywhere because the barriers to entry were low. At the Everyman Fair, anyone who could hold a paintbrush could, and did, call himself a colorist. But in Ketcham's mind, just as not every bartender makes a perfect Martini, not every colorist could produce a stunning color cocktail.

8.8 Hercules Powder Company advertisement, © 1939, Hercules. All Rights Reserved. Courtesy Ashland, Inc.

General Electric's lighting wizard, Matthew Luckiesh, was also pessimistic. He admired the color-light show in Chicago but worried about the deep-seated chromophobia that still dominated mainstream culture. The advances of the recent past—the True Blue Oakland, color forecasting, modernist architecture, the world's fairs—were bright spots in an essentially colorless era. "Why does the artificial world border on drabness?" he asked in his 1938 book *Color and Colors*. Like some others, Luckiesh blamed the chromatic malaise on Puritan and Quaker values: "Mental *color-blindness* is a very general affliction of civilized adults." The White Anglo-Saxon Protestants atop the social pyramid feared color, and the emulative middle classes thought their betters would disdain them for choosing hot pink. Social climbers had to follow the rules of good taste, exemplified by Buick sedans, Sheraton-style furniture, and subtle hues. Luckiesh saw promise in the less civilized, less inhibited working-class people who reveled in the carnival-like Chicago fair: "Persons, whose tastes have been less refined by the processes of civilization, are fundamentally more honest with color because they have less fear. They follow their primitive liking for color and purchase gaudy baubles and garish lamp shades; they sometimes paint their fences and trim their houses with yellow, blue or any color." No wonder inexpensive, colorful merchandise—red-handled spoons, Bakelite costume jewelry, Harlequin dinnerware—flew off the shelves at Woolworth's. The color revolution faced a formidable foe in the "almost colorless taupe age," but Luckiesh held out for a bolder future.[57]

Léon Solon kept silent about A Century of Progress and focused his energy on a soaring monument to the color revolution. From 1934 to 1939, he served as the colorist for Rockefeller Center, the nation's first large-scale, mixed-use urban renewal project. From a distance Rockefeller Center seemed to celebrate the color-blind taupe tradition or to anticipate the International Style. But up close, much as on Fifth Avenue, polychrome embellishments were in evidence at street level, where pedestrians could enjoy them. For example, the RCA Building at 30 Rockefeller Plaza had, above its main doors, massive relief figures representing Wisdom, Sound, and Light, which Lee Lawrie had sculpted and Solon had colorized in a subdued palette of red, black, blue, and gold. Solon also designed color accents for the French, British, Italian, and International Buildings, using a special paint of his own formulation that has withstood New York's harsh climate to this day. "Perhaps, a hundred years from now," he wrote, "one of the things for which people will gratefully remember Rockefeller Center . . . will be its re-pioneering the use of color." Fittingly, Prince Polychrome's last major commission was a tempered Art Deco masterpiece, a tribute to American capitalism, technological ingenuity, and the color ensemble.[58]

9 Mood Conditioning

Functional color was a new practice that came into focus around the time of World War II. Advocates of functional color saw color as having the potential to improve safety and comfort in hospitals, factories, offices, and schools. They colorized interiors to achieve relief from eyestrain and fatigue, lower accident rates, and greater productivity. In other words, they used color to generate tangible results. The new functional colorists had no artistic pretensions. The judicious use of color could produce a visually pleasing interior, but mood conditioning was the ultimate goal.

Multiple interests were addressed by the concept of functional color, including surgeons (who were susceptible to eyestrain in the operating room), architects, advertisers, paint manufacturers, factory managers, and school administrators. Professional colorists added their specialized knowledge of how color affected human psychology. H. Ledyard Towle and Faber Birren developed marketing programs for the paint industry that established functional color as a design solution for public interiors during and after the war. Eventually, Birren applied the principles of mood conditioning to the private sphere as well, developing the ensemble concept for interior decoration in the postwar home.

Putting Color to Work

Color in the kitchen makes it an easier in which place to work. *So does color in the plant.*

—*Factory and Industrial Management*, 1932

The layouts of factories and the designs of machines are subject to changing fashions, much like other spaces and objects. In Victorian times, railroad and powerhouse engineers lovingly painted their locomotives and steam engines in bright

shiny reds and greens. Manufacturers of capital equipment decorated their products—drill presses, saws, sewing machines, and so forth—with decals and gilding. But welfare capitalism and the efficiency craze turned plant managers' attentions to sanitation, ventilation, and electric illumination. Mill white became the preferred paint for clean factories, and people forgot about the Victorian tradition of colorized machinery. In the early 1920s, widespread electrification led to workers' complaints about glare and sparked a new interest in color. Plant managers found that repainting the plain black machinery in bright, pleasant enamels reduced eyestrain, restlessness, and errors at the workbench. They also began to use color-coded paint systems as an aid to factory safety. For first time, maintenance crews hung the fire extinguisher against a red area on the wall and color-coded the overhead pipes to differentiate the heating ducts from the sprinklers.[1]

Hospitals were among the first institutions to understand how color affected the work environment. During World War I, the *California State Journal of Medicine* published Major Harry Sherman's article on the green operating room at St. Luke's Hospital in San Francisco, and magazines like the *American Architect* picked up the story. Soon architects (among them William O. Ludlow) were lobbying for replacing antiseptic white hospital walls (which suggested cleanliness and coldness) with soft greens, pale blues, red accents, and windows that let in lots of healthy sunshine. J. Eastman Sheehan, a professor of surgery at Columbia University, criticized the conventional all-white operating room, whose glossy walls and bright lights caused doctors to see red afterimages when they looked up from an open wound. Drawing on his anatomical knowledge of how the human eye reacted to light, Sheehan used tiles and paint to design a lucent environment that showed the natural hues of the instruments and the body tissue while reducing the fatigue-producing reflexes caused by the bright light. In an operating room at Columbia's medical school, he attached a yellow filter to the overhead lamp; painted the floor light green; covered the walls in green, blue, and yellow bands; and dressed everyone in blue-green smocks. The colorized surroundings contrasted with the patient's pink flesh, allowing the surgeons to see better and to work longer hours without tiring. By the late 1920s, *Modern Hospital* was heralding a new era in medical design and was saying goodbye to antiseptic white and hello to color.[2]

These innovations paralleled ongoing research on light at General Electric's lighting research laboratory under Matthew Luckiesh. The wizard of Nela Park oversaw vast improvements to Mazda-brand electric bulbs, including the Flametint Lamp and the Daylight Lamp. Flametint lamps emulated a flickering fire and were used in the home to create a mood; Daylight bulbs (with Tungsten filaments and transparent blue glass) were designed for settings where it was important to discern colors, such as department stores. These technical developments, in combination with the lower costs that resulted from Corning's introduction of bulb-blowing machines, put better lighting technology into the hands of people concerned with better vision.

Be kind to their eyes

SENSITIVE FILMS are children's eyes. They need enough light and the right kind of light. Gloom and glare are equally dangerous. Yet the difference between poor light and good light is merely a matter of pennies. For your children's sake—and your own comfort, too—be sure you use the right kind of lamps.

Bring your lighting up to standard with the *new* Edison MAZDA Lamps. They mean more and better light per penny's worth of electricity—already the least expensive item in your budget.

Ask your nearest Edison MAZDA Lamp Agent to show you the new lamps. He will gladly help you to select the right sizes for every fixture in your home. He displays the emblem shown below at the right.

In shape and finish the *new* Edison MAZDA Lamps have been likened to a pearl. They are frosted on the *inside* to help protect your eyes, but let the light come through better than any other diffusing lamps. They are stronger and collect less dust. Their few sizes fill practically every home-lighting requirement.

They have all the advantages of the old types of outside frosted lamps and more, but they sell for much less.

 EDISON MAZDA LAMPS
A GENERAL ELECTRIC PRODUCT

9.1 Advertisement for Mazda light bulbs,
Ladies' Home Journal, November 1926.

After the stock market crash of 1929, more and more factories colorized machinery as a means to improve their public image, their safety records, and their production output. During the 1920s, companies had channeled profits into new factories outfitted with motor-powered machinery. Plant tours were a favorite pastime of consumers in the days before television and the Internet. People loved to watch marvelous new machines make textiles and glass, process dairy products and other foods, and fold cardboard boxes. With an eye to entertaining the tourists, the equipment was painted in bright colors.[3]

To learn about machine colorization, the growing electrical, chemical, and aircraft industries leaned on engineering consultants such as the Austin Company, a Cleveland firm known for its systematic approach to factory design. To affect "controlled conditions" at the Simonds Saw & Steel Company, Austin installed orange-colored machinery. Other plants discovered color by serendipity. Managers at the E. T. Wright Arch Preserver Shoe Company worried when assembly-line workers complained about headaches and blind spots. Noticing the lack of contrast between the black shoes and the black machines, one manager instructed an operator to pick a bright color and repaint his station. When other workers followed that operator's example, the accident rate fell by 70 percent. "Paint, at present a maintenance material, becomes paint, a production asset."[4]

The Spider

Color is versatile and does not respond with anything of a scientific accuracy.
—Faber Birren, 1925

In the summer of 1934, the Century of Progress Exposition opened for a second season with a fresh coat of paint. Taking charge of color, Shepard Vogelgesang toned down the palette, inventing ten new hues, "not one of them being comparable with any tint" from 1933. The Ford Motor Company, inspired by the chromatic displays in the Firestone, General Motors, and American Cigar buildings, joined the "plants on parade" in the second year. The Ford Pavilion was colorized inside and out, using the Vogelgesang palette and experimental Sherwin-Williams soybean paints. Visitors responded positively to the moving assembly line and the brilliant colors, which suggested that American taste in interior decoration might be drifting away from taupe and toward tangerine. After the fair, Sherwin-Williams featured the Ford Pavilion in a catalog titled *Plant Conditioning*, asserting that "the workers and the onlookers liked" the bright paints. "Many have taken the hint and put color to work. It serves not only the worker, but the customer." Thus the Chicago exposition helped to establish a place for functional color in paint marketing.[5]

In the shadow of the exposition, a mild-mannered Chicago entrepreneur brooded over the chromatic future. Faber Birren had contributed to the exposition in a modest way, organizing an exhibit for the Society of Typographical Arts, but the brassy palette ran counter to his research in color psychology and the principles he advocated to advertisers, printers, and other clients. "Modernism has led to an overabundance of garishness," he wrote in *Architecture*, "a blunt splurge of hue lacking in both originality and beauty." Architects, he scolded, would be wise to discard brash solutions for thoughtful analysis of "what the eyes and minds of human beings distinguish, like, and dislike."[6]

At the age of 35, Faber Birren was on his way to becoming America's leading proponent of functional color. Born in Chicago in 1900, he was exposed to the arts from the time he could crawl. His father was the only landscape painter among a Luxembourger family of undertakers; his mother was a skilled pianist. In his teens, "the Spider"—as the tall, lanky boy was nicknamed by his playmates—turned in his baseball glove for an artist's easel. He took classes in life drawing at the Chicago Art Institute, but found color and design more to his liking. Unable to buy clothes that were colorful enough for his taste, he dyed white fabrics in loud colors and sewed a "punchy" wardrobe.[7]

The precocious teenager questioned the popular wisdom on color. Why did shoppers refuse to buy butter or oranges unless they were dyed? Why did his Luxembourger grandmother believe that a red flannel bandage would cure the croup and that white socks would prevent corns and bunions? If color could do these jobs, why couldn't it be put to work in a more deliberate way? When professors at the University of Chicago failed to provide answers, Birren dropped out to work in publishing and to undertake independent research. Leading a reclusive life, he pored over books about light and color; corresponded with psychologists, physicists, and ophthalmologists abroad; and translated obscure texts with the help of a retired German physician. Working 16 hours a day, he gradually assembled data on functional color and ran experiments to verify his theories. To test the old folk adage "paint the dungeon red and drive the prisoner mad," he did up a room in vermillion and found that he was "quite comfortable and cheerful" in it.[8]

From the start of his prolific career, Birren expounded on practical color, focusing on "what" moods could be evoked by colors rather than "how" light rays behaved in physics. "A basic understanding of color science is not, as a rule, necessary in general color study," he wrote in *School Arts Magazine*. The "physics of light is quite remote from the emotional side of color use." Psychology was more helpful. Birren's study of art history revealed that many older cultures paired certain natural hues with emotional sensations. Present-day corollaries existed, and they could be exploited. "The use of color demands selection and arrangement of hue," he wrote in *Inland Printer*, "just as the advertiser demands selection and arrangement of words." In packaging, red could suggest action; yellow might

say success, blue truth, orange wealth and plenty, green genuineness and conviction, and violet refinement or vanity. The colorist had to choose colors that would be right in the context. The color scheme of an Impressionist landscape wasn't suitable for a milk carton or for a schoolroom.[9]

Birren applied this utilitarian approach to color harmony, which had been a concern of colorists since Michel-Eugène Chevreul. It seemed that everybody had something to say on this topic, but no one had a solution. Even Matthew Luckiesh at General Electric saw little chance "for a general agreement." In his view, artists were "a hopeless group from the viewpoint as to harmonies," thinking they understood average tastes and avant-garde sensibilities when they really knew "little for sure." The artist was not necessarily a better color harmonist than "one who is primarily an scientist"; the latter could also "have feeling" and "sometimes is human, notwithstanding appearances." Birren was far more diplomatic. Much like Detroit's master of visual streamlining, H. Ledyard Towle, he chose a middle ground in the art-science debate, and dispensed with hard-and-fast rules in favor of design solutions tailored to the situation at hand.[10]

This down-to-earth perspective earned Birren the respect of an older commercial colorist, Egmont Arens, who had co-authored a popular book titled *Consumer Engineering* and who was the director of industrial styling at the Calkins and Holdin advertising agency. In 1935, Arens pondered the fragmentation of the field. Americans were spending $330,000 a minute on colored products, and in factories across the land art directors were trying to anticipate trends by studying sales records, the Automobile Color Index, and "the silk and cotton color statistics." Physicists, chemists, psychologists, etymologists, painters, mobile musicians, and stylists had all "set themselves up to be the *exclusive* authorities on color on a mutually antagonistic basis." Turf wars hampered the chromatic progress of American industry, which needed "a *broader* system which will include all the others."[11]

Many color revolutionaries saw innovation as their mission, and the corporate colorists of the 1930s were no exception. Egmont Arens longed for a "Color Institute" that would gather statistics from far and wide and "create a scientific color system which will embrace all extant color systems." No existing systems, he remarked, "do the job that I—as a practical worker in the application of color to consumer goods—need to have done." The art-science schism of Albert Munsell's day resurfaced. Book learning had robbed the system builders of "their horse sense, their animal sense, if you will, their human sense." What was the solution? Arens believed that the heir apparent to good color sense was Faber Birren, who "has carried on where Ostwald stopped" and "has done the most progressive job in this field in our generation."[12]

When the Depression hit the publishing industry and Birren lost his job, he pursued his dream of becoming a freelance colorist. At first, conservative Midwestern businessmen thought the gangly artist who spouted theories of color and emotion was "wacky," but many remarkable successes put functional color on the map. The managers of a wholesale meat company in Chicago were skeptical

when Birren said he could improve meat sales by colorizing the company's showrooms, where the spotless white walls of the large walk-in coolers created a gray after-image in the customer's eyes and seemed to rob the carcass of its natural redness, and the yellow sawdust on the floor added a bluish tinge. Birren studied fresh porterhouse steaks under different lights and designed a complementary paint scheme. His blue-green walls made the beef look redder, and more of it was sold. After the company redid its 365 national salesrooms, its leading competitor colorized too.[13]

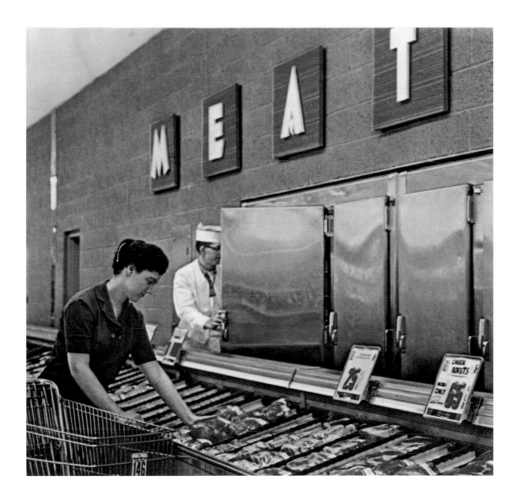

9.2 Photo used in "The Right Light for Good Appearance," *Today's Business*, August 1960. Faber Birren Papers, Manuscripts and Archives, Yale University. Reproduced courtesy of Zoe Birren.

In 1935, Faber Birren moved to New York in search of new business. Setting up an office in the *Daily News* Building on Forty-Second Street, he steered clear of the apparel industry and concentrated on fabrics, furnishings, packaging, plastics, and printing. The going was tough until Birren convinced one Brooklyn plant to paint its ladies' lounges in a delicate rose shade. Some of the men sniggered ("He's trying to turn this factory into a corset shop"), but women loved the pleasant pink lounges. In fact, some women ate lunch in them rather than going out to local diners; this reduced tardiness and improved labor-management relations. Word got around that Birren might not be an eccentric after all. His 1937 book *Functional Color* was the first full-length analysis of how business could use color to increase productivity and morale. The next year, Birren helped the Austin Company conduct a systematic study of functional color in factories. The Austin-Birren partnership combined the best in factory construction with the best in functional color theory.[14]

Businesses began to see functional color as a form of social engineering, which helped Birren secure high-profile contracts. Plant managers began to realize that a functional paint job could reduce the cost of lighting and could improve workers' well-being. His color schemes relieved the monotony of New York Telephone Company operators, reduced accidents at the Caterpillar Tractor Company, and eliminated eye fatigue in Marshall Field's textile mills. The introduction of fluorescent lights brought another rush of contracts. New color schemes were needed to avoid eyestrain and to prevent objects from looking ghostly under the greenish glow.[15]

Another opportunity arose when Hollywood filmmakers adopted the Technicolor process. In 1939, Walt Disney invited Birren to come to California and advise the animators planning *Fantasia*, *Pinocchio*, *Bambi*, and other feature films. The Technicolor film *The Wizard of Oz* carried Depression-weary theatergoers to another time and place. Sensational blues, greens, reds, and yellows, according to *Reader's Digest*, made "you feel the way the director wants you to feel." In a sense, *The Wizard of Oz* was the ultimate example of how color's emotional value could be used: Dorothy had only to click her ruby slippers and the entire world was transformed.[16]

Color Dynamics

The new students of color are only secondarily and incidentally interested in
wave lengths, spectrometer readings and the results of additive mixture as shown
by the Wollaston prism or Maxwell disk. They are interested in how color affects
human beings.
—*California Arts and Architecture*, 1943

H. Ledyard Towle's job as director of the Division of Creative Design and Color at the Pittsburgh Plate Glass Company was to help potential customers—architects, designers, builders, manufacturers,

consumers—better understand the company's high-performance building materials. To that end, he created illustrated booklets, advertisements, and custom drawings that showcased new applications for plate-glass mirrors and high-performance paints. He also designed showrooms for PPG's regional distributors and suggested color solutions for customers who wanted to decorate a fleet of trucks or a chain of hotels.[17]

Towle occasionally worked on projects for Ditzler, the PPG subsidiary in Detroit that made nitrocellulose lacquers. Automobile design had changed substantially since his days at DuPont and General Motors. "The increased use of color brought about the feeling for the need of better design," he wrote in 1937, "and today every automobile manufacturer has on the Staff a number of creative designers"—and "at least one Color Engineer." Harley Earl had expanded GM's Art and Colour Section to 255 people, including color engineers, creative designers, illustrators, sculptors, and model builders. "Design and Color have become so important as a sales factor," Towle wrote, "that they rank equally with 'price' and 'performance' in the minds of the Customers Research Staff maintained by all automobile manufacturers." Although Towle was recognized as a pioneer of color streamlining, Harley Earl, Raymond Loewy, and Eugene Gregorie were credited with transforming automotive design.[18]

Towle followed the tradewinds and applied his camouflage skills to interior design. PPG responded to the mood-conditioning trend with Glorified Light Products, a paint system that amplified the effects of natural and artificial illumination through optical illusion. An updated version of mill white, Glorified Light was endorsed by Matthew Luckiesh at General Electric and by Samuel Hibben at Westinghouse and was supported by Towle's "color engineering service" at PPG, which helped customers pick the correct colors for their walls, machinery, and products.[19]

In 1937, Towle launched an offensive on the Taupe Age, targeting bland taste in the home. His booklet on functional color, *Practical Suggestions for the Interesting Use of Glass and Paint in Your Home*, explained how the right hues could "banish fatigue" from the kitchen and how reverse camouflage techniques could enlarge the small living room.[20]

Household paints were finally moving away from creams and pastels. Popular magazines continued to whet consumers' appetites with more color advertising, as did the Sears catalog, which went from having 94 color pages in 1914 to having 246 color pages in 1941. The downside was that almost everyone—magazine editors, newspaper reporters, interior decorators, painting contractors, housewives—was now a self-described expert in the use of color. As a countermeasure, Towle co-founded a paint styling committee within the National Paint, Varnish, and Lacquer Association in

Washington to study trends in home decorating. His pocket booklet *ABC of Paint Styling* sought to gently correct the know-it-alls. Using simple language and reverse-camouflage methods, Towle explained how to create the illusion of space in tiny quarters and how to select a color scheme that put your guests at ease. For example: "You must remember that light colors always help to make things look larger. Dark colors help to make things look smaller." As a result of the paint industry's powerful public-relations efforts, the basic principles of military concealment became the new guidelines for interior decoration.[21]

With the onset of war, Towle found new applications for his skills. Early in 1941, he redid the interior of the headquarters of the Pittsburgh Chamber of Commerce, showing how the "proper use of paint and color" could hide "the physical defects of office space without other alterations." This impressed the local business elite, who asked him to join their civil defense team. If the Germans were to attack the United States, Pittsburgh's prominence as a manufacturing center would make it a prime target for aerial bombing. The former camoufleur created disruptive patterns to conceal smokestacks and steel mills. Pittsburgh was one the few American cities to have a full-fledged concealment plan. British military authorities invited Towle to advise them on camouflage.[22]

Back in the corporate studio, Towle applied camouflage techniques to wartime paint schemes for hospitals and factories. To conserve raw materials for the military, the federal government outlawed the manufacture of nonessential consumer goods—cars, refrigerators, nylon stockings, silk dresses—but deemed paint necessary to health, safety, and morale. Towle developed Color Therapy, a mood-conditioning program in which paint colors such as Eye-Rest Green were used in veterans' hospitals.[23]

When millions of inexperienced workers—grandparents, teenagers, housewives, maids, farmhands, and the like—flocked to high-paying defense jobs, the industrial accident rate skyrocketed. In the rush to produce more tanks and textiles, fingers were nipped, bones crushed, and lives lost. The War Production Board published booklets that advised factories on safety. Towle saw a chance to promote paint using reverse camouflage and color psychology. In the autumn of 1943, he introduced Color Dynamics, a plan that offered customized PPG paint schemes to factories engaged in war production. The three plants of the Consolidated Vultee Aircraft Corporation (one in San Diego, one in Nashville, and one in New Orleans) were among the customers. The plant engineer in California explained how Color Dynamics worked in his facility. Drab, cheerless surroundings that bred sluggishness, fatigue, and nervousness were banished for an upbeat modern color scheme. Reverse camouflage was applied to the machinery; each moving part was painted in a unique color to help the operator see. Eye-resting colors created a calming atmosphere. "All of this is particularly important to women, because of good housekeeping habits," the engineer told *Industrial Finishing*. "But our men workers are benefiting, too, even though many may not consciously realize it." Towle must have smiled in satisfaction.[24]

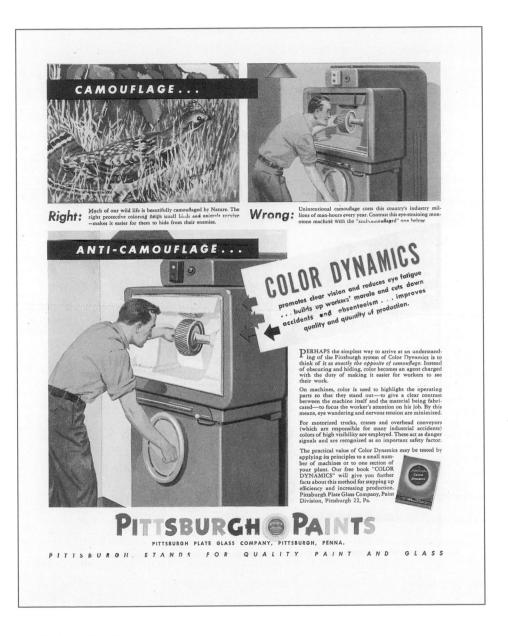

9.3 Pittsburgh Plate Glass Company advertisement, 1940s. Reproduced courtesy of PPG Industries, Inc.

Fighting with Color

During World War I, color's main military use had been in camouflage. By the time of World War II, however, changes in technology and tactics had led the military to expect more from color. Camouflage was still important, but color now had to aid vision and to boost morale.

Color theory held that orange-red had more "attention value" than any other hue. The gunner in the aft turret of a Boeing B-17 over Hamburg might suddenly get a radio alert that the Luftwaffe was on his tail. The turret's eyepiece was made of bright orange-red plastic so that the gunner could find it easily, no matter how rattled he was. In the cockpit, the pilot knew the status of the various systems from the colored lights on his instrument panel. And the B-17's many flexible Vinylite pipes (some for oil, some for fuel, some for brake fluid, some for de-icer) were color-coded according to military standards. The flight crew could repair them by matching the colors.[25]

Functional color helped people organize, simplify, and direct action on airfields, battleships, bombers, and battlefronts. (See figures 9.4 and 9.5.) Training planes were vividly colored to alert others to keep their distance. Ammunition was identified with distinctive colors. Bombs were colorized according to their types. Torpedoes, depth charges, and machine-gun bullets had markings to facilitate loading. Color was also used to combat claustrophobia. Close quarters such as the interiors of tanks, ships, and submarines were painted in delicate tints that soothed the nerves. Pale green made the hot, cramped interior of an M4 Sherman tank rolling across the North African desert seem larger and cooler. The ceilings and upper half of the walls in military bunkers were painted white; the lower half of the walls were painted a light grayish blue suggestive of the sky.[26]

Safety First

These developments coincided with the DuPont Company's research on paint, efficiency, and safety. In 1937, engineers in the DuPont finishes division studied the effective use of color in offices and factories, using the Philadelphia Electric Company facilities as a laboratory. After machine-shop employees complained that their "machines and work areas are too well camouflaged," DuPont engineers re-painted the equipment in different colors and then monitored factors such as fatigue, sight, speed, motion, light, and safety. They concluded that medium-gray machines, highlighted with light-buff working areas, reduced eye fatigue and raised the efficiency of operation. DuPont codified and packaged this knowledge in Three Dimensional Color, a paint program that was marketed to armories, arsenals, textile mills, aircraft factories, and quartermaster depots.[27]

Faber Birren turned Three Dimension Color into the DuPont Safety Color Code for industry. By now, it was common practice for plant maintenance crews to mark hazards with colored paints, but there was no "one best way" to do so. One factory painted the guards on its machines red; another

9.4 U.S. Army photo, 1943. Egmont Arens
Papers, Special Collections Research Center,
Syracuse University Library.

made them yellow. This was a throwback to the days of mismatched railroad signal colors. (See chapter 4.) Hiring Birren as an expert in color psychology, DuPont engineers established a set of standard colors that indicated accident hazards, identified protective equipment, and ensured better factory housekeeping. Safety Green was used to identify first-aid equipment; Precaution Blue to indicate caution; Alert Orange to warn against hazards that might cut, crush, burn, or shock; High Visibility Yellow to mark strike-against hazards such as curbstones; and Traffic White (or Gray or

9.5 Camouflage and reverse camouflage.
The khaki fatigues blended into the desert;
the red parachute did not. U.S. Army photo,
1943, Egmont Arens Papers, Special Collections
Research Center, Syracuse University Library.

Black) for housekeeping and flow control. Use of red was confined to Fire-Protection Red for flame-fighting devices. The U.S. Army adopted the code and later reported that it reduced accidents in government war plants from 46 to 5 per thousand workers. The DuPont Safety Color Code was so effective that in the 1950s the American Standards Association made it a national standard.[28]

DuPont engineers, following PPG's lead, began to recognize that colorization schemes could sell paint. Scientific tests showed that using the right paint on floors and walls could double the effects of most lighting systems without increasing the wattage. This was particularly useful during a war, when electricity was at a premium. In 1945, Faber Birren became the major consultant behind Color Conditioning, DuPont's answer to Color Dynamics. He designed Color Conditioning schemes for apartment buildings, factories, hospitals, hotels, offices, restaurants, schools, and stores, and helped DuPont sell color as the ultimate tool of scientific management.

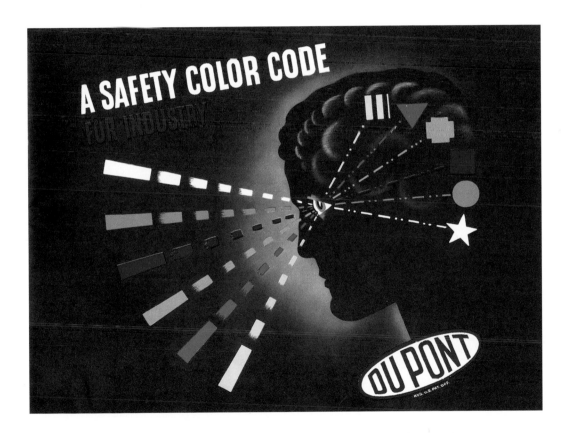

9.6 *A Safety Color Code for Industry*, DuPont Company, 1944. Hagley Museum and Library. Reproduced courtesy of the DuPont Company.

9.7 *DuPont Color Conditioning*, DuPont Company, 1956. Faber Birren Collection of Books on Color, Robert B. Haas Family Arts Library, Yale University. Reproduced courtesy of the DuPont Company.

Pan American Blue

Working closely with Pan-American engineers and with almost one hundred manufacturers, we were able to effect a complete harmony of design and color.

—Howard Ketcham, 1937

In 1935, Howard Ketcham left DuPont and opened an office in the new RCA Building at 30 Rockefeller Plaza. The Fifth Avenue address and the Art Deco décor suited the former Duco colorist, who had spent eight years promoting the proper relationship between the paint and the market. His first client was the DuPont plastics division; the assignment involved updating the Pyralin hairbrush line and designing a display for a Color Exposition and Fashion Review in Atlantic City. His clients soon included Lionel, the toy train manufacturer, and Pan American Airways.[29]

Halfway to Europe between cocktails and coffee

Don't plan to catch up on your reading. There's too much to take in—too much to talk about on your first Jet Clipper® flight.

While the stewardess removes the last cordial glass from your dinner table, she reminds you to set your watch five hours ahead and tells you that

there's barely enough time to finish a chapter before you see the lights of London.

Pan Am Jets are fastest to London, the only Jets to Paris and Rome. And this summer, Pan Am is increasing its schedules to include as many as four Jet flights a day to Europe—with deluxe

President Special service available on every one. You can also fly economy-class Clipper Thrift service, if you wish, with fares starting as low as $453⁰⁰ round trip.

For reservations, call your Travel Agent or any of Pan Am's 61 offices in the U.S. and Canada.

World's Most Experienced Airline

Pan Am Jet Clippers...world's fastest airliners...the only economy-class Jet service... the only Jets to all three capitals: London, Paris and Rome.

9.8 Advertisement for Pan-American Airways, *Life*, April 13, 1959.

Pan American was pioneering long-distance commercial flights to Latin America, East Asia, and Europe. Its Clipper fleet—named after the swift sailing ships of the old China trade—included large seaplanes that took off from the water. As its founder, Juan Trippe, turned Pan American from a mail-delivery service into a tourist airline, the planes had to be re-engineered for human comfort. While at DuPont, Ketcham had designed the interiors for the airline's Ford Trimotor fleet. For this new job, he hopped on a Sikorsky seaplane headed for Latin America. The multi-day trip was exhausting, in part because the sound bounced around the wooden cabin. Ketcham's improved cabin design introduced colored upholstery, curtains, and carpets to reduce the vibrations and to create a sense of security.[30]

The airline's signature color, Pan American Blue, was created for twelve new Boeing 314 Flying Boats. In the early days of air travel, passengers could walk around, but people were skittish about flying and couldn't relax. Despite its whale-like proportions, the Flying Boat had a small interior, owing to mechanical and weight constraints. Ketcham believed that a good floor plan, soundproofing, and an "airy" color scheme could make the 60–70 passengers feel at ease during a five-and-a-half-day flight to Brazil. The design team divided the passenger compartment into a series of small spaces. The seven passenger berths had soft, subdued hues. Travelers wrapped themselves in pale-blue blankets behind darker-blue curtains; in the morning, they freshened up in dressing rooms with soft gray tones. Bold two-tone accents—pale blue with chartreuse, for example—added visual interest throughout. One of these colorized seaplanes, the Dixie Clipper, made aviation history in 1939 when it flew from New York to Lisbon, inaugurating nonstop commercial service from North America to Europe.[31]

Ketcham also colorized Pan American's fleet of Boeing Stratocruisers, the giant duplex luxury aircraft introduced after World War II. He used blue, blue-green, silver-gray, and bisque to create an optical illusion that foreshortened the decks of the planes to make them seem less tunnel-like. "Good colors for airliners are not the same as colors which are good for other modes of transport," he told the *New York Times.* Mood conditioning had taken to the skies.[32]

Visual Public Relations

Between 1945 and 1960, Color Dynamics and Color Conditioning transformed the look and the feel of public interiors. Raymond Loewy Associates, building on its success with Lord & Taylor, applied functional color to other retail stores. The Bloomingdale's store in Stamford, Connecticut, whose restaurant had pink walls, pastel furniture, and bleached wood, was just one example. The spread of mood conditioning created a demand for colorful products. Furniture, carpets, lighting fixtures, dinnerware, curtains, display cabinets, and eating utensils had to match the ensemble. Russel Wright's now-collectible American Modern dinnerware for the Steubenville Pottery, and such lesser-known designs as DuPont's Fabrilite vinyl upholstery and Samsonite's school furniture, were manifestations of the mood-conditioning trend.[33]

Administrators of public schools saw what color had done for factory workers and wanted to give pupils the same advantages. Early in 1945, a new public school administrator in St. Paul, Minnesota, was alarmed at the neglected state of the facilities. A tour of more progressive school districts alerted him to the scientific use of pastel colors as an adjunct to natural and artificial light. He looked to business as a paragon of patriotism and efficiency. "Large industrial organizations had put a good deal of time and money into investigating the relationship of color schemes in factories and workshops to such matters as fatigue, safety, and morale. Important conclusions had been reached, and these had been embodied in color plans for the interior decoration of industrial plants." His colorization plan for St. Paul emulated this effort. Likewise, the New York City school superintendent collaborated with a color expert on a classroom palette, cautioning the "persons charged with the responsibility of color selection" at each site to avoid "the temptation to achieve something startlingly different." The best possible learning environment could be created from the official palette, which had been designed with learning and discipline in mind. Baby Boomers from coast to coast learned their ABCs in similar color-conditioned classrooms.[34]

Egmont Arens was another consultant who put mood conditioning to work for his clients. In the mid 1930s, he left Calkins and Holdin to set up his own consulting business, which offered a variety of design and color services. His clients included A&P, Anheuser-Busch, Bristol-Myers, Coca-Cola, General Electric, Higgins Inks, Singer Sewing Machine, and Western Electric. His functional color projects included a New York linoleum showroom designed in collaboration with his younger colleague Faber Birren. As business began to retool for the consumer boom, Arens became the principal color consultant to the Philip Morris Company, the fourth-largest cigarette manufacturer in the United States.[35]

Between 1947 and 1958, Arens worked on a series of "Visual Public Relations" projects initiated by Philip Morris' chairman, Alfred Emanuel Lyon. While cigarette sales in the United States grew by

9.9 *Brunswick School Furniture* (Brunswick-Balke-Collender Company, 1954). Russel Wright Papers, Special Collections Research Center, Syracuse University Library. Reproduced courtesy of the Brunswick Corporation.

17 percent between 1946 and 1951, Philip Morris' sales grew by 77 percent. Riding on this success, Lyon hired Arens to update the firm's stodgy image by outfitting the new corporate headquarters and remodeling two factories. After the 1954 merger of Philip Morris and Benson & Hedges, Arens also helped to revamp the Parliament brand.[36]

In 1950, the commercial architect Robert Allan Jacobs congratulated Arens on his "grand color job" for the Philip Morris suites at 100 Park Avenue, a Kahn and Jacobs skyscraper built the year before. This white brick structure was worlds apart from the Art Deco jewels of the Léon Solon era. The new International Style was based on high-tech materials and construction techniques. Philip Morris and other tenants rented several floors and hired interior designers to decorate them. Although Jacobs felt that "there is nothing tougher than mass office space," he thought Arens had managed "to relieve the usual monotony." The editors of *Office Management and Equipment* gave the Philip Morris suite a design award.[37]

The Philip Morris interior, a superb example of mood conditioning, was based on Arens' mastery of color psychology and the client's desire for "a general atmosphere of hospitality." "We have a lot of tobacco-auctionmen come in here," explained Lyon—"real he-men" who needed convivial surroundings. Philip Morris was no place for "stuffed shirts," and the offices had to convey that message. President O. Parker McComas liked the open floor plans of modern banks, where "even the Vice Presidents sit out front where they can be seen." Arens set to work, using the color-conditioned war plant as his model.[38]

The Philip Morris palette consisted of cool greens (suggestive of fresh tobacco leaves) and deep reds and browns. The reception area was a lush oasis, with a dark green carpet, mahogany furniture, wood paneling, and red leather chairs that matched the uniform of the brand's advertising mascot, the bellhop Johnny Roventini. This rich color theme, "scientifically designed to create a cheerful mood for the employees," was applied to the open floor plan, where different shades of green mimicked the effects of sunshine on leaves and grass. Arens covered the walkways with variegated plastic tiles, custom-designed "to reflect a portion of the illumination without glare, thus increasing the level of brightness in the room but without causing eyestrain." Similar schemes in factories had "increased output 10 to 15%," and Arens believed the verdant surroundings would perk up office workers.[39]

Arens tailored the private offices in the executive suite to the occupants' personalities. Each executive worked with Arens to personalize his space. Alfred Lyon selected deep green walls, a wine-colored carpet, and leather armchairs that suggested warmth and hospitality, while O. Parker McComas picked cool grays and greens indicative of crisp, friendly efficiency. W. C. Foley, the Irish-American vice-president for purchasing, wanted an all-green room; his sales counterpart "wanted a neutral background of light and dark grays so that he could properly judge colors of displays and other promotion material." These men circulated all day long, never sitting still, always moving from office to office. "The varied and lively color schemes," Arens said, "will stimulate their imaginations and help Philip Morris move up to even higher sales levels."[40]

9.10 Reception area of Philip Morris offices, New York. Egmont Arens Papers, Special Collections Research Center, Syracuse University Library.

Arens next performed his color magic at two aging cigarette plants, one in Richmond and one in Louisville. If new hues such as Foley Green had improved the mood at the corporation's headquarters in Manhattan, why not colorize the stemmeries and the cigarette factories? Some local managers were helpful in this effort; others were not. Arens enjoyed his exchanges with the Richmond plant engineer, who was "very much interested in the use of color for factory interiors," but locked horns with the Kentucky managers, who vetoed some of his recommendations. "The tobacco men in Louisville didn't think the chocolate color and warm beige which was sent yesterday as color for the Drying Room would be used nor would they experiment with Liquid Envelope at this time. They had ordered the ceiling to be painted white as usual." It took some time for Arens to deal with the skeptics and to colorize the two factories.[41]

The remake of Philip Morris' packaging introduced Arens to newcomers in color psychology. There were friendly exchanges with Ernest Dichter, a motivational-research expert from Vienna

whom Alfred Lyon was considering as a consultant. Using interviews, Dichter had begun to tap the subconscious for the reasons why people loved or hated certain brands. He looked for the "deep-seated emotional factors that are buried down underneath the surface" and helped manufacturers and advertising agencies improve their connections to the consumer. Arens thought these methods were well suited to commercial color research. "I think we speak the same language," he told Dichter, "as all my designing is done to evoke a certain pattern of behavior."[42]

Arens had a different opinion of Louis Cheskin, a member of the team charged with "rebranding" Philip Morris' cigarettes. Cheskin, a self-made market researcher based in Chicago, ran the Color Research Institute of America, which did packaging, trademark, and design projects for Procter & Gamble, Standard Oil, and Polaroid. His several books on color psychology were based in part on studies of people's eye movements as they looked at advertising samples. After reading a report on Dunhill cigarette packages, Arens expressed "some skepticism about his basic method." Cheskin was right to recommend another graphic design, but "neither he or his method can give us a *quality* evaluation, especially since he has not yet acquired the first elements of good taste." Arens pointed to Cheskin's book *Color-Tune Your Home*, in which the author's own magenta living room was used as an illustration of exemplary styling. "Here is a color counselor putting his color theories into practical use. Looking at these examples . . . may lead a Cheskin client to equally disastrous results."[43]

Tastes aside, there were striking differences in the methods of the two colorists. A Cheskin report for 1954 stated that "Magenta Red" was the most popular color in America, but Arens disagreed. Magenta was "definitely not a top rater in packaging today because it creates eye fatigue; although it has periodic fashion spurts, they are short-lived." Established barometers, such as Faber Birren's *House and Garden* Color Program (the subject of the next section), "show Cheskin's color chart to be dated." When he reported on consumers' reactions to a sample of red paper, Arens again objected. "Red by itself and white by itself tell you nothing at all about red and white together." A color had to be considered in relation to the whole.[44]

These tensions hinted at a generational divide in the color revolution. Like other pioneers of color management, Arens believed that certain undisputable laws governed the relationships among color, emotion, and motivation. Different colors induced different responses, and corporations could be shown how to tap this power. This view was based on decades of experience and on wartime innovations that fortified the idea of color as a vibrant force. The job of harnessing "*the dynamic attitude—the use of color as a tool to influence human beings into desired patterns of action or of* MOOD" required visual skills and psychological acumen. These took years to develop, and Arens was appalled when newcomers offered fast solutions. The formative years had passed, and it was

inevitable that the next generation of colorists would find their own way—and Arens smiled favorably on the success of his friend Faber Birren.[45]

American Color Trends

Faber Birren was ideally positioned to reshape commercial color practice for the postwar era. His highly visible work for the DuPont Company—the Color Conditioning program and the Safety Color Code—had helped his career. By the 1950s, his company, American Color Trends, a "fact-finding organization . . . devoted to human attitudes, motivations, responses and actions toward color," was the leading color consultancy in the United States. Its clients included the Radio Corporation of America, Sears, Roebuck and Company, and the Monsanto Chemical Company. But its most important client was *House and Garden*, an upscale magazine, published by Condé Nast, that introduced functional color into the home.[46]

The *House and Garden* Color Program adapted the ensemble concept to postwar consumer culture. The idea of color harmony was applied to a broad swath of goods, coordinated across a range of industries, and blessed with the Condé Nast seal of approval. In 1946, this major New York magazine publisher laid the groundwork for a color-licensing program in anticipation of the suburban building boom and a renewed emphasis on home decorating. To get started, the editor of *House and Garden* hired the color consultant Frederick Rahr to "find out what colors people already had and what colors people wanted in home furnishings." When 30,000 readers responded to his survey, the magazine decided to invest in a color program. Initially, the kitchen editor, Elizabeth Burris-Meyer, ran a small color research bureau that created the special *House and Garden* palette. Membership fees were charged to licensees—manufacturers, designers, interior decorators, and retailers who wanted to use the branded colors in their products. Each January, licensees received advance color chips that would enable them to create *House and Garden* designs that could then be advertised or illustrated in the magazine's special September color issue.[47]

In 1954, Condé Nast deepened its commitment to color trends by hiring Faber Birren as its principal research consultant. Birren wrote articles on color in interior decoration for the magazine and contributed to a quarterly newsletter that encouraged advertisers to adopt the *House and Garden* Approved Colors. The powerful Condé Nast publicity machine promoted him as the ultimate authority on color, one who combined psychological analysis with hard facts.[48]

Birren also developed the annual *House and Garden* palette, basing it on data churned out by "I.B.M. equipment." This effort built on the quantitative forecasting methods of DuPont and General Motors, but drew on sales data supplied by the licensees. The data set included figures on a range of nationally sold household products. When the numbers were crunched, Birren could detect broad

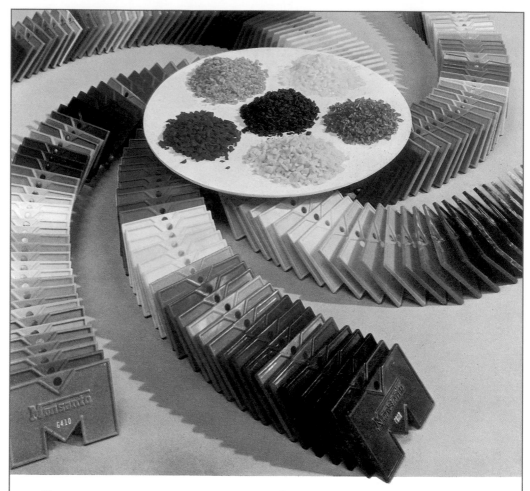

There's a harness on the rainbow

One question—what drew your eyes to this page? The answer, of course, is *color.*

Yet, these are only a *few* of the thousands of shades available in Monsanto Plastics *molding compounds* alone. Add the color range of Monsanto Plastics in sheets, rods, tubes and castings . . . and you find the whole spectrum harnessed to the needs of industry.

Here are materials half the weight of aluminum, warm to the touch, sturdy and long-wearing, with through-and-through color.

Ideal for rapid, economical production, Monsanto Plastics compounds emerge from the molding presses as finished parts with perma-nent gloss, each part as identical to its mates as a newly minted coin.

Color that attracts the eye to the printed page will attract the eye to *your* product in windows, on counters, on salesroom floors. Let the six types of Monsanto Plastics harness the rainbow for your specialized needs. For complete information and names of plastics fabricators, inquire: Monsanto Chemical Company, Plastics Division, Springfield, Massachusetts. District Offices: New York, Chicago, Detroit, St. Louis, Los Angeles, Dayton, Montreal.

MONSANTO PLASTICS

Cellulose Acetate • Cellulose Nitrate
Cast Phenolic Resin • Vinyl Acetal
Polystyrene • Resinox Phenolic Compounds

Sheets • Rods • Tubes
Molding Compounds • Castings
Vue-Pak Transparent Packaging Materials

MONSANTO PLASTICS

SERVING INDUSTRY . . . WHICH SERVES MANKIND

9.11 Advertisement for Monsanto Plastics, *Fortune*, 1939.

patterns and make generalizations. According to one 1962 newsletter, "color trends have turned full cycle in the past ten years," and "what is becoming popular today echoes what was popular after World War II." The 1950s had been a unique moment for interior design, "a truly democratic expression of taste." Consumers who were tired of the wartime "color moratorium" had welcomed the "almost unlimited color ranges brought out by leading paint manufacturers." Having sated this appetite, they next turned "to pastels and subdued tones," as shown by the "steady climb in fancy for beige and sandalwood, pink, aqua—with higher fashion adopting olive greens and golds." The three colors that would become the mass-market favorites of the 1970s—Avocado Green, Sunset Gold, and Sienna Brown—had made their first appearance. "Changes like this do not come from memory. Nor do they seem to be influenced by social or economic conditions." Put simply, "people want change."[49]

By 1962, some 400 manufacturers and 200 stores were offering household merchandise in the *House and Garden* Colors. The upper-middle-class consumer who read this magazine was already familiar with the great works of art and the principles of good taste by virtue of her college courses and her visits to museums. Articles in *House and Garden* explained the value of color harmony in the ensemble; licensees' advertisements told the consumer where to find the right paints, fabrics, furnishings, and equipment. There was no need to run around to several stores to find colors that matched. Mrs. Consumer only need ask for merchandise in the *House and Garden* Colors to ensure that the Dark Green of the pillows matched the Dark Green of the kitchen canisters and the Dark Green of the cloth on the dining room table.[50]

In the 1930s, Egmont Arens longed for a Color Institute that would track major trends and disseminate reports to the business community. As American capitalism matured, the progressive dream of cooperative collaboration yielded to the sway of free enterprise. The idealism of the Textile Color Card Association now seemed dated, or at least out of touch with the entrepreneurial spirit. In many respects, the *House and Garden* Color Program was the wished-for Color Institute, an updated version of the TCCA for a new moment and a new audience. Both initiatives collected membership fees and relied on color experts to create the charts, forecasts, and newsletters used to publicize color trends to their subscribers. But the *House and Garden* Color Program used the power of the press to reach a broad audience of manufacturers, retailers, and consumers. The licensing strategy was also better attuned to the product-development context of the times—that is, to the increasing presence of products such as Disney's Mickey Mouse merchandise and Christian Dior's stockings.

Faber Birren had come full circle and was now applying the principles of mood conditioning to consumer goods. Color Dynamics and Color Conditioning had taught factory managers and school superintendents how the right paint job could affect the emotions and elicit a particular response.

The *House and Garden* Color Program borrowed this behaviorist model to sell the ensemble concept in the housewares market. The ultimate aim of the Color Program was to help the Condé Nast empire grow by profiting from the *House and Garden* brand, but the Color Program also had cultural influence. Building on the work of Hazel Adler and on the Taylor System of Color Harmony, it gave color psychology a permanent place in popular culture. By the 1970s, periodic color features were expected in household magazines, and even amateur interior decorators could talk about the basic rules of color harmony. Faber Birren had thus put color to work as a sales tool that influenced, in the words of his friend Egmont Arens, "human beings into desired patterns of action." He had come along way since his early days in Chicago, where the meatpackers had looked on him with skepticism. The influence of mood conditioning was growing ever greater.

10 Sunshine Yellow

On July 24, 1959, Vice-President Richard Nixon of the United States and Premier Nikita Khrushchev of the Soviet Union toured the American National Exhibition outside Moscow and stopped inside a model home nicknamed "Splitnik." Furnished by Macy's, the prefabricated house showcased the American standard of living and the aspirations of a typical working family who could buy a comparable home for $13,000 (equal to just under $100,000 in 2010). A publicist directed the dignitaries to the kitchen, where they faced off next to a Sunshine Yellow General Electric washer-dryer.[1]

10.1 A 1957 General Electric advertisement.

In 1960, in the United States, a left-leaning journalist launched the latest salvo in his war on the establishment. Vance Packard's book *The Waste Makers* was widely read by the intelligentsia and landed on the *New York Times* best-seller list. *The Waste Makers* was a fast-paced critique of consumer society and of the business apparatus behind it. "Today," Packard wrote, "the average citizen of the United States is consuming twice as much as the average citizen consumed in the years just before World War II. Nearly two-fifths of the things he owns are things that are not essential to his well-being."[2]

Color, though not the focus of either of these debates, had come to symbolize American consumerism. Whereas Nixon pointed to Sunshine Yellow appliances as proof of American ingenuity, Packard saw the color ensemble—the "concept of color 'matching'"—as a duplicitous practice. He singled out as culprits the Big Three automakers, the Bell Telephone System, and Frigidaire (the appliance division of General Motors). Who was right, Nixon or Packard? Had the color revolution remained true to its idealistic roots by expressing the American dream in Sunshine Yellow? Or was color, as Packard claimed, largely a tool of a manipulative "replacement revolution"? To find the answers, let us consider the work of professional colorists such as Howard Ketcham and the stylists of the auto industry.[3]

Calling All Colors

In 1945, Howard Ketcham, who had worked on paints and camouflage as a naval officer during World War II, opened a new color engineering office on New York's Park Avenue. At first, the former DuPont color engineer helped textile and clothing manufacturers prepare for the anticipated boom economy. He conducted a national door-to-door survey for Rosenholtz fabric wholesalers that led to the new Rosewood Consumer Selected Colors for rayon textiles. A sharp dresser given to brown herringbone suits, blue shirts, and Bronzini ties, Ketcham lamented the average "man's apparent desire for protective coloration." His projects for David D. Doniger & Company—manufacturer of McGregor Sportswear, the world's best-selling brand of men's causal clothes—resulted in shirts, jackets, and slacks in interchangeable colors. The objective was to simplify choices and eliminate mismatches.[4]

The growth of America's suburbs brought Ketcham new clients, including transit companies, oil companies, and supermarkets. Commuter trains were color-treated to enhance passengers' comfort, and their quiet diesel engines were conspicuously painted to enhance their visibility at stations and crossroads. There was also a need for roadside architecture that could easily recognized from cars moving at 40 miles per hour. For the Cities Service Oil Company, Ketcham designed a new green-and-white gas station with bright pumps that stood out against foliage, smog, and snow. He helped

10.2 A 1955 advertisement for McGregor
Sportswear.

supermarkets attract customers with colorful facades, signs, and logos. The goals were to distinguish Kroger from First National at a distance and to make the food look more appealing under fluorescent lights. This color engineering was based on visual psychology, historical trends, and market surveys.[5]

Ketcham's work on colored phones for the Bell Telephone Laboratories grew out of this experience. The industrial designer Henry Dreyfuss is often credited with designing all the Bell telephone handsets (both desktop and wall models) from 1937 to 1968. That stems, in part, from his autobiography, *Designing for People*. But while Henry Dreyfuss and Associates created the outer plastic shell for the Bell Model 500 series, Ketcham had full responsibility for the colors.[6]

The colorized Model 500 series was introduced in 1955. The Bell System was a communications giant that consisted of the parent company (American Telephone & Telegraph), regional subsidiaries ("Baby Bells"), a research division (Bell Telephone Laboratories), and a manufacturing division (Western Electric). It monopolized telephony, servicing 80 percent of the 50 million phones in the United States. Customers didn't own their own phones; they rented Western Electric receivers from the local Baby Bell, much as people now lease cable apparatus from a service provider. The Bell System's top managers had long acknowledged the public-relations value of advertising and design, treating the phone as "an ambassador of good will." The company tried to balance the subscribers' demands for better-looking phones with its own commitment to technical superiority. When Dreyfuss was retained as a consultant, he was asked to redesign the old-fashioned French phone. In response, he created the Bell Model 300, a streamlined black desk set that was standard issue from 1937 through World War II.[7]

The end of the war brought a rush of orders for new phones. In 1947, engineers at Bell Labs upgraded the electronic components, while Dreyfuss designed a new black plastic housing, the Model 500 series. The vogue for colored paints, appliances, and home furnishings, combined with the versatile new thermoplastics, created other possibilities. Might a do-it-yourself decorator want a kitchen telephone that matched her color-conditioned cabinets, linoleum, and Russel Wright dinnerware? Bell engineers were brilliant technicians, but they were hard pressed to imagine the idiosyncratic tastes of Mrs. Consumer. "You might wonder how we arrived at a decision on which colors we would utilize in the manufacture of colored telephones. There had to be a limit to the number, but we wanted to have the 'right' color or several 'right' colors, if possible for every home or office color situation," explained a spokesperson for one regional Bell company. "So, we sought the advice of one of the nation's foremost authorities on color, Mr. Howard Ketcham."[8]

The Bell Model 500 wasn't the first colored telephone, but it was the first to be successful in the marketplace. Some prewar novelty phones had been molded of pigmented celluloid, but thermosetting plastics were expensive, brittle, and difficult for fabricators to handle. Postwar

thermoplastics were cheaper, malleable, and more readily colorized, allowing for quantity production. "Telephones," Ketcham wrote, "followed the typewriters, adding machines, and refrigerators in their break from traditional black and white." Within three years of the Model 500 color launch, the Bell System had 10 million colored phones in operation. They were popular with consumers who enjoyed home decorating and with businesses that sought to project a modern image. Offices installed phones in different colors for internal and external calls. Through psychological association and Hollywood intervention, red became the color of a "hot line" phone.[9]

Ketcham's longstanding relationship with the DuPont Company (the manufacturer of the pigments for the plastics) made him valuable to the design and development team at Bell Labs. Dreyfuss spent 15 months on the Model 500, advising the engineers on ergonomics and addressing his own concerns about appearance, cleanliness, function, and space. Like Albert Munsell and other cross-disciplinary colorists, Ketcham bridged aesthetics, engineering, and market research. He initially proposed eight phone colors—ivory, beige, green, red, yellow, blue, gray, and brown—"to blend perfectly with both traditional and contemporary room and office decorating." When this palette proved incompatible with the phenolic resin that was to be used, Ketcham was there to help the engineers design an all-butyrate casing and to overcome the difficulties of matching the rubber cords, the metal dials, and the plastic bodies.[10]

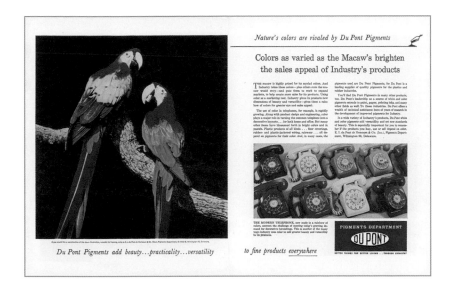

10.3 A DuPont advertisement in *Fortune*, March 1957. Reproduced courtesy of the DuPont Company.

A Dreyfuss staff designer admired Ketcham's cool head and his insights on consumer culture. One of "Howard's strong points was to key all of the colors for the five basic sets together in a family. This seems to have gone over very well from an appearance point of view and certainly the end result is a series of telephone sets which don't either shout at you or disappear into the background but maintain a constant level in a given type of environment." This approach was in keeping with the Bell System's engineering-based product-development policy. In the 1920s, on the advice of design consultants, Bell Labs had experimented with color, but these early attempts to "dress up" the black phone had never amounted to much. However, they had taught Bell managers the value of "having in our organization men who combine training along artistic lines with training and ability in designing objects for manufacture." The managers felt comfortable with a color engineer who could talk to the artists with the sketchpads *and* to the tinkerers in the white lab coats.[11]

Ketcham colorized the Bell Model 500 in response to cultural interest in color-conditioned homes and offices. Though his business records have not survived, the work he did for DuPont and for Bell Labs shows how this master color engineer evolved design solutions that combined style trends, market research, and scientific management. "In addition to adding a vivid accent note to any interior," he explained, the new Bell colors "make telephoning more efficient because they are so easy to see, more pleasant because they so easily adapt to the accent color of any type of décor." Looking at this innovation from the outside, Vance Packard only saw the dark side. "The Bell System sought to get more telephone extensions in each home," he wrote in *The Waste Makers*, by adopting the "there's-a-different-color-for-every-room approach."[12]

Two-Toning Pleases Customers

The selection of a new car now involves as much discussion of color and decoration as the furnishing of a new house.

—Ford Motor Company, 1953

As the Bell System promoted yellow phones, the auto industry bedazzled consumers with its own rainbow. The automotive palette was created through chemical innovation, market research, and strategic design thinking. In the years 1945–1960, the selection generally moved from gunmetal to tropical tones to earth tones. DuPont paint technology was a major driver, but unexpected externalities and design complexity were also important. Design for the consumer culture was not as simple as Vance Packard imagined.[13]

Detroit's color styling reached its apex in the 1950s under the design leadership of Harley Earl at General Motors, Virgil Exner at the Chrysler Corporation, and George Walker at the Ford Motor Company. As the auto industry moved toward consolidation, these automakers—the Big Three—took

MOTOR

OCTOBER 1944

Forecast-Reference Number

CONTENTS PAGE TWO

Automotive Business When the War Ends
Are We Going to Have Lower Priced Cars?
Buildings for the New Competition
28½ Million Vehicles Still Running

10.4 The cover of the October 1944 issue of
Motor. Reproduced courtesy of *Motor*.

the lead in technology, marketing, and styling. During World War II the government had channeled metal, glass, and rubber into war production, and after the war consumers were anxious to junk their jalopies for shiny new cars. To capitalize on the pent-up desires, automakers spent huge sums to make sure they had saleable models. Earl, now a vice-president, led Detroit into the era of tailfins, chrome, and two-tone paint jobs, helping to pioneer the flashy style that the design critic Thomas Hine later called "populuxe." He ran the largest, most influential styling department, producing daring, imaginative designs at the 900-acre, $150 million GM Technical Center outside Detroit, which employed 500 stylists, engineers, coachbuilders, and experts on trim and color.[14]

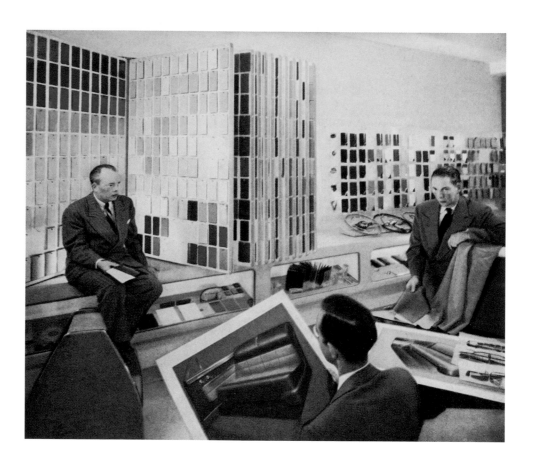

10.5 General Motors stylists at work. From Howard Ketcham, "How to Plan Product Colors," *Product Engineering*, August 1951. Library of Congress; reproduced courtesy of General Motors Corporation.

The styling divisions of Ford, Chrysler, and GM all had access to customer research and understood the gender aspect of the market for new cars. Progress in automotive engineering—automatic transmissions, power steering, power brakes, push-button accessories—made cars easier to drive, and structural advances made their interiors more comfortable. These factors, combined with suburbanization, put more women behind the wheel. By 1955, 40 percent of drivers were female, and the ladies were reported to love "colors and gadgets." The singer Eartha Kitt asked "Santa Baby" to hurry down the chimney with a sable coat, a yacht, and "a '54 convertible, too, light blue." Harley Earl drew on GM customer research when he told *Chemical Week* that women decided on the color of a family's new car 65 percent of the time. An anniversary book titled *Ford at Fifty* elaborated on this theme: "Her decision often depends on where she lives. Texas leans toward tan cars. The Midwest frowns on the beige that is favored in California. Largely because of women, black is slipping from its old Number One position, although it remains strong in conservative New England."[15]

To satisfy Mrs. Consumer, automotive colorists began working 24 months in advance of the model year. They kept track of fashion and style trends, maintained a library of color swatches and chips, and collaborated with the paint manufacturers on the annual palette change. This entailed the laborious task of shifting through some 5,000 samples created by the six leading paint makers, winnowing the pile down to 20 or 30 colors, taking the proposed palette through review committees, and standardizing the approved ensemble for use on 600 components. To get approval, the colorists painted the prospective colors on little plastic model cars for review by a jury of design executives and a team of production specialists. Deciding on the interior colors was more complicated, because it involved different textures and materials. Sometimes the interior was colorized before the exterior.[16]

Harley Earl, often stereotyped as a "man's man," added female designers to GM's styling staff, bringing the "woman's viewpoint" to this complex process. This was a major step forward for an industry that had long relied on male colorists to interpret fashion trends. In 1943, Earl hired a female designer to help select the interior colors and fabrics for the postwar market. By 1958, GM Styling was home to the "Damsels of Detroit," a small group of nine professionally trained woman designers who worked side by side with the men. This move was consistent with Alfred P. Sloan's strategic objective of bringing the product closer to the consumer. Like other businesswomen of the era, the damsels acted as surrogates for consumers and helped GM imagine what women wanted in interior design and color.[17]

Detroit's new rainbow was also an unintended consequence of Cold War politics. In the late 1940s, Earl had re-introduced polychrome styling with a blue-and-silver Buick Riviera and a rust-and-cream Pontiac Catalina, but those models hadn't started a color craze. In 1951, more than 90 percent of new cars still were painted black, green, blue, or gray. It was the Korean War (1950–1953)

that swept Detroit out of drab Kansas and onto the yellow brick road. During the conflict, the government channeled steel into materiel production, which prohibited automakers from retooling their factories and introducing radical new body designs. Detroit balanced the shortage of metals against the desire for novelty by focusing on the exterior paint. Around that time, convertibles gained popularity and a two-color look was introduced, with the metal body in one color and the vinyl roof in another. The two-tone look caught on quickly and was applied to non-convertibles too. By 1952, color was the major selling point in national advertisements and in dealers' showrooms. Pastel, metallic, and two-tone paint jobs were common.[18]

By various estimates, from 25 percent to 40 percent of the 7.4 million cars sold in the United States in 1955 had polychrome paint jobs, and consumers could chose from more than 160 colors in hundreds of combinations. Economists have puzzled over the astonishing sales figures for that year, theorizing about the spike without giving enough consideration to color. But as any color revolutionary knew, the best salesman was a palette created in response to consumer demand.[19]

A new "gaiety and *liveableness*" went into automotive interiors as trim-and-color specialists replaced old-fashioned mohair and velvet upholstery with high-tech synthetics. These miracle materials—vinyl, molded plastics, Lurex metallic yarns, nylon—created the possibilities of greater durability and of "slideability" for seat upholstery. They also added visual delight with sparkle, iridescence, and brilliant color. "The synthetic fabrics have revealed new frontiers in the use of color," one Chrysler stylist explained. Different effects could be achieved by using different fiber blends and by dyeing the fibers in new ways. New materials led designers to look far and wide for inspiration. "The styling studios study magazines on women's fashion and interior decorating, examine furniture, dresses, draperies, carpets, raincoats, and even golf bags with an eye towards using either the material or the pattern for upholstery." The shiny green-white-silver textured upholstery of the Oldsmobile shown here in figure 10.6 was the perfect complement to the green-and-white body, the plain white roof, and the silvery trim.[20]

Audacious color styling was popular among members of upwardly mobile ethnic groups who were buying their first cars. In *The Status Seekers*, Vance Packard admitted that Americans were divided by income and color preferences, with the upper crust leaning toward muted tones and the lower classes preferring "their colors in brilliant hues and large doses." Little had changed since the days of the Century of Progress Exposition, when the unwashed masses reveled in chromatic splendor and an Anglo-Saxon woman went home to her taupe living room. Packard characterized the homes of Polish-Americans as "very garish, with loud, screaming colors." Although he didn't see the link between freedom of choice in interior decoration and freedom of choice in car colors, industry insiders did. "The color trend in automobiles also parallels the nation's tastes in home furnishings,"

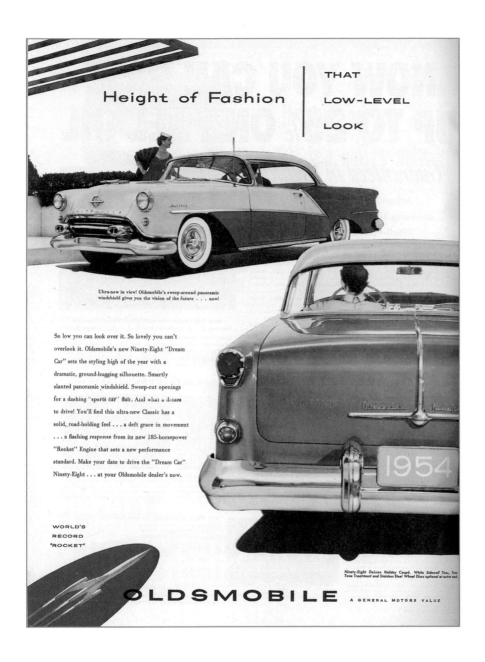

10.6 Oldsmobile advertisement, *Better Homes and Gardens*, May 1954. Reproduced courtesy of General Motors Corporation.

explained William Stuart, president of the Martin-Senour paint company. "Now Mr. and Mrs. America are demanding—and getting—cars as cheerful looking as their family living room. . . . When the auto manufacturers ventured a few pastel colors on the market, the ladies of the house said, 'We like that.' And the men said, 'It looks good to me.'"[21]

Technology in the Driver's Seat

> From a careful evaluation of color emerge two important facts: that color and
> fabric styling is a powerful sales lever, and that it is a science as well as an art.
> —Virgil Exner, 1954

In the years 1945–1955, DuPont introduced a series of new automotive finishes, each superior to the one before it. These innovations, when combined with design economics and market research, gave birth to the distinctive color trend that Vance Packard misconstrued as a styling conspiracy. The colorists and chemists at DuPont's finishes division in Detroit consulted with automotive stylists and engineers to assess and improve the performance of paint. They shared data on durability and data from market surveys of consumers' tastes. This collaborative innovation, which had been established by the Duco Color Advisory Service in the 1920s, resulted in better lacquers—and in a new aesthetic.[22]

Incremental improvements to nitrocellulose lacquers created opportunities for visual novelty. In 1946, DuPont introduced the Duco Metalli-Chromes, a line of luminescent lacquers that seemed to change color with the angle of vision or the lighting. A brown lacquer would look reddish-brown from one angle and gray-brown from another, and a deep black would look gunmetal in the sun. This subdued palette was abandoned during the Korean War, when automakers, unable to retool, turned to brilliant color as a design element and introduced "high intensities in the Yellow, Red, and Turquoise ranges." "In the early Thirties," a DuPont colorist who tracked sales of Duco noted, "it was possible to produce many equally bright colors. However, the bulky models of that era were not conducive to the use of brilliant colors, and it was only with the introduction of the elongated lines of the hard top models that colors of this type effectively complemented the automobiles." DuPont provided the paint, and automotive stylists created the streamlined bodies that were the canvas.[23]

The most dramatic change in auto paint came in 1956. DuPont introduced Lucite lacquer and Dulux 100 alkyd enamel, two coatings technically superior to Duco. After the war, DuPont had developed the acrylic technology that eventually resulted in Lucite just ahead of the Rinshed-Mason Company. Lucite lacquer, chemically related to the DuPont plastic of the same name and to the better-known material Plexiglas, held its color and gloss for the life of the car, eliminating the need

for polishing and waxing. It also had greater resistance to tar and grease, and was less prone to yellowing. Most important, it was receptive to metallic powders and pigments, which allowed for entirely new color effects. Automakers could now design a lustrous palette suited to the "Modern Informal" hot-rod look or to the "Modern Formal" style of the Lincoln Continental Mark II. Market research confirmed that consumers loved "color harmony" but hated the grubby job of maintaining the paint and the wax finish. Lucite delivered color and convenience.[24]

Stylists found that Lucite's shimmer was the ideal complement to elongated, sculptural bodies such as those favored by Harley Earl. "As cars become more beautiful in shape and more unified in design, colors can become more subtle," one Detroit stylist explained. "The combination of line and form, in cars like Chrysler's . . . 'Forward Look' models, does not need the emphasis of very bright color and provides a medium on which subdued hues appear at their best advantage." But there were other reasons why Detroit loved Lucite. The trend away from two-tone paint jobs was a relief to factory managers, who complained that with two-tone designs the "spate of color options" wrecked havoc with production schedules. It was also a relief to distributors, who complained that the flamboyant "rash of colors" had bloated dealers' inventories. It was not surprising, then, that DuPont's sales of pastel paints dropped from 43 percent to 9 percent of its total sales of paints between 1954 and 1959. By 1960, few cars were being offered with two-tone paint jobs.[25]

Lucite didn't banish color styling from Detroit; rather, it gave automotive colorists the ability to extend the Lurex sparkle from the car interior to the exterior finish. The new high-tech look was sophisticated rather than "punchy," and reflected the maturation of mainstream American tastes. As the "GI Generation"—Americans who came to adulthood during World War II—moved into middle age, their ideas of beauty matured, shifting from the Chevy to the Buick. The Buick owner in turn envied the banker's Cadillac. The basic yearning to have a just a wee bit more of the good life was at the heart of American consumer society. Alfred Sloan understood this drive and had put it at the center of a strategy to make "a car for every purse and purpose." Lucite lacquer was just one of the countless production tools that allowed Detroit to respond to consumers' basic desires to have possessions that showed off their taste and their social status.

Lucite's success coincided with the departure of Harley Earl, a man often heard to summarize his approach to automotive styling as "If you go by a schoolyard and the kids don't whistle, back to the drawing board." In 1958, Earl turned 65—the mandatory retirement age at GM—and handed over the Styling Section to William L. "Bill" Mitchell. Always interested in new technologies, Earl probably supported the emerging iridescent look, but he stepped down before its final triumph. By 1961, the Earl aesthetic—the turn-their-heads-and-make-them-whistle approach—was a thing of the past. "Along with fins, those flashy exterior colors are disappearing," *Motor Age* reported. "More subdued hues are returning on the 1962 cars."[26]

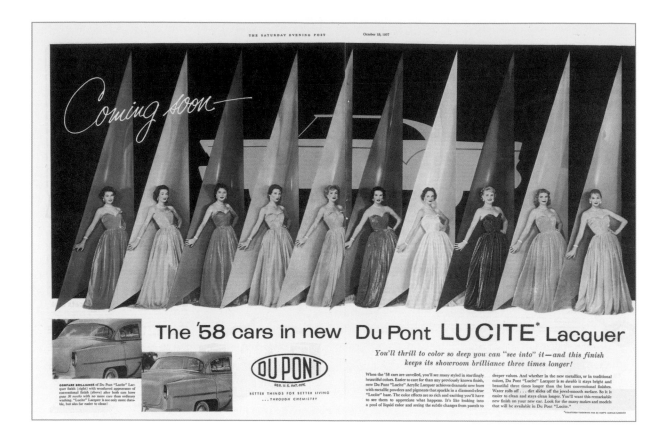

10.7 Advertisement for Lucite lacquer, *Saturday Evening Post*, October 19, 1957. Reproducd courtesy of the DuPont Company.

Do It Yourself

In the postwar do-it-yourself trend, budget-conscious families saved money by doing their own plumbing, carpentry, gardening, and decorating. Inexpensive color effects could be achieved with a ladder, a brush, and a can of paint (figure 10.8). The recent development of fast-drying water-based emulsions enabled paint manufacturers to service this lucrative market segment. Traditional oil-based paints were smelly, messy, and toxic, and were best handled by a professional painter. First-generation latex paints (introduced shortly after World War II) and the improved acrylic paints (available by the late 1950s) offered superior performance without having to be applied by professionals. User-friendly latex paint was perfect for amateurs. Hollywood depicted the do-it-yourself impulse in *Mr. Blandings Builds His Dream House*, with Myrna Loy playing a brush-wielding homemaker.[27]

The first latex paints had evolved from government research on synthetic rubber, but because of poor moisture resistance and a tendency to yellow they had failed to replace traditional oil-based paints. They were, however, less odorous, quick drying, water based, and easy to clean up. The DuPont Company, the Rohm and Haas Company (the Philadelphia-based producer of Plexiglas), and other chemical manufacturers saw an opportunity and pressed ahead with research. When new emulsions were perfected, innovative paint manufacturers (among them Sherwin-Williams, Benjamin Moore, and Pittsburgh Plate Glass) and retailers (including Sears, Roebuck and Montgomery Ward) used them to produce acrylic-latex paints. In Montgomery Ward's 1957 spring-summer catalog, Wardflex acrylic paint was said to enable thrifty consumers to "paint an average 12 × 14 ft. room for as little as $4.98."[28]

10.8 Cover of *Home Decorator and How-to-Paint Book* (Sherwin-Williams Company, 1956). © The Sherwin-Williams Company. Used with permission.

By the mid 1950s, when the do-it-yourself trend was in full swing, consumers spent a good portion of their decorating dollars in paint stores. Painting—once a seasonal chore requiring open windows for ventilation and drying—now could be done year-round. Sales of wallpaper plummeted as sales of interior paints soared. The colorist Frederick Rahr, who studied wallpaper's decline, pointed to the "water and calcimine paints." In 1940, only 29 percent of houses had painted walls, but by 1950, the figure was 81 percent. A 1954 report by the coatings industry estimated that 80 percent of interior painting was now done by homeowners. Paint manufacturers joined forces with women's magazines to promote new color decorating ideas, filling the paint stores with "an almost unlimited choice of color." Sherwin-Williams offered 130 colors, DuPont 572.[29]

Paint appealed to color-conscious consumers because it was inexpensive and easy to change. A consumer could alter her decorating scheme to keep in step with trends. In 1952, *Business Week* remarked on how sales figures from the paint industry revealed how the household palette was evolving. In 1941, the colors ivory, cream, and buff had accounted for about 65 percent of sales; nine years later they accounted for only 17 percent. Green had climbed from 5 percent of sales to 25 percent, blue from 5 percent to 16 percent, and gray and rose each from 5 percent to 11 percent. Fashion cycles became a new marketing strategy for the household paints, owing much to do-it-yourself colors.[30]

What Color Do You Want to Buy?

Color in appliances probably is a thing of mixed emotions to everybody.

—*Good Housekeeping* Institute, 1956

The bright postwar landscape, with its color-conditioned schools, its two-tone Chevys, and its orange-roofed Howard Johnson's restaurants, whetted the appetite for more color in the home. Howard Ketcham's work on the Bell Model 500, a direct response to this taste, was paralleled by the appliance industry's move toward color. In the 1920s, Macy's Color in the Kitchen promotion had popularized pots and pans in bright hues, and Kohler Color Ware had made some headway in the bathroom. But the colorization of big-ticket durable goods for the home had been stymied by the Depression and by World War II. In 1949, the Chambers Company, a small Indiana stove factory, startled everyone by offering stoves in red, black, blue, gray, yellow, and green. Rumors circulated that the colorful models accounted for one-third of the Chambers Company's sales. When a major trade association for the paint industry reported the rising popularity of kitchens in canary yellow and chartreuse, the household equipment industry took notice.[31]

"Let's face it," said a 1951 report on women and electrical appliances compiled for the Ralph H. Jones Advertising Agency by Ernest Dichter's Institute for Motivational Research. "The General Electric refrigerators, Kelvinator, and Frigidaire are not . . . different from one another," making it hard to "capture the consumer's heart by assaulting it . . . with a barrage of publicity." The postwar appliance customer had most likely worked in an office, a store, or a factory during the war, and knew her own mind. Unlike her "old-homebody" mother, she decorated to express "her creativity and individuality." She wanted "electrical appliances not only for their utilitarian value but for their contribution to her kitchen's livability," and she expected "the style of the refrigerator or washing machine 'to harmonize with the rest of the kitchen's décor.'" The manufacturers' challenge was to turn a utilitarian product into a fashion accessory. Dichter, who had probed the minds of consumers for hundreds of companies, recommended a "psychological strategy." Color, he suggested, was a psychological tool that could reach deep into the mind and unlock the consumer's nascent or unrealized desires.[32]

The largest market for color appliances was to be found in new suburban developments such as the three Levittowns (one on Long Island, one in Pennsylvania, and one in New Jersey). Developers knew that the frazzled house hunter, exhausted after an endless Sunday afternoon of open houses, would remember "the one with the red and white kitchen." But the populations of these new communities were less stable than the builders would have liked, and the rapid turnover affected how

houses were designed. "Today," according to a report from a conference on color in interior decoration sponsored by the builders' magazine *House & Home* in 1955, "most people buy their homes ready made, just as they buy their clothes ready made or their cars ready made. Today only one house out of six is built for a known buyer, and even that one house in six will probably be re-sold to an unknown buyer within five years." Color selection, always a risky business, was complicated by the anticipation of mobility.[33]

Bankers and appraisers had to deem a house suitable to be resold before they would lend money to the builder or the homeowner. The "streamlined" kitchen—one with modernistic cabinets, chrome-trimmed counters, and color appliances—was still too unusual for cautious money men. "The builder can take his profit and run once he has found a buyer who likes the colors he has chosen, but the mortgage lender must live with the house for 20 or 30 years through many changes of ownership. He has the biggest stake in the use of safe colors, for he has the most to lose by a color choice that might lower the re-sale marketability of the house." The Federal Housing Authority, which oversaw mortgage lending to veterans under the GI Bill of Rights, took a conservative stance. The editor of *House & Home* explained the realities to an appliance executive: "FHA now tends to give a lower valuation where color is used. This is for two reasons: 1. FHA is afraid color may reduce marketability, because the color that suits one woman may not suit the rest. 2. FHA has no accepted color standards that its appraisers can use as a yardstick." The Housing Act of 1954 provided federal loans for remodeling and encouraged lenders to approve streamlined kitchens if remodelers wanted them. But a builder of new homes still couldn't "use colors his mortgage lender will not finance." In the end, the worries of bureaucrats, bankers, and appraisers limited the dissemination of colored appliances.[34]

As consumers in urban neighborhoods and in older suburbs looked to modernize older homes, manufacturers of electric appliances saw sales opportunities. "One big reason the appliance makers are eager to sell color into the kitchen is their hope that colored kitchens in new houses will also start a big replacement demand as old houses follow the new house lead. That's why General Electric is so pleased that 80% of its new house major appliance sales are in color." GE hoped that the Piotrowskis, the Celluccis, the Goldblums, and the O'Neills would want to keep up with the Joneses, but identifying a market segment was not the same as realizing sales. How should manufacturers approach the replacement market? Should they target the consumer's unrealized desires, or should they cater to her actual needs?[35]

Most appliance executives took a pragmatic approach to these decades-old marketing questions, which had been codified in the 1920s. One salesman who supplied vitreous enamels to appliance makers knew Ernest Dichter's psychological theories and was skeptical. Granting that the "consensus

of the motivational research boys is that colors and built-in appliances are the only things that meet the emotional needs of the modern woman," he expressed belief that the American manufacturing system could satisfy customers without bowing to fashion. Through "economics and mass production," appliance makers could deliver affordable prices and a modicum of style. The purchasing agent for Levitt & Sons also skirted around the popular psychobabble and the idea of style obsolescence: "The idea of the colored kitchen is to attract the consumer to spending more money for her kitchen—money that would otherwise be spent for a television set or automobile—something new. It is eye-catching, appealing and she wants it."[36]

Market researchers at *McCall's*, a popular magazine for middle-class suburban housewives, documented the rising interest in colorful appliances. By early 1955, the average homemaker had seen color appliances in magazines, stores, and showrooms, at open houses in new suburban developments, and in the homes of friends and relatives. Some women still preferred white appliances: "I love a change in decorating, especially in the kitchen where I spend so much time. I would hesitate to buy colored appliances for this reason. I pick neutral colors for counter tops and floors also, so I can change to any new color." But more than half of the women in the *McCall's* survey said they would buy a new appliance in color, even if it were more expensive. "I love color! I spend most of my time when home in my kitchen and like a pretty yellow kitchen. My appliances are white and no matter how I plan my color scheme, my range, refrigerator, [and] broiler stick out like 'sore thumbs.' If they were in pastel colors, they would blend."[37]

The trend toward thinking of the kitchen as a living space encouraged the new outlook. As more blue-collar families moved to suburbs, they took the idea of the all-purpose kitchen with them. In urban apartments, the large kitchen had served as a community gathering space, much as in a farmhouse. This vernacular tradition of adaptive use fit with Frank Lloyd Wright's modernist concept of the open floor plan, with the kitchen opening into a dining-living room. Suburban builders adjusted their designs for Cape Cod cottages and split-level ranches to accommodate "nostalgic feelings for the days when the kitchen was the family living room" and "people ate near the stove and shared stories." If the kitchen was a space for living, then it should be decorated as such, complete with colorful accents. Do-it-yourself paints allowed consumers to satisfy this impulse on a budget. Sunshine Yellow appliances required a more substantial investment and signified a greater commitment.[38]

As public opinion was gravitating toward color in kitchen decoration, a different obstacle to color appliances appeared: three out of four appliance dealers took "a dim view of the whole idea." The retailers worried about higher prices, the difficulty of matching shades, and inventory management—many of the same worries that car dealers had about two-tone paint jobs. "The biggest

In 1939, Frederick E. Sloan designed his first house in Golf, Illinois, where he now lives with his wife, Helen, and son, Toddy. Far from this peaceful atmosphere was his career in the United States Marine Corps, in which he holds the rank of Major. For three war years he was stationed as an engineer in the Pacific, making the landings at Iwo Jima, Saipan, Marshall Island and Tinian.

As an architect he has won awards ranging from a $1,000 major prize in the Chicago Tribune's Prize Homes Competition, to—although he specializes in residences—an award for designing an airport!

10.9 A kitchen featured in the winter 1951 issue of *America's Smart Set*.

headache will be having not only the right model but the right model in the right color and . . . the right shade. What about matching chipped stove panels? What prices will we have to pay for parts due to excessive inventory . . . in our distributors' warehouses?" Stores that stocked different brands were especially concerned about mismatches: "There's Sky Blue, Baby Blue, French Blue, Cadet Blue. . . ." The "color idea" was a big headache—lots of work and no guarantees.[39]

A God-Sent Opportunity

> At Frigidaire, it's pastel. . . . Westinghouse terms it frosting. But top men agree: "A little color brightens a whole line's sales."
> —*Sales Management*, 1956

In 1954, Frigidaire (the Dayton-based appliance division of General Motors) became the first manufacturer of kitchen equipment to offer a "full line" of color appliances. This meant that, like GM cars, Frigidaire color appliances came in several price brackets—Standard, Master, De Luxe, and Imperial—and were designed in Detroit by Harley Earl's styling section. At Frigidaire, color *did* fit into a broader plan for style obsolescence—but not in the way Vance Packard described. In advising dealers to exploit color, Frigidaire headquarters explained how colored appliances fit into GM's "ladder of consumption" strategy. The goal was not, as Packard wrote, to treat appliances like millinery, convincing "Americans they should replace refrigerators, ranges, and washing machines every year or so." It was to encourage consumers to replace their *older* white appliances with the new colorized models bit by bit over the years, until the ensemble was complete.[40]

Frigidaire's well-developed national distribution network encouraged franchisees to push color. One dealer put the burden on the store managers—"the first essential to selling Frigidaire appliances in color is to have the guts to buy . . . color"—but regional tastes played a role. Consumers in warmer climates and in more recently developed regions of the country (the Southwest, the Rocky Mountains, the Pacific Coast) liked color; those in the industrial Northeast, the Midwest, and the Southeast did not.[41]

Down-market stores shied away from color appliances, which had higher sticker prices than white ones. But in a middle-class or upper-middle-class market that could bear higher prices, a Frigidaire dealer could pocket 20 percent more from a color order. The co-owner of an appliance store in Salinas, California spotted a "God-sent opportunity" that would allow his store to compete with a neighboring Montgomery Ward store. "We felt that our big competitors couldn't get into colored appliances quickly enough because their buying procedures and merchandising techniques are not as flexible as the smaller dealer," Paul Kane told a trade journal. "We decided to get so well

established as 'color headquarters' that it would be difficult for these stores to overtake us." The "crusade for color" gave the partners the chance to apply their "selling ability," chatting up style and beauty to an "army of do-it-yourselfers who've been redecorating and have just got to the kitchen." They also sold customers on the idea that tinted appliances would have higher value at trade-in time.[42]

In Texas, the Good Housekeeping Shop in Odessa had success with Frigidaire colors. The Good Housekeeping Shop, opened in the autumn of 1957, was the brainchild of an entrepreneurial appliance salesman familiar with the Houston and Odessa markets. Refusing to stock any brand of appliances other than Frigidaire, the Odessa store and a Midland branch "sold color aggressively." Operating on the principle that "you can sell white over color but you can't sell color over white," the owner kept "complete displays of all colors in both stores." Ensembles of matching appliances—a refrigerator, a range, a washer, and a dryer—were displayed in color groups, creating a rainbow effect that attracted customers into the showroom and held their attention. Salesmen were trained to "sell kitchen beauty and kitchen decoration as well as to sell the product." One explained: "It is our habit to sell the item first, and then ask the customer which color will fit their color scheme the best, 'What color do you want to buy?'" Three out of four shoppers who bought color returned within six months to purchase another major appliance. In 1958, nearly half of the shop's orders were for color appliances.[43]

Despite these successes, appliance dealers still saw white as "a safe bet" and worried about their ability to stock matching appliances down the road. In 1959, the Home Appliance Company in Texarkana, Texas, complained about the lack of colorized stock available in the Standard and De Luxe price ranges. In 1955 and 1956, the store had displayed color models and consumers had responded positively, particularly to mid-price ($300–$400) refrigerators. Forty-nine percent of the refrigerators and 37 percent of the ranges sold that year were colorized. But since then, the dealer had had trouble getting colorized models in low and middle price ranges from the distributor, much to the chagrin of customers. "In the appliance business, we do not sell a complete kitchen every time." When a customer who had bought a Standard refrigerator returned for a matching stove, she found that her only option, if she wanted to match the color, was a top-of-the-line Imperial priced at nearly $450. As a result, sales of colored appliances had fallen by nearly 10 percent. "I don't think it is right to start a customer with color . . . when she could not complete the color due to the high price."[44]

In appliances, as in autos, the color revolution encountered unforeseen contingencies. Production hurdles, inadequate inventories, marketing challenges, and public perceptions made it tough for even the most sophisticated companies to convince consumers to embrace the concept of the color ensemble. Even as consumers warmed up to color appliances, the production and

distribution system was ill equipped to cope. Regional tastes, lingering biases, and socio-economic differences all contributed to the weakening of sales.

In the meantime, cultural critics skewered the manufacturers. "The stylists' fascination with pastels exhausted itself before the 1950s ended, and the trend went right back to white," Vance Packard wrote. "Left in the backwash of the change were several hundred thousand home-owners who had believed pastel to be the wave of the future." The trend did not entirely revert back to white as Packard had predicted. Frigidaire statistics for 1964 showed that color appliances constituted 28.5 percent of national sales. Yet consumers declined to rush out and replace their Sunshine Yellow refrigerator with a new model in a new fashion color such as Avocado Green. Frigidaire designers may have wanted to engineer style obsolescence, but that wasn't in the cards.[45]

Back to Detroit

In the 1960s, as before, statistical research and human hunches supported Detroit's choice of automotive colors, but much of the process was now formulaic. The palette had to be decided 18 months before the December auto shows, and the color stylists used all available tools: Duco forecasts, dealers' sales evaluations, reports from customer research, and advice from external experts. The major objectives were to ensure fashion correctness for the model year, to harmonize the various color combinations, and to make certain that consumers would accept the colors offered.[46]

In 1967, J. S. McDaniel, a design executive at General Motors who oversaw interior styling under Bill Mitchell, described the contingencies. Some things hadn't changed in the four decades since True Blue, and intuition was still important. "Automotive color selection is not an exact science," McDaniel said, echoing H. Ledyard Towle. "It is more of an emotional and psychological matter rather than a technical one. We've found, in fact, that the more our people become involved in the technical aspects of color, the less creative they become in choosing a color that will sell." Decades of color management had created a body of tacit cultural knowledge that was learned on the job and shared with co-workers. Although Eartha Kitt began to coo for a "Cerise Cadillac" in 1958, every professional automotive colorist knew that such a color would never make it onto a Cadillac in the 1960s. "The magentas, high chrome lavenders, 'violent' pinks and orange-reds probably aren't going to show up on production automobiles in the foreseeable future."[47]

Major demographic and cultural transitions affected the color choices of average car buyers. By 1958, Ford marketers understood from consultations with Ernest Dichter that "the symbolic importance of automobiles has declined." The decade between 1946 and 1956 "saw a great many families economically able to reach for higher social status for the first time," and the car was then one of the "most visible symbols of higher status." Now, upwardly mobile consumers no longer

coveted the traditional status symbols of the upper crust—cars, scotch, golf—but sought the "less tangible symbols of the class to which they aspired." Hi-fis, cars, and other material goods were subordinated to other aspirations: a white-collar job, an Ivy League education, membership in a country club. The new emphasis on intangible status symbols pointed to a late modernity in which things would come to matter less than experiences. As part of this shift, color reversed the trajectory it had followed since the days of Queen's Lilac, moving from the center of cultural values to the periphery.[48]

By the late 1960s, the average buyer of a General Motors car was less concerned about impressing the neighbors than about his or her personal comfort. They paid more attention to the passenger compartment, deciding on the upholstery, the dashboard, and the radio before looking at the exterior color. The car was a self-contained bubble that carried the driver from point to point and less of a status symbol to show off to the neighbors. Mood conditioning had moved from the factory and the office to the car interior.[49]

One thing that remained constant was that new color trends seemed to emerge from out of nowhere. Consumers and cultural critics such as Vance Packard were unable to fathom the reasons behind these changes, but Faber Birren tracked the phenomenon for *House and Garden*. In 1954, when one appliance company polled women about colors, no one thought of asking for pink. But when the firm took pink to market, "it accounted for over 40 percent of his color sales in one year—and made his competition jump after him!" This ostensible anomaly was really quite typical. "In the normal course of trends, colors move up from low position to high one—slowly but surely," Birren explained. "There is a rising stream of public consciousness not yet known by the masses at large, or even sensed. However, the consumer will feel the push of this current in due time. This is precisely what happened in the case of pink. It was a mere dribble at the time the public was asked about it." Beige followed a similar trajectory from the late 1950s on. It emerged slowly to appear on "numerous products used inside and outside of the home." It eventually materialized as earth tones, first on automobiles and then on appliances. In 1967, metallic gold, which "didn't even exist as a GM car color three years ago," seemingly appeared out of thin air to become the number two lacquer color. No color ever really materialized out of a vacuum, and it was the job of the colorist to anticipate these emerging trends.[50]

American manufacturers, subjected to a barrage of criticism about planned obsolescence, remained tight-lipped. At Ford in the late 1950s, the product planning office pondered future annual model changes for the Thunderbird. Since World War II the annual model change had evolved into a "styling race." The endless changes led the public to wonder if the 1958 Ford was really a better car

than the 1957. Resentment rose as the critics pointed to a "planned program of styling obsolescence that raises new car ownership costs to an almost prohibitive level." The Ford planners advocated a reassessment of the styling race and a renewed commitment to engineering.[51]

For better or for worse, the great variety of color choices—whether in sedans or stoves—was part of this styling race. When cars began to lose their meaning as status symbols, Detroit responded with simpler body shapes and fewer color choices. Color added complexity to the design process; it complicated procurement, production, and distribution, and it added to the retail price. As automakers sought to reduce costs, styling directors reduced the variety of colors. In an interview conducted in 1985, the longtime Ford designer L. David Ash explained how this affected color decisions: "First of all, in a large car company you have what's called complexity. Complexity is the number of parts times the number of colors. That's loosely it, and it runs into millions of items. Every time you make a blue interior, for instance, you've got blue fabric, blue carpet, blue plastic parts, blue this, blue that, blue everything—headline knobs and all kinds of things. . . . But complexity is something that has to be controlled, even in the top luxury cars. You cannot let these designers muck around with special exterior and interior colors. . . . What we do is we put existing exterior and interior colors together in ways that they haven't been done before and then add some special touches—striping, or this, that, and the other thing—a few touches."[52]

The color explosion of the postwar years was evidence of the extravagances of a growth economy and the maturation of American consumer society. In his focus on the big picture, Vance Packard had offered incisive observations about that consumer culture. But in his critique of design, he had simplified the complexity and overlooked the many cultural and technical contingencies that had led the Bell System, General Motors, and Frigidaire down the color road. Colorists tried to read the popular mood, which was always changing. The best practitioners knew that taste was difficult to pin down and that a shade became passé as soon as it became popular. Obsolescence was part and parcel of the fashion system, which in the course of the twentieth century had migrated from clothing to cars to kitchens. New technologies such as Lucite had introduced better performance and better looks, which the cultural critics read as planned obsolescence. Ultimately the color outburst of the 1950s was contained by an updated version of the simplification project advanced by efficiency advocates such as Herbert Hoover and Margaret Hayden Rorke. A new generation of art directors cut back on the palette in the interest of controlling costs. By the last quarter of the twentieth century, more Americans than ever before had dishwashers, phones, and cars, but they were available in fewer colors.

11 Think Pink!

In the 1957 movie *Funny Face*, Kay Thompson plays Maggie Prescott, a New York fashion editor who storms across her office at *Quality* magazine and orders everyone to "think pink." In a song-and-dance routine, the character predicts that, while the French couturier Christian Dior likes the color rust, American consumers will revel in the red lipsticks, coral swimsuits, and fuchsia frocks worn by the models Suzy Parker and Sunny Hartnett in a *Quality* fashion show. *Funny Face* popularizes the idea that fashion colors originate with a creative genius who uses the media to impose her tastes on consumers.[1]

11.1 The model Suzy Parker (or a look-alike) in a Ship 'n Shore blouse and Hot Strawberry nail polish. Cutex advertisement, *Life*, May 26, 1958. Reproduced courtesy of Cutex Brands.

Was *Funny Face* fact, or fiction? Had a new day dawned? Had the editors of *Vogue* and *Glamour* become color dictators? Maggie Prescott was modeled after Diana Vreeland, a fashion editor known for her flamboyant style and her exceptional eye for color. For decades, the top Parisian couturiers had set the trends that American magazines had illustrated and Seventh Avenue garment makers had emulated. By redefining fashion as spectacle, Vreeland, first at *Harper's Bazaar* and later as editor in chief of *Vogue*, established the fashion magazine as tastemaker. The Seventh Avenue garment district was still the heart of the American apparel industry, but New York City was becoming a global fashion capital dominated by celebrity designers, public relations wizards, and must-have-it-now hype.[2]

This reorientation affected the Textile Color Card Association. Immediately after World War II, the TCCA was still a leading "service organization" that created color cards as "a guide to industry." The goal, as before, was to coordinate standard colors for the textile, millinery, and garment trades while providing subscribers with forecasts from Paris and New York. But as glamorous editors dipped into the paint pot and more and more consumers bought two-tone Buicks, color practice was transformed in New York as it was in Detroit. Although 90 percent of American milliners still heeded the TCCA's advice in 1949, the other style industries responded to the rising tide of individualism with "their own individual shades." In a dramatic Hollywood way, *Funny Face* captured this change in color practice, wherein the older, progressive vision of standardization and coordination was overshadowed in the public eye by the fashion free-for-all. And besides, how many milliners would there be in five years?[3]

Aqualon Pastels

As the Great Depression drew to a close, the Textile Color Card Association's managing director, Margaret Hayden Rorke, continued to spread the gospel of efficiency while she locked horns with tastemakers. The tensions between standards and style resurfaced in 1937 when the commissioners of the 1939 New York World's Fair appointed a fashion director who had her own ideas about color management. Rorke found herself marginalized by Marcia Connor, a former publicist for the Associated Dry Goods Corporation (the large department-store chain that now controlled Lord & Taylor) who allied herself with the city's merchandising elite. Her advisory committee included some of the most important merchants and designers, including Dorothy Shaver (vice-president at Lord & Taylor), the apparel designer Hattie Carnegie, and a former B. Altman buyer who had worked on the Green Ball and now represented Bonwit Teller in Paris. Rorke was sometimes, but not often, asked to their meetings.[4]

America's chief chromatic officer took matters into her own hands. Going over Connor's head, she invited the World's Fair's chief executive, Grover Whalen, to the TCCA's annual luncheon at the Waldorf-Astoria. She proposed to launch the fair's official colors with a gala event to which the mayor of New York and the press would be invited. When Connor got wind of this plan, she blew her top. "I am not sure that it would be wise to have such a color program launched by the Textile Color Card Association." She admitted that Rorke directed "the outstanding organization with which all industry checks"—"even automobile companies, such as Studebaker, Chrysler, and Lincoln"—but thought the TCCA's practical focus was a drawback. As a tastemaker, Connor wanted to educate the masses by exposing them to the rarefied atmosphere of socialite parties, *Vogue* magazine, and Parisian couture. The TCCA occupied a cultural space that was too far removed from the rue de la Paix.[5]

Marcia Connor's hunger for prestige drove her work on the fair's fashion colors. Her ambitious plan was to create six different fashion palettes—Aqualon, Flag, Gala, Mural, Plaza, and Spring—in collaboration with the World Fair's color director, Julian Garnsey, and its lighting expert, Bassett Jones. Each palette would be "keyed to architecture, murals, garden or other Fair motifs" and "checked with Paris and American color cards." Taking cues from Edward Bernays' work in public relations, she hoped to launch these World's Fair palettes with events akin to the Green Ball, getting high society to endorse the colors and then stimulating popular interest. Invitational fashion shows in Palm Beach and other exclusive resorts would be followed by down-market promotions: newsreels, magazine teasers, window displays, retail fashion shows.[6]

When a budget crunch derailed these ambitions, Connor was forced to limit the World's Fair Color Series to the Mural and Aqualon palettes. Margaret Hayden Rorke had to bite her tongue in early 1939 when Connor, sheepishly admitting that the TCCA could "help us get distribution far and wide on our colors," asked her to create the official color cards for Aqualon Pastels and Mural Shades. When the fair authorities came knocking with extended hands, seeking sponsorship for "a large color ballet similar to the one Mrs. Rorke did at the Astor in 1928" and "a large fashion show forecasting Fall Colors," the TCCA politely declined. As war brewed in Europe, the manufacturers grew circumspect. There was no reason for a standards organization, particularly one that had been snubbed, to sponsor highfalutin fetes. There would be plenty of other worries if the transatlantic fashion trade were to be interrupted again by war.[7]

For Margaret Hayden Rorke, the creation of the World's Fair color cards was just another assignment, the latest additions to the roster of thematic palettes she created for the TCCA over the years. Unlike Howard Ketcham, she invested little in the fair, and she had little respect for opportunists. She kept busy as America's chief color officer, analyzing the stream of Paris reports from Bettina Bedwell and Lucien Schloss, responding to subscribers' letters, phone calls, and visits,

and designing seasonal forecasts. If members wanted to use Aqualon Pastels and Mural Shades, so be it. For her part, events of international interest, such as the Canadian-American tour by King George VI and Queen Elizabeth of Great Britain, took precedence. The World's Fair was a minor irritation that didn't distract from the TCCA's larger goal of standardizing and forecasting colors for the mass market.

For the Duration

Color matching is necessary so that when troops are on parade, they will look
like well-dressed soldiers in their olive drabs or sailors in their dress blues and
will not exhibit all the colors found in an Easter parade.
—*American Dyestuff Reporter*, 1944

Mobilization for war gave Margaret Hayden Rorke the chance to apply her skills as diplomat, organizer, and standardizer. When the German troops marched toward Paris in early June 1940, the TCCA's board wondered whether the association could continue to operate without access to French fashion. Rorke was confident "that with our splendid organization and years of experience we could carry on" regardless of the "cessation of color information from abroad." She predicted that American fashion would thrive and expressed hope that the TCCA might "draw on the advice of leading manufacturers and creators of style." The war strengthened Rorke's resolve and alerted her to cultural and economic shifts that would transform color practice.[8]

Between 1937 and 1941, the staff of the TCCA worked on the ninth edition of the Standard Color Card of America, soliciting feedback on the ten-year-old version from subscribers. The enormous popularity of the ensemble concept in fashion accessories led to emulation. There was now color coordination in tableware, towels, and paints—and some members wanted even more matching. The automotive colorist Carleton B. Spencer, a colleague of H. Ledyard Towle at the Pittsburgh Paint Glass Company's Ditzler paint division, was excited about the prospect: "Have you considered the idea of running a few architectural colors? A series perhaps—tying to the woman's frocks, and even car colors with her kitchen, bedrooms, or very special personal rooms—dens—music—recreation, etc."[9]

Technology shaped the color outlook, for better or worse. The rayon wars that wreaked havoc at the Cheney Brothers Silk Manufacturing Company extracted a toll on the members. One of the TCCA's founding firms, John Hand & Sons, a Paterson silk mill established in 1884, was devastated by the changing fashions. "We have retired from the use of color in ribbons and dress silks, and devote all our efforts to men's necktie silks," William Hand lamented. "There are about six colors used and very little change from year to year." Other mills urged Rorke to capitalize on man-made fibers: "There should be a color card with acetate and rayon samples as very often it is difficult to match

your silk samples when dyeing synthetics." Still others wanted fewer color choices and more media hype. "The entire industry would benefit greatly by a maximum of six new shades each season, which can really be promoted and bring results."[10]

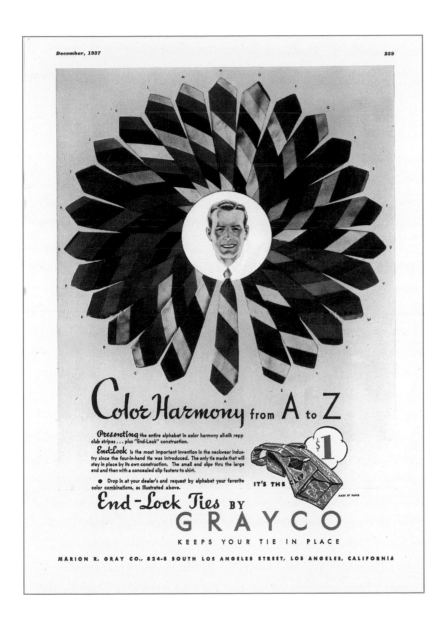

11.2 Advertisement for silk neckties, *Esquire*, December 1937.

In December of 1941, just after the attack on Pearl Harbor and the entry of the United States into World War II, Margaret Hayden Rorke announced the Ninth Standard Color Card of America. The card included updated versions of the basic colors and showed the growing influence of other standard-setting organizations. Additions included the official colors of the American flag, the bathroom fixture colors recommended by the National Bureau of Standards, and the color codes set by the radio and electrical manufacturers. The idea of standardization had spread, as befit the progressive dream that Taylorism could benefit American consumer society by lowering production costs and ultimately reducing retail prices.

A project with the National Bureau of Standards enhanced the TCCA's scientific profile and relevance. With help from the Munsell Color Company and the Inter-Society Color Council, the NBS's colorimetry section had developed color nomenclature for the sciences. The ISCC-NBS notations were widely used by university researchers, government colorists, and industrial scientists. In 1943, the TCCA collaborated with Dean B. Judd, the physicist in charge of colorimetry, to connect the practical needs of the style industries to hard science. A research associate based in Washington used the newest technologies, including a recording spectrophotometer made by the General Electric Company, to calibrate the Standard Color Card to the ISCC-NBS notations. This strengthened the TCCA's ties to the Munsell Color System, "blazing a trail for the future when science and industry would work closer together."[11]

Margaret Hayden Rorke was in her element when she helped military authorities select colors for the Women's Army Auxiliary Corps (WAAC). Volunteers for this corps needed clothing that identified their affiliation, rank, and profession. The military saw attractive uniforms as a morale booster and an advertisement. The military saw attractive uniforms as a morale booster and an advertisement. The Army relied on the Philadelphia Quartermaster Depot to select the materials, plan the wardrobe, and draw up specifications. In February of 1942, the Quartermaster office in Washington invited Rorke to decide on the colors with the help of a special dyestuffs committee. The intentions were good, but there were stumbling blocks. The Quartermaster, which had clothed men since the War of 1812, knew nothing about women's apparel. These headaches were compounded by mandates from Colonel Georges Doriot, chief of the Quartermaster's Military Planning Division, who was modernizing the Army's research and development efforts. The soldier was re-imagined as part of a system, and all uniforms, equipment, and provisions had to be designed with that system in mind. The ensemble concept was thus applied to military gear, but it was not easy. A major turning point occurred when Oveta Culp Hobby, the former first lady of Texas and an executive of the *Houston Post*, was put in charge of the WAAC. She recruited Dorothy Shaver of Lord & Taylor, an organizational wizard, to apply her knowledge of apparel design and production to the challenge. The colors Rorke selected for fabrics, leather, stockings, and insignia were adopted for the new WAAC uniform.[12]

11.3 A 1944 recruiting poster for the women's
branches of the armed services showing the
new uniforms. From left to right: Army (WAAC),
colorized with the help of Margaret Hayden Rorke;
Navy (WAVES), designed by Mainbocher; Marine
Corps Women's Reserve (WR); Coast Guard
Women's Reserve (SPAR). Armed Forces History
Division, National Museum of American History,
Smithsonian Institution.

The experience with the Navy, which needed uniforms for the WAVES (Women Accepted into Voluntary Emergency Services), was less satisfying. The Navy, like the Army, wanted color-coordinated uniforms to promote public awareness of its identity as a discrete unit within the U.S. armed forces and to attract talent, but the men in charge thought fashion was an inconvenient irritation. Rear Admiral Randall Jacobs "heard about the headaches which the Army is having in getting out the WAAC's uniform" and was "not inclined to worry about whether the gals have a spare girdle or three pairs of panties." In June of 1942, the uniform project was handed over to Lieutenant Commander Mildred H. McAfee, who looked for design expertise to the publicity-savvy Chicago-born fashion designer Main Rousseau Bocher, who had achieved acclaim in Paris as the couturier Mainbocher. Upon returning home in 1940, Mainbocher volunteered his services to the WAVES. His fame added prestige to the WAVE uniform. Margaret Hayden Rorke, who preferred anonymity, had little input and received the color swatches after the fact.[13]

Rorke had been right in predicting the ascent of the American fashion industry during the war. The government restricted production of appliances and automobiles because steel, rubber, and fuel were needed for the national defense, but some products were permitted. As was discussed in chapter 9, paint was considered a maintenance necessity; plastics, fur, and apparel were morale boosters. Clothing production was regulated but not prohibited. To conserve fabric, the War Production Board's General Limitation L-85 Order, in effect from 1942 to 1946, outlawed the manufacture of below-the-knee skirts, double-breasted jackets, wool wraps, full evening gowns, bias-cut dresses, and sweaters with dolman sleeves. Cotton, silk, wool, and dye chemicals were reserved for military production. Apparel manufacturers worked around these restrictions, making do with man-made fibers and a limited palette. American fashion came into its own as homegrown designers created innovative apparel that Seventh Avenue produced and Fifth Avenue promoted.[14]

The Army and Navy projects embodied the two color paradigms that would clash in the postwar era: the progressive model of teamwork and the modernist ideal of the creative individual. By a strange twist of fate, the widespread acceptance of simplification and standardization had an adverse effect on the TCCA. Once the authorities agreed on the right shades of Olive Drab and Navy Seal, there was no need for further color exactitude. Government procurement specialists had bigger worries than the shade of wool felt. The quest for chromatic precision took a back seat to the publicity value of a celebrity designer. The Army's uniforms, created by committee, were ridiculed for their stiff fabrics, ill-fitting necklines, and awkward menswear tailoring, while the Navy's more feminine, understated designs were praised. As style triumphed over color, Margaret Hayden Rorke, who had been an expert color advisor to Washington since the 1920s, became a mere disseminator of federal standards.

By the war's end, the standardization function, which had been the Textile Color Card Association's raison d'etre since 1914, increasingly fell to other organizations. The National Bureau of Standards and the American Standards Association had the resources to coordinate information sharing and color planning across industries. When the Department of Commerce decided to write standards for molded urea plastics, Margaret Hayden Rorke had to remind the federal government of the TCCA's role as a color authority. She was included in the deliberations on the new plastics, and the TCCA's Standard colors were written into the specifications alongside the Munsell notations and the ISCC-NBS names. This success caught the attention of the Plastic Materials Manufacturers Association, which invited Rorke to help design a fashionable palette for polystyrene. Around the table at Union Carbide's offices in New York, it became clear that a transition was underway. As usual, Rorke was the only woman present—but she was now sitting next to scientists from Bakelite, the Container Corporation of America, the Monsanto Chemical Company, and the Society of the Plastics Industry. Whereas her first boss, the milliner Frederick Bode, had been versed in fabrics and fashion, the new standardizers were experts in organic chemistry and Munsell nomenclature. The idea of competitive collaboration was alive and well, but the older art industries—millinery, textiles, leather—were no longer the locus of innovation.

Bénédictine Brown and First Lady Pink

The Textile Color Card Association had more than 2,000 members in 1948, but by 1954 it had fewer than 1,600. Many European firms, struggling with currency depreciation and reconstruction costs, could not afford the fees. Fifth Avenue retailers such as Lord & Taylor rejected the TCCA, adhering to the idea of unique colors that would differentiate their brand. The old Northeastern textile industry struggled with aging facilities. All signs pointed to an uncertain future for the TCCA.

The TCCA's newsletter *Broadcast* again took inspiration from Paris, where the creative newcomer Christian Dior had brought fashion-lovers bored with austerity into a new era of abundance with his romantic hourglass silhouette, the "New Look." Coco Chanel re-opened her salon and made the bouclé suit a favorite of socialites and career women who wanted to be comfortable and stylish. Department stores courted wealthy shoppers with swank salons that stocked Paris originals, while the great Seventh Avenue apparel machine created Paris-inspired clothing that made the American gal into the best-dressed woman in the world. The postwar revitalization of Paris created an urgent need for color cables, but one of the TCCA's most important sources was gone. In October of 1939, Bettina Bedwell had fled France for the safety of the United States, but she never saw Paris again, dying shortly after the war. By the late 1940s, however, the commissionaire Adolphe Schloss

Fils et Cie was again under contract, cabling information and mailing swatches of the latest Paris colors for *Broadcast*.[15]

Design piracy, which had been an irritant before the war, became a persistent threat. Margaret Hayden Rorke balked when the office of General Douglas MacArthur, Supreme Commander for the Allied Powers in Japan, wanted to obtain color cards for Japanese manufacturers who were targeting the export market. She remembered her sorry experience with Japan "previous to the War," when there had been "extensive copying of our cards." In Philadelphia, the Independent Association of Stocking Manufacturers issued a shade card that looked much like the TCCA hosiery reports. After considerable pressure the card was removed from circulation, but counterfeiters and copyists didn't go away. Whereas France protected designs as a form of intellectual property, American legislators thought copyright laws on fashion were incongruous with the American way. Why shouldn't Mrs. Main Street be able to wear the same styles as Mrs. Upper East Side? In this environment, there was no stopping anyone from copying the silhouettes, fabrics, and details of high fashion for the mass market. This standard operating procedure spread to color practice, a testimony to the cutthroat nature of the free enterprise system and the waning influence of progressive idealism.[16]

Putting altruism aside, Margaret Hayden Rorke ventured into public relations with promotions that resembled Edward Bernays' work for Cheney Silks. One such effort was the promotion of Bénédictine, a brown inspired by a liqueur invented centuries ago by French monks. Thematic palettes had interested Rorke since the late 1920s, and she occasionally issued a color card based on an art exhibit or dance performance. There had been modest tie-ins with the liquor industry before the war, but greater discretionary income, the popularity of patio cocktail parties, and the interest in glamour à la Christian Dior made the 1950s a more favorable period. Though sales of Bénédictine liqueur were robust in France, executives at Bénédictine, S.A. were chagrined by the fact that copycat cordials had undercut its sales in the United States. In March of 1951, the American distributor of Bénédictine, Julius Wile Sons & Company, launched a $4 million campaign to stimulate women's interest in the genuine aperitif, taking cues from earlier promotions by Dubonnet and Chartreuse. A partnership among Wile, Madison Avenue, and the TCCA made Bénédictine a fashion color.[17]

The inspiration for the promotion of the color Bénédictine came from Virginia Dickson, fashion and beauty director for Robert S. Taplinger & Associates, a New York public-relations firm, in 1951. After the correct shade of amber was selected, the TCCA dispatched swatches, forecasts, and press releases to manufacturers, pronouncing Bénédictine a trendy color for the spring of 1952. Dickson brought her contacts into the loop, which resulted in Bénédictine-colored fashions by Christian Dior and by Sophie Gimbel and forthcoming coverage by *Vogue*. From January through March, the magazine discussed the color in feature articles alongside advertisements for tie-ins by American

Vogue – Feb 1, 1952

The brief dinner dress .. in glowing Benedictine silk shantung taffeta. About 90.

Hannah Troy

SAKS FIFTH AVENUE, ALL STORES
RICH'S, ATLANTA
THE GIDDING CO., CINCINNATI
STRAWBRIDGE & CLOTHIER, PHILADELPHIA

—CARTIER

UARY 1, 1952 You can buy this merchandise at stores listed (Vogue's Buying Guide) p. 238. 49

11.4 Bénédictine in *Vogue*, February 1, 1952.
From Margaret Hayden Rorke's files. Accession
1983, Hagley Museum and Library.

Viscose, Hannah Troy apparel, Jantzen swimwear, and Wear-Right Gloves. The Julius Wile tagline summed it up: "Good taste . . . good fashion!" The *Vogue* promotion inspired high-end retailers such as Saks Fifth Avenue to carry Bénédictine fashions and to advertise the "new name in color" in the daily papers. Meanwhile, Julius Wile distributed newsreels to French clubs and civic groups and sent window-display kits to department stores and liquor retailers.[18]

The Bénédictine project drew other liquor manufacturers into the TCCA's orbit. In the autumn of 1952, French cognac producers began promoting *their* liqueur to Americans, following up with a spring 1953 stateside tour by distiller Maurice Hennessy in his capacity as chairman of the French National Association of Cognac Producers. Fashion tie-ins were on the agenda, and the American publicist tried to butter up Margaret Hayden Rorke. Building on the "very successful promotion of Bénédictine," she hoped the TCCA could "do something similar" for "the entire Cognac industry in France." Back at Paris headquarters, cordial central had joined forces with French textile mills to create some cognac-colored luxury fabrics. When Rorke was slow to make up her mind, the cognac people moved ahead by themselves, backing the August Paris Openings and announcing Cognac as the favorite color of Christian Dior, Elsa Schiaparelli, and Maison Patou.[19]

The TCCA tried to counter the rising commercialization with endorsements that reflected its roots in the Progressive era. Promotions were fine as long as the ultimate goal was to share information that advanced the common good. Rorke understood the popular appeal of stardom as exemplified by the older celebrity culture of European royalty and American high society. This was translated into a series of special color promotions linked to the First Ladies. In 1941, *Broadcast* announced the colors worn by Eleanor Roosevelt at her husband's third inauguration: Rose White, Vermillion, and White House Blue. In 1952, Mamie Eisenhower permitted the TCCA to name the color of her sparkly Nettie Rosenstein inaugural gown First Lady Pink.

Mrs. Eisenhower was an avid follower of fashion whose signature style was a new interpretation of the ensemble concept. The Mamie Look combined couture influences, Space Age hats, and big, bold jewelry. In contrast to the aloofness of French chic, this was an up-to-date, over-the-top, fashion-forward celebration of American Cold War consumerism. This First Lady's style inspired other women who had come of age during the 1920s to update their approach to ensemble dressing.[20]

First Lady Pink didn't introduce the 1950s' vogue for pastels; rather, it gave Mrs. Eisenhower's imprimatur to a trend that was already underway. The fashion for pale pink originated with Brooks Brothers, a venerable New York menswear manufacturer and merchant that broke with tradition in 1949 by opening a small women's department in its Fifth Avenue store. The clothier's hallmark preppy look was applied to women's apparel with the introduction of a ladies' button-down shirt in pale pink. After considerable publicity (notably in *Vogue*), the craze for pink spread from blouses to the home.

11.5 *Mamie Geneva Doud Eisenhower*, oil on canvas, Thomas Edgar Stephens, 1959. White House Historical Association (White House Collection).

Think Pink!

Armstrong began to offer pink vinyl flooring, and General Electric introduced appliances in Petal Pink. By the mid 1950s, men were being urged to wear pink shirts.[21]

Goodbye, Alice Blue

The older style industries loved First Lady Pink. Praising the Textile Color Card Association's "splendid efforts with the White House," the retail director at Millinery Promotion of New York poured resources into this new color for Easter 1953. Importers, manufacturers, and retailers were urged to think pink for spring. "This FIRST LADY PINK is 'Front Page News'," he exclaimed, "and may well rival the success of the 'Alice Blue' of pre-war days." But the milliners couldn't see that the Easter bonnet, like Alice Blue, would soon be a thing of the past, and that the First Lady's evening dress mattered only to middle-aged matrons. The real money was to be had by tapping new market segments in the suburbs, where blue-collar families had Petal Pink appliances and teenagers wore tight mock cashmere sweaters of pink DuPont acrylic.[22]

Margaret Hayden Rorke retired in 1954, and her protégé Estelle Tennis managed the TCCA until 1958. The board of directors now included executives from big businesses at the heart of the American economy: J. P. Stevens, Pacific Mills, and DuPont. Tennis urged them to be wary of "the many color consultants, etc., that have sprung up in recent years" and to renew their commitment to the trade association movement. Under her watch, the Textile Color Card Association adopted a new name that reflected organization's growing presence outside of the textile industry. From 1955 onward, it was called the Color Association of the United States.[23]

Despite her good intentions, Estelle Tennis, like the Easter bonnet people, was shackled to the older world of the industrial arts and based her CAUS projects on past successes. By way of example, she developed heritage tie-ins to the Perkin Centennial in 1956, commemorating 150 years since the discovery of mauve, and to the Jamestown Festival in 1957, celebrating the 350th anniversary of the first British colony in North America. Plenty of chemists bought mauve neckties in tribute to their hero William Henry Perkin, but purple was otherwise a hard sell. This Victorian favorite was now little more than a curiosity, a hard-to-wear color that was at odds with the pastel "populuxe" aesthetic. Likewise, the Colonial Revival and Beaux-arts styles, which had been popular among the pre-World War II taupe set, were irrelevant to the Space Age rush into the future. The times were changing, and the CAUS seemed to be disconnected from popular culture, for which Elvis Presley, Marilyn Monroe, the Beat Generation, *Brown vs. Board of Education*, and the Nixon- Khrushchev "kitchen debate" were harbingers of a new kind of progress.

Upwardly mobile consumers identified with the new fast-paced, high-tech Space Age. The motivational researcher Ernest Dichter identified these trends and grasped the significance. Using

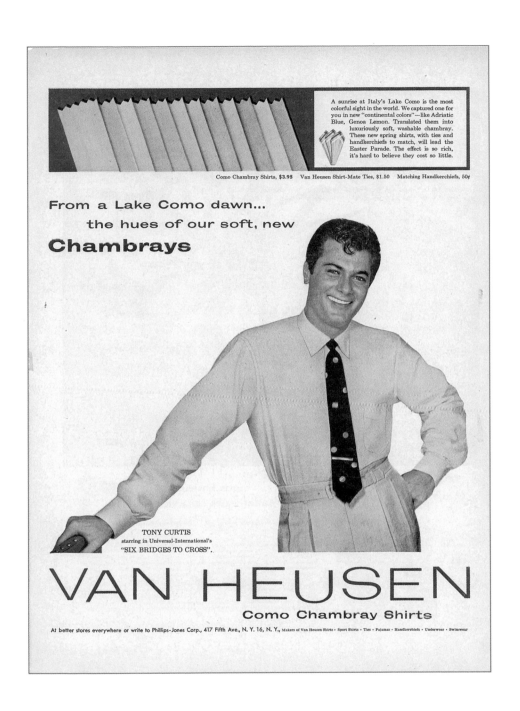

11.6 Advertisement for Van Heusen shirts, *Life*, April 4, 1955. Reproduced courtesy of Phillips-Van Heusen.

consumer surveys and focus groups, his Institute for Motivational Research compiled a mountain of evidence that ran contrary to the stereotype of the "man in the gray flannel suit." Unlike consumers of the modern era, the GI Generation didn't want to keep up with the Joneses and their taupe tastes. They saw the Joneses as a symbol of the staid old middle class, which had long turned up its nose at factory workers. This newfound color-confidence had tremendous ramifications for design practice. Dichter summarized: "The desire for individuality is a very strong one."[24]

The consumer who knew her mind as to color was living, breathing evidence of the cultural transformation launched by Queen's Lilac, followed by Alice Blue, and celebrated by First Lady Pink. She had been trained to be a color-wise shopper by stores, movies, newspapers, magazines, celebrity culture, world's fairs, and street fashion. She knew which colors flattered her complexion and which reverse camouflage schemes made her living room look bigger. The color theories of Chevreul, the Taylor System of Color Harmony, Color Conditioned supermarkets, and washers in Sunshine Yellow had a cumulative effect. Whether she was shopping for appliances or for apparel, the postwar consumer knew how to assert herself: "'I want something that is right for me. . . . I can only wear _____ [sic] color.'" Dichter encouraged manufacturers to accept this reality: "Don't women say that? Don't they have preferred colors?"[25]

The new miracle materials that emerged from wartime R&D helped the color-conscious consumer steer clear of taupe tastes. Two-tone Chevys, water-based household paints, and colorful roadside signs made of Plexiglas thermoplastic were just a few of the new products that the work of chemists had made possible. "There is a strong trend toward synthetics in the majority of products in the consumers goods field," Dichter explained. "Included in this trend are all varieties of products from plastic ladies' pocketbooks to plastic dinnerware." The American chemical industry had expanded during World War II, and with the Allied dismantling of the German cartels it became the world leader in synthetic organic chemistry. The DuPont Company was the largest and most influential firm, dominating the market for paints, pigments, dyes, and fibers.[26]

Before the war, DuPont had invented nylon, the world's first test-tube fiber; after the war, it ventured into polyester production after purchasing the U.S. rights to this British invention from the Imperial Chemical Industries. A third family, the acrylics, was added to the fiber portfolio and research was launched on a fourth fiber, Lycra spandex. Industrial research gave DuPont a dominant position in the fiber market, but the firm continued to be an innovator when it came to technical service, marketing, and advertising. The Duco Color Advisory Service, created by H. Ledyard Towle, served as the model for a much-larger marketing effort for synthetic textiles and their color teammates, the high-tech dyes. Arrangements with La Chambre Syndicale de la couture parisienne, the trade association for Paris couture since 1911, got DuPont fibers into the French *prêt-à-porter* collections of Dior, Givenchy, Chanel, and Balenciaga. The DuPont-Paris connection was widely

publicized in New York, where similar relationships developed with Seventh Avenue garment manufacturers. The powerhouse behind this endeavor was the DuPont sales office in New York, which occupied two entire floors of the Empire State Building.[27]

The revolutions in lifestyle and technology—the rising tide of individual taste and the versatility of test-tube materials—had a major effect on apparel and accessories. Synthetics promised moth resistance, fade-resistance, stretchability, durability, and brilliance. New dyes were created to accommodate the new fibers. The previous generations of aniline, azo, and vat dyes allowed for even brighter tints and increased the American taste for "punch." DuPont, which made fibers and dyes, sold both the steak and the sizzle. For example, the DuPont High Key Colors for 1959 included electrifying shades, such as Blink Pink and Sparkling Gold, that appealed to blue-collar individualists who decorated with do-it-yourself paints and ate under McDonalds' Golden Arches. Punch had found a new home in the budding do-your-own thing casual culture that would bloom during the 1960s, enabled by the forces of consumerism, business marketing, and science-based industry.

11.7 DuPont advertisement, *Holiday*, January 1957. Reproduced courtesy of the DuPont Company.

Midge Wilson, who succeeded Estelle Tennis as managing director of the Color Association of the United States in 1958, spent much of her time reaching out to the fashion and home furnishings industries. The CAUS's basic mission—to establish and disseminate the basic colors—had been accomplished, and standards now played second fiddle to style. Wilson forged connections to Seventh Avenue designers (among them Rose Berger, who worked on swimsuits for Darlene Knitwear), and to outliers such as Alice Carroll of Pandora Industries, a sweater manufacturer in New Hampshire. When Terri Cook, a New York buyer for Sears, Roebuck & Company, pondered colors for the firm's new catalog, she sought Wilson's advice. The swatches came out, and trends evident in *Vogue*, in the windows of B. Altman, in the street, and on color television were discussed. But Wilson was just one of the many sources Cook consulted.[28]

By the 1960s, journalists were more active in setting color trends. *Vogue*'s fabric editor, Margaret Ingersoll, a well-heeled socialite who traced her ancestry back to George Washington, used her good manners to navigate the fashion-industrial district that stretched from the DuPont fiber marketers on Fifth Avenue to the garment factories on Seventh Avenue. "We cannot," she wrote, "sit behind a desk, in a mill, or our showroom and predict color and fabric developments without contact with the constant change that is going on in the world today." Ingersoll reiterated the ideas of Henry Creange of Cheney Brothers, who long before dreamed of a transnational entente of French-American designers, manufacturers, and publishers. But as a journalist within the great Condé Nast publicity machine, she was better positioned to implement this broad vision than almost anyone. If the "one best way" limited the reach of Midge Wilson at the CAUS, the creative nature of fashion journalism gave Ingersoll more freedom. *Vogue* was unencumbered by the trade association's governance structure and its mandate to keep forecasts within the family. There were no planning committees and no confidential color cards. *Vogue* had its own limitations, including a relatively small circulation, but its editor in chief, Jessica Daves, and her successor, Diana Vreeland, turned that elitism into a cachet. Ingersoll and other fashion journalists created new color trends by doing their jobs: watching, networking, mediating, writing, and editing.[29]

The *Vogue* approach was to temper the free flow of ideas with the shrewd hunches of the fashion elite. Typically, Margaret Ingersoll prepared the *Vogue* fabric room for the new season ten months in advance of the ready-to-wear shows, "pinning up snips of colors which might look promising . . . , snippets from the previous French collections, or a color from a fabric of the dark ages." The swatch collection, "a device for reacting to color freshly," provided talking points when marketers from the fiber companies and designers from the textile mills descended on the *Vogue* editors. "In exchanging ideas and discussing trends with the various fabric manufacturers who come to get our thinking, one is reminded of ping-pong—batting the ball back and forth—the decision is not made by one person,

but through an exchange of ideas among creative minds." And the manufacturers of other products also came to *Vogue*'s offices hunting for color clues: "the shoe people, the hosiery, the glove, hat, sweater and cosmetic people," fountain pen companies, factories that made ribbons for gift wrapping, Detroit automakers. These manufacturers sat on pins and needles until market week, when the Seventh Avenue houses showed the new lines, ultimately establishing the fabric, the silhouette, and the color of the season.[30]

A prescient editor could start a color fad. Margaret Ingersoll took credit for the popularity of "pale mauvey pink" in 1961. The previous fall, she had included that tint in *Vogue*'s spring-summer fabric chart, and her fellow editors had deemed the swatches "new and exciting." After Jessica Daves concurred, the *Vogue* staff asked Ben Zuckerman, a Seventh Avenue manufacturer of high-end coats and suits, to tailor a garment from advance lengths of the mauve-pink cloth. After that one-of-a-kind sample appeared in *Vogue*'s issue dated January 1, 1961, other manufacturers began to "think pink." "It was the success suit of the season," Ingersoll trumpeted, and "the color helped sell the fabric and the suit." Another 1961 success story began in Minneapolis. After developing a new Polynesian Red zinnia flower, the Northrup-King Seed Company sought advice from *Vogue* on how to make zinnias fashionable. The editors asked the New York costume jeweler Trifari to design a zinnia pin, Everfast Cottons to print Polynesian Zinnia fabrics, and the B. Altman department store to promote the zinnia motif. By January of 1962, the zinnia craze was in full bloom in *Vogue* and at B. Altman, where the Fifth Avenue windows and "every department on every floor" featured "merchandise made of the zinnia print."[31]

In 1966, Jessica Daves, now retired from the editorship of *Vogue*, reflected on the fashion scene and pointed to a new "era of color in clothes." That fall, the collections in Paris and New York showed unusual and vivid combinations—purple, red, and black; pink, green, and purple; red, blue, plum, and black; yellow, red, and gray—that would have been unthinkable a few years earlier. Daves nodded to the influence of Pop Art and Yves Saint Laurent's famous Mondrian dress but admitted that other forces were at play. She described a trajectory that would have been familiar to Faber Birren. Two years earlier, the American textile mills had shown purple fabrics to American designers and had thereby started the long, drawn-out process of popularizing a color. Little by little, purple gained favor in the stores; then, in the autumn of 1966, its appearance in the Paris collections inspired people who were looking for something different. It was then adopted by more apparel manufacturers, more stores, and more shoppers. The mauve revival of the 1950s was dead, but purple—a color not in the mainstream—seemed just right for the highly individualistic, expressive 1960s.[32]

"Check Your Mood, Invent Your Style"

In the 1960s and the 1970s, Baby Boomers gave full expression to the phrase "there is strength in numbers." The cohort of Americans born between 1946 and 1964 constituted one of the largest market segments in consumer history, and businesses recognized their buying power. The tastes of the Boomers were influenced by what Diana Vreeland of *Vogue* famously dubbed "the youth quake."[33]

The Boomers were the first American generation to be surrounded by affluence. They were the first to grow up with such things as Sunshine Yellow appliances, Radio Flyer wagons in Mickey Mouse Blue, and Cannon towels that matched Kohler bathroom fixtures. Though the roots of these color innovations dated back no further than the 1930s, many "war babies" and Boomers grew up thinking these types of consumer goods were part of every American's birthright. The Boomers' tastes had a considerable effect on the color revolution.

Youthful styles had infiltrated American consumer culture with swing bands, jukeboxes, and bobbysoxers in the 1940s and with the rising tide of individualism in the 1950s, all of which fed into the dramatically new popular culture of the 1960s. The "British invasion" of music and fashion replaced the hat-and-glove formality of the color ensemble with something far more exciting. The British influence began with the Beatles' February 1964 performance on the *Ed Sullivan Show*, the most popular variety hour on television. London was becoming a global fashion center and was bombarding the world with "Mod" styles.

Of course fashion and color were affected. Ernest Dichter coined the term "peacock revolution" to describe how fashionable young men dressed, and the journalist George Frazier popularized that expression in the men's magazine *Esquire*. The Mod style was promulgated by the designer Mary Quant

and by the first ultra-thin model, Lesley Hornby (better know as Twiggy). Quant, who sought to liberate young British women from frumpy woolens, offered vinyl belts, crocheted tops, white "go-go boots," and, most famously, the miniskirt. As Christian Dior's wasp-waisted New Look ran its course and hemlines inched up, pantyhose replaced girdles, garter belts, and stockings. After marrying the Greek millionaire Aristotle Onassis, former First Lady Jacqueline Kennedy traded in her pink Oleg Cassini suits and Givenchy pillbox hats for Emilio Pucci minidresses in bold Pop Art prints. By the late 1960s, the miniskirt was a worldwide phenomenon.[34]

By 1967, Mod was already being replaced the hippie style. The so-called hippies (a small but highly visible youth subculture) criticized American capitalism and consumer culture and explored alternative lifestyles and mind-altering drugs. They decried "the establishment," condemned suburbs such as Levittown as sterile wastelands. As consumers, they ignored mass-market retailers and favored boutiques, "head shops," craft stores, co-ops, army surplus stores, western-wear shops, and used-clothing outlets such as those run by Goodwill. Blue jeans were *de rigueur*, as were bellbottoms and bright polyester or tie-dyed tops.

The hippie look blended with Mod styling to transform mainstream clothing styles and colors. Retailers targeted the burgeoning teen market with "hip" designs. In 1969, the national retailer J. C. Penney issued a special catalog featuring "groovy kid stuff," with an introduction by Mary Quant: "Steal ideas from all around you and pull them into your wardrobe. Check your mood. Invent your style. . . . Stir up your JUST-YOU color combos. . . . Do the last thing anyone would expect. Shove your wardrobe right into tomorrow." Whereas Margaret Hayden Rorke had advised the consumer of her day on how to match her hat, gloves, and shoes to create the perfect ensemble, the young woman of 1969 was told that there were no rules.[35]

11.8 A 1969 J. C. Penney catalog illustrated by
the poster artist Peter Max.

The Color Merry-Go-Round

It is the mass market which confirms the color trends.

—Midge Wilson, 1974

In 1974, the Color Association of the United States celebrated its sixtieth birthday, giving Midge Wilson a reason to reflect. Her historical article in the *Textile Marketing Letter* is worth examining as a summary of the color revolution in fabrics and fashions.

When the organization was founded as the Textile Color Card Association in 1914, "it was the milliners who were setting the color trends and clothing colors were chosen to harmonize with hats." By the early 1920s, "the couture houses gained importance and gradually took over leadership which they maintained until after World War II." Colors were introduced in Paris, were cabled and shipped across the Atlantic Ocean, and were "copied and adapted here for the following year in our top bracket market." Within a year, the Paris colors would appear in the ready-to-wear market, and "by the third season they would have reached real volume." A color's life cycle, including its introduction at the top of the fashion pyramid, its dissemination in the mass market, its declining popularity and movement into staples, and its rebirth and rediscovery, lasted about seven years.[36]

Nothing was the same after World War II. "We have so many new, synthetic products in every field, which depend upon color to give them character, that our entire world is now very colorful." By the 1970s, "the quality of the color styling now frequently determines the success of a product." Two brands might perform equally, but one might sell better if it was "more attractive color-wise." Rapid communications permitted "everyone in every corner of the globe" to know "about a new color, or idea, or product the minute it is introduced." Large-scale production required product planners to "work farther and farther ahead," thereby creating the need for "earlier color information." Factories had to "choose the very newest colors possible to be sure that they will still be new the many months hence when the product finally reaches the consumer."

The Chicago milliners and Paris couturiers who once had dictated colors to New York were now just two of many voices in the market. By the mid 1970s, there wasn't "time for a new color to 'filter down from the top.'" Instead, it "spread like measles from one field to another so that it is important in many fields at the same time." Volume production and distribution meant that a color would "reach saturation much more quickly" and thus would have a shorter lifespan. "It's a fast moving merry-go-round. The trick is to know when to get on and when to get off and most important of all—to catch the gold ring on the first revolution. The right color at the right time is the answer. You must have color when it is new, when it is building a trend. If you wait to follow someone else, it will be too late."

11.9 Congoleum-Nairn advertisement showing new casual styles, *Life*, March 31, 1961. Reproduced courtesy of Congoleum Corporation.

Margaret Hayden Rorke retired just as the new order was about to destroy her life's work. In the twilight of her career, she took the Textile Color Card Association through the 1939 New York World's Fair, the exigencies of World War II, and the early days of the suburban boom. By 1954, when she handed over the management of the association to Estelle Tennis, the dream of a universal standard of living had given way to the tastemakers' hunger for style authority and to the consumers' penchant for "populuxe" designs. Estelle Tennis strengthened the organization's ties to high-tech industries like chemicals and plastics and gave it a new name—Color Association of the United States—that was more in tune with the times.

But these attempts to modernize the association were undermined by changes in the wider culture. The women's magazines, which increasingly saw themselves as fashion arbiters, indulged the rise of individual taste by promoting the personal color palette as a means of self-empowerment. The fictitious Maggie Prescott at *Quality* in *Funny Face* and the real-life Margaret Ingersoll at *Vogue* told the public to "think pink," but consumers talked back with their pocketbooks, choosing colors that showed they could think for themselves.

Rational mediators such as the CAUS belonged to the industrial past—to the world of mass production, efficiency, simplification, and standardization. The drive for color standards had migrated to the sciences, and the National Bureau of Standards, the Munsell Color Foundation, and the Inter-Society Color Council were now the leaders. The CAUS membership base was eroded by the decline of the American textile industry and by the garment manufacturers' shift to offshore production. In the decades ahead, the CAUS continued to advocate a rational approach to color standards and color forecasting. But it was a small voice in the cacophony of the late twentieth century, when new colors and new materials and new fashions were commonplace rather than revolutionary.

Conclusion

The age of color, the auto age, the industrial age, the modern age, the urban age—these names have been used to describe the period that has been the focus of this book: the 1890s through the 1960s. The color revolution was born of this particular time and place, a transnational offspring of European and American parents. It was conceived in Paris, London, and Ludwigshafen, took its first steps in Boston, and matured in New York and Detroit. American colorists took inspiration from European styles, both high and low, as they created palettes for the vast American mass market and its multi-ethnic-cultural dimensions. The color revolution was thus uniquely American in its blend of Old World design thinking and the perpetual re-invention that was part and parcel of modernity.

C.1 The cover of *The Age of Color*, a brochure published by the Glidden Company of Cleveland around 1936.

This book has focused on the color revolution in relation to design practice, the fashion system, and consumer culture. It has opened a window onto a lost high-tech world and its creative devotees, the color stylists, color forecasters, and color engineers. Like present-day digital geeks, these innovators imagined that their pet project—color management—would change the world. They wanted to replace wasteful production and distribution practices with efficiency, lower costs, and visual delight. They were both Taylorites and tastemakers. Their idea of combining Fordism and fashion was bold at the time, distinctively modern, and unabashedly American. Judicious color choices were seen as contributing to the American business system and its commitment to mass production, mass distribution, and mass consumption. The goal of this "one best way" was to improve the standard of living and to realize a colorized utopia.

Revolution Revisited

This historical study has focused on the modern era, during which American industry was preoccupied with color. It was a time of great creativity, generating inventions and innovations such as mobile color music and statistical color forecasting. But the story began in the nineteenth century, when color management vexed the best European design thinkers. Colorists in the "industrial arts" and the "art industries" grappled with the great visual possibilities made possible by the chemical discoveries of fellow "practical men" in Lyon, Mulhouse, and London. The Frenchman Michel-Eugène Chevreul was the mastermind, and his obsession with the color wheel and his vision for international standards inspired acolytes on both sides of the Atlantic. Paris was one of the great creative centers of Europe, and the *cercle chromatique* at Gobelins was a mecca for artist-designers such as Owen Jones of London and Albert Munsell of Boston. Munsell, a man caught between Victorian and modern times, was repulsed by the anything-goes German synthetic palette and imagined a more tasteful world inhabited by consumers who appreciated middle tones. He invented a color system, but until the end of his life he lacked the business contacts that were needed to turn his inventions into marketable innovations.

The textile and millinery industries played important roles in the next stage of the color revolution. During World War I, the art industries picked up where Munsell had left off, developing practical methods for standardizing and forecasting colors suited to the peculiarities of the American business system. The silk and millinery trades used color as a major design element. When the war brought communications with Europe to a halt, they took measures to establish chromatic independence. The Textile Color Card Association identified with the efficiency movement that was being promoted by disciples of Frederick Winslow Taylor, Henry Ford, and Herbert Hoover. The TCCA also bowed to fashion, hiring Margaret Hayden Rorke to bring in the "woman's viewpoint" and

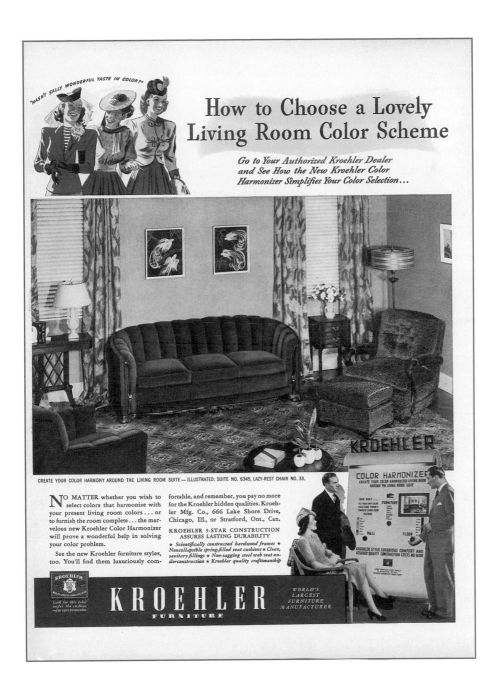

C.2 Kroehler Manufacturing Company advertisement, 1940.

to develop color forecasts for the American context. Rorke kept one eye on the New Jersey silk mills, the other on the Paris couture houses. Her career spanned the age of color and embodied commitments to standards and to style.

Big business introduced statistical rigor to color design. The giant chemical company DuPont, which made a fortune on explosives during World War I, poured its wartime profits into R&D projects that led to miraculous new coatings for the auto industry. This move by DuPont coincided with the rise of Alfred P. Sloan Jr. at General Motors and with his goal of offering "a car for every purse and purpose." Color styling fit into GM's effort to steal market share from Ford, and by the late 1920s it was an undisputed part of Detroit's design strategy. Automotive colorists figured out how to quantify sales statistics by color, model, price, and region, to analyze consumers' past color preferences, and to make educated forecasts about their future preferences. Visual streamlining with polychrome paint transformed the look of the American car and stimulated a color fad that extended to kitchen gadgets, bathroom fixtures, and other durable goods.

Color specialists appeared on the scene to help manage the palette. Design errors such as the use of heliotrope as a color for kitchen sinks created a need for color experts. There were no schools that trained color specialists, and anyone could claim competence. The architectural polychromist Léon Solon picked up color theory from his French father in the Staffordshire potteries and at the Royal College of Art in London. H. Ledyard Towle learned the art of illusion from Impressionist painters and refined his skills as a camoufleur on the Western Front during the First World War. Joseph Urban figured it out on Broadway. Gender bias worked in Margaret Hayden Rorke's favor; she was assumed to be knowledgeable about color and fashion because she was a woman. She rose to the challenge and surprised everyone with her emphasis on efficiency and her ability to deal with businessmen, scientists, and government bureaucrats.

"Functional color," a novel approach to paint and space, influenced architecture and interior design. The theory that human behavior was shaped by the built environment was promulgated by Victorian design reformers such as John Ruskin and William Morris. Solon promoted this concept with architectural polychromy, and it gained momentum when hospitals began to manipulate paint schemes to improve patient psychology. The young colorist Faber Birren saw an opening and decided to specialize in surroundings. In the course of a long career that spanned six decades, Birren perfected the "functional color" approach and became its foremost proponent. Chemical companies backed his work, using it to develop color safety standards and to package total paint systems for use in schools, office suites, factories, apartment buildings, homes, and stores.

Color engineering reached maturity with the consumer culture of the 1950s and the 1960s. Molded plastics and rayon fabrics had sated consumers' chromatic yearnings during World War II

WHITE. For trim on red brick buildings.

NO. 12 SPRUCE GREEN. A trim color for white buildings, poles, fences, etc.

NO. 11 SUN TAN. For dwellings and buildings where glare is to be reduced. NO. 12 SPRUCE GREEN for trim.

NO. 19 LIGHT GRAY. For industrial buildings. NO. 20 MEDIUM GRAY for equipment.

NO. 18 INTERNATIONAL ORANGE. Used with white for tall structures near air fields.

NO. 13 FIRE RED. NO. 33 SEAL BROWN. For lighthouses as prescribed by the applicable Light List.

Chap. 3, Page 15

C.3 A page in the U.S. Coast Guard's 1952 *Paint and Color Manual* illustrating reverse-camouflage techniques developed by Faber Birren. Faber Birren Collection of Books on Color, Robert B. Haas Family Arts Library, Yale University.

and had whetted their appetites for more and better colors when peace returned. Visual color technologies that had been invented before the war—Technicolor movies, Kodachrome photographic film, color television—reached the mass market. As the older "art industries" disappeared (Cheney Brothers, for example, began closing its plants in the 1930s and shuttered the last one in the 1980s), the color revolution migrated to the automobile and electronics industries. Color engineers gave new looks to telephones, cars, kitchen appliances, and other durable goods. Howard Ketcham colorized the Bell Model 500 phone. At General Motors, Harley Earl encouraged color styling to flourish. The New York apparel industry entered its golden age, creating ready-to-wear lines that made the American woman "the best dressed woman in the world" and paying increasing attention to color cycles. The Textile Color Card Association changed its name to the Color Association of the United States and continued to issue standards and forecasts and reached out to more and more industries.

Dramatic changes to color practice came with the cultural and economic transformations of the 1960s and the 1970s. Colorists had to keep up with the growing influence of newspapers, magazines, movies, and TV on design, fashion, and taste. Celebrity tie-ins, special events, and anniversaries always spurred fads, but now one fad followed another at an accelerated pace. In Victorian times, it had taken several months for New Yorkers to get the word about Queen's Lilac and several years for mauve mania to wane. But now cables from Paris arrived during couture shows and airplanes carrying fabric samples arrived the next day. The signs pointed to a new phase in globalization, and the color revolution stood on the precipice of a major transformation.

Color Conspiracy?

While I was writing this book, dozens of people asked me why they couldn't find a yellow sweater, or a black one, or an orange one in the malls. Surely, some exclaimed, this was proof of styling obsolescence and some sort of "color conspiracy." Good history avoids the temptation to make assumptions about the past based on the present and the personal. The absence of yellow sweaters is best understood in the context of the contemporary global business environment, rather than the practices of the modern era. The two periods share common roots, but the different economic and cultural circumstances generated discrete approaches to color. "History does not repeat itself," Mark Twain famously said, "but it does rhyme."

Design, manufacturing, and retailing have evolved since the color revolution. A hundred years ago, international business operated in different ways than the global corporations of our time. The transition was already underway when Margaret Hayden Rorke and Harley Earl handed over their keys to Estelle Tennis and Bill Mitchell. Developments in the years immediately after World War II created fissures on the domestic front. At Bretton Woods, policy makers laid the groundwork for today's global economy with international protocols that fostered free trade, while England, Italy,

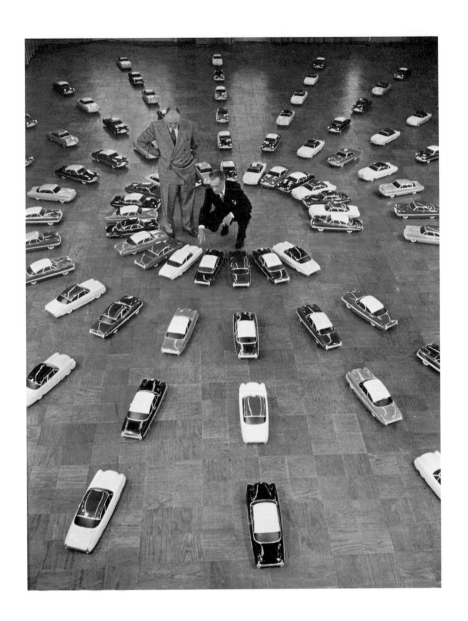

C.4 Ford Motor Company executives
examining dozens of models before approving
paint schemes for new cars. *Ford at Fifty, 1903–
1953* (New York: Simon and Schuster, 1953).
Library of Congress. Reproduced courtesy of
Fordimages.com.

Japan, and West Germany built high-tech factories that could undersell their American competitors. American retailing was transformed by the rapid growth of national store chains such as K-Mart and J. C. Penney. Unable to compete on price, small family-owned shops and department stores disappeared as the new chain stores filled the suburban malls with cheaper merchandise from overseas. The consolidation of retailing meant that fewer people were planning distinctive color promotions. The end result was less color diversity. Many beneficiaries of the color revolution—New York's Garment District, New England's costume jewelers, New Jersey's plastic molders, the East Coast textile industry—shuttered their factories, casualties of the creative destruction. The new economic order bore little resemblance to the world inhabited by Albert Munsell and H. Ledyard Towle.

Color practitioners adjusted to the times. The Munsell Color System migrated away from the style industries and, through a long association with the National Bureau of Standards, settled in the sciences. Chemists in DuPont's R&D labs and researchers in government bureaus came to favor the Munsell Color System in their work on paints, fossils, agricultural commodities, and soil samples. As professionalization begat specialization, umbrella organizations cast in the modern mold lost their utility along with the idea of the "one best way." While the CAUS tried to adapt, the British Colour Council foundered and was absorbed by the Council of Industrial Design, a quasi-public body with oversight for the creative industries. The rebirth of Continental European and East Asian manufacturing led to French and Japanese forecasting organizations that served those textile industries as well as American multinationals.[1]

In the United States, the next generation of color designers set aside the principles of scientific management to keep up with the express-yourself trend of the time. The Color Marketing Group, founded in 1962 by a breakaway contingent from the Inter-Society Color Council, abandoned the dream of collaboration between art and science to focus on the practical needs of marketers. Members of this organization wanted fewer reports on the ISCC-NBS notations and more tips on how to cope with rapid style changes. The legacy of the progressive tradition was evident in the CMG's approach to forecasting. Members attended a semi-annual conference where they met in committees to discuss the cultural, economic, and social influences on color trends. These deliberations flowed up to a small group that synthesized the committees' thinking and created the new forecasts for distribution and use by the membership. Because anyone who worked in color marketing or color styling could join the CMG, its forecasts were based on expertise in a variety of industries, and it produced the tools that business colorists needed: forecasts for the consumer culture.[2]

Companies also introduced new color management tools. Starting in the 1960s, an entrepreneurial former pre-medical student named Lawrence Herbert turned a small New Jersey

printer called Pantone into a major influence in the graphic arts. Herbert used his knowledge of chemistry to create a set of uniform standards for color printing, reducing the stock of pigments to a basic palette of twelve that could be used to mix a full range of colors. In 1963, he introduced the Pantone Matching System and licensed it to the major ink manufacturers. Combining the basic principles of the Standard Color Card of America and the *House and Garden* Color Program, Pantone provided a solution to the lack of uniformity that had vexed the printing industry since the days of Arthur S. Allen. Eastman-Kodak used several different companies to print packages for its Kodachrome film and ended up with boxes in different shades of orange-yellow; consumers declined to buy the film in the darker boxes, thinking it must be old. The Pantone system enabled printers to reproduce the shades of Kodak packaging exactly. In essence, Herbert Lawrence did for printing what Margaret Hayden Rorke had done for textiles in the 1920s.[3]

Pantone quickly adjusted to the times, surpassing the influence of other color standard setters in part because it was not shackled to older sectors such as textiles. By the late 1960s, Lawrence Herbert had adapted his basic matching system to a range of industries and increased Pantone's sales by targeting product designers. Pantone entered the digital world in 1974 when Herbert introduced the Color Data System for computerized ink formulation and matching. Looking to the future, he committed Pantone to the digital era through licensing agreements and cooperative ventures with major software companies. Pantone's influence grew in tandem with the importance of desktop computers. By 2001, this private company was the dominant player in business-to-business color-management solutions. It took measures to extend that influence through a new division, TheRightColor. The objective was to get retailers to adopt the Pantone Textile Color System as a tool for tracking consumers' preferences and for stocking merchandise that would sell.[4]

So why are there no yellow sweaters? Today, certain colors are associated with certain brands, as was anticipated by Schiaparelli's Shocking Pink. Retail consolidation has left Macy's the dominant survivor, a national department-store chain with nearly a thousand branches. Buyers at Macy's New York headquarters decide on the next season's palette and direct Asian factories to make house brands to their specifications. From coast to coast, every Macy's store stocks merchandise in the same colors. Likewise, other major retailers—Ann Taylor, Apple, Crate and Barrel, Banana Republic, IKEA, J. Crew, Sears—rely on their own in-house color experts to create signature palettes. Global corporations—Disney, General Motors, H&M, Hilton, Nike, Toyota—have colorists on their design and marketing teams. The Color Marketing Group and newer organizations such as Première Vision of Paris, which sponsors semi-annual fabric shows and issues trend reports for the global market, serve as forums for exchanges of ideas by color stylists, but increasingly the goal of each company is to perpetuate a distinctive brand identity. Some consumers decry the uniformity even as millions of fellow shoppers shop till they drop. Albert Munsell

would have shuddered at the sight of a Walmart or a Toys "R" Us store filled with merchandise in "hot and vulgar" colors.[5]

The seductive power of the new has shifted our attention from the innovations of the industrial age (automobiles, telecommunications, flight, sound recording, acoustics, broadcasting, cast concrete, and color, to name a few) to the new technologies of the electronic age. The technology behind mauve mania may seem insignificant in comparison with the microchips inside an iPhone, but the rise of the synthetic organic chemicals industry and the changes it wrought in design and fashion were watersheds. All cultural obsessions have historical roots, and the antecedents of our fascination with digital gadgets can be found in the modern fascination with things industrial, chemical, and colorful.

Reliable colors are now so common that we never think about their significance. We are oblivious to the fact that in centuries past almost everything turned pale after brief exposure to the sun. Our sheets, towels, and shirts don't fade after dozens of washings, and our cars' iridescent powder coatings never need polishing. Our black Kenmore refrigerators match our black Maytag dishwashers. Every single Stop sign is the same shade of red, and every British Airways Boeing 747 has the same blue nylon upholstery and buff plastic walls. We live in the chromo-utopia that Frederick Bode imagined and Margaret Hayden Rorke worked so hard to achieve—but we are sadly unmindful of its wonders.

Acknowledgments

Several institutions have been home to this project. At the University of Pennsylvania, I have been blessed with a Visiting Scholar appointment in the Department of the History and Sociology of Science, thanks to two supportive chairs. I am grateful to Ruth Schwartz Cowan for bringing me on board, and to Susan Lindee for continuing to provide me with access to the department and to the university's unparalleled library resources. Elsewhere in the Mid-Atlantic region, I have a research affiliation at the Hagley Museum and Library, which is dedicated to scholarship in business and cultural history. I am grateful for the help of the Hagley staff: Chris Baer, Ben Blake, Lynn Catanese, Lucas Clawson, Elizabeth Fite, Linda Gross, Roger Horowitz, Debra Hughes, Marge McNinch, Michael Nash, Glenn Porter, Philip Scranton, Terry Snyder, and Jon Williams.

At Boston University, Bruce Schulman was a stalwart advocate who arranged for research and travel funds. Paul Schmitz served as a dedicated research assistant, poring over dusty trade and industry journals and tracking down obscure articles in the days before electronic databases. During my time in Boston, I enjoyed fruitful exchanges with other faculty members, students, and visiting scholars, including David Brody, Richard Candee, Sally Clarke, Claire Dempsey, Elysa Engelman, Elisabeth Essner, Louis Ferleger, Walter Friedman, Tom Glick, Larry Glickman, Patricia Hills, Daniel Horowitz, Ella Howard, Lori Kahn Leavitt, Ruth Murray, Joy Parr, Anita Patterson, Cheryl Robertson, Fred Speers, Katherine Stebbins-McAffrey, Marc Stern, and the late Henry "Jay" Wischerath Jr.

Professional colorists shared my enthusiasm for their history. I am grateful to Mary Ann Miller of Desbrow & Associates who arranged for me to attend the Color Marketing Group's 76th annual international conference in Boston. Margaret Walsh of the Color Association of the United States encouraged me to move forward when I was first contemplating this project. Debbie Zimmer at Dow Chemical served as a sounding

board, drawing on her experience with the Rohm and Haas Paint Quality Institute. Lori Sawaya of Color Strategies learned about my research from my website and generously helped to publicize the project among colorists.

Fellowships make the scholarly world go round, and I received some prestigious awards for this project. Foremost, my year as a Charles Warren Fellow at Harvard was rewarding for the faculty, libraries, and a wonderful group of fellows. I am grateful to Lizabeth Cohen and Laurel Thatcher Ulrich for inviting me to be part of the fellowship class that explored the relationships among capitalism and culture. The fellowship announcement came just as I was launching this project and as many new changes were occurring within the fields of business history and design history. My class included scholars from art history, anthropology, intellectual history, and cultural history, and our fruitful exchanges showed that it is possible to think expansively about scholarship on business, society, and the arts. During my year at Harvard, I was fortunate to develop a close friendship with the art historian Patricia Johnston, whose scholarship has been a constant source of inspiration.

In addition to Harvard, I am grateful to several other institutions for financial support, including the Smithsonian Institution's Lemelson Center for the History of Invention and Innovation. The project inched forward with short-term grants and fellowships from the Hagley Museum and Library, the archives and library at the Henry Ford Museum, the Smithsonian Institution Libraries, the Herbert Hoover Presidential Library, the Chemical Heritage Foundation, and the Pasold Research Fund. Support for a year of writing came from the National Endowment for the Humanities. Final manuscript preparation took place while I was The Fellow in the History of Consumption at the German Historical Institute in Washington.

I am beholden to Joyce Bedi and Arthur Molella of the Lemelson Center. Joyce and Art had faith in this project from the start and saw how it could fit into their series at the MIT Press. I am particularly grateful to Joyce, who, with the fortitude of a midwife, watched the manuscript gestate and helped with its birth. Her common-sense approach to editorial matters and her fine eye for illustrations has made this a better book. While a visiting fellow at the center, I also had the privilege to work with many archivists, curators, and librarians at the National Museum of American History. I thank the following staff members for access to the collections and for inspiring ideas: Richard Alhborn, Larry Bird, Kathy Dirks, John Fleckner, Jackie Gray, David Haberstich, Peggy Kidwell, Bonnie Lilienfeld, Steven Lubar, Charlie McGovern, Mimi Minnick, Susan Myers, Shelley Nickles, Craig Orr, Alison Oswald, Kay Peterson, Bob Post, Jim Roan, Harry Rubenstein, Fath Davis Ruffins, the late David Shayt, Roger Sherman, Margaret Vining, Debbie Warner, Roger White, Priscilla Wood, Helena Wright, and Marilyn Zodis.

At the Henry Ford Museum, I am thankful to Linda Skolarus for guiding me through the archives, to Jim Orr for photography, and to Bill Pretzer for giving me the chance to present my work. The library at the Smithsonian Cooper-Hewitt National Design Museum, where I spent a summer as a Spencer Baird Fellow, was made a welcoming place by Stephen Van Dyk and Elizabeth Bauman. At the Chemical Heritage Foundation, I owe much to founder Arnold Thackray, who built a world-class institution from scratch, and to the librarians, curators, and managers who have supported my work: Amanda Antonucci, Elsa Atson, Ashley Augustyniak, Ronald Brashaer, Marjorie Gapp, Shelley Geehr, Neil Gussman, Robert Hicks, Jennifer Landry, Andrew Mangravite, Marti Perrin, Ron Reynolds, John Van Ness, and Rasheedah Young.

This book is stronger for the time I spend abroad exploring transnational connections. My research in Europe helped me to understand that the color revolution was a uniquely American experience linked to mass production and mass consumption. I thank Patrick Fridenson for inviting me to Paris as a visiting professor at the École des hautes études en sciences sociales. I presented my color research to students and colleagues in business history and in American studies through arrangements made by Patrick, Jean-Christian Vinel, Pap Ndiaye, Paul Schor, and François Weil. Several colleagues whom I met in Paris have continued to serve as sounding boards for my work on color, business, and fashion: Florence Brachet Champsaur, Diana Crane, Laura Kalba, Thierry Maillet, Francesca Polese, Véronique Pouillard, and especially Julie Thomas.

In London, Christopher Breward and Liz Miller sponsored my visit to the Victoria and Albert Museum, where I did research in the Archives of Art and Design at Blythe House. My work there furthered my understanding of the Americanness of the color revolution. I appreciate the patience of the archival staff for tolerating my endless stream of call slips; many thanks to Alexia Kirk, Tom Midgley, Nick Smith, James Sutton, Victoria West, and especially Eva White. I am also grateful to Peter Morris for arranging for me to see the Science Museum's William Henry Perkin artifacts, to Neil Parkinson for hosting my visits to the Color Reference Library at the Royal College of Art, to Rowena Olegario and Christopher McKenna for inviting me to the University of Oxford, to Negley Harte of University College London for showing me good eats, to Caroline Evans of Central St. Martins College for morning coffee, to Mary Schoesser for sharing her knowledge of turkey red, and to Ann Eatwell and Alex Werner for hospitality and friendship on various London visits.

I extend my thanks to folks who shared their enthusiasm, scholarship, hospitality, and design expertise over the years: Hartmut Berghoff, Elspeth Brown, Hazel Clark, Susan Cook, Terri Cook, Ellen and Bert Denker, Phyllis Dillon, Colleen Dunlavy, Linda Eaton, Ingrid Giertz-Mårtenson, Javier C. Gimeno, Margaret Graham, Janet Greenlees, Daryl Hafter, John Heitmann, Richard John, Pamela Walker Laird, Stuart "Bill" Leslie, Barbara Buhler Lynes, the late Roland Marchand, Jan Marontate,

Peter McNeil, Giorgio Riello, George Sheridan, David Sicilia, Uwe Spiekermann, Kathryn Steen, Philip Sykas, Tony Travis, and Françoise Viénot. Several scholars deserve special thanks; Roy R. Behrens, Evan-Hepler Smith, and Sarah Scaturro shared research materials on camouflage. I am also grateful to Lisa Schrenk for sharing photocopies of color materials from the Century of Progress Exposition.

The following archivists, curators, and librarians provided assistance with collections and photography: Valerie Steele, Patricia Mears, Jennifer Farley, Lynn Felscher, Varounny Chanthasiri, Eileen Costa, Sonia Dingilian, and Lynn Weidner at The Museum at FIT; Karen Cannell, Clara Berg, and Juliet Jacobson in Special Collections at FIT; the Manuscripts and Archives Division at the New York Public Library; the Special Collections staff at the Cornell University Library; Jennifer Lee, curator of the Theater Collections at Columbia University; Jeanne Swadosh at Parsons, The New School for Design; Deidre Lawrence at the Brooklyn Museum; Carla Bednar, Stan Gorski, Hilary Jay, and Nancy Packer at Philadelphia University; Jae Jennifer Rossman and her staff at the Robert B. Haas Family Arts Library at Yale University; Diane Kaplan at Yale University's Sterling Library; Sean Quimby and Nicolette Dobrowolski at the Syracuse University Library's Special Collections Research Center; Sara Schechner and the staff of Harvard University's Collection of Historical Scientific Instruments; Valerie Harris in Special Collections at the University of Illinois at Chicago; Diane Fagen Affleck at the Museum of American Textile History; Timothy Walch and his staff at the Herbert Hoover Presidential Library; Lesley Whitworth at the University of Brighton for making the Design Archives accessible and for arranging for me to present my research at the IOTA seminar; Deborah Douglas at The MIT Museum; Anne-Catherine Hauglustaine and Anne-Laure Carré at the Musée des arts et métiers in Paris; Alexandra Bosc at the Musée Galliera in Paris; Christina Haugland and other costume curators at the Philadelphia Museum of Art; Orville Butler at the Maytag Company Archives; Pamela Golbin and Caroline Pinon at Les Arts Decoratifs–Mode et Textile, Paris; and Jutta Kissener at the Corporate History Division at BASF.

At the MIT Press I am indebted to Paul Bethge for the editing, Erin Hasley for the design, and Marguerite Avery for oversight of the project.

As always, my greatest debt is to my husband, Lee O'Neill, who read many drafts of this manuscript and improved it in many ways, and to my dear friends Nina and Bill Walls. Color management was in part born in engineering practice, and, as an engineer, Bill would have understood. This book is dedicated to his memory.

Abbreviations Used in References

Journals, Magazines, Newspapers, and Reference Works

AA *Automotive Age*

AABN *American Architect and Building News*

AB *Art Bulletin*

ADR *American Dyestuff Reporter*

ADRN *Authorized Duco Refinisher News*

AF *Architectural Forum*

AGJ *American Gas Journal*

AH *Architectural History*

AHM *Arthur's Home Magazine*

AI *Automotive Industries*

AJP *American Journal of Pharmacy*

AM *American Magazine*

AmA *American Architect*

AmF *American Fabrics*

AR *Architectural Record*

ARC *Autobody and the Reconditioned Car*

ArtA *Art Amateur*

AS *Advertising & Selling*

ASJ *American Silk Journal*

ASRJ *American Silk and Rayon Journal*

ATJ *Automobile Trade Journal*

AtM *Atlantic Monthly*

ATP *Autobody Trimmer and Painter*

AW&AD *Art World and Arts and Decoration*

BHG Better Homes and Gardens

BHR Business History Review

BJHS British Journal for the History of Science

BW Business Week

CDT Chicago Daily Tribune

CE Color Engineering

CGJ Crockery and Glass Journal

CL Current Literature

CMA Chilton's Motor Age

CO Current Opinion

CR&A Color Research and Application

CSM Christian Science Monitor

CTJ Color Trade Journal

CW Chemical Week

DGE Dry Goods Economist

DM DuPont Magazine

EM Electrical Merchandising

EW Electrical World

FIM Factory and Industrial Management

FMM Factory Management and Maintenance

GER General Electric Review

GH Good Housekeeping

GLBM Godey's Lady's Book and Magazine

GM Graham's Magazine

HB Harper's Bazar or Bazaar

HBR Harvard Business Review

IA Iron Age

IF Industrial Finishing

ILN Illustrated London News

IND Independent

IP Inland Printer

IW Illustrated World

JCRA Journal of Color Research and Application

JDH Journal of Design History

JIE Journal of Industrial Economics

JOSA Journal of the Optical Society of America

LAT Los Angeles Times

LD Literary Digest

LHJ Ladies' Home Journal

LLA Littell's Living Age

MA Motor Age

MBPT Motor Body, Paint and Trim

MD Machine Design

ME Materials Engineering

MM Munsey's Magazine

MoA Magazine of Art

MP Modern Plastics

MPAC Modern Packaging

MVM Motor Vehicle Monthly

MW Motor World

NB Nation's Business

NYH New York Herald

NYT New York Times

NYTR New York Tribune

OME Office Management and Equipment

P-PG Pittsburgh Post-Gazette

PE Product Engineering

PGBS Pottery, Glass & Brass Salesman

PI Printers' Ink

PIM Printers' Ink Monthly

PM Popular Mechanics

PMP Plastics & Molded Products

POCR Paint, Oil & Chemical Review

PP Pittsburgh Press

PSM Popular Science Monthly

PST Pittsburgh Sun-Telegraph

PTJ Paper Trade Journal

RD Reader's Digest

RTM Rayon Textile Monthly

SA Scientific American

SAB School Arts Book

SAEJ Society of Automotive Engineers Journal

SAM Scientific American Monthly

SEP Saturday Evening Post

SR Science Record

TAIEE Transactions of the American Institute of Electrical Engineers

TC Textile Colourist

TFR Tobé Fashion Report

TIES Transactions of the Illuminating Engineering Society

TW Textile World

WFW World's Fair Weekly

WSJ Wall Street Journal

WW Women's Wear

WWA Who's Who in America

YC Youth's Companion

Archival Material

AAA Archives of American Art, Smithsonian National Museum of American Art, Washington

AAA-AHT Abbott H. Thayer Papers, Archives of American Art

AAA-AR Abraham Rattner Papers, Archives of American Art

AAD Archives of Art and Design, National Art Library, Victoria and Albert Museum, Blythe House, London

AAD-PRE Presage Fashion Forecast Archives, collection 746.92 PRE, Archives of Art and Design

AAD-TAF T. A. Fennemore Papers, collection 3-1983, Archives of Art and Design

AIC Art Inventories Catalog, Smithsonian American Art Museum, Washington

BBHC McCracken Research Library, Buffalo Bill Historical Center, Cody, Wyoming

BM Museum Library and Archives, Brooklyn Museum

BM-SC Stuart Culin Archival Collection, Brooklyn Museum

CH Cooper-Hewitt National Design Museum, Smithsonian Institution, New York

CH-HD Henry Dreyfuss Archives, Cooper-Hewitt National Design Museum

COL Rare Book and Manuscript Library, Columbia University Libraries

COL-ASA Arthur S. Allen Collection, Columbia University

COL-JU Joseph Urban Collection, Columbia University

COL-ONR Ogden N. Rood Papers, Columbia University

CT Archives and Special Collections, Thomas J. Dodd Research Center, University of Connecticut Libraries, Storrs

CT-CB Cheney Brothers Silk Manufacturing Company Papers, University of Connecticut Libraries

CU Division of Rare and Manuscript Collections, Cornell University Library

CU-FLD Forrest Lee Dimmick Papers, Cornell University Library

FIT Fashion Institute of Technology, New York

FIT-SC Special Collections, Gladys Marcus Library, Fashion Institute of Technology

FMCA Ford Motor Company Archives, Dearborn, Michigan

HFM Benson Ford Research Center, Henry Ford Museum, Dearborn

HFM-DHC Edsel B. Ford Design History Center, Henry Ford Museum

HFM-DTM Douglas T. McClure records series, accession 624, Continental Division Records subgroup, Ford Motor Company Automotive Divisions records collection, Henry Ford Museum

HFM-S&A Sales and Advertising records series, accession 695, Ford Division records subgroup, Ford Motor Company Automotive Divisions records collection, Henry Ford Museum

HHPL Herbert Hoover Presidential Library, West Branch, Iowa

HHPL-C Commerce Department Papers of Herbert Hoover, Herbert Hoover Presidential Library

HML Hagley Museum and Library, Wilmington, Delaware

HML-AD Papers of the Advertising Department, accession 1803, E I. du Pont de Nemours & Company, Hagley Museum and Library

HML-CA Color Association of the United States Papers, accession 1983, Hagley Museum and Library

HML-ED Ernest Dichter Papers, accession 2407, Hagley Museum and Library

HML-HLT H. Ledyard Towle Papers, accession 2191, Hagley Museum and Library

HML-ID Irénée du Pont Papers, accession 228, Hagley Museum and Library

HML-IS Inter-Society Color Council Papers, accession 2188, Hagley Museum and Library

HML-IS-PS TCCA Publicity Scrapbooks, Inter-Society Color Council Papers, accession 2188, Hagley Museum and Library

HML ISA Addendum to the Inter-Society Color Council Papers, accession 2189, Hagley Museum and Library

HML-LM Longwood Manuscripts, accession 851, Hagley Museum and Library

HML-OP Administrative Papers of the Office of the President, accession 1662, E. I. du Pont de Nemours & Company, Hagley Museum and Library

HML-R&D DuPont R&D History Project Files, accession 1850, Hagley Museum and Library

HML-TC Trade and Pamphlet Catalog Collection, Hagley Museum and Library

HSP Historical Society of Pennsylvania, Philadelphia

HSP-MHG Mary Hallock Greenewalt Papers, collection 867, Historical Society of Pennsylvania

K Kettering/GMI Alumni Foundation Collection of Industrial History, Flint, Michigan

K-CFK Charles F. Kettering Papers, Kettering/GMI Alumni Foundation Collection of Industrial History

K-FC Frigidaire Collection, Kettering/GMI Alumni Foundation Collection of Industrial History

LC Library of Congress, Washington

LC-ELB Edward L. Bernays Papers, manuscript collection 12534, Library of Congress

MASS Morton R. Godine Library, Massachusetts College of Art, Boston

MCA Maytag Company Archives, Newton, Iowa

MD Transcript of Albert H. Munsell Diary, Inter-Society Color Council Papers, accession 2188, Hagley Museum and Library

MSI Museum of Science and Industry, Manchester, UK

MSI-K-ICI Kirkpatrick Collection, Imperial Chemical Industry Archives, Museum of Science and Industry, Manchester

NYPL Manuscripts and Archives Division, Stephen A. Schwarzman Building, New York Public Library

NYPL-1939 1939 New York World's Fair Papers, collection 2233, New York Public Library

NYPL-FBP Faber Birren Papers, collection 308, New York Public Library

NYPL-FGI Fashion Group International Papers, collection 980, New York Public Library

OHS Ohio Historical Society, Columbus

PH-DC Design Center, Philadelphia University

PNSD-KA Anna-Maria and Stephen Kellen Archives Center, Parsons The New School for Design, New York

RBAI Ryerson & Burnham Archives, Art Institute of Chicago

RBAI-BB Daniel H. Burnham Jr. and Hubert Burnham Papers, accession 1943.2, Ryerson & Burnham Archives

RBAI-BB-CP Century of Progress Collection, accession 00.18, Burnham Papers

RCA Royal College of Art, London

RCA-CRL Colour Research Library, Royal College of Art

RISD-RBF Royal Bailey Farnum Records, Rhode Island School of Design Archives, Providence

SHSW State Historical Society of Wisconsin, Madison

SHSW-DD Dorothy Dignam Papers, U.S. manuscript collection 19AF, State Historical Society of Wisconsin

SIL-TC Smithsonian Institution Libraries, Trade Catalog Collection

SU Special Collections Research Center, Syracuse University Library

SU-EA Egmont Arens Papers, Syracuse University

SU-RW Russel Wright Papers, Syracuse University

UB University of Brighton, Brighton, UK

UB-DCA Design Council Archive, University of Brighton

UIC Special Collections, University of Illinois, Chicago

UIC-CP Century of Progress Collection, University of Illinois

UM University of Michigan Bentley Historical Library, Ann Arbor

UM-WAM William A. Muschenheim Collection, University of Michigan

UP Special Collections Department, Van Pelt Library, University of Pennsylvania, Philadelphia

UP-PPC Paul Philippe Cret Papers, manuscript collection 295, University of Pennsylvania

UT Harry Ransom Center, University of Texas, Austin

UT-NBG Norman Bel Geddes Theater and Industrial Design Papers, University of Texas

YU Yale University

YU-FBB Faber Birren Collection of Books on Color, Special Collections, Robert B. Haas Family Arts
Library, Yale University

YU-FBP Faber Birren Papers, Manuscripts and Archives, Sterling Memorial Library, Yale University

Notes

Introduction

1. "Color in Industry," *Fortune* 1 (Feb. 1930): 85–94 (90, "master"; 92, "color revolution"). For more on color in industry, see "The New Age of Color," *SEP* (Jan. 21, 1928): 22, and *ADR* 17 (Feb. 6 1928): 102–103; James H. Collins, "A New Salesman Named Color," *Business* 9 (Feb. 1928): 20–22; Rexford Daniels, "A Guide to the Use of Color," *PI* 143 (April 26, 1928): 61–68; idem, "Some Points to Be Considered in the Use of Color," *PI* 143 (May 10, 1928): 121–25; "Color—Is It a Fad?" *NB* 54 (Sept. 1928): 245–47; Nan Hornbeck, "Industry Courts the Rainbow," *NB* 17 (Jan. 1929): 114–17; "Colors Your Product Can Wear," *FIM* 82 (Sept. 1931): 344–45; Mark H. Dix, *An American Business Adventure* (Harper, 1928), 20–21.

2. "Color in Industry"; Regina Lee Blaszczyk, *Imagining Consumers: Design and Innovation from Wedgwood to Corning* (Johns Hopkins University Press, 2002); Stephen Eskilson, "Color and Consumption," *Design Issues* 18 (spring 2002): 17–29.

3. Recent work includes, but is not limited to, Philip Ball, *Art and the Invention of Color* (University of Chicago Press, 2003); Joyce Bedi, "Color Sells!," exhibition at National Museum of American History, Smithsonian Institution, Washington, DC, 1997; Deborah R. Coen, *Vienna in the Age of Uncertainty* (University of Chicago Press, 2007); Francois Delamare and Bernard Guineau, *Colors: The Story of Dyes and Pigments* (Abrams, 2000); Victoria Finlay, *Color: A Natural History of the Palette* (Ballantine Books, 2003); Akiko Fukai, "Fashion in Colors," exhibition at the Cooper-Hewitt, National Design Museum, Smithsonian Institution, New York, 2005–2006; John Gage, *Color and Culture: Practice and Meaning from Antiquity to Abstraction* (University of California Press, 1993); idem, *Color and Meaning: Art, Science, and Symbolism* (University of California Press, 1999); Amy Butler Greenfield, *A Perfect Red: Empire, Espionage, and the Quest for the Color of Desire* (HarperCollins, 2005); Scott Higgins, *Harnessing the Technicolor Rainbow: Color and Design in the 1930s* (University of Texas Press, 2007); Sean Johnston, *A History of Light and Color Measurement: Science in the Shadows* (Institute of Physics Publishing, 2001); Matteo de Leeuw-de Monti and Petra Timmer, *Color Moves: Art and Fashion by Sonia Delaunay* (Cooper-Hewitt, National Design Museum, Smithsonian Institution, 2011); Sarah Lowengard, *The Creation of Color in Eighteenth-Century Europe*, available at http://www.gutenberg-e.org; Michel Pastoureau, *Blue: The History of a Color* (Princeton University Press, 2001); idem, *Black: The History of a Color* (Princeton University Press, 2009); Valerie Steele, *The Red Dress* (Rizzoli, 2001); idem, "She's Like a Rainbow: Colors in Fashion," exhibition at The Museum at FIT, New York, Sept.–Dec. 2006; Sally Ann Stein, The Rhetoric of the Colorful and the

Colorless: American Photography and Material Culture Between the Wars, Ph.D. dissertation, Yale University, 1991.

4. Anthony S. Travis, the leading scholar of the synthetic organic chemical industry, has explored its history in numerous publications, including (with Peter J. T. Morris), "A History of the International Dyestuff Industry," *ADR* 81 (Nov. 11, 1992), available at http://colorantshistory.org; *From Turkey Red to Tyrian Purple: Textile Colors for the Industrial Revolution* (Jewish National and University Library, 1993); *The Rainbow Makers: The Origins of the Synthetic Dyestuffs Industry in Western Europe* (Lehigh University Press, 1993); (with Carsten Reinhart) *Heinrich Caro and the Creation of Modern Chemical Industry* (Kluwer, 2000); *Dyes Made in America, 1915–1980: The Calco Chemical Company, American Cyanamid and the Raritan River* (Hexagon Press, 2004). See also William Haynes, *American Chemical Industry*, 6 vols. (Van Nostrand, 1945–54); John Joseph Beer, *The Emergence of the German Dye Industry* (Arno Press, 1981); Kathryn Steen, Wartime Catalyst and Postwar Reaction: The Making of the U.S. Synthetic Organic Chemicals Industry, 1910–1930, Ph.D. dissertation, University of Delaware, 1995; Ernst Homburg et al., eds., *The Chemical Industry in Europe, 1850–1914: Industrial Growth, Pollution, and Professionalization* (Kluwer, 1998); Mark Clark, *Dyeing for a Living: A History of the AATCC, 1921–1996* (American Association of Textile Chemists and Colorists, 2001); Johann Peter Murmann, *Knowledge and Competitive Advantage: The Co-evolution of Firms, Technology, and National Institutions* (Cambridge University Press, 2003); Robert J. Baptista, Colorants Industry History, available at http://www.colorantshistory.org; Alexander Engel, *Farben der Globalisierung: Die Entstehung Moderner Märkte für Farbstoffe, 1500–1900* (Campus-Verlag, 2009). On the fear of color, see David Batchelor, *Chromophobia* (Reaktion Books, 2000).

5. Terry Smith, *Making the Modern: Industry, Art and Design in America* (University of Chicago Press, 1994); Thomas Parke Hughes, *American Genesis: A Century of Invention and Technological Enthusiasm, 1870–1970* (Penguin, 1990); Regina Lee Blaszczyk, *American Consumer Society, 1865–2005: From Hearth to HDTV* (Harlan-Davidson, 2009); Geoffrey Jones, *Multinationals and Global Capitalism: From the Nineteenth to the Twenty-First Century* (Oxford University Press, 2005); idem, "Globalization," in *The Oxford Handbook of Business History*, ed. Geoffrey Jones and Jonathan Zeitlin (Oxford University Press, 2007).

6. On industrial districts, see Jonathan Zeitlin, "Industrial Districts and Regional Clusters," in Jones and Zeitlin, eds., *The Oxford Handbook of Business History*.

7. The 45-volume *Industrial Arts Index* (H. W. Wilson, 1914–1958) suggests the breadth and scope of the twentieth-century American art industries, the history of which was for many years overshadowed by design stories of High Modernism and technological stories of engineering. Recent work on the industrial-arts trajectory includes Blaszczyk, *Imagining Consumers*; Carol G. Duncan, *A Matter of Class: John Cotton Dana, Progressive Reform, and the Newark Museum* (Periscope, 2009); Ezra Shales, *Made in Newark: Cultivating Industrial Arts and Civic Identity in the Progressive Era* (Rutgers University Press, 2010).

8. Countless authors have discussed Paris as a style capital, but most important to this book is recent work by fashion historians, sociologists, and social historians, including Nancy L. Green, *Ready-to-Wear and Ready-to-Work: A Century of Industry and Immigrants in Paris and New York* (Duke University Press, 1997); Valerie Steele, *Paris Fashion: A Cultural History*, second edition (Berg, 1998); Susan Hay, ed., *From Paris to Providence: Fashion, Art, and the Tirocchi Dressmakers' Shop* (Museum of Art, Rhode Island School of Design, 2000); Diana Crane, *Fashion and Its Social Agendas: Class, Gender, and Identity in Clothing* (University of Chicago Press, 2000); Dilys Blum, *Shocking! The Art and Fashion of Elsa Schiaparelli* (Philadelphia Museum of Art, 2003); Joan E. DeJean, *The Essence of Style: How the French Invented High Fashion, Fine Food, Chic Cafés, Style, Sophistication, and Glamour* (Free Press, 2005); Agnès Rocamora, *Fashioning the City: Paris, Fashion and the Media* (I. B. Tauris, 2009). For a concise reference book on fashion history, see Valerie Steele, ed., *The Berg Companion to Fashion* (Berg, 2010).

9. See, for example, Johann Wolfgang von Goethe, *Zur Farbenlehre* (J. G. Cottas'chen Buchhandlung, 1810); *Goethe's Theory of Colors; translated from the German: with Notes by Charles Lock Eastlake* (John Murray, 1840).

10. "Conference Called to Standardize Color in the Kitchen," *PGBS* 41 (June 19, 1930): 27 ("symbol"); George H. Nash, *The Life of Herbert Hoover*, 4 vols. (Norton, 1983–2010); Richard Norton Smith, *An Uncommon Man: The Triumph of Herbert Hoover* (High Plains Publishing, 1984); Kendrick A. Clements, *Hoover, Conservation, and Consumerism: Engineering the Good Life* (University Press of Kansas, 2000); Timothy Walch, ed., *Uncommon Americans: The Lives and Legacies of Herbert and Lou Henry Hoover* (Praeger, 2003).

11. Efficiency has long been an important thread in the history of business, technology and culture: see, for example, Samuel Haber, *Uplift and Efficiency: Scientific Management in the Progressive Era, 1890–1920* (University of Chicago Press, 1965); Cecilia Tichi, *Shifting Gears: Technology, Literature, and Culture in Modernist America* (University of North Carolina Press, 1987); Martha Banta, *Taylorized Lives: Narrative Productions in the Age of Taylor, Veblen and Ford* (University of Chicago Press, 1993); Robert Kanigel, *The One Best Way: Frederick Winslow Taylor and the Enigma of Efficiency* (Viking Penguin, 1997); Sarah Stage and Virginia B. Vincenti, eds., *Rethinking Home Economics: Women and the History of a Profession* (Cornell University Press, 1997). Like Jennifer Karns Alexander's *The Mantra of Efficiency: From Waterwheel to Social Control* (Johns Hopkins University Press, 2008), this book re-examines the familiar efficiency theme and contextualizes it in a new way. On standards, see M. Norton Wise, ed., *The Values of Precision* (Princeton University Press, 1995); Amy Slaton and Janet Abbate, "The Hidden Lives of Standards: Technical Prescriptions and the Transformation of Work in America," in *Technologies of Power: Essays in Honor of Thomas Parke Hughes and Agatha Chipley Hughes*, ed. Michael Tadd Allen and Gabrielle Hecht (MIT Press, 2001); Martha Lampland and Susan Leigh Star, eds., *Standards and Their Stories: How Quantifying, Classifying, and Formalizing Practices Shape Everyday Life* (Cornell University Press, 2009).

12. Faber Birren [hereafter cited as FB], "Color and the Visual Environment," *CE* 9 (July/August 1971): 31–33 (32, "uglification"); idem, "Color and Compulsion," *CE* 4 (July-August 1966): 29–31; Frederic H. Rahr, "Color Engineering," *PTJ* 125 (Sept. 4, 1947): 37–39.

13. Josef Albers, *Interaction of Color*, revised edition (Yale University Press, 2006); Rudolph Arnheim, *Art and Visual Perception: A Psychology of the Creative Eye*, revised edition (University of California Press, 1974); Eric Larrabee and Massimo Vignelli, *Knoll Design* (Abrams, 1981); Phil Patton, *Michael Graves Designs: The Art of the Everyday Object* (Melcher Media, 2004); Jane Thompson and Alexandra Lange, *Design Research: The Store That Brought Modern Living to American Homes* (Chronicle Books, 2009).

14. On the history of American design, see Arthur J. Pulos, *American Design Ethic: A History of Industrial Design to 1940* (MIT Press, 1983); Arthur J. Pulos, *The American Design Adventure, 1940–1975* (MIT Press, 1988); Jonathan M. Woodham, *Twentieth Century Design* (Oxford University Press, 1997); Jeffrey L. Meikle, *Twentieth Century Limited*, second edition (Temple University Press, 2001); Christina Cogdell, *Eugenic Design: Streamlining America in the 1930s* (University of Pennsylvania Press, 2004); Jeffrey L. Meikle, *Design in the USA* (Oxford University Press, 2005); Susan Currell and Christina Cogdell, eds., *Popular Eugenics: National Efficiency and American Mass Culture in the 1930s* (Ohio University Press, 2006); David Raizman, *History of Modern Design*, second edition (Pearson Prentice-Hall, 2011).

15. Walter A. Friedman, "The Rise of Business Forecasting Agencies in the United States," Working Paper 07-045, Harvard Business School, 2007; Walter A. Friedman, "Warren Person, the Harvard Economic Service, and the Problems of Forecasting," Working Paper 07-044, Harvard Business School, 2007; History of Babson College, available at http://www3.babson.edu.

16. Transcript from the Meeting of the Design and Industries Association, May 9, 1946, box 4, AAD-TAF.

17. Allen L. Billingsley, "Color—A Real Business Problem," *NB* 16 (August 1928): 21–22, 73–76 (76, "invasion").

18. Kjetil Fallan, *Design History: Understanding Theory and Method* (Berg, 2010).

19. David Edgerton, *The Shock of the Old: Technology and Global History Since 1900* (Oxford University Press, 2007).

Chapter 1

1. "The Princess Royal and the Royal Marriage," *GM* 52 (April 1858): 345–50; "Centre-Table Gossip," *GLBM* 56 (April 1858): 381–82; *ILN,* Jan. 30, 1858, cited by Diarmuid Jeffreys, *Hell's Cartel: IG Farben and the Making of Hitler's War Machine* (Metropolitan Books, 2008), 15.

2. "Ladies' Department," *GM* 52 (June 1858): 569–70 ("the Princess"); Travis, *From Turkey Red,* 61. For mauve and lilac in America, see, for example, "The Fashions," *NYH,* March 25, 1858; "Paris Fashions for August," *Albion* 36 (August 21, 1858): 402; "Fashions," *GLBM* 57 (July 1858): 95–96; (Sept. 1858): 287–88; (Nov. 1858): 477–78; "Ladies Department," *GM* 52 (April 1858): 377–84, and 53 (Sept. 1858): 281–88.

3. "The Colors of Coal Tar: Number II," *SA* 6 (May 17, 1862): 309. Natural substances like insects, madder, and metallic salts were used to make other stunning colors—scarlet, red, purple, and lilac—but many of these dyes were fugitive.

4. On mourning dress, see Genio C. Scott, "Interesting to Ladies," *Home Journal* 11 (April 5, 1856): 4.

5. "Life in Paris," *National Era* 11 (June 18, 1857): 97 ("plain"); "Fashion and Dress," *GM* 51 (July 1857): 87–92 (87, "light green"); "Life in Paris," *National Era* 11 (Dec. 24, 1857): 205; "Science and Arts for March," *LLA* (May 19, 1860): 441–43; *London Lady's Paper* ("mauve"), cited in "General Observations on Fashion and Dress," *SEP* (Oct. 3, 1857): 4.

6. Ernst Homburg, "The Influence of Demand on the Emergence of the Dye Industry: The Roles of Chemists and Colourists," *Journal of the Society of Dyers and Colourists* 99 (1983): 325–32.

7. Diane L. Fagan Affleck, *Just New From the Mills: Printed Cottons in America* (American Textile History Museum, 1987), 12; "Science and Arts for March" (statistics); Travis, *From Turkey Red,* 57; "Murexide," in *Encyclopedia Americana,* vol. 19 (New York, 1919), 605.

8. "The Greatest Industrial Victory Ever Won by Applied Science," *CL* 41 (Nov. 1906): 566–68; Anthony S. Travis, "Perkin's Mauve: Ancestor of the Organic Chemical Industry," *Technology and Culture* 31 (Jan. 1990): 51–82; Simon Garfield, *Mauve: How One Man Invented a Color that Changed the World* (Norton, 2001).

9. "Lecture by Robert Hunt, F.R.S., at Breage," *The Friend* (Dec. 31, 1864): 141–42 ("splendid"; skein); William H. Perkin [hereafter cited as WHP] to Heinrich Caro, May 1891, MSI-K-ICI, quoted by Travis, "Perkin's Mauve," 56 ("experimenting"); Robert Pullar to WHP, June 12, 1856, MSI-K-ICI, quoted by Travis, "Perkin's Mauve," 57 ("discovery").

10. Fred Aftalion, *A History of the International Chemical Industry,* second edition (Chemical Heritage Press, 2001), 37; John Pullar to WHP, May 14, 1857, MSI-K-ICI, quoted by Travis, "Perkin's Mauve," 66 ("The Ladies").

11. Hugo Schweitzer, "The Influence of Sir William Perkin's Discovery on Our Science," *Science* 24 (Oct. 19, 1906): 482; Charles O'Neill, *A Dictionary of Dyeing and Calico Printing* (Henry Carey Baird, 1869), ix ("secret"); Travis, "Perkin's Mauve," 72, 74, 78–80.

12. "Permanent Purple or Lilac Dye," *AJP* (Nov. 1859): 568 ("fugitive"); "The Mauve Measles," *Punch* 37 (August 20, 1859): 81.

13. August Wilhelm Hofmann, "Colouring Derivatives of Organic Matter, Recent and Fossilized," *International Exhibition, 1862—Report by the Juries on the Subjects in the Thirty-six Classes into which the Exhibition was Divided*, Class II (William Clowes, 1863), 119–120 ("ostrich," "greatest"), cited by Beer, *Emergence,* 31; "Coal-Tar Colors," *LLA* (Oct. 25, 1862): 189–90 ("gorgeous," "beautiful"); Robert Hunt, *Handbook to the Industrial Department of the International Exhibition, 1862,* vol. II (William Clowes, 1862), 119–24; "Discoveries and Inventions Abroad," *SA* 14 (April 4, 1863): 219 (patents); "Aniline Dyes," *SA* 4 (March 9, 1861): 150 ("fuchsine").

14. Beer, *Emergence*, 25; Homburg, "The Influence of Demand on the Emergence of the Dye Industry," 325–26; Anthony S. Travis, "Science's Powerful Companion: A. W. Hofmann's Investigation of Aniline Red and Its Derivatives," *BJHS* 25 (March 1992): 30–37; Travis, *From Turkey Red*, 61; Willem J. Hornix, "From Process to Plant: Innovation in the Early Artificial Dye Industry," *BJHS* 25 (March 1992): 75.

15. "The Effect of Light Upon Upholstering Materials," *Carpet Trade Review* 5 (Oct. 1878): 110.

16. E. Noelting, *Scientific and Industrial History of Aniline Black* (William J. Matheson, 1889). Unless otherwise noted, my discussion of Caro and of the German chemical industry is based on the work of Travis and Beer as cited in the Introduction.

17. Steen, "Wartime Catalyst," 36–40, 47.

18. British Parliamentary Papers, *Minutes of Evidence Taken before the Select Committee on Copyright of Designs*, 1840, evidence of Edmund Potter, March 4, 1848, para. 1523, cited in Philip B. Sykas, *The Secret Life of Textiles: Six Pattern Book Archives in North West England* (Bolton Museums, Art Gallery and Aquarium, 2005), 54 ("imagination").

19. "Proposed Manchester Museum of Trade Patterns," *Textile Manufacturer* (March 15, 1878): 82, cited in Sykas, *Secret Life*, 11 ("minute"). The Design Museum in Gent, Belgium, has an extensive swatch book collection; the earliest of these swatch books with codifications dates from 1847. Thierry Maillet, e-mail message to author, Feb. 22, 2010.

20. Sykas, *Secret Life*, 54, 90; Fagan Attleck, *Just New From the Mills*, 29–30, 84–87 (29, Cocheco). Another subscription service was operated by the Paris merchant Bilbille, who collected fabrics at the Leipzig trade fair and from the textile mills in Mulhouse and St. Gallen, Switzerland, and sold them to clients; Maillet to author.

21. On eighteenth-century systems, see Alois Maerz, "Standard Colors and Fewer Dyes Would Benefit Textile Industry," *TW* 79 (Jan. 31, 1931): 24–26; on the naturalists, see Lowengard, *Creation of Color*, chapter 6.

22. On the 1869 BASF handbook, see Jutta Kissener, e-mail message to author, and Anthony S. Travis, e-mail message to author, both March 2, 2010; Sydney H. Higgins, *Dyeing in Germany and America with a Chapter on Colour Production* (Manchester University Press, 1906), 91–92 ("pattern-books," "artistic").

23. Charles O'Neill, *Chemistry of Calico Printing, Dyeing, and Bleaching* (Dunnill, Palmer, 1860); idem, *A Dictionary of Calico Printing and Dyeing* (Simpkin, Marshall, 1862); idem, *A Dictionary of Dyeing and Calico Printing* (Henry Carey Baird, 1869); Michel-Eugène Chevreul, *Leçons de chimie appliquée à la teinture*, 2 vols. (Pichon et Didier, 1829–1830); idem, *De la loi du contraste simultané des couleurs, et de l'assortiment des objets colorés* (Pitois-Levrault, 1839); idem, *Théorie des effets optiques qu présentent des étoffes de soie* (Typographie de Firmin Didot frères, 1846); Michel-Eugène Chevreul and René Digeon, *Des couleurs et leurs applications aux arts industriels à l'aide des cercles chromatiques* (J. B. Ballière, 1864).

24. Peter J. T. Morris, e-mail message to author, Nov. 18, 2009 ("bugbear"); Françoise Viénot, "Michel-Eugène Chevreul: From Laws and Principles to the Production of Colour Plates," *CR&A* 27 (Feb. 2002): 4; Laura Anne Kalba, Outside the Lines: The Production and Consumption of Color in Nineteenth-Century France, Ph.D. dissertation, University of Southern California, 2008; "Chevreul's Recollections," *NYT*, April 29, 1889; "Chevreul's Many Years," *NYT*, Sept. 19, 1886; "The Habits of a Centenarian," *NYT*, Oct. 31, 1886; "Michel-Eugène Chevreul: The Oldest Savant Living," *Phrenological Journal and Science of Health* 81 (Oct. 1885): 1–4; "Michel-Eugène Chevreul," *SA* 60 (April 20, 1889): 247–48; Madame de Champ, *Michel-Eugène Chevreul, vie intime, 1786–1889* (Editions Spes, 1930), RCA-CRL.

25. M. E. Chevreul, *The Principles of Harmony and Contrast of Colours, and Their Applications to the Arts* (Longman, 1854), RCA-CRL.

26. Michel-Eugène Chevreul, *The Laws of Contrast of Colour*, new edition (Routledge, 1861); Viénot, "Michel-Eugène Chevreul," 4–8; NASA Ames Research Center, Color Usage Research Lab, Simultaneous and Successive Contrast, available at http://colorusage.arc.nasa.gov.

27. *Cercles chromatiques de M.E. Chevreul, reproduits au moyen de la chromocalcographie, gravure et impression en taille-douce combinées par R.H. Digeon* (E. Thunot, 1855), YU-FBB; "A Uniform System of Colors," *SA* 27 (March 22, 1873): 176; "Michel-Eugéne Chevreul," *Daedalus* new ser. 16 (May 28, 1889): 452–57 (455, "chromatic circle"; 456, "skeins").

28. "A Uniform System of Colors" ("difficulty").

29. On Jones, see Neil Jackson, "Clarity or Camouflage? The Development of Constructional Polychromy in the 1850s and Early 1860s," *AH* 47 (2004): 203, 207; Carol A. Hrvol Flores, *Owen Jones: Design, Ornament, Architecture, and Theory in an Age of Transition* (Rizzoli, 2008). On the English translation, see "Contemporary Literature," *Westminster Review* (US edition) 63 (Jan. 1855): 157. For the US, see Paula F. Glick, "The First Appearance of Chevreul's Color Theory in America," *American Art Journal* 27 (1995–1996): 101–105; F. Crace-Calvert, "On M. Chevreul's Laws of Colour," in *Notices of the Proceedings at the Meetings of the Members of the Royal Institution of Great Britain with Abstracts of the Discourse Delivered at the Evening Meetings*, vol. 2: 1854–1858 (William Clowes, 1858), 428–32; "Colors and Contrasts," *SA* 12 (August 22, 1857): 395 ("exact").

30. On the history of European color cards, see Textile Color Card Association [hereafter cited as TCCA],"Treasurer's Report for the Fiscal Year of November 1, 1925 to October 31, 1926" [March 3, 1927], box 1, HML-CA.

31. J. B. Chambeyron fils, *Printemps 1899 ("teinturier,""teintes nouvelles")*, item 121, HML-IS.

32. For more on Jones, see Barbara Whitney Keyser, "Ornament at Idea: Indirect Imitation of Nature in the Design Reform Movement," *JDH* 11 (1998): 127–44; Katherine Ferry, "Printing the Alhambra: Owen Jones and Chromolithography," AH 46 (2003): 175–88; Sonia Ashmore, "Owen Jones and the V&A Collections," *V&A Online Journal* 1 (2008), available at http://www.vam.ac.uk; Stacey Sloboda, "The Grammar of Ornament: Cosmopolitanism and Reform in British Design," *JDH* 21 (2008): 223–36.

33. Jeffrey Karl Ochsner, *H. H. Richardson: Complete Architectural Works* (MIT Press, 1982).

34. Lauren S. Weingarden, "The Colors of Nature: Louis Sullivan's Architectural Polychromy and Nineteenth-Century Color Theory," *Winterthur Portfolio* 20 (winter 1985): 243–60 (248, Root quotations).

35. Ibid.

36. Elizabeth Lewis Reed, "Woman's World," *AHM* 62 (Sept. 1892): 863–67 (flowers and feathers); Alexandra Palmer, "Haute Couture," in *Berg Companion to Fashion*, 393–96; *Chambre Syndicale de la confection et de la couture, carte de ses nuances nouvelles, saison d'ete 1895* ("passion"), item 121, HML-IS; Margaret Hayden Rorke [hereafter cited as MHR], *Color Standardization* (TCCA, 1921), 5–6, box 20, HML-CA.

37. "New York Fashions," *HB* 27 (August 18, 1894): 655, and 29 (Feb. 1, 1896): 83 ("cards"); "The City in Brief," *LAT* (Sept. 21, 1902) (Gertrude); Miss Sydney Ford, "Facts, Features, and Fancies for Women," *LAT* (Oct. 6, 1909) ("autumn").

38. May Forney, "Fashion Gossip," *Strawbridge and Clothier's Quarterly* 3 (summer 1884): 131.

39. Hippolyte Taine, *Taine's Notes on England* (Thames & Hudson, 1957), quoted by Alison Gernsheim, *Victorian and Edwardian Fashion: A Photographic Survey* (Dover, 1963), 55; *Gazette des beaux-arts* 1 (1874): 104 ["Chaque jour, nos promenades, nos rues, nos salons, nos foyers de théâtre, sont traversés par des femmes aux parures dissonantes."]

40. Louis Harmuth, "Color in Apparel," 2 ("punch"), reprinted from *WW*, Jan. 29–31, Feb. 1–2, 1918, old box 19, HML-IS.

41. "Choice of Colors in Dress; or, How a Lady May Become Good Looking," *GLBM* 50 (April 1855): 330–33 (333, "color-sergeant"); "Becoming Colors," *GLBM* 59 (August 1859): 189–90 (189, "ill").

42. "Color—in Dress, Furniture, and Gardening," *GLBM* 65 (Oct. 1862): 367–68 (368, "Offenses"); *Dry Goods Bulletin and Textile Manufacturer* (March 6, 1886): 6, cited in Fagan Affleck, *Just New From the Mills*, 36; Harmuth, "Color in Apparel," 1 ("clash").

43. Birch Burdette Long, "The Use of Color in Architecture," *Brickbuilder* 23 (June 1914): 125–29 (125, "Victorian"); "An Eye for Color," *AtM* 100 (July 1907): 140–41 (140, "cerise").

44. "Painters, Roofers, Builders, See!" advertisement for Atlas Paint Co., Pittsburgh, in *AABN* 15 (June 7, 1884): 5; ["Examples of beauty"], *IND* 27 (April 8, 1875): 18 ("sample"); "Attractive," advertisement for Harrison Brothers, Philadelphia, in *AABN* 37 (July 23, 1892): XIII; "Use the Best!" (advertisement for J. B. Tascott & Sons), *Ohio Farmer* 57 (May 15, 1880): 305 ("ask"); "Sundry Queries Answered," *ArtA* 41 (July 1899): 48 ("actual"); "Diamond Dyes Color Everything," advertisement for Wells, Richardson & Co., *Christian Advocate* 63 (Feb. 16, 1888): 115 ("Sample Card").

45. Kenneth Fox Jr., "Manufacturers Welcome Order to Reduce 'Lines,'" *PI* 102 (Feb. 14, 1918): 17–19 (17, "Little Italy"); "An Eye for Color" (141, "magenta").

46. "The New Autumn Colors," *LHJ* 9 (Sept. 1892): 20.

47. "Perkin Memorial," *AJP* (June 1906): 300; "Jubilee of the Coal Tar Industry," *AJP* (Sept. 1906): 450–51; "The Greatest Industrial Victory Ever Won by Applied Science," 566 ("hero"); "The Coming of Sir William Henry Perkin: Scientist, Wizard, Revolutionizer of Industry," *NYT*, Sept. 30, 1906; Anthony S. Travis, "Decadence, Decline and Celebration: Raphael Meldola and the Mauve Jubilee of 1906," *History and Technology* 22 (2006): 131–52. On the slow acceptance of synthetics and their co-existence with natural dyes, see Prakash Kumar, "Plantation Science: Improving Natural Indigo in Colonial India, 1870–1913," *BJHS* 40 (Dec. 2007): 537–65; Engel, *Farben der Globalisierung*; Alexander Engel, "Colouring Markets: The Industrial Transformation of the Dyestuff Business Revisited," *Business History* 54 (February 2012): 10–29.

48. "The Great Exhibition," *NYT*, July 28, 1862 ("Angelina").

Chapter 2

1. This chapter is based on an analysis of the A. H. Munsell Color Diary, 1898–1918, HML-IS. In the mid twentieth century, Munsell devotees transcribed his handwritten diary and deposited copies in research libraries; the whereabouts of the original are unknown. The Munsell Color Science Laboratory at the Rochester Institute of Technology has made a copy of the typed transcription available at http://www.cis.rit.edu. For brevity, I have given citations only for direct quotations. MD, 1892 entry, 2 ("War Cloud"); 1898 entry, 66 ("sphere"); Alex Munsell, "Two Anniversaries," May 10, 1948, old box: Munsell Color Foundation, HML-IS. For more on Munsell's influence, see artifacts and archival materials in MASS and RISD-RBF. The Normal Art School is now the Massachusetts College of Art and Design.

2. A. E. O. Munsell, Walter T. Spry, and Blanche S. Bellamy, "Preface," in Albert H. Munsell [hereafter cited as AHM], *A Color Notation* (Munsell Color Company, 1946), 4; AHM, "A New Color System," in Eastern Art Teachers Association et al., *Proceedings of Joint Meeting Held at Cleveland, Ohio, May 8th to 11th 1907* (William T. Bawden, 1908), 56–71 (70, "gaudiest").

3. On the "middle colors," see MD, May 8, 1912, 343; April 25, 1915, 398; "Training the Color Sense," advertisement for the Munsell Color System by Favor, Ruhl & Co., in Western Arts Association, Drawing and Manual Training Association, *Twenty-First Annual Report, Proceedings of Meeting Held at Milwaukee, Wisc., May 6–9, 1914* (Milwaukee, 1914), 176. AHM, *A Color Notation* (G. H. Ellis, 1905), 54 ("anarchy"); idem, *Atlas of the Color-Solid* (Wadsworth, Howland, 1910); idem, *Color Balance Illustrated* (G. H. Ellis, 1913). Munsell revised *A Color Notation* in 1907, 1913, and 1916; the Munsell Color Company did posthumous revisions, starting in 1919.

4. "The Great Transition," *SAM* 14 (Sept. 1914): 1–6 (1, "war").

5. A. E. Ives, "Designing for Lithographers," *ArtA* 32 (Dec. 1894): 15 ("People"); "L. Prang: The Chromo-Lithograph Publisher," *Phrenological Journal and Science of Health* 50 (June 1870): n.p.; "Autobiography of Louis Prang," 1874, collection of Mrs. Louis Roewer, Auburn, Maine, typed transcription in Mary Margaret Sitting, L. Prang & Company, Fine Art Publishers, M.A. thesis, George Washington University, 1970, 123–56; Jay T. Last, *The Color Explosion: Nineteenth-Century American Lithography* (Hillcrest, 2005), 122–24.

6. Peter C. Marzio, *The Democratic Art: Chromolithography, 1840–1900* (Godine, 1979); Philip Dennis Cate and Sinclair Hamilton Hitchings, *The Color Revolution: Color Lithography in France, 1890–1900* (P. Smith, 1978); Pamela Walker Laird, *Advertising Progress: American Business and the Rise of Consumer Marketing* (Johns Hopkins University Press, 1998), 76–77; Katherine Martinez, "At Home with Mona Lisa: Consumers and Commercial Visual Culture, 1880–1920," in *Seeing High and Low: Representing Social Conflict in American Visual Culture*, ed. P. Johnston (University of California Press, 2006); Susan Tucker, Katherine Ott, and Patricia P. Buckler, eds., *The Scrapbook in American Life* (Temple University Press, 2006).

7. Louis Prang, cited by Marzio, *Democratic Art*, 99.

8. Milton Bradley Company, *Milton Bradley, a Successful Man* (J. F. Tapley, 1910); James J. Shea, *It's All in the Game* (Putnam, 1960); James J. Shea Jr., *The Milton Bradley Story* (Newcomen Society in North America, 1973); Jill Lepore, "The Meaning of Life: What Milton Bradley Started," *New Yorker* (May 21, 2007): 38–43; Advertisement for Pillsbury's Microscopic Slide Cabinet, 72, and "Microscopy: A New Case for Mailing Slides," 86, both in *SR* 2 (Feb. 15, 1884).

9. "The Great Transition," 2 ("god-father"); Milton Bradley [hereafter cited as MB], *Color in the School-Room: A Manual for Teachers* (Milton Bradley, 1890), chapter 1; J. H. Pillsbury, "A New Color Scheme," *Science* 19 (Feb. 18, 1892): 114; MB, *Elementary Color*, third edition (Milton Bradley, 1895), 60, 108–109; idem, "Spectrum Color Standards," *Science* new ser. 6 (July 16, 1897): 89–91.

10. C. Stanland Wake, "The Color Question," *Science* 19 (May 6, 1892): 264; Shea, *It's All in the Game*, 124; MB, "The Color Question Again," *Science* 19 (March 25, 1892): 175–76 (175, "avail," "chasm"; 176, "very").

11. *A Conference on Manual Training* (George B. Ellis, 1891), 86 ("learn"); Julia Ward Howe, ed., *Representative Women of New England* (New England Historical Publishing Company, 1904), 40–43; "Color Instruction in the Kindergarten," advertisement for the Prang Educational Company, *Kindergarten Magazine* 8 (Dec. 1895): 316; Louis Prang, Mary Dana Hicks, and John S. Clark, *Suggestions for a Course of Instruction in Color for Public Schools* (Prang Educational Company, 1893), iv ("course").

12. AHM, "Possible Uses of a Revolving Spherical Color-Chart," June 2, 1899, in MD, 13 ("revolving," "facts," "preserve"); AHM, "A New Classification of Color," in *Transactions of the New England Cotton Manufacturers' Association* 78 (April 26–27, 1905): 135–145 (135–36, "imagine").

13. Linda Simon, *"Life Is in the Transitions": William James, 1842–1910*, Houghton Library, Harvard University, available at http://hcl.harvard.edu; W[alter] B[radford] Cannon, "Biographical Memoir Henry Pickering Bowditch, 1840–1911," *Memoirs of the National Academy of Sciences* 17 (1924): 182–96; Dorothy Nickerson, "History of the Munsell Color System and Its Scientific Application," *JOSA* 30 (Dec. 1940): 575–85; idem, "History of the Munsell Color System," *CE* 7 (Sept.-Oct. 1969): 42–51; Rolf G. Kuehni, "The Early Development of the Munsell System," *CR&A* 27 (Feb. 2002): 20–27; Edward R. Landa and Mark D. Fairchild, "Charting Color from the Eye of the Beholder," *American Scientist* 93 (Sept.-Oct. 2005): 436–43.

14. "Amos Emerson Dolbear," *PSM* 76 (April 1910): 415–16; *The National Cyclopaedia of American Biography* (1899), s.v., "Dolbear, Amos Emerson"; Hamlin Garlin, *Forty Years of Psychic Research: A Plain Narrative of Fact* (Freeport, NY: Books for Libraries Press, 1970), 1–16; MD, Nov. 27, 1900, 41–42 ("wave-lengths").

15. MD, March 29, 1900, 14 ("successful"); Nov. 2, 1900, 39 ("unable," "*practically*"). Examples of Rood's watercolors sketches can be found in COL-ONR.

16. Joseph W. Lovibond, *Light and Color Theories and the Relation to Light and Color Standardization* (Spon & Chamberlain, 1915); U.S. Patent No. 686,827, A. H. Munsell, "Photometer," filed Feb. 6, 1901, awarded Nov. 19, 1901 ("measuring").

17. MD, April 8, 1904, 144 ("*desert*"); Dec. 6, 1905, 186 ("very much"); Dec. 7, 1905, 187 ("M.I.T."); Keuhni, "The Early Development of the Munsell Color System," 25–26 (26, "right track").

18. MD, Nov. 19, 1910, 281 ("Prof. T."); Oct. 15, 1916, 421 ("*in us*"); E. B. Titchener, "A Demonstrational Color-Pyramid," *American Journal of Psychology* 20 (Jan. 1909): 15–21; Prang, *Suggestions for a Course,* 4 ("outside").

19. Marie Frank, "Denman Waldo Ross and the Theory of Pure Design," *American Art* 22 (2008): 72–89; MD, 1889, 1–2 ("feeling," "artist," "define"); May 20, 1900, 33 ("masterpieces").

20. *Anson Kent Cross: Artist-Inventor-Teacher, Originator of Vision-Training, 1862–1944* (Cross Art School Alumni, 1950); "Anson K. Cross, Artist, Inventor, Dies in City," *St. Petersburg (Florida) Times,* June 18, 1944; AHM, "Interest of the State in the Advancement of Art," paper read before the Boston Art Club, Nov. 19, 1892, in *Fifty-Sixth Annual Report of the Board of Education* (Wright & Potter, 1893), 325–38 (329, "skill"); MD, Jan. 6, 1902, 90 ("nature"); Jan. 15, 1903, 123 ("discipline").

21. MD, Dec. 1, 1900, 42 ("talk," "schools"); *Sixty-Fourth Annual Report of the Board of Education* (Wright & Potter, 1901), 5, 435.

22. MD, June 4, 1900, 35–36 (35, "necessity"; 36, "train"); June 8, 1904, 154 ("arrange"); *WWA* (1910), s.v., "Pritchard, Myron T."; *Annual Report of the School Committee of the City of Boston* (1904), 295; *Proceedings of the School Committee of the City of Boston* (1906), 183.

23. MD, Oct. 1, 1904, 161 ("solar").

24. MD, Dec. 10, 1903, 134 ("muddles"); Jan. 18, 1905, 173 ("best thing"); March 21, 1906, 197 ("color top").

25. MD, Dec. 28, 1903, 135 ("How"); John W. Leonard, *Who's Who in New York City and State* (L. R. Hamersly, 1909), 257, 842.

26. MD, March 31, 1900, 14 ("Send"); May 2, 1900, 23 ("pet"); Sept. 22, 1904, 159 ("pre-empted"); Oct. 11, 1904, 165 ("Billy"); *Malden: Past and Present* (Malden Mirror, 1899), 86; *Trow Copartnership and Corporate Directory of the Boroughs of Manhattan and the Bronx, City of New York* (New York, 1909), 629.

27. MD, June 19, 1901, 71–72 ("view," "scientists"); Louis Leonard Tucker, *Worthington Chauncey Ford: Scholar and Adventurer* (Northeastern University Press, 2001).

28. MD, Jan. 24, 30 ("property"), 1905, 174. On Ellis, see *The Directory of Directors in the City of Boston and Vicinity* (Boston, 1911), 470; Henry Manly Goodwin, *Physical Laboratory Experiments* (George H. Ellis, 1904); Charles L. Adams, *Mechanical Drawing: Technique and Working Methods for Students* (George H. Ellis, 1905).

29. *Atlas of the Munsell Color System* [after 1915], HML-IS, ("protect"); George L. Gould, *Historical Sketch of the Paint, Oil, Varnish and Allied Trades of Boston Since 1800* (Paint and Oil Club, 1914), 49–50; advertisement for Wadsworth, Howland & Co., in *The Tech* (Boston), April 30, 1910; Wadsworth, Howland & Co., *Catalogue of Artists & Draftsmen's Supplies* (Wadsworth, Howland, 1909); *Who's Who in New England* (1916), s.v., "Howland, Charles F."

30. MD, Oct. 4, 1907, 218 ("best"); Oct. 15, 1907, 218 ("spreading," "revolutionary").

31. MD, Feb. 19, 1906, 193 ("imitation"); Feb. 21, 1906, 194 ("sharp tools").

32. Henry Turner Bailey, "The World of Color," *SAB* 10 (Oct. 1910): 107–21 (114, "Dead Sea"; 121, "celestial").

33. MD, April 13, 1907, 214 ("youngest"); May 7–13, 1907, 215 ("orange"); March 15, 1909, 252 ("buttercup").

34. MD, AHM to Bailey, [June 19, 1909], 66 ("progress"); Sept 20, 1909, 263 ("brain").

35. MD, Sept. 17, 1909, 262 ("*will not*"); May 8, 1912, 343 ("simple"); notes on "Color Balance Illustrated" [Oct. 1912], 349 ("practical").

36. John A. Cairns, "Color—The Catalyst of Commerce," *ADR* 45 (Nov. 5, 1956): 833–40 (836, *Youth's Companion*); Blaszczyk, *American Consumer Society,* Parts I and II.

37. MD, May 25, 1911, 292 ("hot"); Feb. 11, 1916, 412 ("crudity").

38. Haynes, *American Chemical Industry*, vol. 4, 183; MD, Jan. 6, 1903, 123 ("invaluable," "no," "fashionable," "measures"); Nov. 23, 1904, 170 ("swear").

39. AHM, "A New Classification of Color," 145 (Dennett).

40. MD, April 11, 1901, 11 ("fixed," "charts," "exact"); MD, April 26, 1902, 107 ("commercial," "telegraphing").

41. MD, April 26, 1911, 291 ("Mr. Filene's office").

42. MD, June 14, 1911, 293 ("*Atlas*"); June 20, 1911, 294 ("proposition").

43. A. E. Kennelly, "Samuel Wesley Stratton, 1861–1931," in National Academy of Sciences, *Biographical Memoirs* 17 (autumn 1935): 253–60; MD, April 29, 1901, 61 ("asking"); Dec. 18, 1911, 307 ("pleased").

44. MD, May 31, 1910, 274 ("Taylor," "standardization," "system"); March 29, 1911, 290 ("new book"); Henry P. Kendall, "Unsystematized, Systematized, and Scientific Management," in Dartmouth College, Amos Tuck School of Business Administration, *Addresses and Discussions at the Conference on Scientific Management held October 12, 13, 14, Nineteen Hundred and Eleve*, 1912, 112–41.

45. Arthur S. Allen [hereafter cited as ASA], "Color and Its Relation to Printing," in *Proceedings of the Thirtieth Annual Convention, Atlantic City, New Jersey, September 12, 13, and 14, 1916* ([United Typothetae and Franklin Clubs of America, 1916]), 112–20 (117, "glaring," "screams," "soft"); ASA, "The Application of the Munsell Color System to the Graphic Arts," *AB* 3 (June 1921): 158–61; Paul Nathan, *How to Make Money in the Printing Business* (Lotus Press, 1900), 318; *Who's Who in New York City and State*, third edition, s.v., "Ruxton, Philip"; E. C. Andrew, *Color and Its Application to Printing* (Inland Printer, 1911). Allen's interest in high-quality color printing is documented in his personal collection of advertising booklets, flyers, and pamphlets, COL-ASA.

46. ASA, "Color and Its Relation to Printing," 114 ("pink paper").

47. Ibid., 113 ("red 55"); Charles Matlack Price, *Poster Design: A Critical Study of the Development of the Poster in Continental Europe, England, and America*, revised edition (George W. Bricka, 1922), 170–88, 276, 284–86; "Frederic G. Cooper," in *Some Examples of the Work of American Designers* (Dill & Collins, 1920), n.p.; Thomas Commerford Martin, *Forty Years of Edison Service, 1882–1922* (New York Edison Company, 1922), 153–54 ("Edison Man"). Cooper later wrote the *Munsell Manual of Color; Defining and Explaining the Fundamental Characteristics of Color* (Munsell Color Company, 1929).

48. MD, Oct. 12, 1915, 403 ("market"); Nov. 6, 1915, 405 ("secretary"), ("travelling").

49. On the board, see "Notable Talks on Color-Photography," *Photo-Arts Magazine* 36 (Feb. 1916): 95. On Greenleaf, see George Creel, *How We Advertised America* (Harper, 1920); Albert Eugene Gallatin, *Art and the Great War* (Dutton, 1919); Art Directors Club, *Annual of Advertising Art in the United States, 1921* (Publishers Printing Company, 1922).

50. MD, Jan. 1917, 422 ("attack").

51. MD, March 27, 1917, 422 ("commercial," "filing cabinet"); May 26, 1917, 423 ("survive").

52. Nickerson, "History of the Munsell System and Its Scientific Application," 579–81.

53. MD, Feb. 15, 1912, 316–17 ("Science," "Bureau"); Dec. 23, 1912, 355–56 ("personal").

54. MD, Dec. 5, 1900, 42 ("scale").

55. Dorothy Nickerson to FB, Nov. 28, 1966, old file: Correspondence—B, HML-ISA.

Chapter 3

1. My discussion of the Textile Color Card Association in this chapter and in chapters 7 and 11 is based on a thorough study of the organization's business records in HML-CA, HML-IS, and HML-ISA. For brevity, I have given citations only for direct quotations. "Business World," *NYT,* August 12, 1914 ("famine," "shortage"); "More Expressions of Confidence,"

NYT, Jan. 20, 1915 (80 percent); John A. Heitmann and David J. Rhees, *Scaling Up: Science, Engineering, and the American Chemical Industry* (Beckman Center for the History of Chemistry, University of Pennsylvania, 1990).

2. W. D. Darling, "As It Looks to Me," *DGE* 81 (Oct. 15, 1927): 37 (percentages).

3. "Launch of the 'Made in America' Corporation," *WSJ,* Oct. 2, 1914 ("citizens"); "The Merchant's Point of View," *NYT,* August 30, 1914; "Made in America," *NYT,* Oct. 1, 1914; "'Made in U.S.A.' Movement Urged," *NYT,* Oct. 18, 1914.

4. "Wants American Styles," *NYT,* June 16, 1909 ("Empire"); Caroline Rennolds Milbank, *New York Fashion: The Evolution of an American Style* (Abrams, 1996), 59–65; Edward Bok cited by Marlis Schweitzer, "American Fashions for American Women: The Rise and Fall of Fashion Nationalism," in *Producing Fashion: Commerce, Culture, and Consumers,* ed. Regina Lee Blaszczyk (University of Pennsylvania Press, 2008), 141 ("cleverness"); Genevieve Champ Clark, "Our Women to the Rescue," *LAT,* March 21, 1915 ("label").

5. "Wondrous Impetus for All American Industries," *LAT,* August 8, 1914 ("heads"); "Madame Ise'bell," *LAT,* Oct. 4, 1914 ("esthetics").

6. Milbank, *New York Fashion,* 62; Edmonde Charles-Roux, *Chanel and Her World: Friends, Fashion, and Fame* (Vendome Press, 2005), 135; "Women Indorse U.S. Made Dress," *CDT,* Nov. 14, 1914 ("simple"); "Fashion Fête for Charity," *NYT,* Sept. 24, 1914; "Will Hold a 'Fashion Fête' Here," *NYT,* Sept. 27, 1914; "Society Asks New York Designers to Create Fashions," *NYT,* Oct. 25, 1914; "Our Own Fashions Displayed at Fête," *NYT,* Nov. 5, 1914; "Society Follows in the Wake of Fashion and Charity Affairs," *NYT,* Nov. 8, 1914; Edna Woolman Chase and Ilka Chase, *Always in Vogue* (Doubleday, 1954), 115–33; M. D. C. Crawford, "Design Campaign Not an End, But a Means to an End," *WW,* Oct. 4, 1916, cited by Lauren D. Whitley, Morris de Camp Crawford and American Textile Design, 1918–1921, M.A. thesis, Fashion Institute of Technology, 1994, 29–30 (30, "freedom").

7. Philip B. Scranton, ed., *Silk City: Studies on the Paterson Silk Industry, 1860–1940* (New Jersey Historical Society, 1985); Suzanne Benton, The American Silk Industry at War: A Study of Military and Civilian Applications of Silk During World War I, M.A. thesis, Fashion Institute of Technology, 1994; Jacqueline Field et al., *American Silk, 1830–1930: Entrepreneurs and Artifacts* (Texas Tech University Press, 2007); Vernon and Irene Castle, *Modern Dancing* (Harper, 1914), 144–54; Irene Castle, *My Husband* (Da Capo, 1979); Catherine Lynn Campbell, Social Dance: The Influence on Fashion, 1910–1914, M.A. thesis, Fashion Institute of Technology, 1997.

8. Scranton, *Silk City,* 139 (1914–19 increase); Field, *American Silk,* 154 (65 percent).

9. "Paterson's Great Industrial Show," *NYT,* Oct. 11, 1914; "Show We Don't Need Styles from Paris," *NYT,* Oct. 13, 1914 ("foreign"); "American Silks in Lucile Spring Gowns," *ASJ* (Feb. 1915): 66, cited in Field, *American Silk,* 224 ("American").

10. "'Made in U.S.A.' Movement Urged"; "To Popularize American Goods," *NYT,* Dec. 4, 1914 ("imported").

11. "Use of the Color Card," *Silk* (April 1917) ("wholly"), clipping, HML-IS-PS; "Business World," *NYT,* August 12, 1914 ("its own"); Julius Lyons, [Frankel, Frank & Company, St. Louis] to Ramsey Peugnet [hereafter cited as RP], Silk Association of America, New York, Nov. 4, 1914 ("syndicating"), and John J. Fitzgerald, Chamber of Commerce, Paterson, to RP, Nov. 25, 1914 ("break"), both in box 2, HML-CA; "Business World," *NYT,* Nov. 18, 1914 ("designing," "question"); "Business World." *NYT,* Nov. 25, 1914 ("from").

12. "Little Praise for Color Card," *NYT,* Dec. 11, 1914 ("sand," "wide"); "Proposed American Color Card," *NYT,* Dec. 12, 1914.

13. "America's Standard Color Card," *ASJ* 34 (July 1915): 37–38 ("off-shades"); *Centennial History of the City of Chicago, Its Men and Institutions* (Inter Ocean Building, 1906), 186–87 ("talent," "hundreds"); Edward F. Roberts, "Frederick Bode, Chicago Business Man, Began Career as Errand Boy," *CDT,* Oct. 18, 1908.

14. Roberts, "Frederick Bode" ("tact," "humor"); "American Color Card," *NYT*, Jan. 19, 1915 ("French," "season"); transcript of addresses from Annual Meeting [hereafter cited as AM] No. 7, March 1, 1922, 9 ("American People"), box 1, HML-CA.

15. Regina Lee Blaszczyk, "No Place Like Home: Herbert Hoover and the American Standard of Living," in Timothy Walch, ed., *Uncommon Americans*.

16. "Standard Color Card Invaluable in Many Industries and Exports," *New York Commercial*, June 5, 1920 ("riot"); "E. J. Reading Explains Value to Dressmakers," *WW*, August 31, 1917 ("conditions"); "Color Card Dependency," *CTJ* (August 1917): 27–29 (29, "doomed"), clippings, all in HML-IS-PS.

17. "Color Card Dependency," 29 ("one," "No one"); unidentified article from *Maine Farmer*, July 16, 1917 ("Never"), clippings, both in HML-IS-PS; Paul Poiret, *My First Fifty Years* (Gollancz, 1931).

18. "Association to Classify Colors," *NYH*, Feb. 21, 1915 ("gray"); Frederick Bode, Typescript of speech on the history of the Standard Color Card, 1918 [hereafter cited as FB speech], 3 (23 companies), Item 50, HML-IS; "Meeting of Dress Fabric Jobbers," *NYT*, July 21, 1915.

19. Frederick Bode, "The Standard Color Card of America Is Ready," May 21, 1915 ("experienced"), box 3, HML-CA; "William J. R. Frutchey," *NYT*, June 9, 1951.

20. "The American Color Card," *NYT*, April 25, 1915; "Standard Color Card," *NYT*, June 7, 1915 (2,000).

21. "Gov. Fielder Opens Big Silk Convention," *NYT*, Oct. 13, 1915 ("domination"); "Standard Color Card" ("75 percent"); "The Textile Color Card," *NYT*, June 2, 1915; FB speech, 3; "Fact and Commentary," *ASRJ* 52 (Feb. 1933): 17–18. The first edition of the Standard had a run of 5,000; see Transcript of AM No. 1, Nov. 23, 1915, 1, box 1, HML-CA.

22. Frederick Bode, Typescript of "The Story of the Standard Color Card" [hereafter cited as FB "Story"], 3 ("dead stock"), addendum to Board Minutes [hereafter cited as BM] No. 27, Feb. 15, 1918, box 1, HML-CA; "New Trades Join Move for Color Standardization," *WW*, Feb. 20, 1917 ("task"), HML-IS-PS.

23. FB speech, 4 ("whims"); "Color Card Dependency," 29 ("costume").

24. Transcript of addresses from AM No. 7, March 1, 1922, 6 (Bernard).

25. "Will Issue Spring Color Card," *NYT*, August 6, 1915; "The Spring Color Card," *NYT*, Sept. 17, 1915; BM No. 6, June 4, 1915, 1 ("as many"); Minutes of Meeting of the Board of Directors and Special Color Committee [hereafter cited as BSCC] [No. 7], July 14, 1915, 2 ("other side"), 3 ("consensus"), both in box 1, HML-CA.

26. Hawes quoted by Jennifer Farley and Colleen Hill, *His & Hers*, exhibition at The Museum at FIT, Nov. 30, 2010–May 10, 2011, available at http://www3.fitnyc.edu.

27. Blaszczyk, *American Consumer Society*, chapter 2.

28. BSCC [No. 7], July 14, 1915, 4 ("she," "Italian," "reverse").

29. BM No. 20 and Special Color Card Committee [hereafter cited as SCC] No. 12, Feb. 18, 1916, 1 ("pastel"), box 1, HML-CA.

30. Transcript of BM No. 24, Feb. 7, 1917, 4 ("establish"); Transcript of AM No. 3, Feb. 6, 1918, 2 ("Utopian"), both in box 1, HML-CA.

31. "Made in America," *LAT*, Oct. 31, 1915 ("patriotic," "genius"); Clark, "Our Women to the Rescue" ("glitter").

32. Peter Fearon, *War, Prosperity & Depression: The U.S. Economy, 1917–45* (University of Kansas Press, 1987), 7–15; FB speech, 5 ("economize").

33. Transcript of AM No. 1, Nov. 23, 1915, 3 (quotations on Munsell), box 1, HML-CA.

34. Edward Mott Woolley, "Secrets of Business Success: John Claflin," *World's Work* 27 (Nov. 1913): 68–74; William H. Lough, *Business Finance* (Ronald Press Company, 1917), 610–12; FB "Story," 5 ("unsalable"); Transcript of BM No. 27, Feb. 15, 1918, 1–3 (2, "head," "spread"), box 1, HML-CA; "Color Card of Value," *NYT*, May 2, 1917.

35. Transcript of BM No. 27, Feb. 15, 1918, 6 (quotations).

36. Fearon, *War, Prosperity & Depression*, 7; Jan Whitaker, *Service and Style: How the American Department Store Fashioned the Middle Class* (St. Martin's, 2006); Transcript of BM No. 26, 2 ("Fifth").

37. "Spring and Summer 1918 Colors," *ASJ* 36 (Nov. 1917): 42 (Claude Frères); Transcript of BM No. 27, 10 (230 at $25; "running," "strong").

38. "Textile Color Card Assn., Luncheon, Waldorf Astoria, Oct. 26, [1918]," box 3, HML-CA.

39. "News of the Society World," *CDT*, June 8, 1909 (Simpson); MHR, *Letters and Addresses on Woman Suffrage* (Devin-Adair, c. 1914).

40. "Cotton Converters Adopt Card," *WW*, Oct. 22, 1917 ("American idea"); Edna McBreen, "No Trouble to Match Colors If You Know Their Names," *New York Evening Sun*, Jan. 11, 1921 ("ingenuity"), clippings, both in HML-IS-PS.

41. Transcript of addresses from AM No. 7, 9; FB speech, 6–7 ("artistic," "atmosphere").

Chapter 4

1. H. Ledyard Towle [hereafter cited as HLT], "What the American 'Camouflage' Signifies," *NYT*, June 3, 1917 ("join"); "Seeing But Not Seen," *SA* 118 (May 18, 1918), 451, 464; "French Artists Remobilized," *LD* 53 (August 19, 1916): 411; "Camouflage: Art's Aid in Modern Warfare," *CO* 1 (July 1917): 50; "Camouflage Now a Regimental Essential," *NYT*, May 26, 1918; clipping of "Camouflage," *Pittsburgh Plate Products*, 1939, 9–11, scrapbook, HML-HLT; Matthew Luckiesh [hereafter cited as ML], "The Principles of Camouflage," *TIES* 14 (July 21, 1919): 234–55 (240 "hocus-pocus"). For the history of camouflage, see Hardy Blechman, *Disruptive Pattern Material. A Encyclopedia of Camouflage* (Firefly Books, 2004); Tim Newark, *Camouflage* (Thames & Hudson, 2007); Guy Hartcup, *Camouflage: The History of Concealment and Deception in War* (Pen & Sword Military, 2008); Roy R. Behrens, *Camoupedia: A Compendium of Research on Art, Architecture and Camouflage* (Bobolink Books, 2009); idem, *Camoupedia*, available at http://www.bobolinkbooks.com; John S. Major, "Camouflage Cloth," in *Berg Companion to Fashion*, 115–16 (115, "putting").

2. *Who Was Who in American Art*, s.v., "Towle, H. Ledyard"; "Ledyard Towle," *NYT*, Nov. 11, 1973; *DuMond: The Harmony of Nature: The Art and Life of Frank Vincent DuMond* (Lyme Historical Society, 1990); "Towle-Smith Wedding on June 18," *NYT*, June 14, 1912; "News and Notes of the Art World," *NYT*, Dec. 10, 1911; "Art at Home and Abroad," *NYT*, March 17, April 28, 1912; "New Rochelle Art Exhibit," *NYT*, May 17, 1914; HLT, "Summer Night, Grand Canal," painting exhibited at the Salmagundi Club, 1913, IAP 73262272, AIC; advertisement for Arlington Art Galleries, *NYT*, Jan. 24, 1915; "Exhibitions and Other Matters of Fine Art," *NYTR*, Jan. 24, 1915 ("aptitude," "appeals"); "Camouflage Now?" clipping from (Pittsburgh) *Bulletin*, [ca. 1939], scrapbook, HML-HLT.

3. Everett L. Warner, "The Science of Marine Camouflage Design," *TIES* 14 (July 21, 1919): 215–19 (217, "appear"); Roy R. Behrens, "Iowa's Contribution to Camouflage," *Iowa Heritage Magazine* (fall 1997): 98–109.

4. Roy R. Behrens, "The Theories of Abbott H. Thayer: Father of Camouflage," *Leonardo* 21 (1988): 291–96; idem, *False Colors: Art, Design and Modern Camouflage* (Bobolink Books, 2002), chapter 2.

5. "Wreck in Massachusetts," *NYT*, Sept. 7, 1898; "Whittenton Junction Wreck," *NYT*, Sept. 11, 1898.

6. For more on signal glass, see Regina Lee Blaszczyk, *Imagining Consumers: Manufacturers and Markets in Ceramics and Glass, 1865–1965*, Ph.D. dissertation University of Delaware, 1995, chapter 7 (465, "muddle"; 469, "mess"; 474, "mecca").

7. Hanna Rose Shell, "The Crucial Moment of Deception," *Cabinet* 33 (spring 2009), available at http://www.cabinetmagazine.org; idem, *Hide and Seek: Camouflage, Animal Skin and the Media of Reconnaissance*, Ph.D. dissertation, Harvard University, 2007; Edward B. Poulton and Abbott Henderson Thayer [hereafter cited as AHT], "The Meaning of the White Under Sides of Animals," *Nature* 65 (April 24, 1902): 596–97; AHT, "The Law Which Underlies

Protective Coloration," *The Auk* 13 (April 1896): 124–29; "Recent Literature," *The Auk* 27 (April 1910): 222–25. Thayer's interest in color is documented in AAA-AHT.

8. Lida Rose McCabe, "Camouflage—War's Handmaid," *AW&AD* 3 (Jan. 1918): 313–18; "Abbott Thayer, 'Father of Camouflage,'" *LD* 69 (June 18, 1921): 29; Gerald H. Thayer, *Concealing-Coloration in the Animal Kingdom* (Macmillan, 1909); "'Camouflage' in War and Nature," *AW&AD* 9 (July 1918): 174–78.

9. Benedict Crowell and Robert Forrest Wilson, *The Road to France,* vol. 2: *The Transportation of Troops and Military Supplies, 1917–1918* (Yale University Press, 1921): 492 ("on the theory"); "The 'Dazzle' System Fools the U-Boats," *IW* 30 (Oct. 1918): 283 (gray); Frank Parker Stockbridge, *Yankee Ingenuity in the War* (Harper, 1920), 317 (gray).

10. Gerome Brush and AHT, U.S. Patent No. 715, 013, filed April 17, 1902, awarded Dec. 2, 1902; Crowell and Wilson, *Road to France,* vol. 2, 495–96.

11. Maximilian Toch, *The Chemistry and Technology of Paints,* second revised edition (Van Nostrand, 1916), 118–19 (119, "Gray").

12. AHT to *NYTR,* cited in "Protective Coloration of Fleets," *LD* 53 (August 26, 1916): 458; Robert Cushman Murphy, "Marine Camouflage," *Brooklyn Museum Quarterly* 6 (Jan. 1919), 36 (*Titanic*).

13. "The Value of 'Dazzle-Painting,'" *LD* 62 (July 19, 1919): 31 ("retain"); Roy R. Behrens, "The Art of Dazzle Camouflage," *Defense Analysis* 3 (1987): 233–43; idem, "Blend and Dazzle: The Art of Camouflage," *Print* (Jan.-Feb. 1991); 92–98, 147; Claudia T. Covert, "Art at War: Dazzle Camouflage," *Art Documentation* 26 (Nov. 2, 2007): 50–56.

14. Murphy, "Marine Camouflage"; Alon Bement [hereafter cited as AB], "Tricks by Which You Can Fool the Eye," *AM* 87 (1919): 44–46, 132–36 (136, "came up"). Battleships had to be partially repainted every three to six months; see Henry A. Gardner, *Paint Researches and Their Practical Application* (Judd & Detweiler, 1917), 123.

15. "Frank D. Millet's Career," *NYT,* April 16, 1912; McCabe, "Camouflage—War's Handmaid," 317 ("What if").

16. Ibid., 317–18 (318, "Daylight"); Gallatin, *Art and the Great War,* 50; Murphy, "Marine Camouflage," 39.

17. Crowell and Wilson, *Road to France,* vol. 2, 496.

18. Ibid., 496–97.

19. "The Art of Camouflage," *AmA* 112 (Nov. 14, 1917): 360 ("nearly"); "Camouflage," *AmA* 114 (Oct. 23, 1918), 486 ("pattern").

20. AB, "Camouflage," *Teachers College Record* 18 (1917): 462; Harold Van Buskirk, "Camouflage," *TIES* 14 (July 21, 1919): 225–33.

21. "Strategic Camouflage," *AmA* 114 (August 28, 1918): 261 ("harmonized"); "The Art of Deception in War," *SA* 112 (Feb. 6, 1915): 124, 143–44 (khaki); "Tricks of the War-Trade," *LD* 51 (July 3, 1915): 33–34; "Camouflage from Gideon to Daniels," *LD* 56 (Feb. 16, 1918): 47–49; "The Tricks of the Camoufleur," *YC* 93 (July 3, 1919): 360.

22. McCabe, "Camouflage—War's Handmaid," 313–14.

23. Sherry Edmundson Fry, "An American Corps for Camouflage," *AmA* 112 (July 25, 1917): 68; Maximilian Toch, "The Fine Art of Military Camouflage," *MM* 64 (June 1918): 5–8.

24. "How the Artists Fool the Enemy," *AmA* 112 (July 18, 1917): 48.

25. J. André Smith, "Notes on Camouflage," *AR* 42 (1917): 468–77 (476, color choices); Joseph Whitney-Ganson, "Artillery Camouflage on the West Front," *NYT,* Nov. 11, 1917 ("time," "wood," "radiation").

26. Smith, "Notes on Camouflage," 477 (*systematize,* "business").

27. McCabe, "Camouflage—War's Handmaid," 314; Roy R. Behrens, "Among the Dazzle Painters: Sherry Fry and the Invention of American Camouflage," *Tractor* (fall 1996): 26–28; idem, "Iowa's Contribution to Camouflage"; "Faking as an Art in Conducting War," *NYT,* June 24, 1917; "Even the Man with the Whitewash Brush Is Needed," *LAT,* Sept. 2, 1917.

28. "Wants Camouflage Force," *NYT*, August 30, 1917; "To Teach Our Troops Arts of Camouflage," *LAT*, August 31, 1917 ("ingenious"); "Call for 'Fakers' to Fool Germans," *NYT*, Sept. 4, 1917; "Safeguarding Industry," *AmA* 112 (Sept. 12, 1917): 191; "To Organize a Company for Camouflage," *AmA* 112 (Sept. 12, 1917): 190; "Wartime Activity Rules at Columbia," *NYT*, Sept. 17, 1917 (Boring); "Angelenos to Go as Camoufleurs," *LAT*, Sept. 23, 1917; McCabe, "Camouflage—War's Handmaid."

29. H. G. Wells, cited by Smith, "Notes on Camouflage," 470 ("Mars"); C. H. Claudy, "Gun Camouflage," *SA* 119 (Dec. 7, 1918): 460, 467 ("slopped"); Smith, "Notes on Camouflage," 470 ("daubing").

30. "Company A: American Camoufleurs," *LD* 55 (Oct. 13, 1917): 32–33 (33, "artificial").

31. Army War College, *Notes on Camouflage, September 1917*, War Department Document No. 663 (Government Printing Office, 1917), 6 ("grass"); idem, *Camouflage for Troops of the Line, January 1918*, War Department Document No. 727 (Government Printing Office, 1920), 21–22 ("All"); War Department, *Camouflage*, Engineer Instruction Manual No. 3 (Government Printing Office, 1917).

32. "Camouflage Now a Regimental Essential" ("values"); "Plans Industrial Camouflage," *Greater Pittsburgh* 22 (Sept. 1941): 4–5, 24; "It's a Wise Hun Who Can Tell a 'Camoufleuse,'" *NYTR*, April 28, 1918; "Camouflage Gowns Hide Girls Amid Trees and Rocks," *NYTR*, May 8, 1918; *Opportunities for War Time Training for Women in New York City, 1918–1919* (Council of Organizations for War Service, 1918), 157; "Hide and Go-Seek-a-Hun," *Vogue* (July 1, 1918): 58, 86–88 (courtesy of Sarah Scaturro).

33. "It's a Wise Hun Who Can Tell a 'Camoufleuse,'" ("whys"); "Organizing Philadelphia Women's Camouflage Corps," (Philadelphia) *Evening Public Ledger*, April 19, 1918 ("almost," "fabrics").

34. Bessie R. James, *For God, For Country, for Home* (Putnam, 1920), 166 ("crowd," "fantastic"); "Camouflage the Recruit," *NYT*, July 12, 1918.

35. "Columbia to Install School of Camouflage," *NYTR*, May 17, 1918 ("military"); Henry Collins Brown, ed., *Valentine's Manual of Old New-York* 3, new ser. (1919): 256.

36. *Who Was Who in America, 1961–1968*, s.v. "Luckiesh, Matthew"; "The Reorganization of Nela Research Laboratories," *Bulletin of the Society for the Promotion of Engineering Education* 11 (Sept. 1920): 38; ML, "The Principles of Camouflage," 235 ("artist").

37. ML, "The Principles of Camouflage," 236 ("subjectively"), 242 ("wild," "rescue"); Stockbridge, *Yankee Ingenuity in the War*, 316–17 (316, "systematize"; 319, "combination"); ML, "Abstract—An Aspect of Light, Shade, and Color in Modern Warfare," *TIES* 13 (April 30, 1918): 216–17.

38. Behrens, *False Colors*, 51–53 (TR); Warner, "The Science of Marine Camouflage Design," 217 ("object," "misconceptions").

39. Stockbridge, *Yankee Ingenuity in the War*, 322 ("camoufleuse"); Benedict Crowell and Robert Forrest Wilson, *The Armies of Industry*, vol. II: *Our Nation's Manufacture of Munitions for a World in Arms, 1917–1918* (Yale University Press, 1921), 549–50 (standardization).

40. McCabe, "Camouflage—War's Handmaid"; "Address of Herbert B. Briggs, Secretary," *AmA* 113 (March 13, 1918): 311–12 (311, "visualize," "surfaces"); "Plans Industrial Camouflage," 4; Toch, "The Fine Art of Military Camouflage," 7 ("light effects"); Hamilton Holt, "Keeping Up with the Front," *IND* 96 (Oct. 5, 1918), 18–19, 34–35.

41. Claudy, "Gun Camouflage," 467 ("futurist," "eye," "magic"); "Distinguished Speaker," *East Liberty Post No. 5 Gazette* 18 (April 11, 1940): 1–2.

42. "How Color of Surroundings Affects Health," *AmA* 115 (June 4, 1919): 787 (quotations).

43. AB, "Tricks by Which You Can Fool the Eye," 136 ("winning"); idem, draft letter, Dec. 28, 1932, in f: General Motors Corporation, Dec. 1932, correspondence, box I:175, LC-ELB.

44. AB, "Tricks by Which You Can Fool the Eye," 44 (cottage), 45 ("shrewd").

45. Ibid., 45–46 (interiors and fashion).

46. HLT, "Color Dynamics Presentation to Architects," 1946, 1 ("DISTORTED"), box 1, HML-HLT.

Chapter 5

1. On Duco, see Arthur Lloyd Welsh, The DuPont–General Motors Case, Ph.D. dissertation, University of Illinois, 1963, chapter 5; DuPont Company, "Chariots of Content," advertisement from *SEP* (Oct. 11, 1924), box 43, HML-AD. The Duco Color Advisory Service was part of DuPont's Paint, Lacquer, and Chemicals Department, renamed the Fabrics and Finishes Department in 1929; see William M. Zintl, "History of the DuPont Paint Business," 1947, [83C], 84, HML-R&D.

2. H. C. Wendt, "The Trend in Body Styles," *Autobody* 8 (July 1925): 19–23 (20, "One"); "In the Hues of the Rainbow," *MW* 81 (Oct. 8, 1924): 33 ("early days"); Howard Ketcham [hereafter cited as HK], "Color Comes of Age," *RTM* 18 (July 1937): 441–44; HK, "Choosing Product Colors," *IF* 14 (Dec. 1937): 16–19 (16, percentages).

3. Ray Giles, "Color as a Factor in Selling," *PIM* 1 (June 1920): 39–40; Harold Parlin, "Color—Its Use as a Sales Maker," *PIM* 1 (Sept. 1920): 69–71; W. Livingston Larned, "What You Can Do with Two Colors to Improve Your Packages," *PI* 115 (April 7, 1921): 89–98; Crete M. Cochrun, "Cashing in on Color," *PI* 140 (Sept. 15, 1927): 150–54; "The Power of Color in Advertising," *AS* 38 (April 1945): 56–58, 108 (58, percentages); ML, *Light and Color in Advertising and Merchandising* (Van Nostrand, 1923).

4. O. H. Briggs, "Duco Solves the Auto Finishing Problem," *DM* 17 (April 1923): 13; Sidney D. Kirkpatrick, "The New Pyroxylin Automobile Finish," *Chemical and Metallurgical Engineering* 31 (August 5, 1924): 3–7; William A. McGarry, "Duco—The Beginning of a New Finish," *DM* 20 (Feb.-March 1926): 19–22; HK, "Fashion Factors in Automobile Colors," *DM* 37 (Sept.-Oct. 1933): 15, 17 (15, 80 percent); Robert Casey, *The Model T: A Centennial History* (Johns Hopkins University Press, 2008), 67; Trent E. Boggens, "The Customer Can Have Any Color He Wants—So Long as It's Black," *Vintage Ford* 32 (Nov.-Dec. 1997): 26–41; R. J. Hole, Greensboro, NC, to Charles F. Kettering, General Motors Research Corporation, Detroit, MI, Feb. 5, 1924, K-CFK.

5. J. Edward Schipper, "Body Engineering Session," *AI* 46 (Jan. 19, 1922): 117–20 (119, "killed"). "Why Paint Them Black?" *AI* 48 (April 26, 1923): 938 ("funeral," "cheapness").

6. "Let's Have More Cars in Color," *Motor* 40 (July 1923): 42, 84 (42, "vivid"); Clifford B. Knight, "The Women Decide," *Motor* 40 (Oct. 1923): 56, 96 (96, "biggest"); "Exterior Decoration of Motor Cars," *Autobody* 5 (June 1924): 230–32; "Employment of Color Conjunctives," *MVM* 59 (Nov. 1923): 26 ("Milady").

7. Blaszczyk, *American Consumer Society*, Part II; Richard Tedlow, *New and Improved: The Story of Mass Marketing in America* (Harvard Business School Press, 1996).

8. Casey, *The Model T*, 87–88 (88, "importance"); William L. Mitchell, Transcript of oral history, 17 ("clothes horse"), August 1984, HFM-DHC; Alfred P. Sloan Jr., *My Years with General Motors* (Doubleday, 1964).

9. David A. Hounshell and John Kenly Smith Jr., *Science and Corporate Strategy: DuPont R&D, 1902–1980* (Cambridge University Press, 1988), 141–44; "The Adorable Blues," *MVM* 58 (August 1922): 31; "'True Blue' Oaklands Entirely New," *Motor* 40 (Oct. 1923): 46–47, 96; "Duco Used on Oakland Show Cars," *AI* 50 (Feb. 7, 1924): 297; F. H. Kane, "1924 Oaklands Finished in Duco," *DM* 18 (April 1924): 6–8; L. R. Beardslee, GM, New York, to J. J. Moosman, DuPont Company, Parlin, NJ, 14 Feb. 1924, HML-R&D; "'Duco' Lacquer . . . 25th Anniversary," *DM* 43 (April 1949): 21–23; *Buick Motor Cars for Nineteen Twenty-Eight* (Buick Motor Company, 1927), 11–12, 17.

10. Herbert Chase, "Exceptional Durability Is Claimed for New Body Finish," *AI* 49 (July 26, 1923): 158–59; W. L. Carver, "Labor Costs Halved by Use of Duco in Finishing Oakland Bodies," *AI* 49 (Sept. 13, 1923): 524–26; F. H. Kane, "1924

Oaklands Finished in Duco," *DM* 18 (April 1924): 6–7; "What Duco Means to the Automobile Owner," *DM* 18 (May 1924): 3, 16; George Rice, "Why Colors of Automobile Finishes Sometimes Fail," *MVM* 64 (Jan. 1927): 58.

11. Herbert Chase, "Egyptian Lacquer Develops New Nitro Cellulose Automobile Finish," *AI* 50 (April 10, 1924): 828–29; "New Valentine Varnish System Said to Double Life of Finish," *AI* 50 (May 1, 1924): 968–69; Isolde J. Ketterer, "Motor Cars Are Going in for Brighter Hues," *Motor* 41 (June 1924): 41, 58, 72; "Egyptian Colors Introduced for Automobiles," *MVM* 59 (Feb. 1924): 34; Ditzler Color Company, "The Sales Appeal of Color to the Fore," advertisement in *AI* 51 (Sept. 4, 1924): 1.

12. "Out of the Kitchen Into the Parlor," *Motor* 46 (Sept. 1926): 34–35, 172–84 ("selected"); DuPont Company, "Every Automobile Show is a DUCO Exposition!" advertisement in *Motor* 43 (Jan. 1925): 293; Herbert Chase, "Finishing and Refinishing Approaching High Engineering Standard," *AI* 50 (May 22, 1924): 1134–37; J. J. Riley, "Recommendations for Refinishing with Pyroxylin," *MVM* 61 (Oct. 1925): 44, 46, 65.

13. F. B. Davis to Fin Sparre, color letter, Jan. 8, 1925 ("practical"), box 62, HML-OP.

14. "Activities in the Motor Trade," *NYT*, Oct. 4, 1925 ("latest"); *Who Was Who in American Art*, s.v. "Towle, H. Ledyard"; HLT to Philip R. Goodwin, three 1919 letters, in box 1, Ms. 28: Philip R. Goodwin Collection, BBHC; "Towle Joins General Motors," *MVM* 64 (July 1928): 52; Smithsonian Institution, *Report on the Progress and Condition of the United States National Museum for the Year Ending June 30, 1919* (Government Printing Office, 1920), 64; "H. Ledyard Towle with Frank Seaman," *PI* 121 (Oct. 5, 1922): 114; "H. Ledyard Towle . . . Will Speak on Color," announcement for lecture to the Pittsburgh Advertising Club on Jan. 21, 1941, HML-HLT.

15. HLT, *Second Annual Report, Division of Creative Design and Color, 1936–1937* [Pittsburgh Plate Glass Company, 1937], 4 ("color engineer"), HML-HLT.

16. George P. Smith, "The Duco Color Advisory Service," *DM* 20 (May 1926): 4–5, 18–19 (5, "Choosing," "face"); DuPont Company, "Duco Color Advisory Service," advertisement in *Autobody* 8 (Nov. 1925): 205 ("average," "experts," "certainty").

17. HLT, "Paris Ablaze with Color! Motor Cars Express Individuality," *Providence Tribune*, Nov. 21, 1926 ("mad," "rainbow"); "Duco Colors Are Revealed," *News* (Cleveland), [Oct.? 1926]; HLT, "Duco Expert Sees Colors of Paris in Bright Array," *New Orleans Times-Picayune*, Nov. 21, 1926, clippings all in HML-HLT; "Color and Sales," *AI* 54 (Feb. 4, 1926): 195; "Color as a Sales Appeal," *AI* 54 (May 13, 1926): 825.

18. HLT, "Color Trends in Paris," *ASJ* 47 (Feb. 1928): 49; [HLT, "The Motor Car Show at Olympia Is Filled with Color"], Oct. 26, 1926 (quotations); "Duco Colors Are Revealed," HML-HLT; "Paris Gowns for Motor Cars," *DM* 21 (Feb. 1927): 1; "Bright Colors Now Mark Foreign Autos," *NYT*, Oct. 17 1927; HLT, "Color Effects at the Olympia Show," *Autobody* 11 (Nov. 1927): 156.

19. "Show Reveals Many Interesting New Trends in Body Design," *AI* 54 (Jan. 14, 1926): 43–49; "Body Colors at the Show," *AI* 54 (Jan. 14, 1926): 57; "Color Dominated the Show," *ATJ* 30 (Feb. 1, 1926): 23–40; "Review of the Automobile Show in New York," *Autobody* 9 (Feb. 1926): 47–53 (51–52, colors); "As Others Saw Us," *Motor* 45 (Jan.-Feb. 1926): 19 ("plumage"); HLT, "As Many as Six Hues Found in One Machine," *Brooklyn Standard Union*, Jan. 23, 1927 ("harmonies," "mass-production man"), and idem, "Motor Industry Answering Demand of Public for Color," *Gazette-Times* (Pittsburgh), March 6, 1927, clippings in HML-HLT; "Finds Auto Show Blaze of Beauty," *NYT*, Jan. 14, 1927 ("high water").

20. "Getting Good Body Design," *AI* 52 (March 26, 1925): 590–91 (591, "barber"); "Pastel Shades and Graceful Lines Add Charm to New Body Models," *AI* 52 (Jan. 8, 1925): 48–52; HLT, "Automobile Color Schemes," *AI* 54 (Feb. 4, 1926): 183.

21. Smith, "The Duco Color Advisory Service," 18–19 (18, "lengthened"); HLT, "As Many as Six Hues Found in One Machine" ("stripes"); "Color Appeal," *Autobody* 12 (Sept. 1927): 89.

22. "Color and Sales" ("arrived"); Irénée du Pont, Wilmington, DE, to Harry Bassett, Flint, MI, August 17, 1926, box 33, HML-ID; "Towle Joins General Motors"; Morris Midkiff, "$25,000 in Exhibits Placed on Display as Architects Meet," *Austin Statesman*, Sept. 26, 1940 ("first"), clipping, HML-HLT. GM used the British spelling "colour," perhaps to add prestige.

23. Minutes of the General Technical Committee, General Motors Proving Ground, June 8, 1927 ("beauty," "Art"), K-CFK; HLT, "Projecting the Automobile into the Future," *SAE Journal* 29 (July 1931): 33–39, 44; idem, "Art and Color in Body Design," presentation before the Society of Automotive Engineers, Detroit Section, Feb. 3, 1941, 12–14, and idem, "Color Dynamics Presentation to Architects" [1940s], 2 ["reverse"], both in HML-HLT.

24. David Gartman, *Auto Opium: A Social History of American Automobile Design* (Routledge, 1994), 77–81 (79, "Chevrolet"); Sally H. Clarke, "Managing Design: The Art and Colour Section at General Motors, 1927–1941," *JDH* 12 (1999); 65–79; idem, *Trust and Power: Consumers, the Modern Corporation, and the Making of the United States Automobile Market* (Cambridge University Press, 2007), chapter 5. On Earl, see "Harley Earl Has Concluded Tests," *LAT*, June 11, 1922; "Doll Up Cars for Company," *LAT* April 16, 1922; U.S. Design Patent 76,728, Awarded to E. W. Seaholm and Harley J. Earl, filed Nov. 15, 1926, awarded Sept. 25, 1928; "Harley J. Earl Dies; Car Design Pioneer," *Detroit News*, April 10, 1969, available at http://www.carofthecentury.com.

25. Harley Earl, transcript of interview with Stanley Brams, Detroit, Jan. 1954, 3–4 (4, "remarkable"), available at http://www.carofthecentury.com.

26. John C. Wood and Michael C. Wood, ed., *Alfred P. Sloan: Critical Evaluations in Business and Management* (Routledge, 2003); Minutes of the General Technical Committee ("scientific").

27. HLT, "Projecting the Automobile into the Future," 35–36 ("blue").

28. [HLT, Art and Colour Section, GM], *Forecast with Colour News and Notes*, June 1929, 4 and appendix (percentages); [idem], *Forecast with Colour News and Notes*, May 1929 and Nov. 1929, all in K-CFK.

29. HLT, "As Many as Six Hues Found in One Machine" ("brains," "leading"); "Reflections of the National Show," *Autobody* 11 (Feb. 1927): 48; "Body Design, Building and Finish," *SAEJ* 20 (Feb. 1927): 169–73; "Color Expert Explains How to Get Harmonious Combinations," *AI* 56 (Feb. 5, 1927): 152–53 (152, "accidents"); *Forecast with Colour News and Notes*, May 1929, 4 ("risky").

30. "More Colors Coming," *ATP* 10 (Sept. 1931): 29 ("ketchup"); Edith M. White, "Hints and Suggestions on Automobile-Body Design," *Autobody* 13 (Jan. 1928): 20–22 (21, "coats," "camouflage"); idem, "The Idealized Automobile of Tomorrow," *Autobody* 13 (April 1928): 134–35; HK, "Fashion Factors in Automobile Colors," 15, 17; "Somber Colors," *MBPT* 66 (Sept. 1930): 11; HK, "The Automobile Develops COLOR," *ATP* 15 (Feb. 1936): 18–24; Harold F. Blanchard, "Now Comes the Artist-Engineer," *Motor* 47 (June 1927): 42–43, 98–104; "New-Model Advances Reviewed," *SEAJ* 28 (March 1931): 295, 393; M. C. Hillick, "Colors, Decorative Effects and Finishing in 1930," *MVM* 65 (Jan. 1930): 32–33, 56.

31. HLT to Charles F. Kettering, June 19, 1929 ("vale of tears"), K-CFK; "Motors and Motor Men," *NYT*, Dec. 14, 1930 (to CE); HLT to G. D. Crain Jr., Advertising Publications, Chicago, 5 Dec. 1952, HML-HLT; Nan Hornbeck, "Color Treatment of Automobiles," *Autobody* (Jan. 1928): 22–25; idem, "Sex in Automobile Colors," *Autobody* 14 (August 1928): 59–60.

32. Earle A. Meyer, "If Out of Tune with Color of Car Then Beware of Pestering Jinx," *New York Motor News* (May 1928), (18, "Watch"), clipping, f: Dodge Brothers, box I:155, LC-ELB; "Howard Ketcham, Authority on Color Use to Corporations," *NYT*, May 7, 1982; "Industrial Color Expert Opens New York Office," *IF* 11 (Feb. 1935): 49–50; Geoffrey T. Hellman, "An Emolument for Heliotrope," *New Yorker* 28 (March 8, 1952): 39–53.

33. Matt Denning, "Know the Trends of Style in Merchandise," *DM* 22 (Nov. 1928): 1–2. On Duco Brush, see Zintl, "History of the DuPont Paint Business," 84–87.

34. Paul Thomas, "The Secrets of Fashion and Art Appeal in the Automobile," *SAEJ* 23 (Dec. 1928): 595–601; idem, "Educating Dealers to Buy and Sell on Forecasted Trends," *PIM* 16 (Jan. 1928): 60; Mr. Price, Duco Color Advisory Service, to W. A. Hart, Advertising Director, Oct. 20, 1928; Matt Denning, Asst. Advertising Director, to Lammot du Pont, Oct. 24, 1928, both in box 3, HML-OP.

35. J. Harry DuBois, *Plastics History U.S.A.* (Cahners, 1972), chapter 5.

36. J. Brent to Mr. Geddes, "Case History—Emerson Radio," June 3, 1941 (quotations), box 25, f: 414, Emerson Radio, UT-NBG.

37. "New Duco Colors Developed," *MVM* 64 (Dec. 1928): 60 (quotations); Duco Information Service, "Bulletin," Oct. 17, 1928, box 3, HML-OP.

38. "Automobile Color Index," *Autobody* 16 (July 1929): 12–13; "Colors in the Automobile Industry," *ADRN* 9 (Feb. 1931): 14–15; HK, "Fashion Factors in Automobile Colors," *DM* 37 (Sept.-Oct. 1933): 15, 17; James Spearing, "At the Wheel," *NYT*, 16 June 1929; P. H. Chase, "Color at the Paris and London Shows," *Autobody* 14 (November 1928): 170–71; "Blue Now Leads Automobile Colors," *MBPT* 66 (June 1930): 40.

39. HK, "Calibrated Colors I," *IF* 9 (Nov. 1932): 26–30 (26, "80 variations"); idem, "Calibrated Colors II," *IF* 10 (Dec. 1932): 34–36.

40. HK, "Selection of Colors I," *IF* 9 (Jan. 1933): 14–16, 18; idem, "Selection of Colors II," *IF* 9 (Feb. 1933): 24, 26–27; idem, "Color Schemes for Autos," *IF* 9 (June 1933): 12–15 (12, "light maroon"); HK, "The Automobile Develops COLOR."

41. HK, "Choosing Product Colors," *IF* 14 (Dec. 1937): 16–19 (19, quotations).

42. "Practical Use of Color Harmony," *MBPT* 67 (Oct. 1931): 22 ("Mr.").

43. Alfred T. Marks, "Trade Reports from Washington," *ARC* 18 (Nov. 1939): 22.

44. HK, "Fashion Factors in Automobile Sales," 17.

45. Press release, "Automotive Industry America's Foremost Teacher of Art Appreciation Say Authorities," Jan. 6, 1933 ("beauty"), in f: General Motors Corporation, Dec. 1932, Correspondence, box I:175, LC-ELB; "Fashion Trends in Automobile Colors Change and GM Styling Staff Must Study Them," *WSJ*, Nov. 12, 1938.

Chapter 6

1. Cherington quoted in Blaszczyk, *American Consumer Society*, 116.

2. Adolph Judah Snow, *The Book of Happiness: Predicated upon the Scientific Selection of Colors for Interior and Exterior Decoration* (John Lucas, 1922); Ethel Carpenter, "Creating Color Schemes," *LHJ* 39 (April 1922): 99–102; International Correspondence Schools, *Show-card and Color Schemes* (International Textbook Company, 1923).

3. MHR, "Color as Silk Salesman," *ASJ* 42 (Jan. 1923): 157–158, 165; "Women in the Silk Industry," *ASJ* 45 (Oct. 1926): 45–46; "Women in the Textile Industry," *ASJ* 49 (March 1930): 37 ("judgment"); "Women in the Silk Industry," *ASJ* 50 (Feb. 1931): 58 ("original"); "Business: Corporations," *Time*, Oct. 8, 1934.

4. Hazel H. Adler [hereafter cited as HHA], New York, to Elizabeth V. Maguire, Philadelphia, Oct. 22, 1921 ("If"), box 5, HSP-MHG; HHA, *The New Interior: Modern Decorations for the Modern Home* (Century, 1916); "Making the Home Beautiful," advertisement for R. H. Macy & Co., *NYT*, Oct. 11, 1919; HHA, *Planning the Color Schemes for Your Home* (George W. Blabon, 1923) ("colorless"), HML-TC; idem, "Color! Color! Who Knows Color?" *GH* 77 (Oct. 1923): 40, 254; idem, "The Color Families: How to Know and Use Them," *GH* 77 (Nov. 1923): 36, 100.

5. Genevieve A. Callahan, "Bringing Color to Your Kitchen," *BHG* (June 1925): 26, 52 (26, quotations).

6. "Personality and Color Enter the Kitchen," *DGE* 81 (Oct. 8, 1927): 32; "Kaufmann's Finds Eager Response to Color in the Kitchen," *DGE* 81 (Oct. 22, 1927): 13 ("garb"), 43; "'Color in the Kitchen' Is the Latest Note in Good Housefurnishings," *CGJ* 105 (Dec. 15, 1929): 144–45; "The Movement for Colored Kitchen Utensils Is Spreading," *PGBS* 36 (Oct. 6, 1927): 15;

"More and More Colored Wares," *PGBS* 36 (Nov. 24, 1927): 33; "Colored Kitchen Wares," *PGBS* 36 (Dec. 15, 1927): 167; "Colored Kitchen Wares," *PGBS* 30 (Dec. 13, 1928): 147; Ernest Elmo Calkins, "Beauty, the New Business Tool," *AtM* 140 (August 1927): 145–56; Kenneth Collins, Vice-President, R. H. Macy & Company, Lecture to The Fashion Group, New York, [Jan. 1931], 3 ("goose"), box 72, NYPL-FGI.

7. "Color Appears on the Kitchen Stove," *PI* 142 (Jan. 12, 1928): 10–12 (12, "ranges," "fight").

8. William C. Agee, "Rediscovery: Henry Fitch Taylor," *Art in America* 54 (Nov.-Dec. 1966): 40–43; *Who Was Who in American Art*, s.v., "Taylor, Henry Fitch"; Christine I. Oaklander, *Cos Cob's Surprising Modernist: Henry Fitch Taylor, an Exhibition at Bush-Holley Historic Site* (Greenwich Historical Society, 2005); idem, "Arthur B. Davies, William Fraetas, and 'Color Law,'" *American Art* 18 (2004): 10–31; Will South, *Color, Myth, and Music: Stanton MacDonald-Wright and Synchromism* (North Carolina Museum of Art, 2001); Wanda M. Corn, *The Great American Thing: Modern Art and National Identity, 1915–1935* (University of California Press, 1999).

9. "Books and Other Publications," *Printing Art* 39 (May 1922): 275; Henry Fitch Taylor, Means for Determining Color Combinations, U.S. Patent 1,308,512, filed May 19, 1917, issued July 1, 1919; HHA, Means for Determining Color Combinations, U.S. Patent 1,564,743, filed June 30, 1921, issued Dec. 8, 1925; "The Taylor System of Color Harmony," *CTJ* 12 (Feb. 1923): 55–58 (55, "It," "elastic"); "Color Insurance for Manufacturers," *TW* 61 (June 24, 1922): 23; "Color Insurance by Chart," *LD* 76 (Jan. 6, 1923): 26–27; HHA to Maguire, ($15); Mabel Brooks, "Taylor System of Color Harmony, No. 7 East 39th Street, New York City, The Color Chart," offprint from *Arts and Decoration* (July 1921), box 5, HSP-MHG.

10. "Gray Auto Plates Anger Traffic Men," *NYT*, Feb. 17, 1924 ("artistic"); HHA, "The Right Colors for License Plates," *Motor* 41 (April 1924): 37, 72 (37, "alarming").

11. "Color Insurance by Chart," 27 ("hit-or-miss"); HHA, "Capitalizing on Color," *ADR* 14 (Dec. 14, 1925): 819–20 (819,"keyboard").

12. "Ford Model 'A' Cars Have Steel Bodies," *Autobody* 12 (Dec. 1927): 202; HHA, "Capitalizing on Color"; idem, "Color Problems and Sales Stimulation," *AGJ* 19 (March 1931): 58–59; idem, "Color by Trial and Jury," *PE* 3 (July 1932): 289–91 (290, "thrust," "New York"). On Kohler Color Ware, see Blaszczyk, *Imagining Consumers*, chapter 5.

13. Corn, *Great American Thing*, 7 ("most authentic").

14. Barbara Buhler Lynes, *O'Keeffe, Stieglitz and the Critics, 1916–1929* (University of Chicago Press, 1991); idem, "Georgia O'Keeffe and Feminism: A Problem of Position," in *The Expanding Discourse: Feminism and Art History*, ed. Norma Broude and Mary D. Garrard (HarperCollins, 1992).

15. Alfred Stieglitz, "Women in Art," 1919, cited by Corn, *Great American Thing*, 241 ("Womb"); Georgia O'Keeffe, "To *MSS*. and Its 33 Subscribers and Others Who Read and Don't Subscribe," letter to the editor, *MSS*. 4 (Dec. 1922): 17–18 ("significant"), and Helen Appleton Read, "Georgia O'Keeffe—Woman Artist Whose Art Is Sincerely Feminine," *Brooklyn Sunday Eagle Magazine* (April 6, 1924): 4, both in Lynes, *O'Keeffe, Stieglitz and the Critics, 1916–1929*, appendix A.

16. Read, "Georgia O'Keeffe—Woman Artist Whose Art Is Sincerely Feminine" ("apples"); "Exhibitions in New York: Georgia O'Keeffe, Intimate Gallery," *The Art News* 24 (Feb. 13, 1926): 7–8 ("pure," "tones"); Helen Appleton Read, "Georgia O'Keefe [*sic*]," *Brooklyn Daily Eagle*, Feb. 21, 1926; Henry McBride, "New Gallery for Modern Art," *New York Sun*, Feb. 13, 1926, all cited in Lynes, *O'Keeffe, Stieglitz and the Critics, 1916–1929*, appendix A.

17. Henry McBride, "Modern Art," *Dial* 80 (May 1926): 436–37 ("screams"), in Lynes, *O'Keeffe, Stieglitz and the Critics, 1916–1929*, appendix A.

18. Hornbeck, "Industry Courts the Rainbow" ("Color, of course"); "Styling Fabrics for American Fashions," *ASJ* 34 (Sept. 1915): 38–40; "The Mallinson Campaign to Popularize American Made Styles," *ASJ* 34 (Oct. 1915): 39; "New Art in Autumn Silks," *ASJ* (July 1916): 32; "Another Fashion Success," *ASJ* 38 (May 1919): 77; "Women in the Silk Industry," *ASJ*

50 (Feb. 1931): 58; Lola McKnight, The Americana Prints: A Collection of Artist-Designed Textiles, M.A. thesis, Fashion Institute of Technology, 1993.

19. On Cheney, see Michele Boardman, *All That Jazz: Printed Fashion Silks of the '20s and '30s* (Allentown Art Museum, 1998); Field et al., *American Silk.*

20. Grace W. Ripley, "The Use of Color in Selling," *TW* 70 (Oct. 9, 1926): 96, 163 ("Rayon"); Pauline Beery Mack et al., *Resume of an Eight-Year Series of Consumer Studies on Silk and Rayon*, Pennsylvania State College Home Economics Research Series, no. 3 (Pennsylvania State College, 1939), 79. Cellulose fibers were marketed at "artificial silk" until retailers invented the name "rayon"; see Ramsay Peugnet, "Rayon Takes Its Seat Among the Elect," *PI* 131 (May 28, 1925): 25–28; "How Rayon Got Its Name," *AmF* 84 (fall 1969): 78.

21. H. S. Gelbtrunk, "The Manufacturer's Duty to the Retailer," *ASJ* 50 (March 1931): 48, 58–60. On department stores, see Whitaker, *Service and Style*; Jan Whitaker, *The World of Department Stores* (Vendome, 2011).

22. "New Association Leads Industry's War on Design Piracy," *TW* 80 (Oct. 17, 1931): 36–37; "Fashion Data: Clearing House Established by Silk Association," *TW* 83 (Jan. 1933): 56; Hélène Volka, "New Fabric Styles," *TW* 83 (Feb. 28, 1933): 71–74 (72, registry); "The Vanishing Pirate," *TW* 86 (Dec. 1936): 89; Bernice Jamieson and Grace Ripley, "Creative Art in Textile Design," *ADR* 26 (Jan. 25, 1937): 36–38 (37, registry).

23. On Henry Creange [hereafter cited as HC], see "Art in the Silk Industry," *ASJ* 44 (March 1925): 47–48; HC, "Art in American Industry," *ASJ* 43 (March 1924): 59–60; "Creange Now to Center on Style and Art," *WW*, August, 25, 1925, and "Creange Tells of Broad Plan for New Work," *WW*, [August 27, 1927], clippings, box 155, HHPL-C; HC to Harold Phelps Stokes, Jan. 16, 1925, box 172, HHPL-C; "Henry Creange, 68, Industrial Adviser," *NYT*, August 15, 1945; Carol Dean Krute, "Cheney Brothers: The New York Connection," in *Creating Textiles: Makers, Methods, Markets* (Textile Society of America, 1998), 120–28

24. "Bares 'Science' of Propaganda," *Boston Herald*, Jan. 10, 1926 ("mind"), clipping, box 49, HHPL-C.

25. Edward L. Bernays [hereafter cited as ELB], "Cheney Brothers," typescript, box I:457, LC-ELB; *Chronique et Croquis de la Mode Nouvelle*, [1923], and *Croquis de la Mode Nouvelle en Cheney Silks*, 1923, 1930, all in box 7, series I, CT-CB; Carol Dean Krute, *Cheney Textiles: A Century of Silk*, gallery guide, Wadsworth Atheneum, Hartford, ca. 2000.

26. "New Art Period Expressed in American Silks," *ASJ* 43 (Oct. 1924): 58; advertisements for Cheney Silks, box I:133, LC-ELB; *Vogue* 65 (March 1, 1925): 17; 66 (April 11, 1925): 16; *Vogue* 66 (August 15, 1925): 87; *Vogue* 66 (Oct. 15, 1925): 118; *Vogue* 67 (June 1, 1926): 124; *Vogue* 68 (August 15, 1926): 100; *Vogue* 68 (Oct. 15, 1926): 1; *Vogue* 69 (April 15, 1927): 15; *HB* 61 (Oct. 1926): 140.

27. Advertisement for Cheney Silks, 1925, box I:133, LC-ELB.

28. ELB, *Biography of an Idea: Memoirs of a Public Relations Counsel* (Simon and Schuster, 1965), chapter 21; Herbert Hoover to Charles Richards, Feb. 14, 1925, box I:22, LC-ELB; U.S. Department of Commerce, *International Exposition of Modern Decorative Art and Industrial Art in Paris, 1925* (Government Printing Office, 1925).

29. "International Scope, Plan for Art Center," *WW*, August 7, 1925 ("entente"), and "Creange's New Work Held Development of Idea of International Art Center," *WW*, August 25, 1925, clippings, box 155, HHPL-C; HC, "Quantity or Mass Production as It Is Affected by Art and Style Changes," transcript of address to the New England Council of the New England Conference, Breton Woods, NH, Sept. 25, 1926, 1–28 (18, "Art Direction"; 16, "not regulate"), box I:149, LC-ELB.

30. HC, "Quantity or Mass Production," 9 ("Just").

31. HC, "Quantity or Mass Production"; idem, *The 3-Phase System for the Mass Production of Style Goods*, 1926, box 11, series I, CT-CB; idem, "Quantity Production in Art Industries," *TW* 120 (Sept. 4, 1926): 65–67; Edward Alden Jewell, "Design Becomes the Soul of Industry," *NYT*, July 8, 1928 ("three-phase," "mills busy").

32. "The Cheney Color Index and What Color Means to Business," *TW* 72 (Sept. 17, 1927): 1539–40 (1539, "Color," "relative," "public").

33. HC, "Quantity or Mass Production," 9–10 ("demand").

34. "What the Newspapers Said About the Recent Exhibition of Cheney Silks for Spring, 1925" ("prevailing," "copper-red"), box I:133; Cheney Style Service, "Red Popular," 1925, Scrapbook: Cheney Brothers, box I:537, both in LC-ELB; "Ina Bourskaya as Carmen," *NYT*, Dec. 5, 1924; Olin Downes, "Opera: Edward Johnson Sings Don Jose," *NYT*, Feb. 7, 1925; "Now 'Carmen's' 50 Years Again Makes Paris Gay," *NYT*, March 15, 1925; "Fleta Sings in Madrid," *NYT*, March 4, 1925; "Jean Gordon as Carmen," *NYT*, April 4, 1925.

35. ELB to A. Lincoln Filene, March 21, 1927; Minutes, Weekly Advertising and Sales Promotion Meeting, March 19, 26 ("psychological," "original," "vogue"), 1926, all in box I:134; *The Color Mode for Fall 1926, Forecast by Cheney Brothers*; *The Cheney Style Service Chart for Fall and Winter 1926*, both in box I:133, all in LC-ELB.

36. "Color Dominates Cheney Fall Line," *ASJ* 45 (June 1926): 48 ("To obtain"); Advertisements for Cheney Silks, *Vogue* 68 (August 15, 1926): 100 ("vogue"); (Oct. 15, 1926): 1; (Nov. 15, 1926): 44; (Dec. 15, 1926): 119; Daniel Marchesseau, *Marie Laurencin: Catalogue Raisonné de l'Oeuvre Peint* (Musée Marie Laurencin, 1986), 159; Charlotte Gere, *Marie Laurencin* (Rizzoli, 1977); Douglas K. S. Hyland and Heather McPherson, *Marie Laurencin: Artist and Muse* (Birmingham Museum of Art, 1989).

37. Minutes, Weekly Sales Promotion and Publication Meeting, April 24, 1926 ("Duco people"), box I:34, LC-ELB.

38. Ward Cheney, "Creating Styles in Fabrics," typescript of address to the New England Council of the New England Conference, Bretton Woods, New Hampshire, Sept. 25, 1926, 29–35 (32, "creation"), box I:149, LC-ELB.

39. ELB, *Biography of an Idea*, chapter 21; idem, "Cheney Brothers," 33–39; idem, "Georgia O'Keeffe and Alfred Stieglitz," typescript, second draft, 2 ("erotic," "symbols"), box I:459: LC-ELB.

40. ELB, "Cheney Brothers," 35–37; idem, "Georgia O'Keeffe and Alfred Stieglitz," 3.

41. ELB, "Cheney Brothers," 37; Minutes, Weekly Advertising and Publicity Meetings, box I:134, LC-ELB; "Color Dominates Cheney Fall Line"; "Art Happenings Seen in the New York Galleries," *NYT*, Jan. 9, 1927 ("symphonies"). On the posters and the paintings, see Barbara Buhler Lynes, *Georgia O'Keeffe: Catalogue Raisonné* (Yale University Press, 1999), I: 266–267; II: 1104–5.

42. Paul Thomas, Cheney Brothers, to "Advertising Manager"; "Introducing the New Color"; "Color Makes Its Debut!"; "The Smart Woman Chooses the Right Colors"; "Color Takes Its Place in the Sun," all 1926, box I:133, LC-ELB; ELB, "Cheney Brothers," 38-39 (quotations).

43. ELB, "Georgia O'Keeffe and Alfred Stieglitz," 5 ("forged").

44. Walter G. Baumhogger, "Tuning in on Consumer Demand," *ASJ* 48 (June 1929): 35–36, 50 (50, "Everything").

45. Daphne Carr, "What Is Wrong with American Silk Styling?" *ASJ* 44 (June 1925): 47–48 (47, "accent").

46. On the Green Ball, see the American Tobacco Company client files, LC-ELB.

47. Dorothy Dignam to Mr. Jordan, Memorandum on "Marshall Field and Company Silk Division," Oct. 12, 1933, box 1: Misc. Reports, Notes, SHSW-DD.

48. N. R., "And Now, Colored Rayons!" *TC* 58 (July 1936): 451–52; Boardman, *All That Jazz*; "Fashion Group Considers: Tell Women What They Are Buying," *ASRJ* 56 (April 1937): 12–15; "Rayon Featured in Technicolor Film," *ASRJ* 57 (Sept. 1937): 14.

Chapter 7

1. On sportswear and the ensemble, see "Sporty Apparel for Spring and Southern Resort Wear," advertisement for Stewart & Co., *NYT*, Jan. 15, 1922.

2. Edward S. Johnson, President's Address, AM No. 12, March 3, 1927, box 1; MHR, Managing Director's Report [hereafter cited at MHR Report], AM No. 12, March 3, 1927, [4] ("harmony"), box 2; MHR Report, AM No. 15, April 17, 1930, 7 ("progress"), box 1, all in HML-CA.

3. Hugh E. Agnew, "When There Is Service as Well as Goods to Sell," *PI* 114 (Jan. 20, 1921): 47–52 (50, "emerald"); Transcript of AM No. 6, Feb. 16, 1921, 18 ("old fashioned," "gospel"), and Transcript of AM No. 7, March 1, 1922, 12 ("gospel"), both in box 1, HML-CA.

4. Transcript of AM No. 6, Feb. 16, 1921, 6–7, 23–24 (24, "Oh, well"); "Favor Broader Representation in Color Choosing," *WW*, May 5, 1920; "Fall Waist Colors to Be Bright," *NYT*, May 10, 1922; "Announce Fall Waist Colors," *NYT*, May 19, 1923; "Adhering to Standards," *NYT*, May 20, 1923; "Garment Men Join Hands," *NYT*, Oct. 7, 1923 ("harmony"); "Spring Colors for Waists and Skirts," *NYT*, Oct. 28, 1923.

5. Minutes of the Special Color Committee and Committee of Shoe & Leather Industries, No. 1, June 22, 1920 ("dyed"), box 2, HML-CA.

6. Minutes of the Committee of Shoe & Leather Industries, No. 2, Jan. 4, 1921, 1 ("allied"); John C. McKeon quoted in J. D. Smith to MHR, August 5, 1925 ("concise"), both in box 2, HML-CA; "Here's Good Spring Color Dope for Buyers," *DGE* 79 (Nov. 7, 1925): 65; "Chart for Color Harmony," *NYT*, Feb. 19, 1927; "Color Correlation Chart," *ADR* 19 (Feb. 17, 1930): 135

7. Regina Lee Blaszczyk, "No Place Like Home: Herbert Hoover and the American Standard of Living," in Walch, ed., *Uncommon Americans*.

8. Federated American Engineering Societies, *Waste in Industry* (McGraw-Hill, 1921).

9. On "standardization," see Herbert Hoover, "Progress in Elimination of Waste," in *Commerce Reports* (Nov. 1926), f: 03390, HHPL-C.

10. On "simplification," see ibid.; Edward Eyre Hunt, "Elimination of Waste Program," March 18, 1925 ("self control"), f: 03389, HHPL-C; Henry D. Hubbard, "Quality of Textiles and Manufacturing Methods Standardized on Basis of Federal Research," *ADR* 19 (March 17, 1930): 179–80.

11. Hunt, "Elimination of Waste Program" ("standards of living"); "Stalking Waste in the Mill," *ADR* 14 (Jan. 24, 1927): 69–70; Edwin W. Ely, "Does the Color Wave Defeat the Aims of Simplified Practice?" *PI* 144 (July 26, 1928): 33–34; Edwin W. Ely, "Colors in Commerce," *ADR* 17 (Sept. 3, 1928): 572; "Standardization," *ADR* 20 (July 20, 1931): 467; "More Easter Bonnets," *Monthly News Bulletin* 6 (Nov. 15, 1925), in f: 03389, HHPL-C.

12. MHR Report, AM No. 14, April 11, 1929, [6] ("movement"), box 2, HML-CA.

13. U.S. Congress, H. R. 8350, 68th Cong., 1st session, 66 ("color standards"), box 6, HML-CA; "Color in Industry," *LD* 95 (Nov. 5, 1927): 71–73 (71, "teeth"; 72, "mahogany").

14. MHR to R. H. [*sic*] Hudson, Dec. 11, 1923 ("As"), box 6, HML-CA.

15. MHR, Memorandum on visit to the Quartermaster Depot on March 20, 1922 ("quartermaster"), box 6, HML-CA.

16. Typescript of MHR Report, AM No. 21, April 23, 1936, 4 ("observer"), box 1; Typescript of MHR Report, May 9, 1940, 4 ("Red"), box 2, HML-CA.

17. F. L. Maytag, "Maytag Tells How Advertising Help Build $50,000,000 Annual Retail Sales," *PI* 142 (March 8, 1928): 3–6, 169–76; "Maytag Adopts Trade-In Policy on Used Washers," *PI* 138 (Feb. 10, 1927): 66–68.

18. Data sheets on production of Maytag washers, MCA.

19. John C. Pemberton, "Color Can Be Legally Protected Against Imitation," *PI* 158 (Feb. 4, 1932): 52–54 (54, "Mere"); "The Weakness of Color as a Trade-Mark," *PI* 147 (May 23, 1929): 49–52; *Maytag Co. v. Meadows Mfg. Co.*, 35 Fed. 2d, 403, decided by the Circuit Court of Appeals, Seventh Circuit, Oct. 29, 1929 ("Udylite," "gray"), available at http://scholar.google.com.

20. Data sheets, MCA.

21. Ibid.

22. "Ensemble Selling," *PI* 137 (Dec. 2, 1926): 178–79 ("ensemble idea"); Cheney Brothers, *Silk News for the Selling Staff*, no. 2 (Oct. 1925): 4 ("old ensemble," "daring"), box I:133, LC-ELB. For the early *tout ensemble* see, for example, "Dress," *National Advocate* (New York), March 5, 1823; "Tales of the Wedding, No. IV," *New-York Spectator*, July 18, 1828.

23. Bettina Bedwell [hereafter cited as BB], "Stepping Out for the Paris Olympics," *CDT*, May 25, 1924; "Stylish Dress for Summer Play," *NYT*, June 1, 1924 ("ideal"); "New Tunic Blouse Becomes Established and Paris Designers Send Many Models," *NYT*, August 17, 1924 ("slogan"); "Trend to More Rigid Lines," *NYT*, April 26, 1925.

24. Minutes of the Hosiery Committee [hereafter cited as HoC], No. 1, Sept. 24, 1924, 1 ("creating style"); HoC No. 2, Oct. 2, 1924, 1 ("radio"), both in box 2; Transcript of the Shoe and Leather Conference, Oct. 9, 1924, 11–12 ("great"), box 1, all in HML-CA.

25. "'*L'Art Moderne*' Marks the Beginning of a New Movement in Fabric Design," *DGE* 79 (Oct. 10, 1925): 46.

26. Paul Hyde Bonner, "Organizing for Style and Design," *ASJ* 47 (Dec. 1928): 45–46, 74, 82 (74, "take," "staples").

27. TCCA, Special meeting of the Board and Color Committee, Dec. 18, 1923, 1 ("races," "hands"), box 1, HML-CA.

28. BM No. 50, June 5, 1924, 3 ("representative"); BM No. 56, April 30, 1925, 1 ("advising"), both in box 1, HML-CA.

29. Adeline B. Cardinet, application for U.S. passport, May 6, 1918, roll 0520, and Estelle Marguerite Tennis, application for U.S. passport, March 31, 1919, roll 0764, U.S. Passport Applications, 1795–1925; "Estelle M. Tennis" (1890–1985), California Death Index, 1940–1997; "Tennis, Estelle M.," U.S. Population Census for Alameda, CA (1880), e.d. 30, sheet. 3?; "Cardinet, Adeline" and "Tennis, Estelle," U.S. Population Census for Sacramento, CA (1900), e.d., 90, sheet 8; "Tennis, Estelle M.," U.S. Population Census for Sacramento (1910), e.d. 109, sheet 8, all available on ancestrylibrary.com.

30. A. Cardinet & Co. to MHR, August 18, 1926, item 20 ("The person"), HML-IS.

31. Adolphe S. Ortenberg to MHR, March 19, 1927 ("dictator"), box 35, HML-CA; Edna Hughes Roberts to Edward S. Johnson, Jan. 18, 1927 ("violet"), item 20, HML-IS.

32. BM No. 61, June 24, 1926, ("more efficient"), box 1, HML-CA; Estelle Tennis [hereafter cited as ET] to MHR, July 15, 1927 ("concise"), item 20, HML-IS.

33. ET to MHR, July 30 ("dissertation"), August 5, 1927 ("*vendeuse*"), item 20, HML-IS.

34. ET to MHR, August 5, 1927 ("Patou's"), item 20, HML-IS; Caroline Evans, "Jean Patou's American Mannequins: Early Fashion Shows and Modernism," *Modernism/Modernity* 15 (April 2008): 243–63.

35. Transcript of AM No. 22, April 22, 1937, 24–25 (25, "using"), box 1, HML-CA. See, for example, *Broadcast*, Feb. 20, 1926, item 34, HML-IS.

36. "Solving the Colour Problem in Matched Spring Accessories," *TFR* (Jan. 27, 1938): 1A-3A (1A, "coloured"), FIT-SC. Typescript of MHR Report, AM No. 15, April 17, 1930, 4 ("heterogeneous"), box 2, HML-CA.

37. "Tobé Coller Davis Dies in New York," *St. Petersburg Times*, Dec. 27, 1962.

38. "Abraham Rattner, Colorist Painter, Printmaker, and Tapestry Designer," *NYT*, Feb. 15, 1978; Allen Leepa, compl., *Abraham Rattner* (Abrams, 1974); Abraham Rattner, *Abraham Rattner: The Tampa Museum of Art Collection* (Tampa Museum of Art, 1997); Robert Henkes, *The Spiritual Art of Abraham Rattner: In Search of Oneness* (University Press of America, 1998); BM No. 146, Nov. 12, 1946, n.p. ("entrée"), box 1, HML-CA.

39. BB to MHR, April 15, 1936 ("hope," "coats"), June 13, 1936, both in item 24, HML-IS; Dilys Blum, *Shocking! The Art and Fashion of Elsa Schiaparelli* (Philadelphia Museum of Art, 2003), 79.

40. BB to MHR, May 14, 1929 (Vert), item 24, HML-IS.

41. BB to MHR, Jan. 22, 1936 (all quotations), item 24, HML-IS.

42. BB to MHR, Jan. 22, 1936 ("she"); March 30, 1936 ("Bright"); April 1, 1936 ("tulle," "shops"), all in item 24, HML-IS; Rene Hubert, "Psychology of Gloria's Talent for Smart Frocks Is Simplicity," *LAT*, May 31, 1925 ("fashionable"); "Opening of Paris Season Brings Out New Styles," *NYT*, Oct. 26, 1930; Lydia Kamitsis and Bruno Remaury, eds., *Dictionnaire internationale de la mode* (Éditions du Regard, 2004), 27.

43. BB to MHR, April 24, 1936 ("I wish"), item 24, HML-IS. Schiaparelli may have intended the 1936 colored stockings for her large customer base in the American market; Dilys Blum, conversation with author, Dec. 21, 2010. The Philadelphia Museum of Art has two 1930 pairs of silk stockings in raspberry and lime, stamped "Powder Tints" and labeled "Fabrimode Costume Hosiery Sponsored by Schiaparelli Paris," acc. 1967.61.1a.b.

44. LS to MHR, April 21, 1936 ("world"), item 22, HML-IS; "Colour Fashions in Stockings for Spring 1938," in *TFR* (Jan. 6; 1938): 1A-6A, FIT-SC.

45. LS to MHR, Dec. 2, 1935 ("Peacock"); Oct. 16, 1936 ("names," "Rochas"); Jan. 28, 1937 ("Director"); Feb. 2, 1937 ("imagine"); "By Wireless from Paris," *NYT*, Jan. 10, 1937, clipping, all in item 22, HML-IS; Virginia Pope, "Spectator Sports Togs That Will Look Well While Looking On," *NYT*, Jan. 10, 1937; "Three European Women Arriving This Week," *NYT*, Jan. 10, 1937; "Reception Honors Niece of Rossetti," *NYT*, Feb. 14, 1937.

46. LS to MHR, Feb. 19, 1937 ("advanced"), April 29, 1937 ("her pink"), both in item 22, HML-IS; Blum, *Shocking!* 114–15, 297; "American Ideas Rule Spring Style, Experts Back from Paris Report," *NYT*, Feb. 18, 1937.

47. LS to MHR, Feb. 8, 1935 ("by memory"), item 18; Jan. 15, 1937 ("made on paper," "such or such"), Feb. 4, 1937 ("by memory"), both in item 22, all in HML-IS.

48. Typescript of MHR Report, AM No. 25, May 9, 1940, 2 ("Mauve," "pebble"), box 2, HML-CA; MHR to Stewart Culin ("to promote"), Feb. 5, 1925, General Correspondence 1.4 [082], BM-SC.

49. Typescript of MHR Report, AM No. 25, 5–6, 8–10; Typescript of MHR Report, AM No. 24, April 20, 1939, 4, both in box 2, HML-CA.

50. Typescript of MHR Report, AM No. 25, 2 ("modern"; "sound").

51. MHR Reports, AM No. 11, [Feb. 26, 1926], 8 (Manchester), and AM No. 14, April 5, 1928, [4] ("imitation"), both in box 2, CA-HML; "Molded Plastics Are Featured at the Exhibition on Color," *PMP* 7 (Feb. 1931): 83–84; Dorothy Nickerson, "Fifty Years of the Inter-Society Color Council. I. Formation and Early Years," *JCRA* 7 (spring 1982): 5–11. The history of the ISCC is documented in HML-IS, HML-ISA, and CU-FLD, and that of the British Colour Council in UB-DCA.

52. Typescripts of MHR Reports, AM No. 19, April 19, 1934, 5, box 1; AM No. 23, April 28, 1938, 6 ("scooped"); AM No. 24, April 20, 1939, 3–4, both in box 2, all in HML-CA. On Ketcham see "Flash! Overnight—You Can Have Paris Colours on Your Doorstep!" *TFR* (Jan. 27, 1938): 22 ("cabling"); "Paris Sponsors Yellow—So Should You!" *TFR* (Feb. 17, 1938): EE; "The New Paris Colors," *TFR* (Feb. 17, 1938): 1D-2D; "The Colorcode Paris Colours from the Mid-Season Openings," *TFR* (May 12, 1938): 1D-2D, all in FIT-SC. For more examples, see Colorcode Corporation, *Colorcoded* (August, 1938); "Tobé's Paris Cables Translated into Today's Fashion Headlines!" *TFR* (August 11, 1938): E; "Mustard Tones—The Season's Smartest Colour Story," *TFR* (Sept. 22, 1938): 1–2, both in FIT-SC.

53. M. D. C. Crawford, Fairchild Publications, New York, to Stewart Culin, Brooklyn Museum, Brooklyn, Nov. 10, 1924 ("Mrs. Rorke"), General Correspondence 1.4 [075], BM-SC.

54. AM No. 22, transcript, April 22, 1937, 16–23 (20, "different"), box 1, HML-CA.

55. "Color and What to Do About It," *MPAC* 11 (July 1938): 32–35, 94; "Lord and Taylor's New Fashion Floor Is the Talk of the Town," *TFR* (Sept. 8, 1938): 13–15 (13, "last word," "elevator," "Startling," "promenade," "No. 1"; 15, "pink"), FIT-SC.

56. AM No. 22, transcript, April 22, 1937, 8–19 ("create a demand"), 30–31 ("stop").

Chapter 8

1. "Exposition's New Concept of Lighting Is Significant," *BW* (May 31, 1933): 13 ("5,000," "first").

2. "The Pan-American Exposition at Buffalo in 1901," 2 ("heavy"), transcript from *New International Encyclopedia*, NYWF-1939; Imogene C. Strickler, diary (available at http://members.fortunecity.com), May 8, 1901 ("It").

3. Susan Tunick, *Terra-Cotta Skyline: New York's Architectural Ornament* (Princeton Architectural Press, 1997); ML, *Light and Shade and Their Applications* (Van Nostrand, 1916), 166–68 ("The tower").

4. Mrs. M. L. M. Carter, "First Exposition at San Francisco," *Colman's Rural World* 67 (August 13, 1914): 10 ("Rome," "oriental"); "Nature and Science: Lighting an Exhibition," *YC* 87 (March 6, 1913): 122–23 (123, "bay"); "The European War and the Panama-Pacific Exposition—A Monumental Contrast," *CO* 58 (May 1915): 315–20 (320, "flaming").

5. Collins, "A New Salesman Named Color," 61 ("theater"). On color-light instruments, see Kenneth Peacock, "Instruments to Perform Color Music: Two Centuries of Technological Experimentation," *Leonardo* 21 (1988): 397–406; Maarten Franssen, "The Ocular Harpsichord of Louis-Bertrand Castel," *Tractix* 3 (1991): 15–77. On Rimington, see clippings, box 1, HSP-MHG; Sarah A. Tooley, "The Romance of Colour-Music," 1912, 269, photostat, box 31, HSP-MHG.

6. Charles W. Person, "Seeing Music in Colors," *IW* 24 (Sept. 1915): 44–45 (45, "entire"), clipping, box 1, HSP-MHG; "Color Music: Scriabin's Attempt to Compose a Rainbow Symphony," *CO* 58 (May 1915): 322–23 (322, "It").

7. On Wilfred and Greenewalt, see Manager, Lighting Services Dept., Westinghouse Electric and Manufacturing Co., to Warren Ripple, George Cutler Works, South Bend, IN, March 6, 1922, box 1352, HML-LM. On Wilfred, see Peacock, "Instruments Perform Color," 404–5 (405, "eye," "Arabian"); misc. clippings and offprints, box 26, HSP-MHG.

8. "New 'Color Organ' to Interpret Music," *NYT*, Nov. 12, 1922 ("Sunlight"); "Columbia Artist Applies 'Color to Music,'" *Music Trades* (May 28, 1921) ("C"), clipping, box 30; Mary Hallock Greenewalt [hereafter cited as MHG], "The Pulse Origin of Rhythm," typescript of lecture at The Carlisle, Oct. 16, 1903; idem, "Ornamentation and Repose," typescript, n.d.; Handwritten announcement of the "Light and Music" phonograph, n.d., both in box 24, HPS-MHG.

9. MHG, *Nourathar: The Fine Art of Light Color Playing* (Westbrook Publishing, 1946), 350a ("distinguished"); Charles P. Steinmetz, Schenectady, New York, to MHG, Sept. 19, 1919 ("I"), box 24, HSP-MHG.

10. Russell P. Brewer, "The Story of the Design, Installation and Operation of the Electrical Apparatus of the Open Air Theater at Longwood," 1927, box 1352, HSP-MHG; "Orchestra of Color in P. S. Du Pont Home," (Philadelphia) *North American*, Oct. 29, 1922, and "Color with Music, Latest," *(Wilmington) Evening Journal*, Jan. 27, 1926, clippings, box 1352, HML-LM. MHG had a close relationship with Pierre S. du Pont by virtue of her sister's marriage into his family; her son Crawford worked as a chemical engineer at the DuPont Company and would eventually become its president.

11. "Contributing Facts in the Process of Infringement by the Fox Theater, 16th & Chestnut Sts., Philadelphia, Taken between 2-30 and 5-30 P.M., February 18, 1928" ("auditorium"), box 3, HSP-MHG.

12. "Color and Music in Infringement Suit in Federal Court," *Delmarvia Star*, Oct. 18, 1929 ("show," "emotional"); "Patent Suit Decided in Favor of Stanley Co.," *Wall Street News*, April 1, 1930, clippings, both in box 30, HSP-MHG. Michael Betancourt analyzes some of MHG's legal claims in "Mary Hallock-Greenewalt's Abstract Films," *Millennium Film Journal* 45/46 (fall 2006): 52–60.

13. "Genius Recognized," (Philadelphia) *Evening Bulletin*, April 1, 1930 (quotations), clipping; Reprint of editorial from (Philadelphia) *Evening Bulletin*, Jan. 16, 1932, both in box 30, HSP-MHG.

14. H. W. Steinhoff, "An Electrical Theater," offprint from *Electrical World*, 1929, box 26; *Mobile Color Lighting, Bulletin 74* (Ward Leonard Electric Co., Sept. 1928), box 26; A. I. Powell, *The Coordination of Light and Music* (General Electric Company, August 1930), box 25. all in HSP-MHG; Alistair Duncan, *American Art Deco* (Abrams, 1986), 206; O. W. Wentz, "The St. George Goes Modern," *DM* 24 (August 1930): 14–15, 22 (22, "inviting").

15. "Color Treatment in City Buildings," *NYT*, Jan. 30, 1927 ("Colored"). On Solon, see Regina Lee Blaszczyk, "'This Extraordinary Demand for Color': Léon Victor Solon and Architectural Polychromy, 1909–1939," *Flash Point* 6 (July-Sept. 1993): 1, 10–16; Duncan, *American Art Deco*, 25, 27; Riley Doty, Transcript of interview with David Solon and Marie Martin, Santa Barbara, CA, Nov. 30, 1991, 4 ("Prince Polychromy"), copy in author's possession.

16. H. Van Buren Magonigle, "A Potter and His Work," *AR* 45 (April 1919): 303–10; Grant Muter, "Minton Secessionist Ware," *Connoisseur* (August 1980): 256–63; idem, "Léon Solon and John Wadsworth: Joint Designers of Minton's Secessionist Ware," *Journal of the Decorative Arts Society, 1850–the Present* 9 (1985): 41–49.

17. Léon Victor Solon [hereafter cited as LVS], "Architectural Polychrome Decoration," *AR* 42 (Nov. 1917): 452–57 (454, "planning").

18. LVS, "A Method for Color Description," *AR* 53 (Sept. 1922): 164–68 (168, "inadequacy").

19. "We Are Learning to Appreciate Color: From the Field of Art in the October *Scribner*," *AmA* 112 (Oct. 31, 1917): 326–27 (quotations).

20. [LVS], *Tile Design* (American Encaustic Tiling Company, ca. 1917), n.p. Schneider Collection, OHS; LVS, "The Display Rooms of a Tile Manufactory," *AR* 52 (Nov. 1922): 362–70; "Fall Meeting Proves Big Success," *Ceramic Industry* 1 (Oct. 1923): 235; "The Role of Ceramics in Decoration," *NYT*, August 12, 1928; "Tile Showroom Is One of New York's Show Places," *Tiles and Tile Work* 1 (Oct. 1928): 16–19; LVS, "Color in the Tile Industry," *Keramic Tile Journal* 2 (June 1930): 35–37.

21. LVS, "The Philadelphia Museum of Art, Fairmount Park, Philadelphia," *AR* 60 (August 1926): 96–111 (105, "Many"); "Use of Terra Cotta in the Philadelphia Museum of Art," *Ceramic Age* (May 1927): 139–41; Edward H. Putnam, "Architectural Polychromy," *Art and Archeology* 24 (July 1927): 15–20 (18, "structural," "decorative"); John Gregory, "Collaboration of Artists Promises New Beauty in Cities," *American City* 38 (March 1928): 114–15; Anne Lee, "Color Sculpture and Architecture: Philadelphia Revives the Ancient Art of Greek Polychrome," *Mentor* 16 (May 1928): 41–44; idem, "Contemporary American Murals," *AF* 54 (April 1931): 478–82; "Creating Colossi in Terra Cotta," *AmA* 143 (July 1933): 63–66; "Color Treatment in City Buildings," *NYT*, Jan. 30, 1927.

22. "Predict New York as City of Color," *NYT*, Feb. 20, 1927 (all quotations).

23. Lee, "Contemporary American Murals," 481 ("reaction").

24. H. R. Cole, Wilmington, DE, to MHR, April 28, 1928 ("Up," "Today," "For instance"); Dec. 7, 1928 ("clientele"), box 7, HML-CA.

25. LVS, *Revised Views on Faience* ([Zanesville, OH]: Mosaic Tile Company, 1930), ("We"), Schneider Collection, OHS; idem, "Color in the Tile Industry," 36 ("assumed").

26. Alvin Johnson, "Chapter XXIX, The New School Building," typescript, 1952 (8, "Urban"), f: 32.4, COL-JU. On Joseph Urban [hereafter cited as JU], see Randolph Carter and Robert Cole, *Joseph Urban: Architecture, Theater, Opera, Film* (Abbeville, 1992); C. D. Innes, *Designing Modern America: Broadway to Main Street* (Yale University Press, 2005); John Loring, *Joseph Urban: The Urbane Architect* (Abrams, 2010).

27. I am grateful to Edward Tenner for the reference to Schönbrunn Palace, see http://www.schoenbrunn.at. Otto Teegen, "Joseph Urban's Philosophy of Color," *Architecture* (May 1934): 257 ("Alexandria"); Deems Taylor, "The Scenic Art of Joseph Urban," *Architecture* 59 (May 1934): 275–90.

28. Johnson, "Chapter XXIX, The New School Building," 5–6 (quotations); idem, *Pioneer's Progress: An Autobiography* (Viking, 1952).

29. Peter R. Rutkoff and William B. Scott, *New School: A History of The New School for Social Research* (Free Press, 1986), chapter 3; Shepard Vogelgesang, "The New School for Social Research," *AR* 67 (April 1930): 305–309; idem, "The New School for Social Research," *AR* 69 (Feb. 1931): 138–50 (143, "proper"); Alvin Johnson, "A Building for Adult Education,"

T-Square Club Journal 1 (Oct. 1931): 16–19; Otto Teegen, "Joseph Urban," *Architecture* 59 (May 1934): 250–56; JU, "Color Diagram for Circular Room in Basement," PNSD-KA.

30. JU to Lenox R. Lohr [hereafter cited as LRL], Nov. 26, 1932 ("polychrome festival"), f: 71, box 6, series XV, UIC-CP; Eugene H. Klaber, "World's Fair Architecture," *MoA* 26 (June 1933): 293–98 (294, "Color"). For background, see LRL, *Fair Management: The Story of a Century of Progress Exposition* (Cuneo, 1952); John E. Findling, *Chicago's Great World's Fairs* (Manchester University Press, 1994); Lisa D. Schrenk, *Building a Century of Progress: The Architecture of Chicago's 1933–34 World's Fair* (University of Minnesota Press, 2007); Cheryl R. Ganz, *The 1933 Chicago World's Fair: A Century of Progress* (University of Illinois Press, 2008).

31. *Painting with Light* (Pittsburgh: Westinghouse Electric and Manufacturing Co., 1929), 3 ("wave"), box 26, HSP-MHG; Daniel H. Burnham Jr. [hereafter cited as DHB], diary, Sept. 23–24, 1929 ("far"), box 5, RBAI-BB, cited in Findling, *Chicago's Great World's Fairs*, 87.

32. "Report of D. H. Burnham on the Paris International Colonial Exposition," 1931, 26 ("Electric"), f: DP 3, RBAI-BB.

33. Fernand Léger and [Le Corbusier], "Déductions consécutives troublantes," from "L'Architecture au Salon d'automne," *L'Esprit Nouveau* 19 (1923), n.p., quoted in Jan de Heer, *The Architectonic Colour: Polychromy in the Purist Architecture of Le Corbusier* (011 Publishers, 2009), 213 ("Polychromy," "Dutch").

34. DHB to JU, Oct. 13, 1931 ("consultant"), and other documents in f: 1–14991, box 466, series I, UIC-CP; [Memorandum on the history of the Design Section, n.d.], UIC-CP (courtesy of Lisa Schrenk); Otto Teegen, "Painting the Exposition Buildings," *AR* 73 (May 1933): 366–69.

35. United Shoe Machinery Company materials, f: 5, box 28, COL-JU; JU to DHB, June 18, 1932, f: 1–14991, box 466, series I, UIC-CP; William Jordy, "The Reminiscences of William Muschenheim," Oral History Research Office, Columbia University, August 1987, 1–32 ("left it"), box 1, UM-WAM; Otto Teegen, "Color Comes to the Fair," *WFW* (May 6, 1933), 19–20; W. D'Arcy Ryan [hereafter cited as WDAR], "Lighting 'A Century of Progress,'" *TAIEE* 53 (May 1934): 731–36.

36. William Muschenheim [hereafter cited as WM], "The Color of the Exposition," *AF* 59 (July 1933): 2–4 (3, "strongest"); "A Story of Light and Color," *WFW* (Sept. 23, 1933): 5–7 (7, "pageant").

37. For the Vogelgesang and Teegen quotations, see Press Release, "Urban," July 10, 1933, [2], f: 1–14990, box 466, series I, UIC-CP; for the "happy" quotation, see "Exterior Color on the 1933 Exposition," May 1, 1933, UIC-CP (courtesy of Lisa Schrenk).

38. Otto Teegen, "Painting the Exposition Buildings," *AR* 73 (May 1933): 366–68; Charles E. Fawkes, "Synthetic Coatings at the Century of Progress," *Plastic Products* 9 (August 1933): 222–27. On the paints, see American Asphalt Paint Company, *Color and Protection*, 1933, box FF3.7, RBAI-BB-CP; Contract between American Asphalt Paint Company and A Century of Progress, Feb. 1, 1933, and "Summary of the Application of Paint," n.d., both in f: 70, box 6, series XV, UIC-CP; Louis Skidmore, "Planning the Exposition Displays," *AR* 73 (May 1933): 345–46; Shepard Vogelgesang, "Color Treatment of Exhibit Space," *AR* 73 (May 1933): 370–74; idem, "Color Inside of the Buildings of a Century of Progress," June 23, 1933, f: 72, box 6, series XV, UIC-CP; DHB to Albert Kahn, May 17, 1932, UIC-CP (courtesy of Lisa Schrenk).

39. Firestone Tire and Rubber Company, *How Firestone Gum-Dipped Tires Are Made; The Firestone Factory and Exhibition Building, A Century of Progress, Chicago, 1933; The Florida Tropical Home at A Century of Progress, 1933* (Kuhne Galleries, 1933); *The Italian Pavilion, A Century of Progress, 1933* (Cuneo, 1933), all in HML-TC.

40. WM, "The Color of the Exposition," 2 (quotations).

41. Ibid., 3; "A Story of Light and Color," 6.

42. H. W. Magee, "Building with Light," *PM* 58 (July 1932): 8–14 (9, "paramount"); John Winthrop Hammond, "A Tribute to Walter D'Arcy Ryan," *GER* 37 (April 1934): 160; "Merchandising and Lighting Topics at the N.E.LA. Convention," *EM* 21 (June 1919): 302–14 (313, "Detroit!"); Otto Teegen to JU, Dec. 8, 1932 ("Mr. Ryan"), f: 1–14991, box 466, series I, UIC-CP.

43. WDAR, "Lighting an Exposition," *EW* 101 (May 27, 1933): 687–88, 697–98 (687, "blending"); Charles J. Stahl, "The Rainbow of Light that Came to the Fair," *Commerce* 30 (Jan. 1934): 53–63; WDAR, "Illumination of a Century of Progress Exposition, Chicago, 1933," *GER* 37 (May 1934): 227–38.

44. "Paul P. Cret (Symposium on the Chicago '33 Fair)," 1933, 2 ("I saw"), f: 627, UP-PPC; Douglas Haskell, "Architecture: 1933: Looking Forward at Chicago," *The Nation* 138 (Jan. 24, 1934): 109–10 ("eye rack"); Eugene H. Klaber, "World's Fair Architecture," *MoA* 26 (June 1933): 293–98 (294, "future").

45. "Exposition's New Concept of Lighting Is Significant," *BW* (May 31, 1933): 13 ("strikingly"); "Color and a Century of Progress," *Inland Printer* 93 (May 1934): 61–64; Fawkes, "Synthetic Coatings at the Century of Progress," 227 ("Thousands").

46. "Business and 'The Fair,'" *BW* (May 31, 1933): 11–14.

47. MHG, "Century of Progress Exposition—Values Brought into Being" and "Music of Science and Industry" ("tribute," "wholesale"), typescripts, n.d., box 19, HSP-MHG; MHG, *Nourathar*, 66 ("painting"); misc. docs., box 1532, HML-LM.

48. "In Mr. Whalen's Image," *Time* (May 1, 1939); "Report of the Committee on Theme of the Fair to the Board of Design," July 16, 1936, 1; "Light and Color in the World of Tomorrow," Typescript of *NYT* article approved by Grover Aloysius Whalen [hereafter cited as GAW], [Sept. 30, 1938], 4-5 ("cocktails"), both in NYPL-1939.

49. "Light and Color in the World of Tomorrow," 1 ("Tawny"); "Minutes of Meeting of the Fashion Council," New York, June 16, 1937 ("Neon"), NYPL-1939; Allen Brown, *Golden Gate: Biography of a Bridge* (Doubleday, 1965); Richard Reinhardt, *Treasure Island: San Francisco's Exposition Years* (Scrimshaw, 1973); John Bernard McGloin, "Symphonies in Steel: Bay Bridge and the Golden Gate," available at http://www.stmuseum.org.

50. U.S. District Court, Eastern District of New York, *Howard Ketcham vs. New York World's Fair, Inc.*, Plaintiff's Amended Complaint, 1 ("A World's"); U.S. District Court, Eastern District of New York, *Howard Ketcham vs. New York World's Fair 1939 Incorporated*, July 11, 1940, Opinion of D. J. Moskowitz, 7 ("experienced"), both in NYWF-1939.

51. Julian E. Garnsey [hereafter cited as JEG], employment application, 1936; C. L. Lee to JEG, Jan. 12, 1936; JEG to GAW, July 9, 1936 ("There"); Ernest Peixotto to C. L. Lee, Oct. 11, 1936; Gilmore D. Clarke to Mr. Lee, Jan. 10 [1937]; Gilmore D. Clarke to Stephen F. Voorhees [hereafter cited as SFV] et al., Jan. 12, 1937; SFV-JEG letters; "Color," Dec. 23, 1938; NYWF Board of Design, Minutes of Meeting No. 42, Jan. 29, 1937, 2, all in NYWF-1939.

52. JEG, "The Color Scheme of the New York World's Fair 1939, Inc.," n.d.; J. L. Hautman to SFV, Sept. 29, 1937; SFV to [GAW], Dec. 6, 1938; JEG to J. L. Hautman, March 10, 1938; JEG to SFV, April 20, 1937, and SFV to JEG, March 24, 1937 (flag), all in NYWF-1939.

53. JEG to [SFV], Oct. 12, 1938 ("We") and Jan. 10, 1939, both in NYWF-1939.

54. JEG, "The Color Scheme of the New York World's Fair 1939," 4 (quotations).

55. HK to Arthur Freeman, Oct. 11, 1938; HK to Marcia Connor [hereafter cited as MC], Oct. 29, 1938; A. C. Leyton Newsom to HK, Nov. 25, 1938; C. W. Merritt, "Howard Ketcham v. Fair Corporation," Sept. 13, 1939, NYWF-1939.

56. Opinion of D. J. Moskowitz, 5 ("esthetic"); "Artist's Suit Dismissed," *NYT*, July 12, 1940.

57. ML, *Color and Colors* (Van Nostrand, 1938), 3 ("Mental"), 22 ("taupe"), 151 ("drabness," "garish").

58. Eugene Clute, "Color in Stone," *Architecture* 69 (March 1934): 143–46; [LVS], undated memo, in Rockefeller Center Archive Center, cited by Christine Roussel, *The Art of Rockefeller Center* (Norton, 2006), 91, 302 (quotation).

Chapter 9

1. T. J. Maloney, "Color Increases Shop Efficiency," *FIM* 83 (April 1932): 139–42 (139, "color in the kitchen"); "Simple Uses of Color that Make Management Easier," *Factory* 30 (March 1923): 282–83; "Factory Machinery No Longer Black," *AmA* 119 (Feb. 2, 1921): 130–31; "Color Where and How," *PE* 3 (April 1932): 157–59.

2. "The Use of Color in Operating Rooms," *AmA* 114 (Dec. 4, 1918): 681-88; William O. Ludlow, "Color in the Hospital," *AmA* 118 (August 18, 1920): 226–27; FB, "The Application of Color to the Hospital," *Modern Hospital Yearbook* (1927): 313; idem, "The Psychologic Value of Color," *Modern Hospital* 31 (Dec. 1928): 85–88; J. Eastman Sheehan, "Colors to Relieve Eye Strain in the Surgical Operating Theater," *AR* 71 (March 1932): 209–11; "Color Conditioning," *DM* 39 (Oct. 1945): 9.

3. "Color: Where and How," *PE* 3 (April 1932): 157–59.

4. Maloney, "Color Increases Shop Efficiency" 140 ("controlled"), 142 ("asset"); Matt Denning and Arthur A. Brainerd, "Color for Efficiency," *PE* 13 (Jan. 1942): 19–22 (19, 70 percent); Roy C. Sheeler, "Has Color a Place in Plant Maintenance?" *DM* 39 (Sept. 1935): 7, 24; A. F. Donovan, "How Color in the Factory Helped Sales and Advertising," *PI* 154 (Jan. 8, 1931): 57–59; T. J. Maloney, "When Industry Discovers Color," *Review of Reviews* 84 (July 1931): 80–84.

5. FB, "The Harmony and Attraction of Color," *IP* 75 (June 1925): 386–88 (368, "Color"); *Ford at the Fair* (Ford Motor Company, 1934), HML-TC; Press Release, "Whittlesey," June 7, 1934, f: 1–13491, box 418, series I, UIC-CP; "Color," April 12, 1934 ("not one"), UIC-CP [courtesy of Lisa Schrenk]; *Plant Conditioning* (Sherwin-Williams, 1935), n.p. ("workers"), SIL-TC.

6. FB, "Why Fear Color?" *Architecture* 72 (July 1935): 19–20 (20, "Modernism"); FB, "Biographical Notes," Dec. 1988, box 1, YU-FBP.

7. Ibid.; Clarence Woodbury, "Color Chases the Blues," *AM* 144 (August 1947): 40–41, 126–29.

8. Woodbury, "Color Chases the Blues"; *Current Biography 1956*, s.v., "Birren, Faber" (52, "red"). On Birren's early work, see NYPL-FBP.

9. FB, "The Power of Color," *IP* 74 (Oct. 1924): 52–54 (52, "use of color"); idem, "The Language of Color," *IP* 74 (Nov. 1924): 212–14; idem, "What the Physicist Offers to Color Study," *SAM* 30 (May 1931): 552–55 (552, "basic"); idem, "Psychology Answers Problems of Color Harmony," *PTJ* 101 (Oct. 10, 1935): 31–33; National Alliance of Art and Industry, *News Letter to Members* (Jan. 1935), box 58, SU-EA.

10. ML, Cleveland, to Egmont Arens [hereafter cited as EA], Director, Industrial Styling Division, Calkins and Holden, New York, Oct. 2, 1934 (quotations), box 58, SU-EA.

11. Roy Sheldon and Egmont Arens, *Consumer Engingeering* (Harper, 1932); Don Romero, "Egmont Arens—Industrial 'Humaneer,'" *Mechanix Illustrated* (Dec. 1946); EA, "The Color Racket," typescript sent to *Advertising Age*, Jan. 22, 1935 (1, $330,000; 3, "set"; 3–4, "broader"; 4 "statistics"), box 58, SU-EA.

12. Ibid., 5 ("scientific," "job," "horse"); 6 ("carried," "generation"). Arens learned about the Spider from one of Birren's clients, the Beckett Paper Company, and they struck up a friendship in late 1934 and early 1935; see EA to C. H. Creer, Beckett Paper, Hamilton, Ohio, Oct. 17, 1934; FB to EA, Jan. 18, 1935; Wanda Martin to EA, Feb. 26, 1935, all in box 58, SU-EA.

13. Wanda Martin Birren, *Records and Recollections, Stamford, Connecticut, 1974*, 87–88, YU-FBB; Woodbury, "Color Chases the Blues," 126 ("wacky"); FB, *Functional Color* (Crimson, 1937), 109–10; Harland Manchester, "Meet the Color Engineer," *RD* 38 (June 1941): 134–35; ML, "Color at Work," *PM* 77 (March 1942): 17–25, 176 (18, packers).

14. Wanda Martin Birren, *Records and Recollections*, 89; Wolfgang Saxon, "Faber Birren, 88, Expert on Color," *NYT*, Dec. 31, 1988; Woodbury, "Color Chases the Blues," 128 ("corset"); FB, *Functional Color*.

15. Ibid.; HK, "Putting the Rainbow on the Pay Roll," *NB* 27 (June 1939): 88–89, 104–107.

16. FB, "Colors for Comfort," *RD* 30 (Feb. 1937): 4; "Meet the Color Engineer," *RD* 38 (June 1941): 134–35 ("you feel"); FB, "Biographical Notes," 3.

17. Hilaire Hiler, "Color in Architecture," *California Arts and Architecture* 60 (Sept. 1943): 18, 46 (18, "new students"); [HLT], "Second Annual Report, Division of Creative Design and Color, 1936–1937," Pittsburgh Plate Glass, HML-HLT; *Walls of Carrara: The Modern Structural Glass* (Pittsburgh Plate Glass, 1935), SIL-TC.

18. "Pittsburgh Plate Glass Buys Ditzler," *MVM* 64 (July 1928): 53; [HLT], "Second Annual Report" (quotations).

19. *Glorified Light* (Pittsburgh Plate Glass, 1936), 10–13, 32 ("color engineering") SIL-TC.

20. *Practical Suggestions for the Interesting Use of Glass and Paint in Your Home* (Pittsburgh Plate Glass, 1937), 14 ("banish"), SIL-TC.

21. "HLT, "Styling with Paint," clipping (July-August 1938): 6–7; *ABC of Paint Styling* (National Paint, Varnish, and Lacquer Association, 1938) ("You must"); "The U.S. Paint Industry Wants to Make Your Home Beautiful," *San Francisco Chronicle*, Nov. 2, 1939, all in Large Scrapbook, HML-HLT; "The Power of Color in Advertising," 58 (Sears).

22. "Trouble-Shooting with Paint," *Buildings and Building Management* (April 1941): 30–31 (30, "proper"); "Camouflage Is Proposed for City in Event of War," *P-PG*, July 18, 1941; "Camouflage Campaign Planned Here," *PST*, July 18, 1941; "If War Comes to Pittsburgh," *PP*, Sept. 10, 1941; "Camouflage Veteran Reveals Plan to Protect Pittsburgh," *PP*, Jan. 9, 1942; "Deception Guard Urged in District," *P-PG*, Jan. 10, 1942; "County May Test 'Pattern Blackout,'" *PST*, June 11, 1942; "Company Color Expert Wins Award," *Pittsburgh People* (May 1944): 8; *Maintenance Painting* (Pittsburgh Plate Glass, 1941), SIL-TC. On Britain, see "Greensdale, the Gay Colored, Will Subside into Soft Hues," *Milwaukee Journal*, Sept. 1941, Large Scrapbook, HML-HLT.

23. HLT, "Color Therapy" [1942–1944], clipping, Large Scrapbook, HML-HLT; Walter Rendell Storey, "Color Therapy in Naval Hospitals," *National Painters Magazine* (August 1944): 7 8, 24.

24. *Plant Efficiency: Ideas and Suggestions on Increasing Efficiency in Smaller Plants* (War Production Board, 1942); E. D. Peck, General Paint Manager, PPG to U.S. Commerce Dept., Oct. 25, 1943; *Pittsburgh Color Dynamics* (Pittsburgh Plate Glass, 1943); *Pittsburgh Paints Smooth as Glass*, 1944 edition (Pittsburgh Plate Glass, 1943), all in SIL-TC; "Machine and Work Room Colors," *IF* 21 (Feb. 1945): 76–78 (78, "women").

25. EA, "The War Front," in *Color in the War* (General Printing Ink Corporation, 1943), box 58, SU-EA.

26. Ibid.; Ellen H. Crosman, "With the Colors: The Story of Pigments in the War-Service," *DM* 38 (Jan.-Feb. 1944): 7–9, 24.

27. Arthur A. Brainerd and Matt Denning, "Improved Vision in Machine Tool Operations by Color Contrast," paper presented before the Thirty-fifth Annual Convention of the Illuminating Engineering Society, Atlanta, Sept. 22–25, 1941, box 58, SU-EA; Denning and Brainerd, "Color for Efficiency," 19 ("camouflaged"); [Matt Denning, Arthur Brainerd, and Robert A. Massey], "Co-ordinates Paint and Light to Improve Working Conditions, Increase Production," *Steel* 111 (Dec. 21, 1942): 74, 108; Vernon E. Brink, "Color Speeds Production," *Commerce* (March 1943): 25, 108.

28. FB, "Why Not Use Color?" *National Safety News* 47 (June 1943): 12–13, 58–66; idem, "Local Color," *National Safety News*," 50 (Sept. 1944): 16–17, 60–61; Robert A. Massey, "A Safety Color Code for Industry," *DM* 38 (April-May 1944): 18–21; *Standards for the DuPont Safety Color Code*, 1944, HML-ISA; *DuPont Safety Color Code*, 1944, YU-FBB; *A Safety Color Code for Industry* (1944), YU-FBB; "The Use of Color in Industrial Safety," *American Journal of Public Health* 36 (Sept. 1946): 992; "A Safety Color Code," *AF* 80 (May 1944): 16; "A New Safety Color Code," *FMM* 112 (March 1954): 113.

29. HK to MC, August 19, 1937 ("Working"), NYWF-1939; Hellman, "An Emolument for Heliotrope"; "Industrial Color Expert Opens New York Office," *IF* 11 (Feb. 1935); 49–50; "Color's Growing Importance," *MP* 13 (Oct. 1935): 38, 52; Max Rosedale, "The Natural Beauty of Amber and Rock Crystal Is Reproduced in Boudoir Sets Made of DuPont 'Pyralin,'" *DM* 39 (midsummer 1935): 8–9; "Rare Colors Revived," *DM* 39 (Oct. 1935): 20; Max Rosedale, "That House at Wanamaker's," *DM* 39 (Dec. 1935): 17–22; "Business Leases," *NYT*, July 24, 1936.

30. HK, *Color Planning for Business and Industry* (Harper, 1958), 121; HK, "Color and Design in Air Transportation," *Aero Digest* 33 (Sept. 1938): 46–48, 90. In 1933–1934, Norman Bel Geddes designed aircraft interiors for Pan American; see Regina Lee Blaszczyk, "Norman Bel Geddes and American Consumer Culture," in Donald Albrecht, ed., *I Have Seen the Future: Norman Bel Geddes Designs America* (Abrams, 2012).

31. "Atlantic Clipper Has Modern Interiors," *Life* 3 (August 23, 1937): 39, and "This Is the Clipper Ship That Will Fly Atlantic," *Life* 3 (August 23, 1937): 40–41; John Zukowsky, ed., *Building for Air Travel: Architecture and Design for Commercial Aviation* (Prestel, 1996): 16–18; HK, "Designing Interiors for Air Travel," *Interior Design and Decoration* (June 1940): 55–58.

32. Frederick Graham, "Aviation: Décor," *NYT*, Feb. 27, 1949 ("Good colors").

33. FB, *New Horizons in Color* (Reinhold Publishing, 1955), 125; Glenn Porter, *Raymond Loewy: Designs for a Consumer Culture* (Hagley Museum and Library, 2002); Donald Albrecht, Robert Schonfeld, Lindsay Stamm Shapiro, *Russel Wright: Creating American Lifestyle* (Abrams, 2001); Sample cards for Fabrilite (DuPont, 1952), box 7, SU-RW; *Samsonite Presents a Complete Line of Colorful Mobile School Furniture Designed by Russel Wright*, and *Announcing the Classroom Furniture of Tomorrow . . . Today [by] Samsonite,* both in box 26, SU-RW.

34. William C. Davini, "Origins and Purpose of This Manual," in M. Pleason, ed., *Color Planning for School Interiors* (St. Paul Department of Education, n.d.), 13–16 (13, "Large"), box 26, SU-RW; Harold D. Hynds and Lester Baker, *Color Planning for School Interiors* (City of New York, Board of Education, Bureau of Plant Operation and Maintenance, n.d.), 4 ("persons"), box 27, SU-RW.

35. *Egmont Arens, Industrial Design,* [ca. 1955], client list on verso front cover, box 24; EA, "Design for Living," tearsheet, n.d.; "Egmont Arens Designs New Paraffine Companies Showroom," n.d., both in box 48, all in SU-EA.

36. EA to Joseph F. Cullman III, Philip Morris, NY, Dec. 19, 1958 ("Visual"), box 21, SU-EA; Elspeth H. Brown, "Marlboro Men: Outsider Masculinities and Commercial Modeling in Postwar America," in Blaszczyk, ed., *Producing Fashion*, 191; "Two Men on a Horse," *Time* (Nov. 2, 1953), available at http://www.time.com.

37. Robert Allen Jacobs to EA, April 20, 1950 ("grand," "monotony"), box 22, SU-EA; "Office of the Year Awards," *OME* (Nov. 1950): 28–21; "New Philip Morris Office Is Highly Functional, Colorful," *OME* (Dec. 1950): 38–41.

38. Press release, "Color Schemes and Interior Decoration," 1950 (quotations), box 21, SU-EA.

39. Ibid. (quotations); "More Cigarets?" *Time* (March 26, 1945), available at http://www.time.com.

40. EA to O. Parker McComas [hereafter cited as OPM], Philip Morris, New York, June 30, 1949, box 21, SU-EA; Press release, "Color Schemes and Interior Decoration" (quotations).

41. "Report by Egmont Arens," Nov. 9, 1950; EA to OPM, May 15, 1950 ("interested"); "Telephone Conversation with Mr. Ames of Philip Morris," typed memo by Kay ?, March 3, 1952 ("chocolate"), all in box 21, SU-EA.

42. EA to Alfred Lyon, Nov. 10, 1947; EA to Ernest Dichter, New York, Nov. 6, 12 ("same language"), Dec. 29, 1947; EA, "Interview with Dr. Ernest Dichter," Nov. 11, 1947; ED to EA, Jan. 29, 1948; "Proposed Letter from Dr. Dichter to Mr. Lyon" [Jan. 29, 1948], all in box 23, SU-EA.

43. For Cheskin's role, see, boxes 21 and 23, SU-EA. For EA's reaction, see EA to Hugh Cullman, Philip Morris, New York, Oct. 27, 1954 ("skepticism," "good taste"); EA, "Some Comments on the Cheskin Color and Design Evaluation System," Oct. 27, 1954, 1 ("disastrous"), both in box 23, SU-EA.

44. EA, "Some Comments on the Cheskin Color and Design Evaluation System," 2 ("Magenta Red") 3 ("white").

45. EA, "Color Dynamics," typescript of lecture on "Showmanship through Color" for Eastern Conference of AFA Women's Advertising Club, NY, Feb. 6, 1954 ("dynamic"), box 21, SU-EA.

46. *American Color Trends: A Brief Statement of Service in a Special Field of Research*, pamphlet, ca. 1960 ("fact-finding"), box 8, YU-FBP.

47. Frederick H. Rahr, "Can the Public Choose Colors?" *Textile Colorist and Converter* 69 (Dec. 1947): 30, 53 (30 "find"); Nadine Bertin, "The House & Garden Color Program," *CR&A* 3 (summer 1978): 71–78.

48. FB, "Biographical Notes," 5.

49. *House and Garden* [hereafter cited as *H&G*], *Economic Trends in Color* 7 (Third Quarter, 1960): 1 ("I.B.M."); idem, *Economic Trends in Color* 8 (Fourth Quarter, 1960): 2 ("people want change"); idem, *Economic Trends in Color* 12 (Second Half, 1962): 5 (long quotation); idem, *Economic Trends in Color* 15 (1964–1965): 1.

50. *H&G, Economic Trends in Color* 11 (First Half 1962): 6.

Chapter 10

1. Greg Castillo, *Cold War on the Home Front: The Soft Power of Midcentury Design* (University of Minnesota Press, 2010), vii–xi; Cristina Carbone, "Staging the Kitchen Debate: How Splitnik Got Normalized in the United States," in *Cold War Kitchen: Americanization, Technology, and European Users*, ed. Ruth Oldenziel and Karin Zachmann (MIT Press, 2009).

2. Vance Packard [hereafter cited as VP], *The Waste Makers* (D. McKay, 1960; reprint edition: Penguin, 1966), 21 ("average").

3. VP, *Waste Makers,* 38 ("matching"), 42, 116 ("replacement").

4. "Consumers Select Rayon Fabric Colors," *RTM* 28 (August 1947): 438; HK, *Color Planning*, 204–12 (209, "protective"); Hellman, "An Emolument for Heliotrope."

5. "The Color Man," *Newsweek* 32 (June 28, 1948): 68–69; Stanley Frank, "There's a Hue for You, Too," *NB* 37 (Feb. 1949): 43–54, 58; HK, *Color Planning*, 7, 48–55, 135–37.

6. See, for example, Russel Flinchum, *Henry Dreyfuss, Industrial Designer: The Man in the Brown Suit* (Cooper-Hewitt, National Design Museum, Smithsonian Institution, and Rizzoli, 1997); Henry Dreyfuss, *Designing for People* (Simon and Schuster, 1955).

7. Dreyfuss, *Designing for People*, 105 ("ambassador"). On phone design, see Janin Hadlaw, Communicating Modernity: Design, Representation, and the Making of the Telephone, Ph.D. dissertation, Simon Fraser University, 2004; Sally Clarke, "Negotiating between the Firm and the Consumer: Bell Labs and the Development of the Modern Telephone," in *The Modern Worlds of Business and Industry: Cultures, Technology, Labor*, ed. Karen R. Merrill (Brepols, 1998), 161–82.

8. "Color Comes Calling: A Lecture-Demonstration," Typescript, Chesapeake and Potomac Telephone Company of Virginia, 1957 ("You"), old box 22, old folder: Jamestown Festival—Correspondence, HML-IS.

9. "Tenite Speaking," advertisement for Tennessee Eastman Corporation, ca. 1938, author's collection; HK, *Color Planning,* 131 ("typewriters").

10. On the role of Dreyfuss, see Memo on Bell Telephone Laboratory, Project 39: Hand Set and Project 42: Combined Set, May 1953, box: Photostat of Brown Book, CH-HD. HK, "How to Apply Color in Design," *MD* 29 (Feb. 7, 1957): 90 ("blend").

11. "RHH" to [Henry Dreyfuss], "Book," June 9, 1953 ("Howard's"), box: Publications 1, CH-HD; R. L. Jones to H. P. Charlesworth, Feb. 18, 1930, f: Correspondence with Outside Consulting Artists, case 35585, vol. A., AT&T Archives ("men"), cited by Hadlaw, Communicating Modernity, 83.

12. HK, *Color Planning,* 2–3 ("In addition"); VP, *Waste Makers,* 38 ("Bell").

13. *Ford at Fifty, 1903–1953* (Simon and Schuster, 1953), 78 ("selection").

14. HK, *Color Planning*, 124–26; P. K. Thomajan, "General Motors Styles for Sales," *AmF* 25 (spring 1953): 74–78; Thomas Hine, *Populuxe* (Knopf, 1986).

15. Jack D. Hunter, "Colors for Colorful Cars," *DM* 59 (March-April 1965): 22–26; Research Department, "Ford Theatre Commercials: A Survey of Regular and Short Versions," June 1955 ("gadgets"), box 1, HFM-S&A; "Cater to the Ladies," *MA* 81 (Feb. 1962): 52–53, 101, 142; lyrics for "Santa Baby" (1954) available at http://www.earthakittfanclub.com; "Keeping Up with the Ladies," *CW* 75 (Nov. 27, 1954): 82–86 (84, 65 percent); *Ford at Fifty*, 78 ("Her decision").

16. "Color—The Catalyst of Commerce [Part I]," *ADR* 45 (Nov. 5, 1956): 833–40; "Putting Color on Wheels," *CW* 75 (Nov. 6, 1954): 50–54.

17. Jessie Ash Arndt, "Behind the Wheel," *CSM*, April 7, 1958 ("Damsels"); "General Motors . . . A Fashion Factor in the United States," *AmF* 37 (summer 1956): 112–16.

18. "New Car Colors," *DM* 45 (Dec. 1951–Jan. 1952): 26–27; "Bolder Use of Color Seen in Automobiles of Future," *CMA* 72 (Sept. 1953): 40 (1951); "Developing Trends in Automobile Fabrics," *AmF* 25 (summer 1953): 127.

19. "Colors: Three-Tone Combinations Get Special Treatment," *IA* 175 (March 24, 1955): 71 (25 percent); "Multi-tones Create Multi-problems," *IA* 175 (March 31, 1955): 52 (40 percent); "Two-Toning Pleases Customers," *CMA* 75 (Jan. 1956): 54–55, 114; "Pastel Demand Spurs Research," *CW* 79 (August 25, 1956): 51–52; Timothy F. Bresnahan, "Competition and Collusion in the American Automobile Industry: The 1955 Price War," *JIE* 35 (June 1987): 457–82. The last article makes no reference to color.

20. "Auto Upholstery Fabrics Get a New Sparkle," *AmF* 27 (autumn 1953): 107–109 (107, "gaiety"); S. L. Terry, "Glamour Goes Scientific," *SAEJ* 62 (Oct. 1954): 76–77 (77, "new frontiers"); "Colorful Cars," *AI* 109 (Dec. 15, 1953): 52–53 ("styling studios").

21. Daniel Horowitz, ed., *American Social Classes in the 1950s: Selections from Vance Packard's The Status Seekers* (Bedford/St. Martin's, 1995), 62–63 (63, "screaming"); "New Car Colors," *DM* 45 (Dec. 1951–Jan. 1952): 26–27; "Car Colors Add Safety and Performance Benefits," *POCR* 118 (April 7, 1955): 57 (Stuart).

22. Virgil M. Exner, "The Use of Color," *AmF* 29 (summer 1954): 94–95 ("From"); "Timing on Metallic Paint Program, Mark II," 1956, box 32, HFM-DTM.

23. Herbert E. Eastlack, "New Color Effects for Automobiles," *DM* 40 (August-Sept. 1946): 12–14; "New . . . strikingly beautiful!" (advertisement for Duco Metalli-Chrome Lacquer), *DM* 42 (April 1948): back cover; N. J. Mooney, *Automotive Color Popularity [January through June 1954]* (Color Advisory Service, E. I. du Pont de Nemours & Company, 1954) ("intensities"), YU-FBB; idem, *Automotive Color Popularity [January through December 1954]* (Color Advisory Service, E. I. du Pont de Nemours & Company, [1955]) ("Thirties"), YU-FBB.

24. "Announcing Two New Auto Finishes," *DM* 50 (Feb.-March 1956): 6–7; Roy B. Davis, "Trends in New Automotive Finishes," *SAEJ* 62 (Sept. 1954): 41; Ford Motor Company, Continental Division, "Minutes of Product Committee Meeting—March 8, 1956," March 13, 1956, box 32; "Styling Objectives: Special Product Operations Styling Section" [1952], [2] ("Formal" vs. "Informal"), box 24; William C. Ford, "Styling Objectives of the X-1500 Program," Jan. 22, 1953 box 86; "First Owner Survey, 1954 Models," Report by Marketing and Car Distribution Department, General Sales Office, Ford Motor Company, July 31, 1954, 3, Table 4 ("harmony"), box 19, all in HFM-DTM.

25. N. J. Mooney, *Automotive Color Popularity [January through December 1957]* (Color Advisory Service, E. I. du Pont de Nemours & Co., [1958], YU-FBB; "Color—The Catalyst of Commerce, Part II," *ADR* 46 (April 8, 1957): 235–36, 243 (236, "Forward"); "Color Rash May Die Soon," *CMA* 74 (April 1955): 34 ("rash," "spate"); N. J. Mooney, *1959 Automotive Color Popularity* (Color Advisory Service, E. I. du Pont de Nemours & Co., [1960] (1954–1959 percentages), YU-FBB.

26. Mitchell transcript, 10 ("whistle"), 37 (age 65); "Subdued Colors for '62's," *MA* 80 (Oct. 1961): 50 ("fins").

27. Caroline M. Goldstein, *Do It Yourself: Home Improvement in 20th-Century America* (National Building Museum and Princeton Architectural Press, 1998); Richard Harris, "The Birth of the North American Home Improvement Store,

1905–1929," *Enterprise and Society* 10 (Dec. 2009): 687–728; Regina Lee Blaszczyk, *Rohm and Haas: A Century of Innovation* (University of Pennsylvania Press, 2009), chapter 6.

28. Ibid.

29. [Frigidaire Div., GM], [Digest of news items on colored appliances and color in the kitchen], [1955], [7]; Meredith Publishing Co., "A Report of the Paint and Wallpaper Market and Buying Habits of Consumers," 25 (Rahr), both in K-FC.

30. "Picking the Color that Sells," *BW* (July 12, 1952): 66.

31. "Color—The Catalyst of Commerce [Part I]," 839 ("everybody"); "Imagine a Beautiful Showplace Kitchen Paid for Through More Efficient Kitchen," advertisement by the Chambers Company, *BHG* (Sept. 1950), in [Frigidaire Div., GM], [Digest of news items on colored appliances and color in the kitchen]; HK, "How to Plan Product Colors," *PE* 22 (August 1951): 139–46.

32. ED, "The New Psychology of Electrical Appliances," Research report for Ralph H. Jones Advertising Agency, [c. 1951], 1–4 (1 "face" and "psychological"; 2 "old homebody"; 3 "livability" and "décor"), HML-ED.

33. "Decorative Hues Help Realty Men Win Buyers, Influence Tenants," *NYT*, Dec. 27, 1959 ("red and white"); Transcript from *House & Home* Kitchen Roundtable, July 7–8, 1955; "The Infinite Variety of Color Challenges Makers and Users Alike," Report from the Round Table Discussion on Color at *House & Home*, held Oct. 24–26, 1955, [7] ("Today"), both in K-FC.

34. "The Infinite Variety" [7–8] ("builder can take"), [8] ("will not finance"); P. I. Prentice, *House & Home*, NY, to J. K. Kay, Frigidaire, Dayton, Oct. 18, 1955 ("FHA"), K-FC.

35. "The Infinite Variety" [19] ("One big"), [20] ("80%").

36. John R. McCord, Ferro Corporation, Cleveland, to R. F. Nicholas, Marketing Research, Frigidaire, Dayton, June 10, 1955 ("consensus"), K-FC; Kitchen Round Table transcript, [5] ("idea").

37. [Digest of news items on colored appliances and color in the kitchen], [8], [18] ("yellow kitchen"), [19], "change in decorating").

38. ED, "The New Psychology of Electrical Appliances," 3 ("nostalgic").

39. [Digest of news items on colored appliances and color in the kitchen], [17] ("dim," "headache," "Sky Blue," "color idea").

40. "Colored Appliances Liven Promotion, but White Still Gets the Vote," *Sales Management* 77 (Sept. 21, 1956): 50–58 (50, "At Frigidaire"); J. K. Kay, Letter No. 4863, Feb. 23, 1954; Robert M. Bell, Letter No. 4909, June 28, 1954, K-FC; Packard, *Waste Makers*, 116 ("Americans").

41. Report by R. W. Fesmire, Good Housekeeping Shop, Midland, TX, [1959] ("first"), K-FC [hereafter cited as Fesmire report]. For regional preferences, see C. R. White to F. G. Jones, "District Sales to Dealers in Color," Table I: "District Sales to Dealers, 12 Mo. 1958 Model Years," April 24, 1959, K-FC.

42. On downscale neighborhoods, see Fesmire report. On Kane and Zech, see Howard J. Emerson, "$100,000 a Year in Colored Appliances," *EM* 88 (Nov. 1956): 49–52 (quotations).

43. W. H. Anderson to R. L. Hatfield, March 6, 1959 ("aggressively," "white over color"), K-FC; Fesmire report ("beauty," "habit").

44. Charles P. Coogan, Sales Promotion Manager, Frigidaire, New York, to E. J. Will, Frigidaire Division, General Motors Corporation, Dayton, June 30, 1959 ("safe"), K-FC; Home Appliance Company, Texarkana, to Les Turner, Frigidaire Sales Corporation, Fort Worth, June 27, 1959 ("appliance business," "I don't think"), K-FC.

45. Packard, *Waste Makers*, 121 ("stylists'"); R. V. Hutchins to Ken Kay, Feb. 26, 1964 (Frigidaire statistics), K-FC.

46. "What Will Be the Color Trends for the New Cars?" *DM* 54 (Sept.-Oct. 1960): 6–7; Carleton B. Spencer, "Automotive Color Production: From Premise to Product," *CE* 2 (Jan. 1964); 12, 26; Dudley J. Smart, "A Stylist Looks at Color," *CE* 3

(May-June 1965): 26–28; "Car Colors Discussed by GM Stylist," *ADR* 56 (Nov. 6, 1967): 57 (18 months); John A. Mock, "The Importance of Color in Product Design," *ME* 77 (May 1973): 22–28; HK, *Color Planning*, 125.

47. For McDaniel, see "Car Colors Discussed by GM Stylist," *ADR* 56 (Nov. 6, 1967): 57; lyrics for "Just an Old Fashioned Girl" available at http://www.earthakittfanclub.com.

48. Ford Motor Company, Car and Truck Divisions, Marketing Research Office, "Motivations in the Medium-Priced Car Market: Suggested Actions for Mercury and Edsel," April 24, 1958, 26 (quotations), AR-66-34:3, FMCA.

49. "Car Colors Discussed by GM Stylist."

50. FB, "Choosing the Right Color," *MD* 31 (August 6, 1959): 100–106 (105, "pink"); "Car Colors Discussed by GM Stylist" (beige).

51. John B. Stewart, "Planned Obsolescence," *HBR* 37 (Sept.-Oct. 1959): 14–18, 21–24, 169–174; Ford Motor Company, Ford Division, Product Planning Office, "Forward Thunderbird Program," April 14, 1958, 14–15 (14, "planned program"; 15, "styling race"), AR-63-1438:3, FMCA.

52. L. David Ash, Transcript of oral history, 55–56, Jan. 25, 1985, HFM-DHC.

Chapter 11

1. *Funny Face,* directed by Stanley Donen (Paramount Pictures, 1957).

2. Grace Mirabella with Judith Warner, *In and Out of Vogue: A Memoir* (Doubleday, 1995); Diana Vreeland, *D.V.,* ed. George Plimpton and Christopher Hemphill (Da Capo, 1997).

3. BM No. 156, Feb. 21, 1949, n.p. ("service," "own"), box 1, HML-CA.

4. "Promotion Committee to Launch World's Fair Colors," 1937; MC to Director of Concessions, "Progress on Color Program," April 3, 1937 (Green Ball), both in NYWF-1939; MC, "Merchandising of Fashions," in *How the Fashion World Works*, ed. Margaretta Stevenson (Harper & Brothers, 1938).

5. MHR to GAW, Nov. 5, 1937; MC to GAW, "Color Promotion Suggested by Margaret H. Rorke," Dec. 6, 1937 ("not sure," "outstanding," "Studebaker"); [MC], "Color Merchandising Program for 1938," 7, all in NYWF-1939.

6. MC to [GAW], "Suggestions for Planning the Fashion Program for the New York World's Fair 1939," May 28, 1937 ("checked"); [MC], "Color Merchandising Program for 1938: Pre-Fair Promotion for New York World's Fair 1939," both in NYWF-1939.

7. MC to GAW, "Color Promotion Suggested by Margaret H. Rorke" ("help"); I. A. Jacoby to MC, "Silk to Modern Music," March 30, 1939, NYWF-1939; MC, "First Fashion Bulletin on Colors," March 25, 1938, box 8; BM No. 125, June 8, 1939, 1 ("large color ballet"), box 1, both in HML-CA.

8. F. T. Simon and E. L. Stearns, "Why Small Color Differences Are Important in Textiles," *ADR* 33 (May 22, 1944): 232–35 (232, "Easter parade"); BM No. 129, June 27, 1940, n.p. ("splendid"), box 1, HML-CA.

9. Carl[ton B.] Spencer questionnaire, March 15, 1938 ("Have"), old box 38, HML-IS.

10. William Hand to MHR, March 9, 1938 ("necktie silks"); H. J. Stratton questionnaire, March ?, 1938 ("acetate"); C. V. Offray, C. M. Offray & Son Inc., N.Y., to TCCA, March 16, 1938 ("entire"), old box 38, HML-IS.

11. BM No. 138, April 13, 1944, n.p. ("blazing"), box 1, HML-CA.

12. "'Major' Hobby's WAACs," *Time,* May 25, 1942; Jessica Daves, *Ready-Made Miracle: The American Story of Fashion for the Millions* (Putnam, [1967]), 143; Spencer E. Ante, *Creative Capital: Georges Doriot and the Birth of Venture Capital* (Harvard Business School Press, 2008); Margaret Vining, e-mail to author, Dec. 13, 2010.

13. "Senate Group Backs Bill for Women's Navy Reserve Corps," *WW,* June 24, 1942 ("girdle"); Bernard Roshco, *The Rag Race: How New York and Paris Run the Breakneck Business of Dressing American Women* (Funk and Wagnalls, [1963]), 135–36.

14. Amy T. Peterson and Ann T. Kellogg, eds., *The Greenwood Encyclopedia of Clothing through American History, 1900 to the Present* (Greenwood, 2008), 225.

15. BB, Expense Report to *Chicago Tribune-New York News* Syndicate, Nov. 16, 1939, f: Bettina Bedwell Expense Reports, 1939–1940, AAA-AR; "Bettina Bedwell Dies; Noted Fashion Writer," *New York News*, April 30, 1947; "Bettina Bedwell," *NYT*, May 1, 1947.

16. BM No. 156, Feb. 21, 1949, n.p. ("copying"), box 1, HML-CA; Roshco, *The Rag Race*, 10–11; Véronique Pouillard, "Design Piracy in the Fashion Industries of Paris and New York in the Interwar Years," *BHR* 85 (summer 2011): 319–44.

17. "Bénédictine to Sue Its Imitators Here," *NYT*, Oct. 26, 1950; James J. Nagle, "Advertising and Marketing Round-Up," *NYT*, Feb. 24, 1952.

18. Nagle, "Advertising and Marketing Round-Up"; "Bénédictine Tries to Become Generic Color," *Tide* (Feb. 29, 1952): 27; Saks Fifth Avenue, advertisement, "Vogue Toasts 'A New Name in Color: Bénédictine," *NYT*, Jan. 13, 1952. For the promotion, see *Vogue* 119 (Jan. 1, 1952): 108–10, 144–47; (Feb. 1, 1952): 48–57, 202–203 (48, "Good taste"); (Feb. 15, 1952): 78–79; (March 1, 1952): 64–65, 154–55.

19. "Cognac Trend Hopeful," *NYT*, March 15, 1953, clipping; ET, "Memo for Mrs. Rorke," March 5, 1953 ("successful," "entire" "similar"); idem, ["Memo for Mrs. Rorke"], March, 11, 1953; "AM," "Cognac," April 1, 1953; Press release, "A New Color Is Born . . . Cognac," issued by McGarry & Scher, Paris, n.d., all in box 19, HML-CA.

20. For the Mamie Look, see Karl Ann Marling, *As Seen on TV: The Visual Culture of Everyday Life in the 1950s* (Harvard University Press, 1994).

21. Mary E. Monze and Gertrude Brooks Dixson, "Everybody's Mad for Pink," *American Home* 53 (March 1955): 57–61, 138; Brooks Brothers, "The Pink Shirt for Women," available at http://www.brooksbrothers.com.

22. Matthew P. Hyland, Millinery Promotions, New York, to MHR, Feb. 13, 1953 ("White House"); Millinery Promotions, Press release for "First Lady Pink," Feb. 1953 ("Alice Blue"), both in box 22, HML-CA.

23. Board of Directors, Executive Committee Meeting No. 3, March 30, 1955, 4 ("consultants"), box 1, HML-CA.

24. ED to Charles Feldman, Young and Rubicam, New York, "Cannon Nylons," May 26, 1952 ("individuality"), HML-ED.

25. Ibid. (quotations).

26. Institute for Motivational Research, "A Creative Problem Analysis and Suggested Areas of Research Seeking to Increase the Sale and Use of Nylon Bed Sheets," report submitted to the DuPont Company, Nov. 1956, 16 ("synthetics"), HML-ED.

27. Regina Lee Blaszczyk, "Styling Synthetics: DuPont's Marketing of Fabrics and Fashions in Postwar America," *BHR* 80 (autumn 2006): 485–528.

28. Terri Cook, interview by author, New York, May 26, 2009.

29. Margaret Ingersoll, "How Color Comes to Life in Fashion," *ADR* 51 (June 11, 1962): 58–59 (58, "desk").

30. Ibid., 58 ("pinning," "dark ages," "device," "ping-pong"), 59 ("shoe people"); Daves, *Ready-Made Miracle*, 101–107.

31. Ingersoll, "How Color Comes to Life in Fashion," 59 ("new," "success," "zinnia print"); Daves, *Ready-Made Miracle*, 60. On pink, see *Vogue* 138 (Jan. 1, 1961): 92–97, 144–45 (95, "mauvey"); *Vogue* 138 (Feb. 1, 1961): 178–79. On the zinnia, see *Vogue* 138 (Sept. 15, 1961): 140–45; *Vogue* 139 (Jan. 1, 1962): 28–33, 110–11; *Vogue* 139 (Jan. 15, 1962): 92–93.

32. Daves, *Ready-Made Miracle*, 232–34; Roshco, *The Rag Race*, 209–13.

33. Blaszczyk, *American Consumer Society*, chapter 8.

34. Regina Lee Blaszczyk, "Ernest Dichter and the Peacock Revolution: Motivation Research, the Menswear Market, and the DuPont Company," in *Ernest Dichter and Motivation Research: New Perspectives on the Making of Post-War Consumer Culture*, ed. Stefan Schwarzkopf and Ranier Gries (Palgrave Macmillan, 2010).

35. *Penneys Special Edition with Groovy Kids Stuff* (J. C. Penney, 1969), 2 (quotations).

36. Midge Wilson, "The Color Merry-Go-Round," *Textile Marketing Letter* 9 (Jan. 1974): 1, 4–5 (quotations).

Conclusion

1. The decline of the British Colour Council is documented in UB-DCA. On new forecasting organizations in Japan, see Nippon Color and Design Research Institute, "History of the Institute," May 1977, and *This Is the Color Planning Center* (Color Planning Center, 1969), both in old box 105, and press release, "Japan Fashion Color Association," n.d., old box 80, all in HML-IS. For Europe, see Presage Paris Fashion Forecasts for 1961–1987 in AAD-PRE and the Bilbille forecasts in PH-DC.

2. "Shades for Marketing Shown by Color Group," *CE* 2 (Feb. 1964): 8–9.

3. On Pantone, see http://www.pantone.com/pages/pantone/index.aspx and http://www.fundinguniverse.com/company-histories/Pantone-Inc-Company-History.html.

4. Pantone has recently ventured into the history of color trends; see Leatrice Eiseman and Keith Recker, *Pantone: The Twentieth Century in Color* (Chronicle Books, 2011).

5. On the recent past, see Mary Lisa Gavenas, *Color Stories: Behind the Scenes of America's Billion-Dollar Beauty Industry* (Simon & Schuster, 2007). Première Vision was founded in 1973 by weavers from Lyon, France (see http://www.premierevision.com/en).

Index

Gloves, 18, 84, 89, 163, 172, 182, 184, 283, 276, 284

Gobelins, Manufacture des, 33–36, 44, 46, 290

Goethe, Johann Wolfgang von, 7, 34

Golden Harvest, 18

Goldman, Jacob, 165

Good Housekeeping Institute, 256

Good Housekeeping Shop, 261

Gotham Silk Hosiery, 170

Gowans, James, 79

Grammar of Ornament (Jones), 38

Graphic arts, 66–68, 95, 147, 297. *See also* Chromolithography

Graves, Michael, 12

Great Depression, 15, 115, 134, 160, 170, 187, 205, 208, 213, 220, 222, 256, 266

"Great Masculine Renunciation," 84

Great White Fleet, 100

Green Ball, 160, 266, 267

Greenewalt, Mary Hallock, 193–196, 211

Greenleaf, Ray, 68

Gregorie, Eugene, 223

Gregory, John, 200

Gropius, Walter, 12, 203, 205, 207

Guerin, Jules, 192, 207

Guild, Lurelle, 134

Guinon, Marnas et Bonnet, 24

Guirand de Scévola, Lucien-Victor, 104

Hadley Mills, 64

Hall, Virginia Chandler, 141

Hand, William, 88, 268

Hannah Troy, 276

Hartley, Marsden, 146

Hartnett, Sunny, 265

Harvard University, 51–55, 187, 212

Hats. *See* Millinery

Haute couture, 10, 16, 18, 39, 40, 73, 74, 83, 86, 88, 125, 130, 138, 149, 153, 160, 172, 174, 177, 184–189, 267, 276, 280, 281, 286, 292, 294. *Also see names of individual houses*

Hawes, Elizabeth, 84

H. B. Claflin Corporation, 89, 90

Hennessy, Maurice, 276

Herbert, Lawrence, 296, 297

Hibben, Samuel, 223

Hicks, Mary Dana, 49, 50, 57

Higgins, Sydney H., 32

Tobé, 180, 188, 189

Toch, Maximilian, 101, 207

Toulouse-Lautrec, Henri de, 47

Towle, H. Ledyard, 1, 3, 12, 44, 84, 168, 296
 in advertising, 123, 124, 130, 140
 camouflage, 8, 95, 97, 108–113, 292
 at DuPont, 115, *123–126*, 132, 137, 138, 220, 280
 fine art, *94*
 at GM, 13, *127–130*, 138, 220, 262
 at PPG, 130, *131*, 215, 223–225, 268
 reverse camouflage, 113, 115, 128, 137, 138, 223–225

Toyota, 7, 297

Tracy, Evarts, 107

Trade associations, 10, 39, 92, 278. *See also* names of individual associations

Trinity Church (Boston), 38

Trippe, Juan 231

True Blue color, 119, 129, 164, 214, 262

Tufts College, 52

Turkey red, 27

Tuscan color, 144

Tutankhamen's tomb, 152

Twiggy, 284

Two-tone automobiles, 1, 18, 125, 128, 137, 248, 250, 253, 256, 258, 266, 280

Tyrian purple, 22, 26

Under-consumption, 8, 15

Uniforms, military, 104, 169, 187, 270–272

Union Carbide and Carbon Corporation, 273

Unique Suit and Cloak House, 88

United Ladies' Tailors' Association of America, 73

U.S. Army, 95, 106–112, 169, 187, 229, 270–272

U.S. Department of Commerce, 8, 138, 151, 166–169, 273

U.S. Navy, 96, 100–103, 106, 108, 169, 272

U.S. Shipping Board, 101, 106, 107

U.S. Treasury Department, 101

United Waist League of America, 165

University of Chicago, 219

University of Groningen, 53

Urban, Joseph, 16, 84, 202, 203, 207–212, 292

Valentine & Company, 121

Valentino, Rudolph, 152

Woman's National Made in the U.S.A. League, 88

Woman's viewpoint, 18, 91, 141, 188, 249, 290

Women Accepted into Voluntary Emergency Services (WAVES), 272

Women's Army Auxiliary Corps (WAAC), 270–272

Women's magazines

 Delineator, 91

 Good Housekeeping, 91, 141, 256

 McCall's, 91, 258

 Woman's Home Companion, 91

 See also fashion magazines

Women's Reserve Camouflage Corps, 108

Women's Wear. See newspapers

Woodward, William L., 66

Woolworth & Company, F. W., 192, 198, 214

World War I, 8, 12, 15, 16, 68, 70–74, 86, 88, 95–113, 116, 146, 148, 170, 180, 197, 202, 216, 226, 290, 292

World War II, 12, 15, 16, 84, 213–216, 224–231, 239, 242, 244, 248, 253–256, 263, 266–273, 280, 286, 288, 292, 294

World's Fair Color Series, 267

Worth, Charles Frederick, 39

 Maison, 138, 178, 182

Worumbo, 79, 91

Wright, Frank Lloyd, 203, 258

Wright, Russel, 232, 244

Yale University, 98

"Youth quake," 284

Youth's Companion, 62

Ziegfeld Follies, 202, 208

Zuckerman, Ben, 283